The finest
Cloths in the World

WOVEN IN
VIRGIN WOOL

Royal Seal

MATERIALS

for fashionable clothes

HOLLAND & LEWIS (Ladies' Fabrics) LTD.
LONDON & LEEDS

FINE PIECE-DYED
AND YARN-DYED
WORSTED SUITINGS
by

Kessler & Co. Ltd.

Established
1830

NEW STREET MILLS
PUDSEY, YORKSHIRE

Offices & Warehouses : 64 Vicar Lane, Bradford
to which all correspondence should be addressed

BRAEMAR
KNITWEAR

INNES, HENDERSON AND COMPANY LTD.
HAWICK, SCOTLAND

OVERSEAS REPRESENTATIVES
U.S.A.
Hunt & Winterbotham Mills Ltd., 10 East 49th St.,
New York City.
CANADA
A. Affleck, Room 503, 11 King St. West, Toronto, 2.
S. AMERICA
Adams & Cunat, Calle Rivadavia. 973, Buenos Aires.
AUSTRALIA
P. B. Sheather & Sons Pty., Ltd., 117 York St., Sydney.
S. AFRICA
Horace E. Babb, 302 Monarch House, 58-60 Long St.,
Cape Town.
N. ZEALAND
T. M. Hawes, P.O. Box 566, Auckland.

CW00516193

WOOLLEN MANUFACTURE

G. & J. STUBLEY Ltd.

BOTTOMS MILLS & HICK LANE MILLS · BATLEY

The Cloth Manufacturers . . .

W. F. STEWART & CO. LTD.

Woollen and Worsted Manufacturers and Spinners
WAUKRIGG MILL, GALASHIELS, SCOTLAND

Holland & Sherry Ltd

7 & 8 Warwick Street · Golden Square · LONDON, W.1

WOOLLEN MERCHANTS

Cloths of distinction for the leading
bespoke tailors throughout the World

POROUS · POROUS SECO . ZEPHAIR · DUROMOL · SANGTWIST

JAMES HARE

Woollens and Worsteds – Ladies' and Men's

JAMES HARE LTD.
LEEDS & LONDON, ENGLAND.

THE AMBASSADOR MAGAZINE

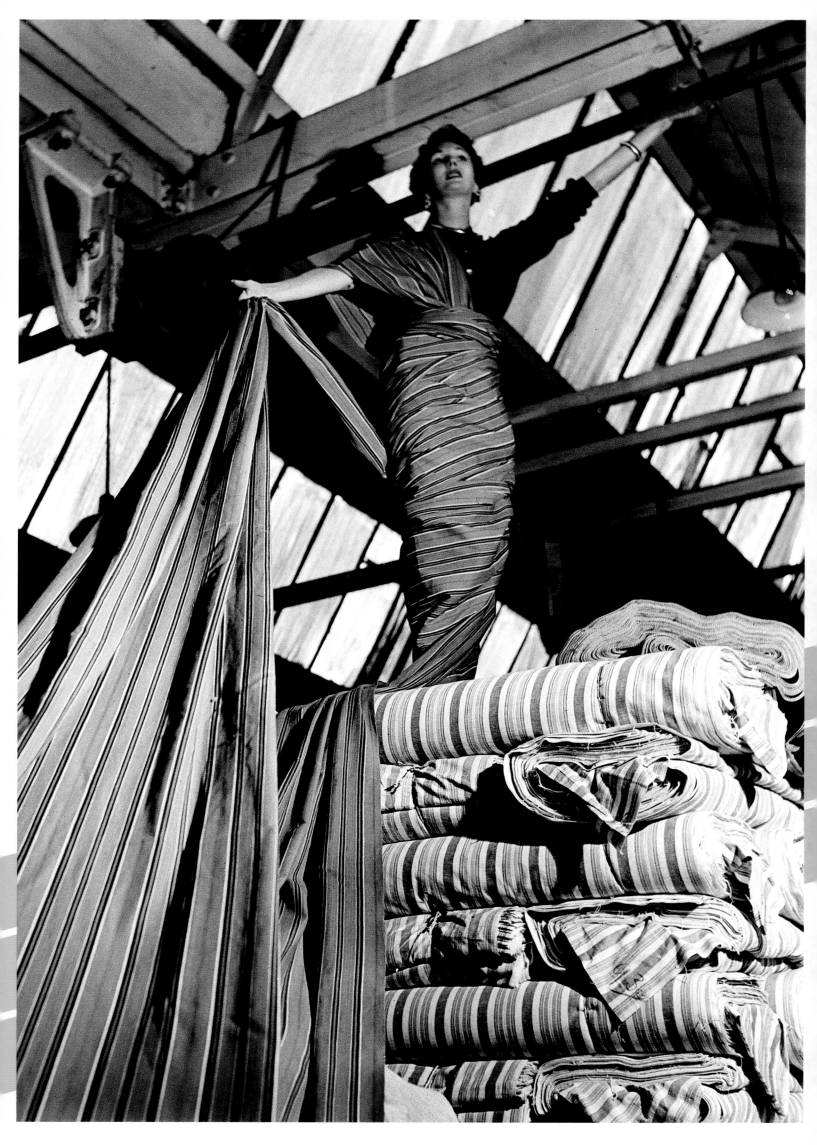

THE AMBASSADOR MAGAZINE

MAGAZINE

PROMOTING POST-WAR BRITISH TEXTILES AND FASHION

Edited by Christopher Breward & Claire Wilcox

V&A PUBLISHING

First published by V&A Publishing, 2012
Victoria and Albert Museum
South Kensington
London SW7 2RL
www.vandabooks.com

Distributed in North America by Harry N. Abrams Inc., New York

© The Board of Trustees of the Victoria and Albert Museum, 2012

The moral right of the author(s) has been asserted.

Hardback edition
ISBN 978 1 85177 677 1

Library of Congress Control Number 2011935127

10 9 8 7 6 5 4 3 2 1
2016 2015 2014 2013 2012

A catalogue record for this book is available from the British Library.
All rights reserved. No part of this publication may be reproduced,
stored in a retrieval system, or transmitted in any form or by any means,
electronic, mechanical, photocopying, recording or otherwise,
without written permission of the publishers.

Every effort has been made to seek permission to reproduce those
images whose copyright does not reside with the V&A, and we are grateful
to the individuals and institutions who have assisted in this task.
Any omissions are entirely unintentional, and the details should be
addressed to V&A Publishing.

Front jacket illustration: Barbara Goalen photographed for
'Milling around Lancashire, *The Ambassador*, 1952, no.9 (see pp.60–61)
Back jacket illustration: Cover by Graham Sutherland, 1960, no.7 (see p.121)
Pages 38–43: 'Out of This World', 1957, no.12
Pages 96–101: 'Portland Stone – Portland Colours', 1954, no.6
Pages 128–33: 'Tex-Tiles', 1963, no.6
Pages 166–71: 'Country Weekend', 1951, no.5
Pages 212–17: 'Fab Pop Fash', 1964, no.4

Designer: Lizzie Ballantyne
Copy-editor: Delia Gaze
Index: Christine Shuttleworth

New V&A Photography by V&A Photographic Studio

Printed in Hong Kong

V&A Publishing
Supporting the world's leading
museum of art and design,
the Victoria and Albert
Museum, London

Contents

Introduction

Christopher Breward

Cover by 'Ett' **1956, no. 3**

The Ambassador No.3 1956

British Export magazine

ett.

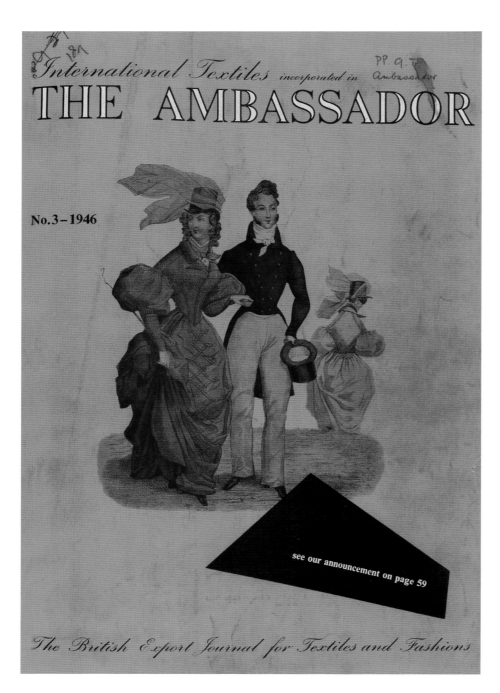

Cover showing name change from
International Textiles to *The Ambassador*
1946, no.3

IN MARCH 1946, barely a year after the end of the Second World War, the established trade journal *International Textiles* (founded by Ludwig Katz in Amsterdam and London in 1933 and published solely in London from 1940 by Hans Juda) re-launched itself under Hans's sole proprietorship. Inside its bright fuchsia cover, which cleverly combined the shock of modern typography and colour printing with a nostalgic reproduction of an early nineteenth-century engraved fashion plate, an ambitious editorial note explained:

Our readers will have noted that a new name has been added to 'International Textiles': THE AMBASSADOR. We have felt for a long time that the word 'international' does not do justice to the fact that ours is a BRITISH Export Journal. We

have always considered ourselves as THE AMBASSADOR of Britain's textile and fashion industries . . . THE AMBASSADOR stands for the principles which 'International Textiles' has increasingly emphasized in the past: to show the world what British creative ability and craftsmanship can offer in the field of textiles, fashions and allied goods, and to transmit to our overseas friends this British atmosphere so naturally linked with those products.[1]

In this move to harness a sense of intensified patriotism without jettisoning the internationalism that had driven the Modernist project in the inter-war years, the nascent *Ambassador* was entirely in step with the times. As Brian Harrison has suggested in a recent history of post-war Britain,

by the 1940s the Foreign Office had long abandoned 'splendid isolation' as a strategy for the UK, but nations draw closer for many reasons other than diplomatic: traders, tourists, communicators, writers, and thinkers promote contacts far broader and more continuous. The UK in 1951 was at once more and less insular than later: more insular because the Second World War and postwar currency restrictions . . . precluded overseas travel for its civilian population, [and] . . . the UK, united in war against outsiders, came to view itself as a large cohesive family whose values included fair play, moderation, common sense, decency.[2]

Such insular values expressed themselves in the gentle humour of British film comedy, with its focus on home and the idiosyncrasies of a seemingly unchanging national character, and the distrust of foreign accents, foreign food, foreign clothes and foreign weather. Yet as Harrison continued,

Men in two world wars had at every social level experienced more overseas travel than they desired . . . War correspondents demonstrated how the media could transcend national boundaries . . . the UK still saw itself as a great power with worldwide responsibilities . . . even if it was already becoming common to acquiesce, privately and somewhat ruefully, at being number three in the international pecking order.[3]

The need to look increasingly outwards for trade, whilst retaining a strong grasp on internal issues of reconstruction and stabilization, was, of course, an industrial and economic as much as a social and political desideratum for the British establishment in the late 1940s and '50s, and as a journal whose function was primarily commercial but also cultural, *The Ambassador* was intensely bound up with the drive both to promote sales of British products abroad and to shape and sustain the nation's battered sense of itself at home. Its crucial role in these initiatives was acknowledged by no other

than Sir Stafford Cripps of the Board of Trade, whose letter of encouragement was printed inside the issue of March 1946:

During the years of war we determined that no production problem should be impossible of solution. It needed the best that we could devise and do to defeat our enemies and free the world. The lessons of production which we learnt in the hard school of war are now being applied in our peacetime industry. We are, too, paying especial attention to the question of design to ensure that in their appearance as well as in the quality of their manufacture goods made in Britain are at the forefront of progress . . . The change from war to peace in industry is now well on its way. Men and women have returned and are returning daily from war service to our factories and workshops. I look forward to the day when we shall be able to send you everything you want in the quantities, qualities and designs that you wish, but we must discharge our obligation to the people of Great Britain, who for six years have endured shortages of every kind, particularly of clothes and textiles. As soon as we have made good our most urgent deficiencies at home, we shall expand with all speed and vigour our overseas trade. The volume of our exports is small at the moment but their quality excels anything that we have hitherto manufactured. They are worth waiting for and I hope that the wait will only be for a short time.[4]

Cripps's optimistic appraisal introduced a slim volume (paper restrictions were still in force) that showcased a behind-the-scenes tour of the Royal Opera House at Covent Garden, an extended promotion of menswear textiles and accessories, a preview of the spring collections of the Incorporated Society of London Fashion Designers and major wholesale fashion houses, and the regular update and comment section 'Thinking Ahead', which in this edition offered a digest of comparative statistics for wool production across the world, a reflection on the science of spectroscopy and its

application in the textile industry, and an analysis of labour issues. Book-ended by lavishly coloured advertisements for British companies including Horrockses and Viyella, the inaugural issue of *The Ambassador* was distributed to agents in Eire, the USA, Canada, Australia, New Zealand, South Africa, Portuguese East Africa, Rhodesia, Belgian Congo, Nyasaland, France, Egypt, India, Ceylon, Burma, Argentina, Bolivia, Brazil, Chile, Colombia, Costa Rica, Cuba, Ecuador, El Salvador, Guatemala, the Honduran Republic, Magellan Territory, Mexico, Nicaragua, Panama, Paraguay, Peru, Uruguay and Venezuela.

Readers did not have to wait too long for Cripps's promise of expanded volume and continuing quality. The careful combination of Elsbeth Juda's atmospheric photographic essays, alongside expertly styled mood boards of swatches and drawings evoking seasonal trends, and incisive overviews of corporate growth and technical advances that were present in March 1946 became the staple editorial signature of *The Ambassador* for the rest of its 26 years. Successive issues presented an informed compendium of the best that Britain could offer, and whilst the winning format of editorial insight, style intelligence and promotional creativity remained a constant, the focus and balance of each were inevitably tied to the United Kingdom's economic and industrial fortunes, its shifting alliances with particular trading regions and its developing sense of itself as a nation in a post-war, post-colonial context. By March 1956, with confidence in Britain's growth at home growing, yet also checked by its declining political and military influence overseas (this was the year of the Suez crisis), *The Ambassador*, under the sure leadership of the pioneering Judas (Elsbeth, Hans's wife, was both in-house photographer and associate editor), was able to publish a volume that fully vindicated the aspirations of its first editorial. A bright racing green cover adorned with a torn-paper collage of a potted spring daisy announced an issue packed with articles on the latest beachwear, Ardil fabrics

(synthetics derived from the proteins of groundnut oil), 'luxury' couture lines by the Incorporated Society, cottons for Canada and collaborations between British fine artists and Edinburgh Weavers – whose new London showroom had just opened.

Leafing through the pages of *The Ambassador* at its zenith in the late 1950s, one is inevitably reminded of the Tory prime minister Harold Macmillan's often misquoted observation of July 1957: 'most of our people have never had it so good'. As the historian Dominic Sandbrook suggests, Macmillan took up office at a moment of

low unemployment, high wages and technological innovation. Rationing was fading into history, and all the talk was of supermarkets, washing machines, record players, televisions, advertisers and airline tickets – all the trappings of what Queen magazine would call the age of BOOM. The trick was to keep the economy expanding while ensuring that prices did not rise too quickly; at the same time the government needed to restrain consumers from spending too much on imports, and to encourage manufacturers to produce goods for export overseas, in order to protect the country's vulnerable currency reserves.[5]

The content and remit of *The Ambassador* reflected that double bind perfectly – it might almost have been created as a visual aid for the Bedford 'never had it so good' speech – and whilst Hans Juda's personal political sympathies may not have chimed closely with Macmillan's, his understanding of national priorities and ability to convey them with a visual and cultural assuredness was, as ever, astutely in tune with the official line (or to use a cruder term, the 'zeitgeist'). So much so that when he came to edit what would be his valedictory (and biggest ever) issue of *The Ambassador* in November 1964, Juda found himself retiring at precisely the same time as the former prime minister, while providing a platform for

*189 PP9T

THE AMBASSADOR

no. 3-1964

FINE LINEN, TURKEY CUSHIONS
BOSS'D WITH PEARL

Gremio The Taming of the Shrew Act II Scene 1

ENROBE THE ROARING WATERS WITH MY SILKS

Salarino The Merchant of Venice Act I Scene 1

MY HANGINGS ALL OF
TYRIAN TAPESTRY

Gremio The Taming of the Shrew Act II Scene 1

PRAY YOU, SIR, HOW MUCH CARNATION RIBBON
MAY A MAN BUY FOR A REMUNERATION?

Costard Love's Labour's Lost Act III Scene 1

RICH GARMENTS, LINEN, STUFFS
AND NECESSARIES

Prospero The Tempest Act I Scene 2

LAWN AS WHITE AS DRIVEN SNOW

Autolycus A Winter's Tale Act IV Scene 3

FIFTEEN HUNDRED SHORN,
WHAT COMES THE WOOL TO?

Clown A Winter's Tale Act IV Scene 2

I PYRAMUS AM NOT PYRAMUS,
BUT BOTTOM THE WEAVER

Bottom A Midsummer Night's Dream Act III Scene 1

SHE HAS A GOOD FACE, SPEAKS WELL,
AND HAS EXCELLENT GOOD CLOTHES

Boult Pericles, Prince of Tyre Act IV Scene 2

CALLING MY OFFICERS ABOUT ME,
IN MY BRANCHED VELVET GOWN

Malvolio Twelfth Night Act II Scene 5

the new incumbent's renewed rhetoric of modernization. In October of the previous year, Harold Wilson, leader of the Labour Party and prime minister in waiting, had delivered the speech that would replace Macmillan's as the mantra of the new decade. Suggesting that the Conservatives would be consumed by 'a white heat of technology' that they could not understand, Wilson demanded that 'in the Cabinet Room and the boardroom alike ... those charged with the control of our affairs must be ready to think and speak in the language of the scientific age'.[6]

The Ambassador had always spoken in a progressive language, and the 'Creative Britain' issue of November 1964, with its dynamic Union Jack cover, was a fitting summation of the Judas' mission. The editorial put it well:

Some of our readers may feel that we have given a disproportionate amount of editorial space to subjects which do not normally find a place in a trade publication; but we have always believed that the Arts are not luxuries, leading gentle lives of grace and piety – they are a tough, living force in our world . . . For well over 25 years, the vocation of *The Ambassador* has been the furthering of British exports. We have travelled the world developing new techniques in promotion,

Winston Churchill, October 1954

Opposite: Cover by Theo Crosby
1964, no.11

forging trade ties and personal friendships, which make much of our publishing business a pleasure.[7]

The content of the ensuing bumper volume both conveyed that sense of pleasure and maintained the prophetic vision that had underpinned the success and relevance of *The Ambassador* over the preceding years. Elsbeth Juda's revealing photographs taken in 1954 of Winston Churchill as he sat in pinstriped boiler suit for the portrait painter Graham Sutherland were reprinted as an opener. Homage was paid to the journal's printer, Hunt Barnard & Co. of Aylesbury, in an extended review of their portfolio. The coming of the financial markets was acknowledged in a review of the revival of the City of London, accompanied by a fashion shoot using its brave new buildings. Full sections were devoted to the household names of the British textile industry, from Courtaulds to British Nylon Spinners at Pontypool, while Paul Reilly provided an overview of the activities of the Council

*189 PPgT

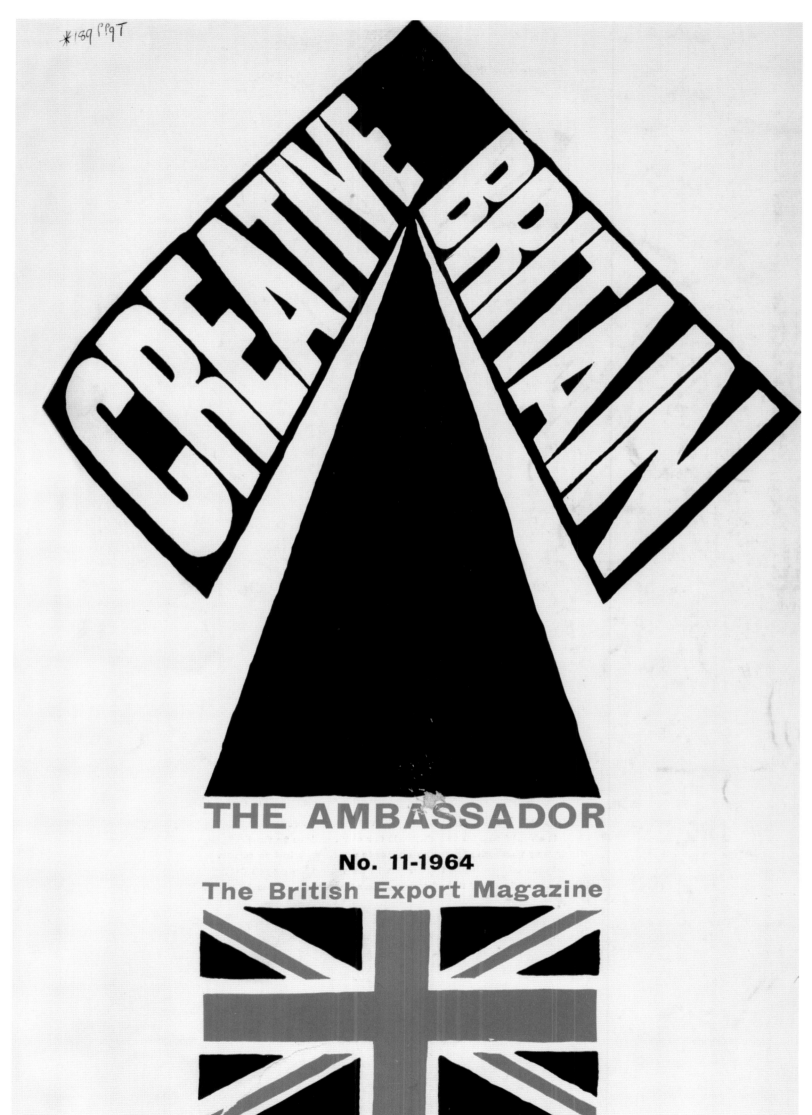

CREATIVE BRITAIN

THE AMBASSADOR

No. 11-1964

The British Export Magazine

S.P⋇

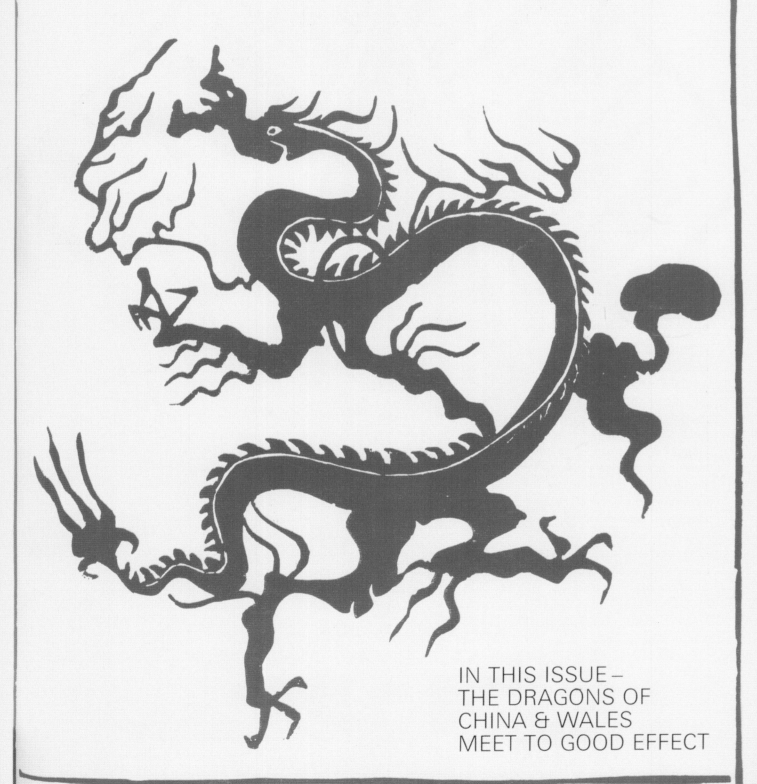

IN THIS ISSUE –
THE DRAGONS OF
CHINA & WALES
MEET TO GOOD EFFECT

The Ambassador No.8-1972

Cover by Sue Cater
1972, no.8

of Industrial Design, and Kenwood demonstrated the sleek modernity of its kitchen wares. The coming of 'Swinging London' was intimated in Sir Robin Darwin's celebration of the Royal College of Art: 'A beehive of visual usefulness . . . busy, practical and nationally valuable'; and J.M. Richards, editor of the *Architectural Review*, identified what he considered to be the best of contemporary British architecture. In choices that included the new town of Peterlee, Sussex University, the railway stations of the new British Rail and the hospital at Swindon, the sense of a rapidly changing and confident nation was palpable. Crucially, the Judas understood that progress in Britain was rooted in a sense of and appreciation for the past, and in true *Ambassador* style the exciting shock of Brutalism and Pop was juxtaposed with a panorama of unchanging British places: the Inner Temple, Kedleston Hall and Conwy Castle.

It is perhaps fair to claim that Thomson Publications, the multinational publisher who bought *The Ambassador* from the Judas in 1961, whilst epitomizing the corporate future lauded by Wilson, were less interested in cultural nuance and creative vision. After Hans's retirement they also inherited an economic and political context that was less amenable to the overseas promotion of British textile and fashion goods. By the end of the 1960s the manufacture of most of these had shifted to the Far East, and the relatively luxurious travel and production budgets that had supported the publication of the journal in its prime no longer seemed justifiable. The final issue in August 1972 was, suitably, devoted to trade in

Hong Kong; and though the editors pointed out that the flaming dragon image that adorned the cover was a symbol of prosperity in both China and Wales, the editorial statement said it all:

After 30 years of serving the textile, fabric and fashion industries of 91 countries *The Ambassador* is to cease publication . . . Continually rising costs forced the decision which was announced in the management statement: 'Following a very careful assessment of the position occupied by *The Ambassador* in the current magazine market and its projected near and long-term performance the Board of Illustrated Newspapers Ltd has decided that the magazine is no longer commercially viable. It is therefore decided, with regret, that the magazine will cease publication as from the August issue.'[8]

The journal's sad demise, like the collapse of the manufacturing nation that sustained it, should not, however, distract us from the richness of its content between 1946 and the years around 1966. Apart from providing a unique record of Britain's art and design culture in the post-war era, *The Ambassador* was one of the most bravely conceived and strikingly designed trade magazines ever to be published. In the essays and images that follow we hope to provide a sense of its importance at the time and a rehabilitation of its values for the future.

end of feature

Hans and Elsbeth Juda

Annamarie Stapleton

HANS JUDA'S LIFELONG COMMITMENT TO SOCIALIST values did not prevent him from emerging as a successful and prominent businessman in post-war Britain. He was devoted to the idea of an alliance between the arts and industry, and constantly strove to promote cross-fertilization of ideas across the sectors and actively to encourage young musicians and artists. His role as editor and publisher of *The Ambassador* was more a vocation than a career, and through it he facilitated his many other interests, with far-reaching consequences for individuals, institutions and even, perhaps, the country's economy.

Hans and Elsbeth Juda, photographed by Elsbeth, on-site during the construction of their weekend home at Fawley Bottom, late 1950s

National Portrait Gallery, London

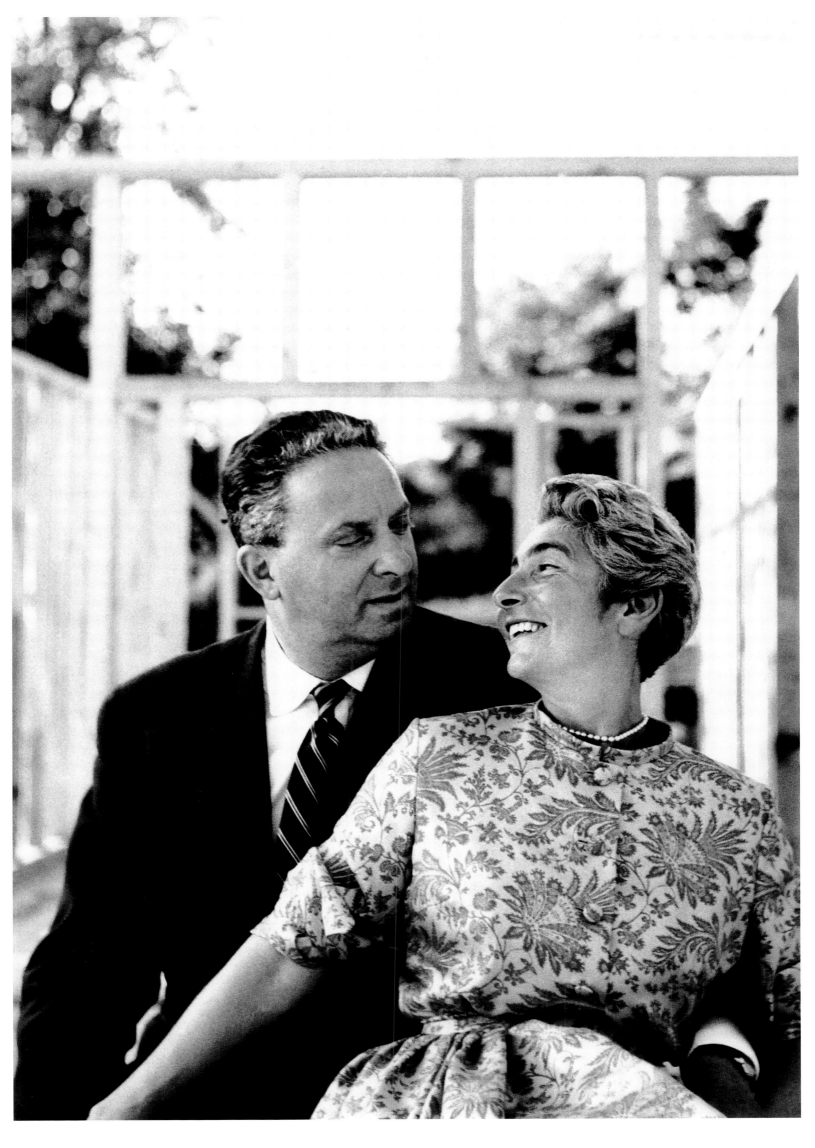

Hans with puppies in his apron,
at the Judas' weekend house near Henley,
probably taken in the late 1960s
Collection of Elsbeth Juda

EARLY YEARS IN GERMANY

For much of his young life Hans (1904–1975) was an only child, and his parents were devoted to him. He met his future wife, Elsbeth Goldstein (b.1911), daughter of family friends, when he was fourteen years old and she only seven. From the outset, Hans was an original personality and extraordinarily gifted; hugely successful at almost everything he turned his hand to. His family background was both artistic and academic, and this was reflected in his interests and subsequent multi-faceted career, in which he was to focus on ensuring the successful recognition of those he considered the most talented. His superb networking skills and generous spirit may have been inherited from his French mother, an open and welcoming woman who offered support and sound advice to all who cared to visit her.

A talented violinist and sportsman, competing at water polo in university teams, Hans studied economics, law and music at Frankfurt, Freiburg, Augsburg and Paris. He was involved in the student political movement at his various universities and headed the Socialist Student Union at Augsburg. During these years the atmosphere in Germany grew politically, intellectually and artistically more repressive. The persecution of Jews, socialists, intellectuals and artists drove like-minded people together to discuss ideas, work together and often, ultimately, to leave Germany altogether. Like Elsbeth's father, Julius Goldstein, Hans supported the growing socialist ideology within the Weimar Republic.

The Goldstein family was well connected and cultured, though not wealthy.[1] Despite the difficulties, especially the scarcity of food, the door was always open to visitors and everything was shared. Julius Goldstein was close to the centre of a prominent group of activists who supported the idea of a republic but were not enamoured with the undemocratic and unstable Weimar Republic that had emerged after the First World War.[2] He spoke out publicly against racism, anti-Semitism and fascism, and wrote books on the subject, most famously *Rasse und Politik* (1924). Gretel Goldstein, Elsbeth's mother, was also politically active; she chaired the Darmstadt Women's War-Work Committee (Frauenhilfe im Krieg), carrying out welfare work and a food education programme.[3]

Although he was absorbed in his work, Goldstein found time to press his children to further their studies, and he exposed them to his world and the circles in which he mixed. Elsbeth was expected to complete her studies at Oxford and was sent to Britain to learn shorthand and typing in English, which her father perceived essential prerequisites of a successful university education. Elsbeth, however, had other ideas and, after her father's death in 1929, she put her new skills to use in Paris, working as a secretary to a Hungarian stockbroker. She returned to Germany and married Hans Juda in 1931.

Hans worked at the *Berliner Tageblatt*, as a correspondent and sub-editor whilst finishing his studies, and then from 1928 as a financial editor, crucially, for his later career, overseeing the textile industry. In 1932, as a recently married journalist and economics analyst, with a passion for world trade, he chaired the World Economic Forum in Berlin. But the following year the Judas' lives took a dramatic turn. The situation for Jews in particular was deteriorating, and in 1933 a dispute with a Nazi Brown Shirt in a Berlin restaurant resulted in Hans receiving a court summons. After consulting a close friend, who showed Hans his Nazi party card, Hans was warned to take his wife and belongings and to leave Germany immediately. So with only two cases, one filled with books, and Hans's violin, they fled. Although Hans had family in France, they chose to travel to Britain, a country he had long admired as one of the great trading nations. Elsbeth was not only fluent in English but also had family and other connections in England, and the couple settled in an attic room in Hammersmith, London. Hans was enamoured by England from the moment he arrived, and on his return from travels in subsequent years he always loved to see the white cliffs of Dover, which he felt signified England and 'home'.

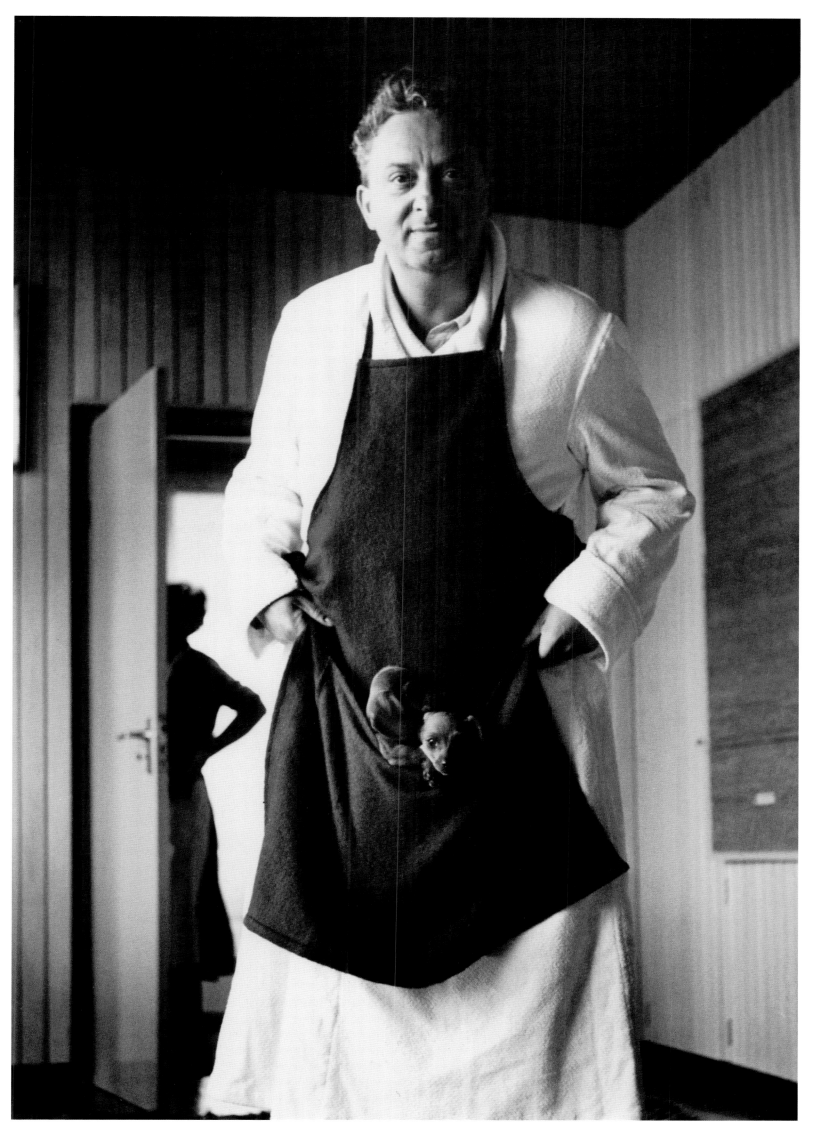

Elsbeth, known professionally as Jay, in the studio
with her Gandolfi 10 x 8-inch plate camera, 1942

ÉMIGRÉS IN LONDON AND *INTERNATIONAL TEXTILES*

Given their backgrounds and personalities, it is not surprising that the Judas were able to plug straight into the informal networks that were developing amongst the recent émigrés and the political and artistic circles to which they were accustomed. Hans relied on contacts from the Berlin paper to provide him with a workspace in their Strand offices and on Elsbeth to translate, since he had no knowledge of English. Typically determined and focused, however, he sat through long judgements at the Law Courts in his lunch break to improve his English.

In March 1933, after founding Pallas Studios in Amsterdam, Ludwig Katz launched *International Textiles*, a multi-lingual textile magazine, with László Moholy-Nagy as art director. A former advertising manager for Schottlaender, publishers of the textile periodical *Der Konfektionär*, and a substantial patron of the Bauhaus School in Dessau, Katz had arrived penniless in Amsterdam after fleeing from Germany.[4] Moholy, who had been a leading artist of the Bauhaus, had a radical vision for the future of art and a strong socialist credo; he too had sought refuge from the Nazis in Amsterdam, where he combined his work for Katz with other freelance interests. His influence on the layout of the magazine, and its subsequent reincarnation under Hans Juda as *The Ambassador*, was immense. Later the same year Hans, who had known Katz from Germany, established the magazine's London office, from the premises of the *Berliner Tageblatt*. The job fitted Hans's three essential requirements perfectly: an outlet for his interests in world trade; the continuation of his career as a journalist; and a means to earn a living. Moholy was to visit London on several occasions, sharing the Strand office space with Hans, before settling briefly in the city. He was already well connected with the British artistic cognoscenti, a number of influential émigrés and, of course, the recently established Judas.

Elsbeth meanwhile was busy translating for Hans and from time to time assisted at the magazine, helping to interview tailors and garment manufacturers. She recalls her first interview discussing spring fashions in men's tailoring; she did not know what a lapel or an inside leg was, but wrote it all down faithfully in order to ask at the office later. After assisting Moholy on a colour photographic shoot for a Viyella advertising promotion, she was introduced to his ex-wife, Lucia Moholy-Nagy, who had taught photography at the Bauhaus and who took Elsbeth under her wing (see page 48). Later, while trying to establish her credibility as an operator, Elsbeth showed her portfolio to potential employers and explained that she had a Bauhaus training, but the response was more often 'bow-wow who?' Eventually finding a job at a photographic studio in Soho with offices in Paris, she reinvented herself as 'Jay', the darkroom boy, and learnt the complex process of colour film and the art of retouching, working as an assistant operator. Through a lucky break she carried out an assignment for Révillon Frères; the result so pleased the company that she carried on photographing their furs for the next thirty years. She became an essential part of the Soho firm; when her boss had to go to America, Elsbeth ran the Paris studio.

THE WAR YEARS

After the Soho studios were bombed during the Blitz, Elsbeth began to work as a freelance operator, renting her own studio. Being a woman, especially a married one, was unusual in the photographic trade: the cameras and equipment were large, and Elsbeth spent much of her day carting around a huge Gandolfi camera and plates and climbing scaffolding to get the best shots. During the early war years she was occupied with her photography clients and with work for the war effort, but as her photography became more accomplished, and with the difficulties and costs of maintaining a studio during constant air raids, Hans increasingly brought Elsbeth into the *International Textiles* office as a photographer and to assist with art direction.

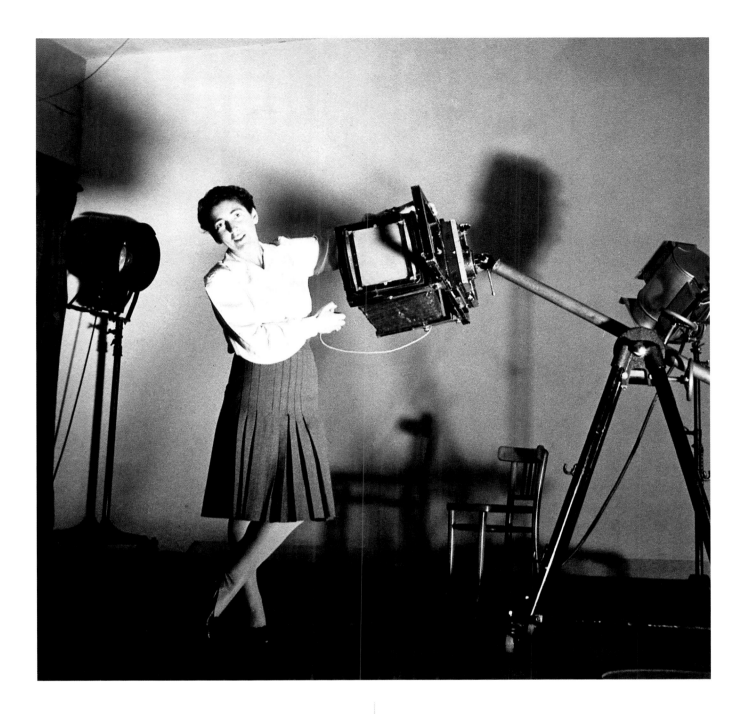

The outbreak of the Second World War had a profound effect on all businesses in Britain. Happily for Hans, *International Textiles* was regarded as an asset to British industry, as well as a propaganda vehicle, and publication continued throughout the war. His specific task, at least ostensibly, was to promote British trade. Far from being seen as an alien and interned, he was 'visited' early on by the Ministry of Information, whose role was to censor and supply information and promote positive publicity for Britain both at home and abroad. With his 'steely grasp of essentials',[5] his economic and journalistic experience, and his genuine love for his new homeland, Hans was an excellent contributor.

An agreement was made with the Amsterdam headquarters of *International Textiles* that the magazine would continue to be published from London if the Nazis occupied the Netherlands. Paper was to be supplied by the British Government and issues would be exported to subscribers via Portugal. In May 1940 production in Amsterdam was suspended.[6] Not an issue was missed throughout the six years of the war,[7] and Hans subsequently laid claim to the publication in a lawsuit, which was settled successfully in 1946, for the 'virtual farthing', with the Judas taking control of the title and of IT Publications Ltd.

Hans coined the mantra 'Export or Die' as the magazine's motto, believing strongly that it was only by earning foreign exchange that Britain would get back on its feet after the devastation of its infrastructure and public morale. He believed that the products of the British textile and

Sir Charles and Lady Lloyd Jones with Hans in their home in Sydney, 1952.

Jones had attended the Slade School of Art, London, but after failing to exhibit at the Royal Academy he returned to Sydney and joined his family's retail business, at which he proved extremely successful. He was a generous patron of the arts and the founding chairman of the Australian Broadcasting Commission.

AAD/1987/1/106/2

garment industries could compete on the world stage, but he realized that there were two essential prerequisites: that the British textile industry had to have an edge over Paris and Milan; and that foreign buyers needed to be attracted to British goods. As an émigré Hans was able to take a wider view of what Britain meant to the outsider, to see its strengths and weaknesses. He had always admired Britain as a trading nation but believed it did not understand how to market itself. During the early 1940s the magazine's emphasis changed fundamentally from an 'international' publication to '*the British export magazine*'.[8] He re-launched *International Textiles* in March 1946 as *The Ambassador*, a more fitting title for its extended remit, and he made it his mission to promote not only the textile and garment industries but also leading companies, such as BOAC and Rolls Royce, and British culture: art, music and dance.

THE AMBASSADOR

After the long interruption of the war, Stanley Marcus, of the American department store Neiman Marcus, remarked that *The Ambassador* 'more than any other publication from any other country supplied us with useful information and kindled our desire to get back to Europe to buy'.[9] With subscribers in more than eighty countries by 1947,[10] one could argue that Hans was one of the first promoters of branding for the nation: *The Ambassador* promoted tourism as much as textiles.

Hans believed strongly in the merits of a subscription-only magazine, considering that people would read and value it more if they had paid for it. He aimed to include interesting and informative articles relating not just to the textile industry but also to world trade and culture. The annual subscription for overseas companies was $5, 'post free';[11] advertising was accepted from UK-based companies only. It was imperative to advertising sales that the magazine was read, and evidence from correspondence to the firm confirms that not only were the subscriptions effective, but that also

the results of editorial and advertising exceeded companies' expectations. In 1951 the managing director of Andrew Stuart (Woollens) Ltd wrote to *The Ambassador* requesting the cancellation of a forthcoming knitwear promotion. He went on: 'the trouble is that your influence in the export trade – particularly in the USA – is far too effective compared with our capacity',[12] but he hoped that the magazine would be able to do something for the tweed and rug lines, where the company's capacity might be able to keep up with the demand.

From 1943 onwards the magazine included a section called 'Thinking Ahead: An Impartial Discussion of Present and Future Trade, Industry and Finance Problems'. This commonly included statistical analysis of current and future economic and monetary trends relating to the textile industry throughout the world, including shipping, power, foreign investment, productivity theories and the factory environment. It promoted books and pamphlets on British industry and international exhibitions. In August 1946 the cover, and much of the editorial space, was devoted to Misha Black's extraordinary architectural proposal for a 'Universal International Exhibition' in 1951, which was to become the Festival of Britain, alongside articles and pictures of *Britain Can Make It* at the Victoria and Albert Museum and the London couturiers Victor Stiebel, Hardy Amies, Norman Hartnell, Peter Russell and Bianca Mosca. Hans acknowledged and flattered the international buyers and retailers across the globe by incorporating features on social events and launches, featuring the most important players.

RAISING BRITAIN'S PROFILE

By the end of the war Hans and Elsbeth had extended their network of friends and colleagues and gained respect from leading industrialists. The magazine was well known not only in Britain but also in North and South America, and throughout the textile-producing and importing countries of the British Empire. *The Ambassador* office grew rapidly to

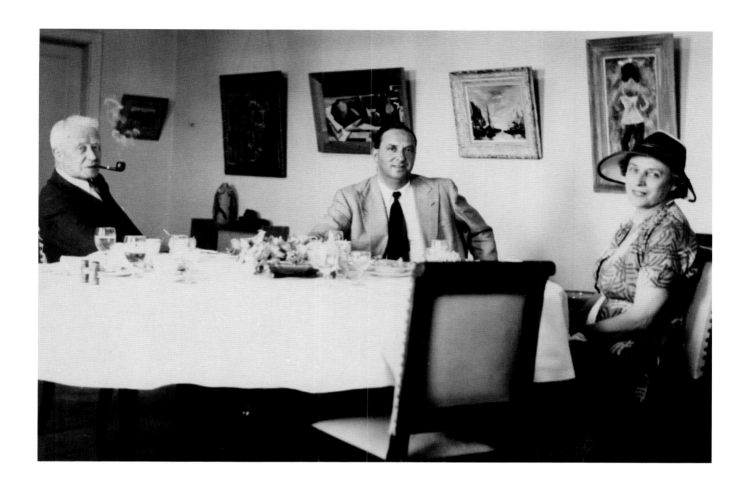

100 employees; Hans was horrified, since this gave him less control, but with a monthly turnaround and much advertising and editorial space to fill it was perhaps not surprising. Even midway through the war, in 1943, IT Publications had agents representing it in 28 countries; by 1945 there were 45 countries, and three years later 73. At its pinnacle in 1953 *The Ambassador* had subscribers in more than 90 countries.

One of the first American retailers to visit Britain after the war was Stanley Marcus, who was introduced to the Judas through a college friend, Gordon Yates, sales manager of Elizabeth Arden's European Division (whose range then extended to fashion as well as cosmetics). Marcus and the Judas subsequently worked together on many projects, introducing one another to mutually beneficial contacts, and became lifelong friends. Marcus advised them on the items he felt would appeal most to the US market – Scottish tartans, traditional uniform styles and Irish linens – and the Judas accordingly built up a series of promotions around these ideas. The resultant articles and their combined work with manufacturers, cajoling and persuading them to look at their ranges, can be seen throughout *The Ambassador*. Articles such as 'Teen-Age Fashions'[13] were also obviously aimed at this emerging market in the USA.

During the 1940s Hans tried to support and promote his other passions, modern art and music, by giving them similar treatment to *The Ambassador*. Neither *The Pavilion*[14] nor *The Score*, however, were in any way as successful as the trade magazine. A large and lavish monograph on Graham Sutherland's work, published in 1950 by Ambassador Editions, was critically acclaimed and successful enough to reach the planning stages for a second edition, although this was never realised.

But Hans's influence did not stop at the promotion of Britain and British industry through the written press; he and his staff were proactive in looking for other ways to raise Britain's profile abroad by building relationships with potential importers, department store owners and government officials from emerging economies and possible future markets. Hans and Elsbeth were acquainted with almost everyone of significance in the industry: they worked hard to inform and influence British textile converters and garment manufacturers, encouraging them to produce what they believed the American, Brazilian and Japanese markets would buy.[15] They took young artists around Britain and continental Europe, to inspire and create designs for British textile firms. They built relationships with art colleges and lent exhaustively;[16] they bought and commissioned art for

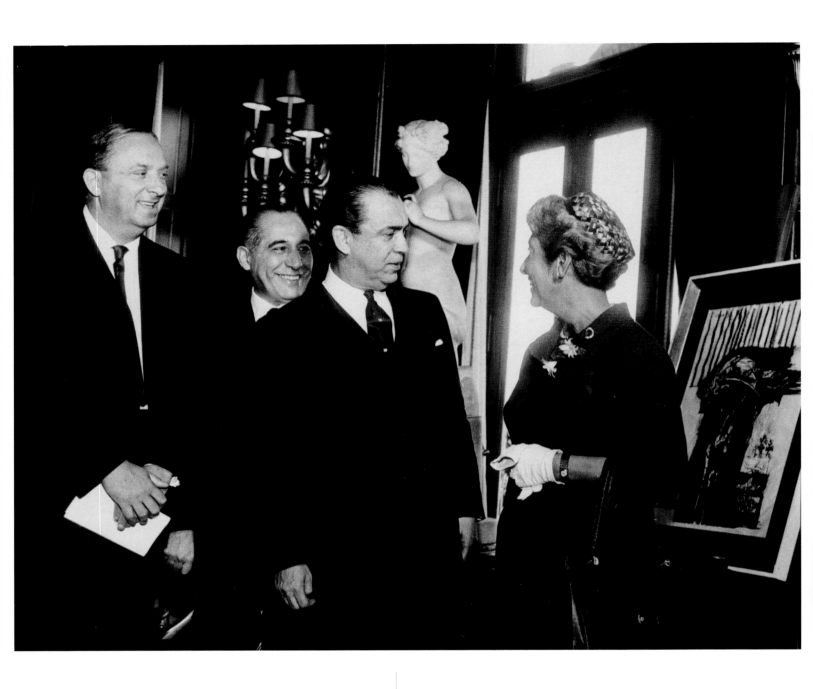

Hans and Elsbeth visiting the Palácio das Laranjeiras in 1959 to present Juscelino Kubitschek, the Brazilian President (second from right), with 12 paintings by contemporary British artists including works by Sutherland (pictured on the easel), Piper, Tunnard and Kneale.
The collection was intended for Brazil's museums of mordern art. Behind Kubitschek is Alberto Soares Sampaio, the railroad and oil financier.

AAD/1987/1/154/2

use in the magazine, sponsored the Sadler's Wells Ballet tour, and became increasingly influential as both patrons and advocates of the arts.

In 1946 the magazine moved to new offices on Park Lane, and these were announced as being 'at the disposal of our overseas readers when they are visiting London'.[17] In addition to all this the 'movers and shakers' of the garment and textile industries from around the world were given 'the Penthouse Treatment' – as the advertising staff called it – at Palace Gate, where they could network and relax in Elsbeth's 'salon'.

From 1949 *The Ambassador* initiated 'British Weeks', later extended to 'Fortnights', in department stores abroad, first in the USA but later in cities throughout South America, Australia and Canada. In these promotions, which encouraged the

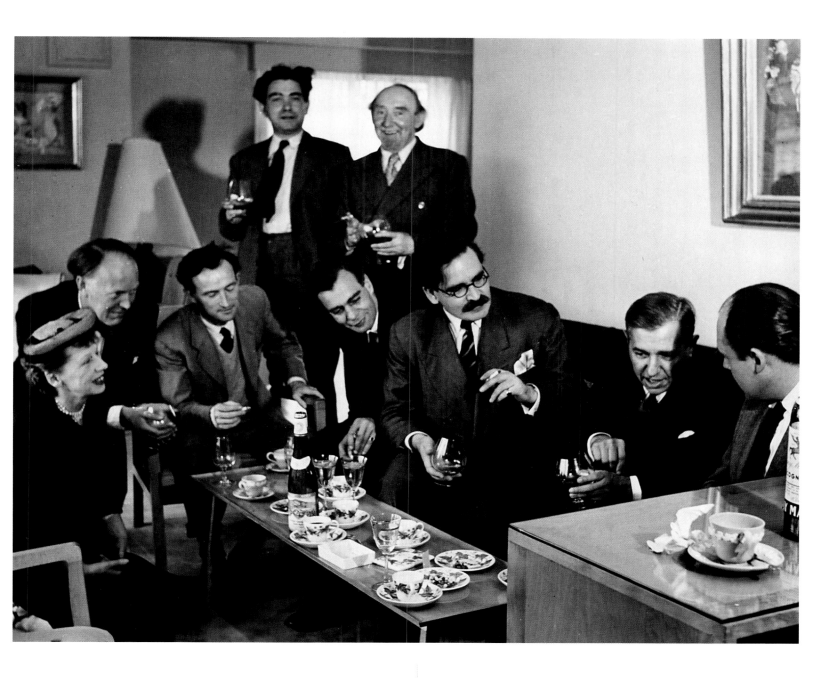

sales of specific British products or ranges, *Ambassador* staff collaborated with companies in the host countries to ensure that marketing materials, posters and photographs were sent out ahead of time; that window displays were effective; that press releases went to the right newspapers, and that invitations for launch parties were sent to the appropriate embassy dignitaries. Hans and Elsbeth travelled exhaustively as part of each promotion. *The Ambassador* branding was a central theme, giving the magazine a high profile as well as providing quality assurance for the consumer. The sponsorship of the Sadler's Wells Ballet tour across North America was one of the highest-profile promotions (see pages 54–7), and letters and news cuttings in the Juda archive attest to the tour's impact on American retailers.

Lunch party at the Judas' Penthouse, 10 Palace Gate, 1958, for the Brazilian Ambassador, Dr Assis Chateaubriand (second from right) and teachers and professors from the Royal College of Art including Robin Darwin, Madge Garland, Robert Godden, Frank Dobson, R.W. Baker, Richard Guyatt

AAD/1987/1/165/14

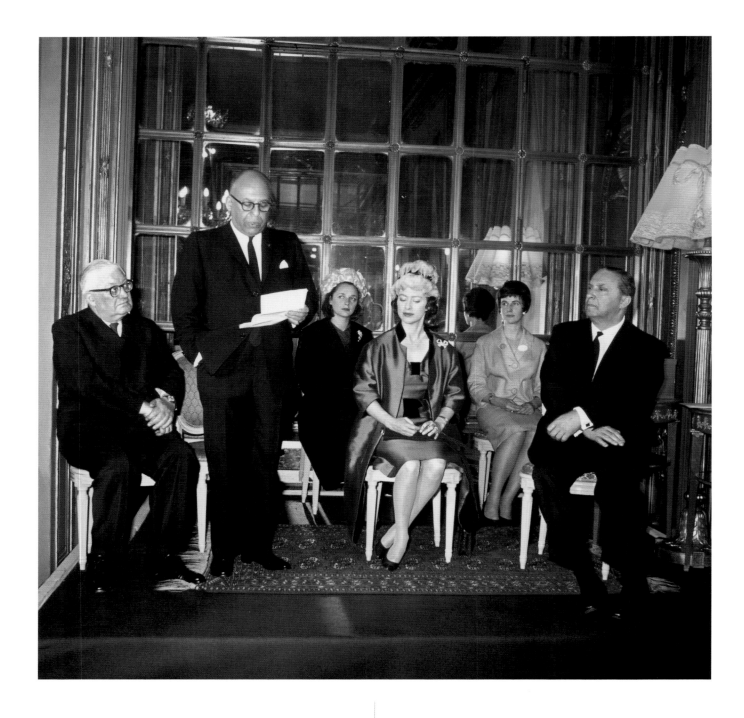

ART AND INDUSTRY

Painting into Textiles has proven one of the best-known *Ambassador* initiatives. Held at the Institute of Contemporary Arts in London in 1953, this was an attempt to encourage manufacturers and textile converters to experiment with new sources of inspiration. Although acknowledging that some progressive companies had explored this area in the early 1940s, Hans felt that it had been largely disregarded since then. The Judas commissioned art works from 25 contemporary artists, not only John Piper, Graham Sutherland and Henry Moore, but also artists still in their twenties, Eduardo Paolozzi, James Tower, Donald Hamilton Fraser, Geoffrey Clarke, Sandra Blow and Pat Albeck. Deemed a huge success, the exhibition drew great interest from the textile industry, and many of the paintings were adapted by manufacturers into dress and furnishing fabrics (see also pages 98–115, 150–52).

One of the last *Ambassador* initiatives, to promote the alliance of art and industry that Hans was so devoted to, was the annual Ambassador Awards for Achievement. Kenneth Armitage was commissioned to design the award itself, and the first ceremony took place in 1961 with Princess Margaret as the prize-giver. Recipients were drawn from a wide group of designers, retailers, industrialists and artists selected for their contributions to design policy, exports, and the fine and applied arts. Amongst the recipients were Jean Muir, Alex Moulton, the Amadeus Quartet, Graham Sutherland, Neiman Marcus and Sotheby's.

ARTIST FRIENDS

Throughout their tenure of *The Ambassador*, Hans and Elsbeth devoted their lives and income to modern art, encouraging young artists and stacking their penthouse flat with paintings three deep against each wall, as well as painting and drawing themselves whenever they could.[18] John and Myfanwy Piper were close friends from the 1940s, and they persuaded the Judas, who had rented weekend cottages in Kent and elsewhere, to buy a row of condemned cottages next door to their farmhouse at Fawley Bottom; here Lionel Brett was commissioned to build a modern weekend retreat.[19] The lives of the Pipers and Judas overlapped in many areas, not only in the professional sphere but also in their mutual interest in music, and particularly opera. At Glyndebourne,

Hans with John and Myfanwy Piper, c.1946, discussing John's drawings for possible inclusion in *The Pavilion*, edited by Myfanwy and published by IT Publications Ltd.

AAD/1987/1/184/1-32

Opposite: *The Ambassador* Awards Ceremony at the Ritz Hotel, London, at which Princess Margaret presented the awards, 1963. Left to right: Sir Roy Thomson, Stanley Marcus (standing), unidentified lady-in-waiting (?), HRH Princess Margaret, Valerie Wilson, Hans Juda.

Image courtesy of Valerie Wilson

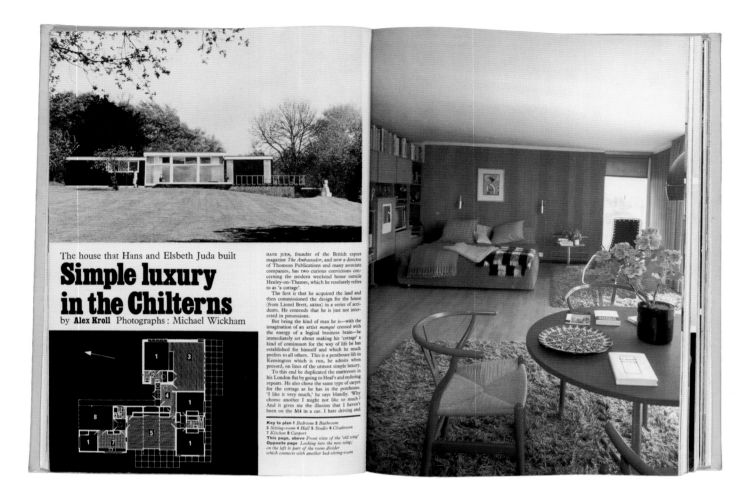

The house that Hans and Elsbeth Juda built

Simple luxury in the Chilterns

by **Alex Kroll** Photographs : Michael Wickham

HANS JUDA, founder of the British export magazine *The Ambassador*, and now a director of Thomson Publications and many associate companies, has two curious convictions concerning the modern weekend house outside Henley-on-Thames, which he resolutely refers to as 'a cottage'.

The first is that he acquired the land and then commissioned the design for the house (from Lionel Brett, ARIBA) in a series of accidents. He contends that he is just not interested in possessions.

But being the kind of man he is—with the imagination of an artist *manqué* crossed with the energy of a logical business brain—he immediately set about making his 'cottage' a kind of continuum for the way of life he has established for himself and which he much prefers to all others. This is a penthouse life in Kensington which is run, he admits when pressed, on lines of the utmost simple luxury.

To this end he duplicated the mattresses in his London flat by going to Heal's and ordering repeats. He also chose the same type of carpet for the cottage as he has in the penthouse. 'I like it very much,' he says blandly. 'Why choose another I might not like so much? And it gives me the illusion that I haven't been on the M4 in a car. I hate driving and

Key to plan 1 *Bedroom* **2** *Bathroom* **3** *Sitting-room* **4** *Hall* **5** *Studio* **6** *Cloakroom* **7** *Kitchen* **8** *Carport* **This page, above** *Front view of the 'old wing'* **Oppsite page** *Looking into the new wing; on the left is part of the room divider which connects with another bed-sitting-room*

The Judas' house at Fawley Bottom, near Henley-on-Thames, built by Brett, Boyd and Bosanquet, 1958, and extended in the late 1960s, featured in *House & Gardens*, July–August 1968.

Oppsite: Hans Juda, by Graham Sutherland, 1955
Oil on canvas
Collection of Elsbeth Juda

where Piper had designed a number of sets, Hans became involved in the production of the season's programme as the opera festival sought to re-establish itself after the war. Miki Sekers, a successful industrialist, looked after the advertising and Hans's role was to organize the design and printing, which he did by putting Valerie Sargent of *The Ambassador* in charge. The publication continues to be designed by Sargent today, still retaining the lavish size and reproduction quality of its early issues.

Perhaps the more significant relationship was with Graham and Kathy Sutherland, with whom the Judas corresponded for many years. As well as collaborating on a monograph of Sutherland's work, Hans acted to some extent as an agent for the artist, providing financial support and promoting his designs through the magazine. Sutherland turned to Elsbeth in 1954 when he was painting Winston Churchill's portrait, asking her to photograph the ex-prime minister whilst he worked at

Chartwell.[20] Elsbeth's photographs are all that remain of that chapter, since Churchill and his wife disliked the oil painting and had it destroyed. Sutherland was simultaneously working on a portrait of Hans, which was a gift from *The Ambassador* staff for his 50th birthday. Completed for the relatively modest sum of £450, this proved more of a success.

WORKING ON THE MAGAZINE

Hans always remained the final arbiter and editorial 'sign-off' at *The Ambassador*. Strong-willed, demanding and dominant, he had a generous and genial spirit, and was known affectionately as 'Papa', or just 'HPJ'. The atmosphere at *The Ambassador* offices was focused and hard-working, but, by all accounts, enjoyable and inclusive. Hans's loyal staff enjoyed the benefits of a benign employer who treated them as an extended family. Birthdays were celebrated, lunches held, and loans made to help tide over difficult times; Christmas parties at the Judas' penthouse were a regular occurrence. Many of the staff kept in touch for decades afterwards. Hans paid his staff well and fairly; he recognized the input of advertising salesmen to the success of the publication, in particular Alan Bowden and Fred Flowers, and for a time those working in sales were the best paid in the company, a situation queried by the Inland Revenue. *The Ambassador* had a flat structure;

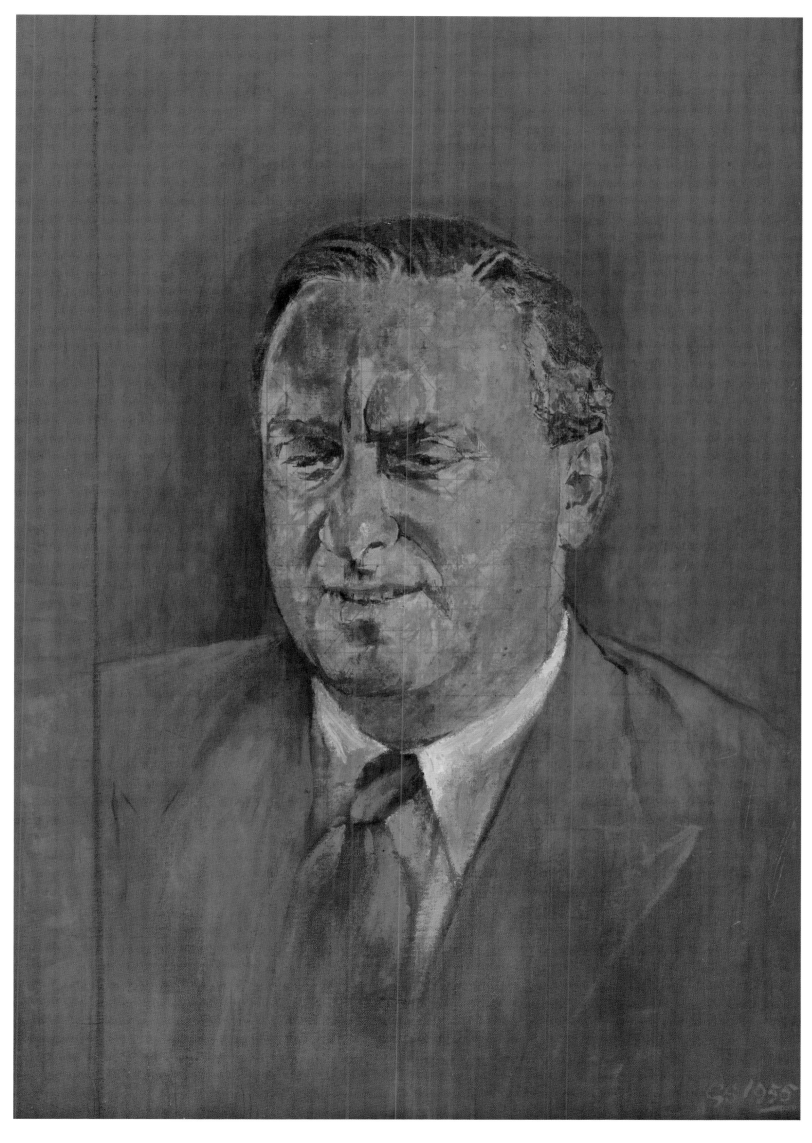

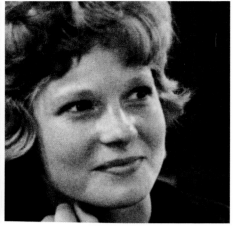
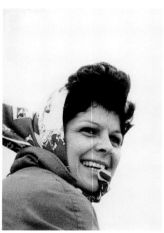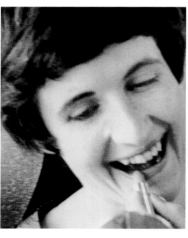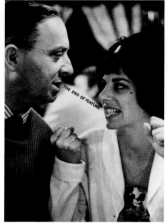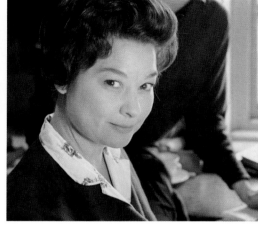
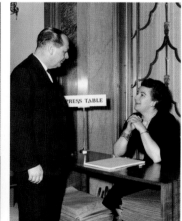

Ambassador staff c.1961

ABOVE; Top row: Valerie Wilson, Alan Bowden (advertising), Peggy Mortimer (filing), Val Sargeant (studio)

Middle row: Kit Crammond (editorial), Valerie Wilson (secretary to Hans), Hans and Shelagh Rae, Sandra Weston (advertising)

Bottom row: Don Kidman and Jean Dawney (model), Peter Dean (editorial), Jenny Corbett, Hans and Diane Harris at *The Ambassador* Awards

OPPOSITE; Top row: Jose Mitchell (accounts), Sonia Neale Fraser (Elsbeth's secretary), Shelagh Rae (receptionist), Ursula Staples-Smith (advertising sales)

Middle row: Pat Jenner, seated, (unidentified, Pat's secretary), Mario (messenger), Shelagh Dunn (editorial), Paddy Butt (studio)

Bottom Row: Hans and Gordon Brunton, Diane Harris, Mary Miller (advertising secretary), Fred Flowers

even when it reached 100 employees there very few directors. Hans kept a sign on his desk that read 'No Escalation'; his message was if something needs doing, do it. Everybody was expected to muck in to get the issue to print, and no input or ideas were dismissed without good reason.

The Ambassador staff was a glamorous and talented bunch from diverse backgrounds. Ursie Staples Smith, who covered Scottish, Irish and Cumberland industry, had been born into a trading family in the Far East; like Hans, she was devoted to music and art. The small studio producing artwork was run by Don Kidman and John Dibbel, who were joined by Valerie Sargent, but the real enduring presence here was Trude Ettinger, better known as 'Ett', a meticulous Czech artist who drew the fashion figures, designed covers and coordinated

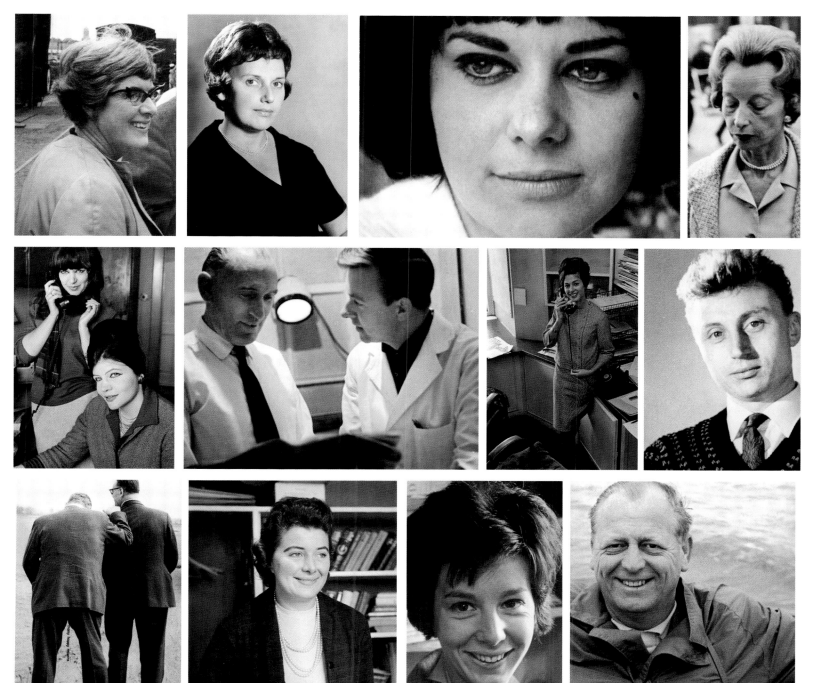

much of the design work for the publication throughout the 1950s and '60s. Diane 'Didi' Miller (later Harris) joined *The Ambassador* in 1954, having made a connection through her best friend's father who ran a Scottish mill, Wilson & Glennie. She was keen to work in fashion and joined temporarily to cover someone's leave, but stayed there until after Hans's retirement in 1965, and then went on to work for Elsbeth until 1969. Didi recalls Hans's generosity on her 21st birthday, not long after she had joined the firm. Lunch in South Audley Street with six other members of the staff and a cheque for £21 was a huge treat; when she got married, Miki Sekers, one of the magazine's biggest advertisers, gave her silk for her wedding dress. Valerie Wilson joined *The Ambassador* in 1961 as Elsbeth's secretary, towards the end of Hans's and Elsbeth's involvement with the

magazine, but was quickly moved under Hans's control when he realized how good she was. She continued to work at *The Ambassador* under Gordon Brunton, Hans's successor, whilst he took on his new board role. Like many of *The Ambassador* staff, Wilson never lost touch with Elsbeth.

With frequent glamorous and famous visitors, lavish parties and dinners, everyone was involved. Correspondence between Tempe Davies, Hans's secretary, and Kathy Sutherland suggests that friendships between staff and the Judas' friends were open and acceptable. Members of staff were expected to treat the various people that Hans and Elsbeth befriended and brought into their lives as part of *The Ambassador* family. Like clients and friends, staff were treated to weekends away at the Judas' weekend retreat or parties at

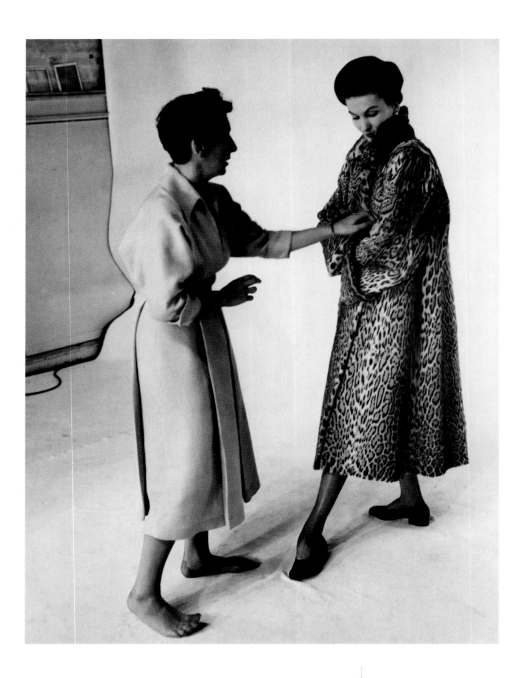

the penthouse in Palace Gate. Didi recalls a weekend in Fawley Bottom when she dined with the Pipers and Priscilla Conran, briefly an assistant to Elsbeth in the late 1950s.

Elsbeth's involvement with the running of the magazine increased during the 1950s, researching features and writing them up, and taking trips to glamorous – and not so glamorous – destinations to photograph models in the latest British fashions. Barbara Goalen, Shelagh Wilson and Fiona Wylie were amongst those she worked with, and on occasion they worked at the magazine offices too. In 1951, whilst in South America shooting a fashion feature, Elsbeth met Assis Chateaubriand, an extremely wealthy and well-connected Brazilian media mogul, who was to become a longstanding friend; despite the fact that he was older than

either of them, Hans and Elsbeth adopted him as their 'son'. He arranged introductions to Oscar Niemeyer and Candido Portinari, both committed Communists, whose architecture and art Hans and Elsbeth hugely admired, and whom Elsbeth photographed. Chateaubriand, like Hans, was something of an anglophile. He treated the couple to a lavish lifestyle when they visited Brazil, showering them with gifts and arranging for them to be treated like royalty; the Judas brought him into their circle at the penthouse, particularly when he was appointed Brazilian ambassador to Britain. In return for his gifts the Judas donated a dozen modern British paintings to the Brazilian president, Juscelino Kubitschek, for the nation's new modern art museum in Brasilia, including work by Piper and Sutherland, John Tunnard and Bryan Kneale.

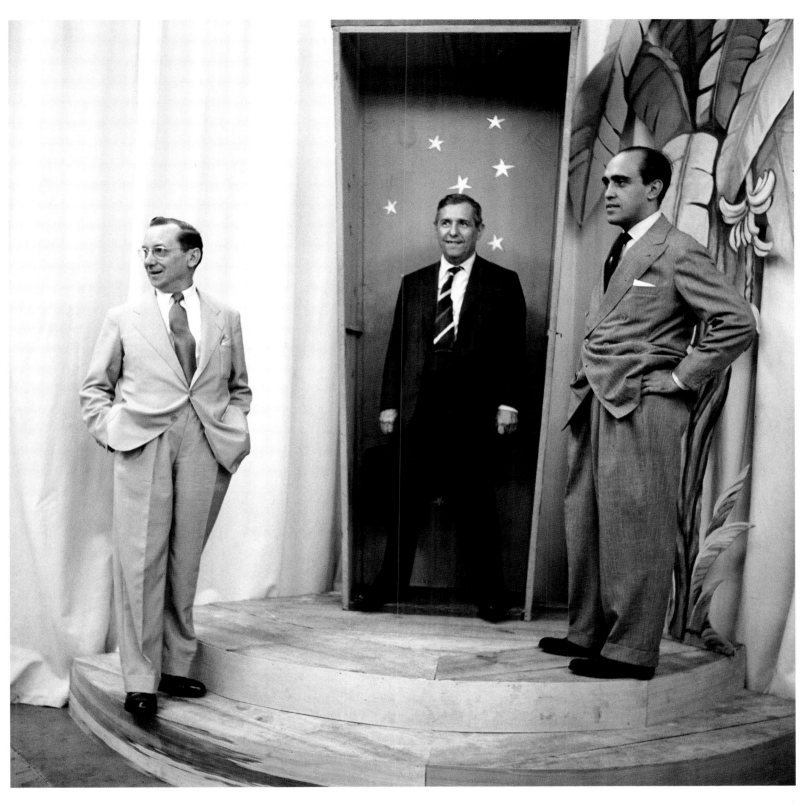

Candido Portinari, Dr Francisco Assis Chateaubriand and Oscar
Niemeyer, photographed at Chateaubriand's television studio, Brazil,
by Elsbeth, 1951
AAD/1987/1/94

Opposite: Elsbeth photographing Barbara Goalen for a Révillon Frères
catalogue, 1950s
AAD/2010/5/4/2

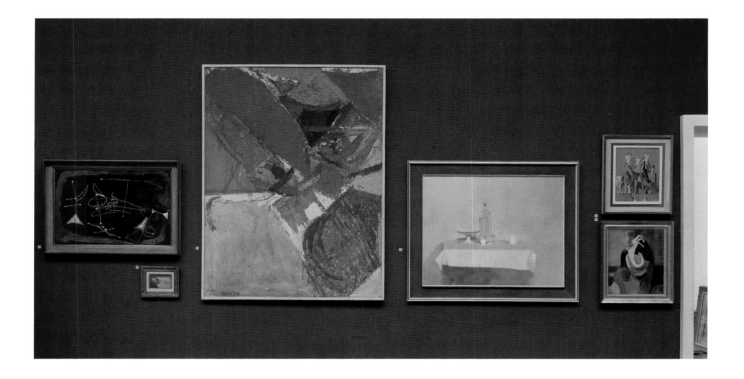

TAKEOVER AND RETIREMENT

By 1961 Thomson Publications had approached the firm to offer to buy out the Judas and take Hans onto the board of the parent company. The process was a long one and Hans was to stay at *The Ambassador* as editor for three years, taking a percentage of the profits during this time; his last issue in November 1964 was noted as a true bumper one, supposedly viewed by Lord Thomson as a way of Hans getting his last drop of blood. Elsbeth hoped the move to Thomson would give Hans a new outlook, but it was too bureaucratic and he disliked spending his days in meetings at the offices in Gray's Inn, missing the nitty-gritty of seeing an issue through. He was central to the purchase of the *Burlington Magazine*, providing a valuable link between the editorial staff and the managing board, but much of the work was related to reproduction of vintage publications and, as the only board member with an active interest in modern art, it must have been a frustrating time.

Despite not getting his teeth into a regular magazine, and with continuing problems with his eyesight, Hans found plenty of other things to do. He continued his interest in music, becoming involved with the London Fires as Treasurer and maintained his association with Glyndebourne, but it was probably his work in the field of art education that had most impact at this time. He had been appointed a governor of the Central School of Arts and Crafts in 1958 and an honorary fellow of the Royal College of Art the following year, but he now became more proactive, frequently visiting art colleges and encouraging those whose talent he admired. In 1965 he took on the chair of the Central School and was elected to the Council of the RCA, eventually being appointed a senior fellow in 1969.

At something of a loose end after the sale of *The Ambassador*, Elsbeth had been asked to act as a design consultant to ICI by Eric Sharp, then marketing director; her contact at the firm was Peter Byrom, who was crucial in developing the idea of design-led merchandising. Elsbeth provided the perfect link between industry and artists to get the project going, but it grew rapidly when other areas of ICI as well as clients wished to use it. Eventually the work became too much for her alone and a small studio or workshop was set up in the apartment below the penthouse, supported by ICI's marketing budget. Elsbeth was charged with inspiring designers to use the new synthetic fibres and yarns that ICI was producing, the likes of Terylene and Crimplene. Hans took it upon himself to find talented students for Elsbeth who would be open to working with new materials, all of them graduates of the RCA or Central School. Inge Cordsen was spotted by Hans whilst she was a student at the Central School. He encouraged her to visit Elsbeth at the studio at 10 Palace Gate, and persuaded his wife to take her on. Cordsen recalls the fun they had creating crazy designs that ICI and their clients, to her amazement, took up. Demand continued to grow, and when it necessitated becoming an independent business Elsbeth handed over the reins happily to Deryck Healey, an ex-Sanderson employee.

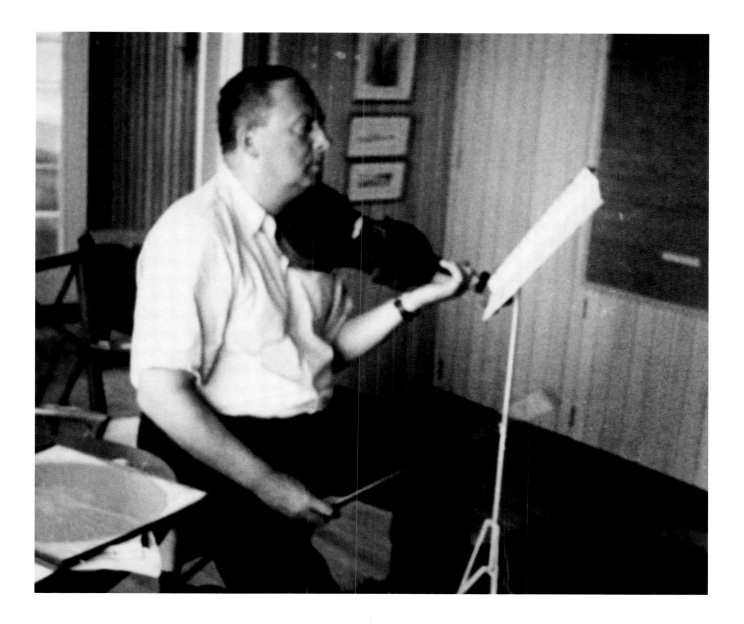

After the exhibition in 1967 of their accumulated pictures at the Graves Art Gallery in Sheffield, *In Our View*, Hans persuaded Elsbeth that they should sell the entire collection and create a fund to help young artists. The sale at Sotheby's in November that year was given plenty of press coverage and raised £45,000 for the fund. Hans was determined that it should all be spent in his lifetime and that he wanted no complicated committees or decision-making to hinder it. He asked students to submit a single side of foolscap explaining why the fund should support them; true to form, he was the sole arbiter.

Neither Hans nor Elsbeth ever really 'retired'; they carried on entertaining, travelling and expanding their network of friends, painting and encouraging others. Hans had been struggling with problems with his eyes for some years, but in 1975 he became very ill with a brain tumour and died. The tributes, both published and unpublished, speak

Hans playing his violin at the Judas' country home, late 1950s
AAD/1987/1/190/55–61

Opposite: Installation of *In our View* at the Graves Art Gallery, Sheffield, May–June 1967, including work by Joan Miró, William Brooker and Graham Sutherland
AAD/1987/1/185/16–55

for themselves.[21] Stanley Marcus doubted that 'the British Government ever realised what this remarkable magazine and its publisher, Hans Juda, contributed to the economic recovery of its textile and garment industries',[22] while the British art critic Robert Melville considered that *The Ambassador* was the most enterprising trade journal ever launched.[23] Huge accolades indeed for a trade publication driven, created and sponsored by two émigrés who had arrived with two suitcases and a violin.

end of feature

LEFT: *Neanderthal Man.*

RIGHT: *Chaldean Ziggurat.*

ONCE UPON A TIME

. . . men were not men but beasts. In those days these brutish precursors of man were preoccupied only with the processes of hunting, fighting and mating.

But as the first herdsmen discovered the direction-finding usefulness of the stars, and the first agriculturists realised the procession of the seasons could be forecast by studying the night sky, astronomy was born.

Men made gods of the sun and the moon and the stars, which seemed to govern their lives. And in the great river valley civilisations of Mesopotamia a new priest caste built great platforms above the desert to advance that knowledge of the heavenly bodies which was the secret of their power.

And as they studied the heavens the priests discovered numbers and geometry; and mathematics,

man's intellectual key to the universe, was born.

Then one day early in the seventeenth century a Dutch gentleman holding two pairs of spectacles some distance apart noticed that a neighbouring spire was brought nearer to view. Accidentally he had discovered the principle of the telescope.

From that time onwards the new scientific man, armed with the twin tools of physical observation and

RIGHT: *Stonehenge.*

LEFT: *One of the first telescopes.*

BELOW: *The huge radio telescope at Jodrell Bank.*

intellectual speculation, the telescope and mathematics, began to probe space with increasing precision. Today, we, who stand indebted to the first sun-worshippers, the Egyptian priests, the Greek speculators and the long line of great men of science such as Copernicus, Galileo, Newton and Einstein; we, who have for much of our history worshipped and studied the heavenly bodies, have now in a fantastic epoch-making achievement, added to them.

Photographs on this page and on page 83 reproduced by courtesy of the Hulton Picture Library, and the Athlone Press.

INFINITE BLUE The deep deep blue of a vast starry sky just after darkness has fallen.
(The recipe for this colour is on the wrapper to this feature.)

Out of this World (continued)

COLOUR IN SPACE

When 'The Ambassador' decided to explore the colour possibilities of space, it went to the highest authority for advice – the Royal Greenwich Observatory. From the Royal Observatory, founded in 1675 by Charles II and home of Greenwich Mean Time, we received the stimulating note which we reproduce here, and the intriguingly factual article below by Dr Olin J. Eggen. It is to Dr Eggen's helpfulness and the swift technical co-operation of I.C.I. Ltd. Dyestuffs Division that we owe these vibrant and exciting new colours.

ROYAL GREENWICH OBSERVATORY.
HERSTMONCEUX CASTLE,
SUSSEX.

The Editor,
Ambassador Magazine,
49, Park Lane,
London, W. 1.

In response to your call and to your letter – which in the hectic events of the past week I have misplaced – the enclosed is the best I can do under the circumstances: perhaps under any circumstance. If I have missed your requirements completely I am sorry.

The only attempts to pictorially reproduce the expected view of earth from space would be of no use to you at all – they are hopeless to an extreme and I believe you have the field to yourself.

If there is anything else I can do, please ask.

Yours sincerely,

Olin J. Eggen

"There are many who regard the conquest of space, like the conquest of Everest, as merely another skirmish in man's continuous battle to overcome his natural environment. Just another scientific – or at least technological – victory. But when – if ever – man first ventures into space, one of the lasting, and largely unforeseen, results that will make the trip worthwhile may well be the exposure to a brand new artistic experience – the colour and spectacle of the firmament.

At satellite height – say 400 miles – 99.999 per cent. of the earth's atmosphere is below us.

Primarily a source of oxygen and of weather, this atmosphere is also a protective shield against cosmic bullets – crumbs from the rubble of space – that would in no time make sieves of our bodies if they were not consumed in "shooting stars". And the atmosphere gives us colour, scattering only the short-wave-length light of the sun to produce the blue sky and passing only the long wave-length red light to produce fabled sunsets.

At times, when the scattering particles are water globules, ice crystals, or dust – all ingredients of

(continued overleaf)

METEOR RED The vivid, fiery red of a rocket streaking away from the earth and out into space. (The recipe for this colour is on the wrapper to this feature.)

Out of this World

(continued)

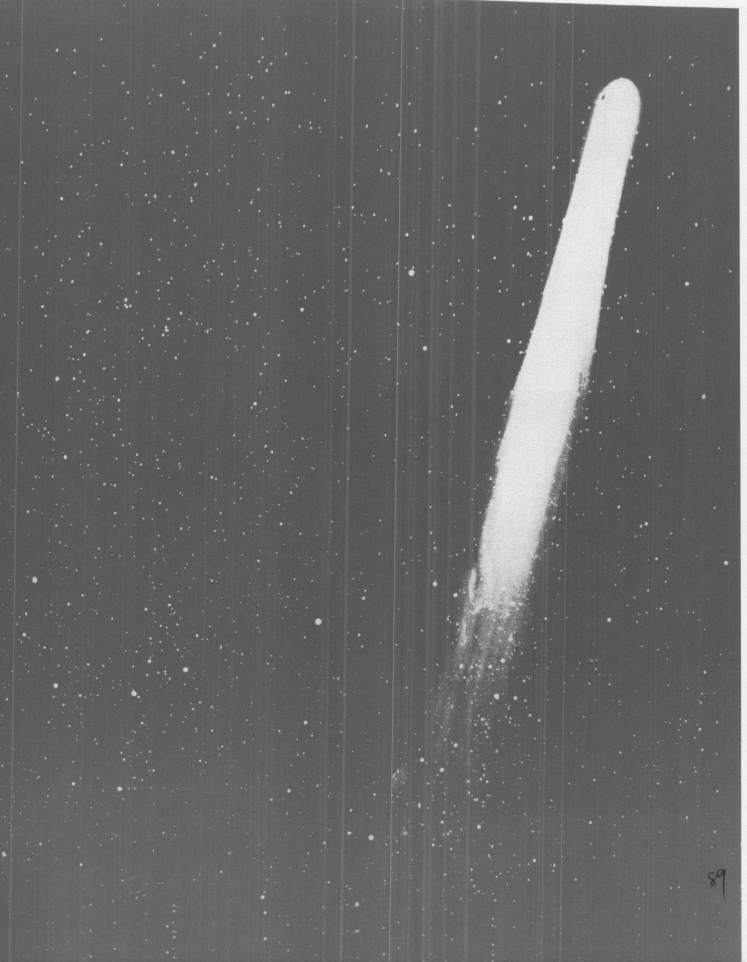

Out of this World 89

smog – the sky is muddy white. Then, again, when the air is clean and the scattering particles are only atoms of oxygen, the colour is deep blue. The higher our observing site or, what is the same thing, the cleaner the air, the deeper the blue.

From our satellite the 'cleanliness' is complete and even the oxygen atoms are gone. The sun pelts us with unprecedented intensity – the raw sunshine is normally filtered and processed by the atmosphere – and appears as an orange-yellow ball with a well defined edge. Right up to this edge the sky is jet black and filled with stars – which are only more distant suns – some deep red and others white hot.

But the real spectacle is the earth itself. Around its periphery appears a narrow white band, shading with infinite variations into darker and darker blue and finally disappearing into the total blackness of the sky.

The features on the earth – the continents and oceans – are the familiar colours of water and brown earth but have a washed-out appearance, since we see them through the total extent of the atmosphere below us. Individual features disappear – an uncritical eye cannot pick out California or Mexico and even the closest examination does not separate the British Isles from the Continent.

This, in words, is what we expect to see. It will be with no less difficulty that, when the time comes, we will describe what we have seen."

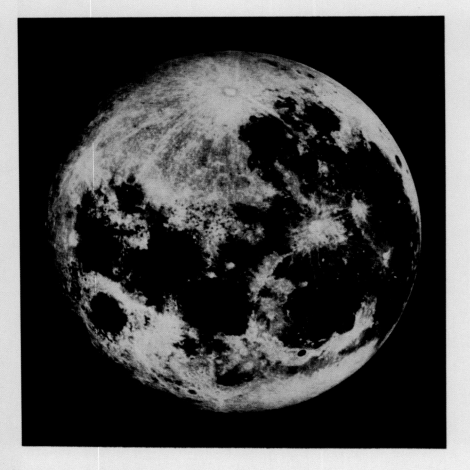

REAL LUNACY?

Is it our imagination or has the Man in the Moon developed a slightly apprehensive look these last weeks? The first step has been taken. Already the feverish scientists plan to land unmanned objects on the moon's surface within the next few years.

Are we ordinary mortals to applaud unreservedly the undoubted genius of such men? Or are we perhaps, mindful of all that science has yet to do in the easing of suffering and the creation of happiness on this our own sweet earth, to look upon these latest musings and machinations of the scientists as *real* lunacy?

SPACE GLOW A colour that might be seen on a journey to the moon:
the glow of a nebula below the limit of the solar system.
(The recipe for this colour is on the wrapper to this feature.)

Out of this World (continued)

Photography and Graphic Design: 'Just a Job Lot'

Abraham Thomas

ALTHOUGH NOMINALLY A TRADE EXPORT MAGAZINE – with a simple, practical purpose – *The Ambassador* was a surprisingly experimental platform for presenting textiles in the context of a refreshingly modern approach to graphic design and photography. As director of the magazine, Hans Juda was adamant that the magazine should be available by subscription only, asserting the opinion that 'if somebody *pays* for something, they will *look* at it'.[1] This reveals not only the magazine's collaborative working relationship with advertisers, but also explains its steadfast commitment to ambitious and skilfully executed editorial layouts that stood out in sharp relief from other trade journals.

'Knitting In Fashion'
1951, No.6

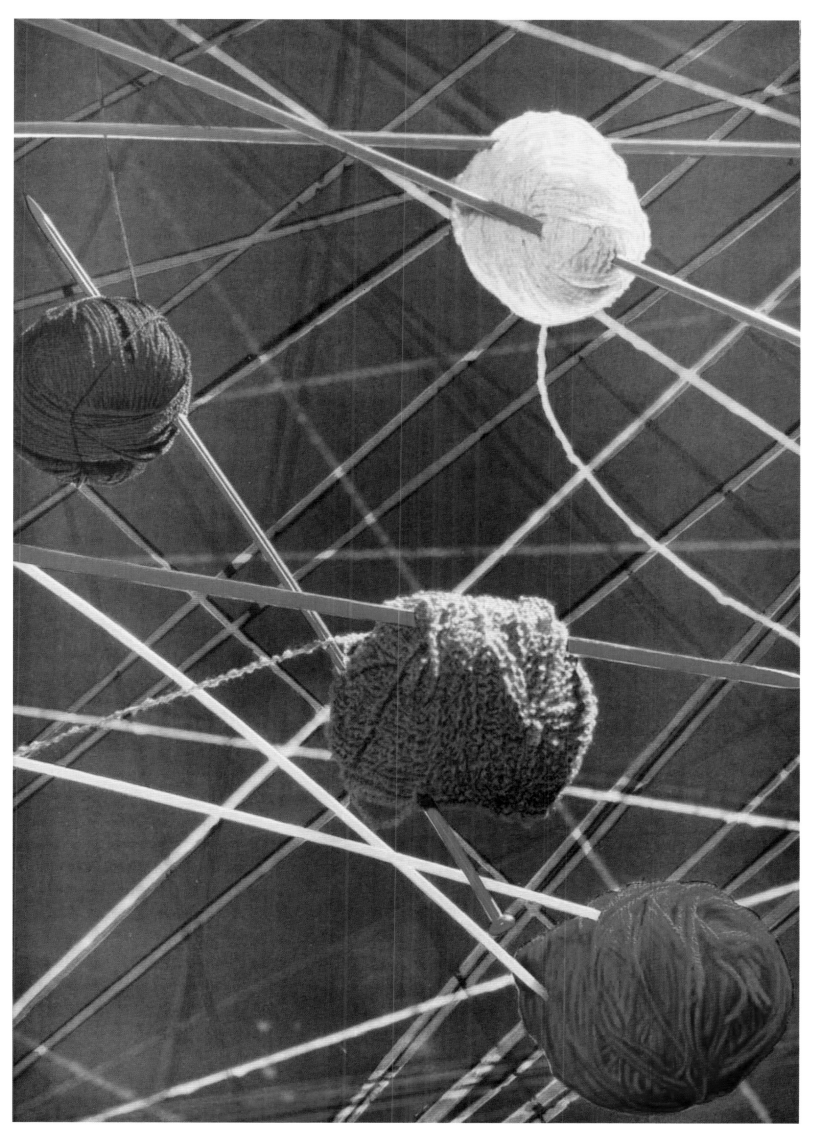

EUROPE AND THE BAUHAUS

The influential ex-Bauhaus teacher and artist László Moholy-Nagy had known Hans Juda in Berlin, and the two men found themselves working together on *International Textiles*, with Moholy-Nagy as art director and Juda as head of the London office. Terence Senter has observed that the 'demanding' Moholy-Nagy dictated the magazine's format, using a 'wide range of elementary graphic devices' applied with an 'agile permutation to direct the reader's mind through forceful, clear, legible and fresh layouts'. It is interesting to consider the impact that Moholy-Nagy's 'constant questioning of page space and sequence, supported by judicious, visual, contrasts', had on Hans Juda's early ideas for *The Ambassador*.[2]

Just before he settled permanently in London, accepting Juda's offer of a small room in the *International Textiles* office as a workspace, Moholy-Nagy came in January 1935 to produce a lavish 12-page promotional feature for Viyella, taking over Hans and Elsbeth Juda's one-bedroom flat in Queen's Gate.[3] His assistant, György Kepes, had not yet arrived in London from Berlin, so Elsbeth stepped in as studio assistant. She recalls that they could not afford to hire a photography studio for this ambitious staged set-up (which incorporated numerous pinned-up swatches of fabric and 'paper birds on wires'[4]) and so they converted the Judas' bedroom into a makeshift studio. At that time, colour processing took three days, and the set could not be touched until the final images were approved, so Elsbeth and Hans resigned themselves to a few nights in a nearby boarding house while they waited for the prints to come back from the developer.[5] Moholy-Nagy was pleased with the results, and told Elsbeth that she had 'a good eye'. He suggested that she speak to his ex-wife, Lucia Moholy, a fellow Bauhaus émigré who was working for a reprographics service at the Science Museum. Lucia Moholy agreed to teach photography to Elsbeth on an informal basis, setting up a studio darkroom at the Judas' flat. Elsbeth describes their tiny kitchen becoming the developing room, and their bathroom the print washroom – 'poor Hans didn't know whether one day he would be drinking developer fluid, or if he might suddenly find himself bathing in a tub of stopper/fixer'. Determined to find work (and, crucially, a studio space), Elsbeth took a portfolio of work to a number of studios all over London. She finally secured a job as 'darkroom boy' at Scaioni's, a commercial photography studio in Soho's Dean Street. It was here that she reinvented herself as 'Jay' – the name that later would accompany all her photographs for *The Ambassador*. When her boss, Captain Richard Everett, was unexpectedly late returning from holiday, Elsbeth was asked to take over a fashion shoot for the fur company, Révillon Frères. Both studio and client were delighted with the prints, and Elsbeth was rewarded with a job offer to replace Everett as 'lead operator' on a permanent basis.

COMMERCIAL WORK

Elsbeth maintained a freelance commercial career throughout the 1930s and '40s, working for a number of advertising agencies and art directors. She was regularly employed by the W.S. Crawford agency, which was considered one of the most progressive advertising agencies in the UK, in no small part due to its creative director, Ashley Havinden. He had travelled to Germany in 1926, becoming a devotee of the Bauhaus, and in particular of Moholy-Nagy. Crawford's regular clients included Wolsey, Liberty's, DAKS and Pretty Polly.[6] It is possible that Elsbeth's early exposure to Havinden's work at Crawford's was not only influential in the future creative direction of *The Ambassador*, but also helped facilitate introductions at significant textile and fashion companies. Havinden created the artwork for a number of *Ambassador* covers during the 1940s,[7] but his work converged most explicitly with the magazine's mission when he designed the menswear section of the *Britain Can Make It* exhibition at the V&A in 1946 – an opportunity to present a visual grammar of objects in the context of post-war recovery. Many years after

Liberty's poster by Ashley Havinden for
the W.S. Crawford agency, 1949
V&A: CIRC.464–1971

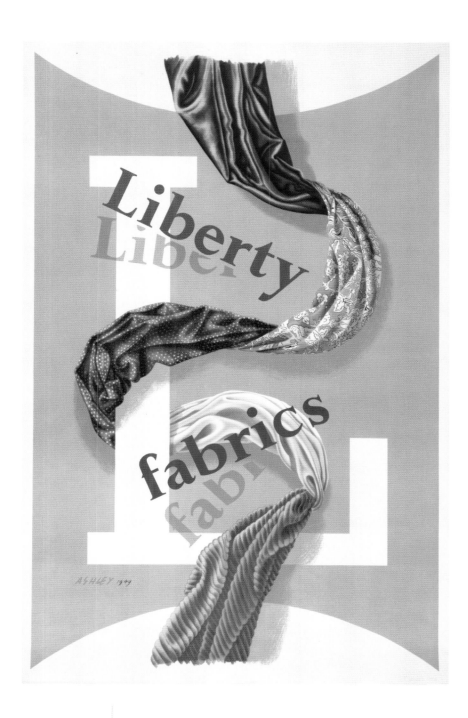

her early work for Crawford's, Jay would go on to photograph Havinden for an *Ambassador* feature of December 1951 entitled 'The Man – The Detail – The Style'. This 'sartorial investigation' gathered together London's most elegant and debonair gentlemen (Havinden included) for an impromptu fashion shoot in a Soho oyster bar, over a long, leisurely lunch.

FREELANCE INFLUENCES

Owing to *The Ambassador*'s status as a trade export magazine, the editorial photography required textiles to be presented, and handled, in a precise context – highlighting formal qualities such as texture, weight and movement. Careful lighting and a strategic arrangement of the featured objects were crucial to this approach, one that drew upon techniques

such as collage and still life. It is likely that the Judas had witnessed the development of the 'Neue Sachlichkeit' (New Objectivity) in Germany during the 1920s, an aesthetic that reacted against the domination of 'pictorialism'. During their time in Berlin the Judas may have known Walter Nurnberg, an ambitious young advocate for the 'New Objectivity', who worked at an advertising agency while also attending Bauhaus photography classes delivered by Elsbeth's tutor, Lucia Moholy. Nurnberg moved to England in 1934, one year after the Judas. He set up his own London advertising studio, and later became a major influence on a generation of industrial photographers.

The Ambassador continued to publish during the war, and Elsbeth continued with freelance jobs. In consideration

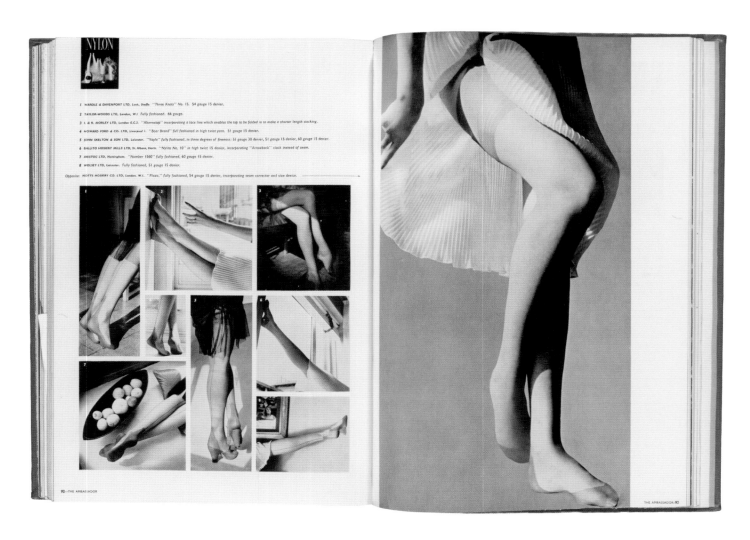

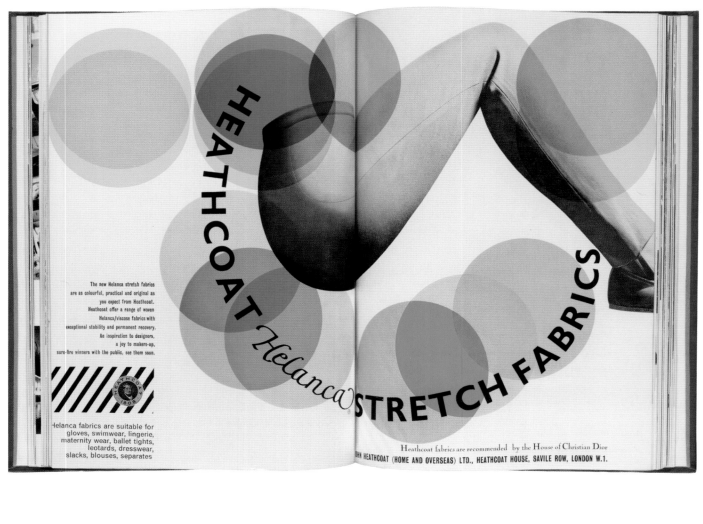

The new Helanca stretch fabrics
are as colourful, practical and original as
you expect from Heathcoat.
Heathcoat offer a range of woven
Helanca/viscose fabrics with
exceptional stability and permanent recovery.
An inspiration to designers,
a joy to makers-up,
sure-fire winners with the public, see them soon.

Helanca fabrics are suitable for
gloves, swimwear, lingerie,
maternity wear, ballet tights,
leotards, dresswear,
slacks, blouses, separates

HEATHCOAT Helanca STRETCH FABRICS

Heathcoat fabrics are recommended by the House of Christian Dior
JOHN HEATHCOAT (HOME AND OVERSEAS) LTD., HEATHCOAT HOUSE, SAVILE ROW, LONDON W.1.

Top: '10 Years in the Lifetime of British Nylon'
1951, no.6

Bottom: Advertisement for Heathcoat fabrics
1963, no.5

of the precision and abstraction of the 'New Objectivity', it is interesting to note that she was employed as a medical photographer during the war years. Elsbeth was based at the Queen Victoria Hospital in East Grinstead, working under the direction of the pioneering surgeon Archibald McIndoe. His Centre for Plastic and Jaw Surgery began to receive pilots within weeks of the start of the Battle of Britain in 1940. Elsbeth was tasked with photographing badly burnt and injured RAF aircrew, before and after their surgical treatment. Working in high-pressured conditions that were, no doubt, distressing, Elsbeth recalls wearing 'operating greens' and describes the difficulty of operating a bulky, heavy, 10 x 8-inch camera, standing over an injured airman, 'being careful not to fall on top of him'.

The influence of the 'New Objectivity' is apparent not only on the editorial pages of *The Ambassador*, but also within the advertising spreads. Although the magazine was one of the first to separate advertising pages from editorial ones, the Judas also pioneered what is now a common device: the promotional/merchandise feature, or 'advertorial'. This blending of commissioned editorial copy and carefully targeted advertising is exemplified by a feature of 1951 celebrating '10 Years of the Lifetime of British Nylon', produced in collaboration with the Pontypool-based British Nylon Spinners. Twelve pages of advertisements for BNS-sourced nylon products from firms such as Wolsey and Raywarp provide the warm-up act for a lavish 16-page editorial featuring ambitious, full-bleed spreads of images that evoke the photograms of Man Ray and Moholy-Nagy. The 'still-life' qualities of these photographs are enhanced by playful editorial copy that imagines nylon products as precisely arranged 'gallery objects': 'Nylon stockings have reached a point in public estimation when they can be offered to the Louvre with the formal hope that a place will be found for them among the works of art.' We see a later echo of this aesthetic in an advertisement of 1963 for Heathcoat fabrics (see opposite). No expense was spared with this generous double-page spread revelling in the exuberance of pop-culture colour references.

COLLABORATIONS

A copy of *The Ambassador* from 1948 provides an excellent example of an advertisement integrating coherently with the design layout of an editorial feature. Showcasing a group display of British buttons organized by the Casein Plastics Joint Development Council at the British Industries

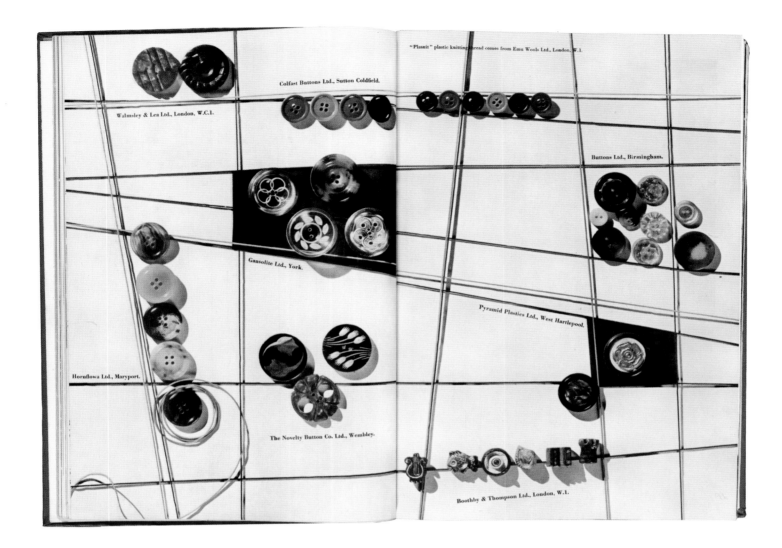

'A Display of Buttons'
1948, no.4

Opposite: Advertisement for Lacrinoid buttons
1948, no.4

Fair, the editorial feature blends seamlessly with a related advertisement for Lacrinoid buttons. Both use a Constructivist composition reminiscent of Alexander Rodchenko's early commercial graphics work.

As Elsbeth herself explained, 'it was unusual for a trade paper to have an independent editorial policy, and it was unusual for a trade paper to apply a kind of aesthetic standard to production, to the quality of production, the quality of photography, the quality of coverage'. She pointed out that one of the keys to the success of the magazine was the existence of an in-house studio, led by a 'fabulously talented and wonderfully eccentric' artist known to everyone simply as 'Ett', but whose real name was 'Trudie'. Elsbeth describes her as 'idiosyncratically Czech, in her black jumper and black skirt and the cigarette constantly and coffee . . . she was magnificent, *very* talented, enormously witty'.[8] She was married to the Russian émigré architect Michael Rachlis, who was responsible for a number of projects in London, including alterations to Aquascutum's flagship store on Regent Street. Working alongside *The Ambassador*'s art director,

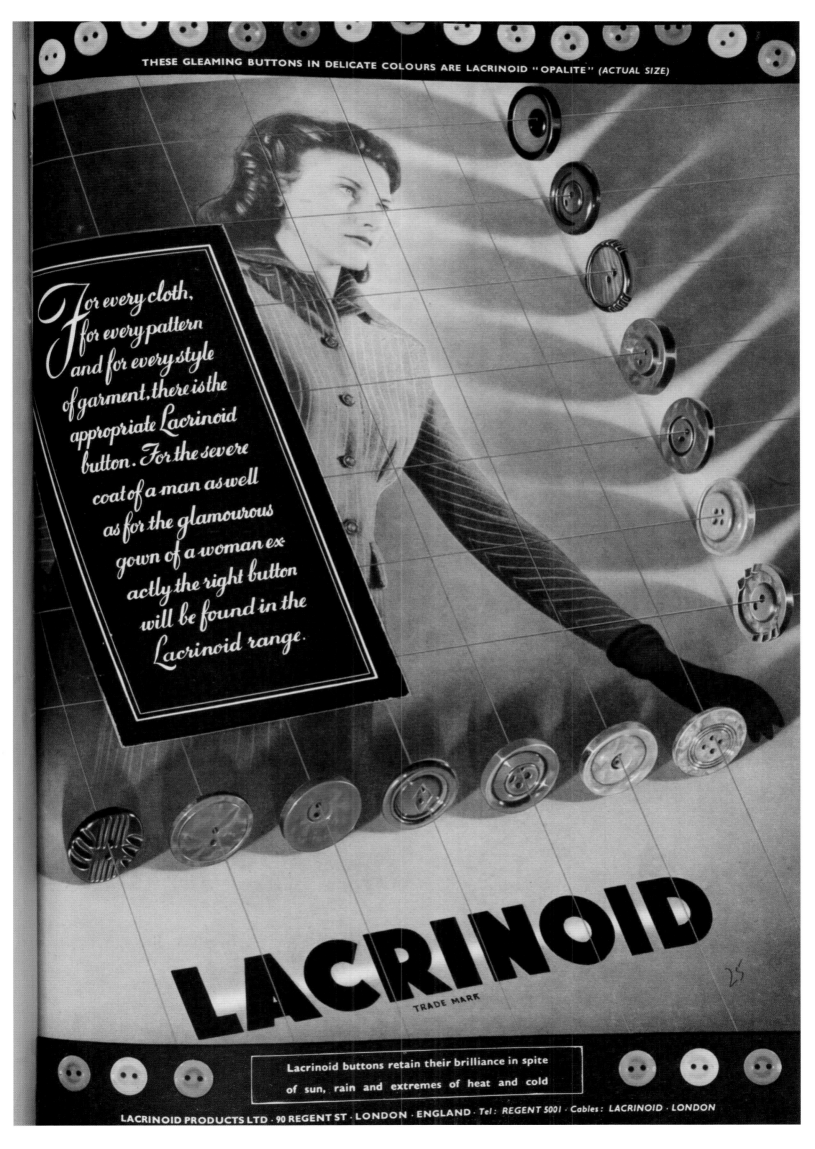

THESE GLEAMING BUTTONS IN DELICATE COLOURS ARE LACRINOID "OPALITE" (ACTUAL SIZE)

For every cloth, for every pattern and for every style of garment, there is the appropriate Lacrinoid button. For the severe coat of a man as well as for the glamourous gown of a woman exactly the right button will be found in the Lacrinoid range.

LACRINOID
TRADE MARK

Lacrinoid buttons retain their brilliance in spite of sun, rain and extremes of heat and cold

LACRINOID PRODUCTS LTD · 90 REGENT ST · LONDON · ENGLAND · Tel : REGENT 5001 · Cables : LACRINOID · LONDON

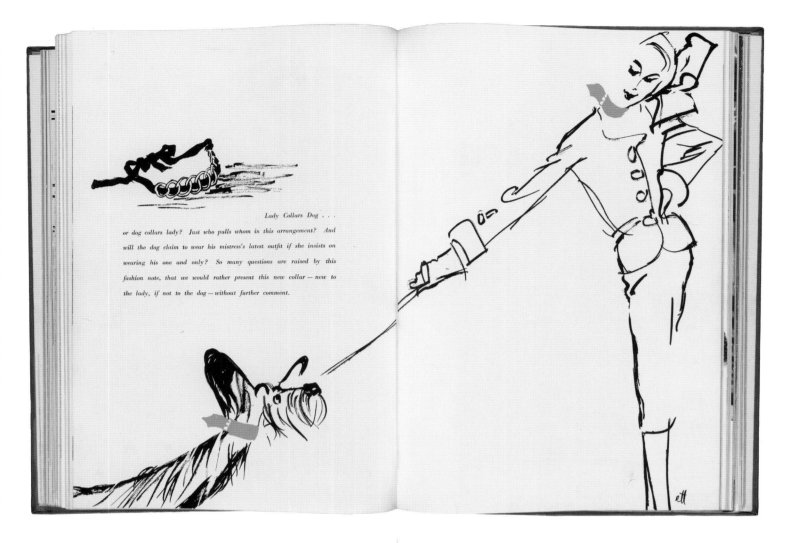

Above: 'Lady Collars Dog'
1947, no.5

Opposite: 'The Ballet is Dressed'
1950, no.9
Photograph
AAD/1987/1/85

Don Kidman, Ett produced artwork for numerous covers, and was responsible for the fashion sketches often found punctuating an editorial spread of Elsbeth's photographs. Ett also helped with page layouts, and worked with advertisers to improve the quality of their promotional campaigns. Annamarie Stapleton has previously observed that the standard of design in the magazine's advertising images, encouraged by the editorial team, visibly improved during the 1940s and '50s. Madeline Ginsburg has also suggested that advertisers were increasingly using *The Ambassador* as their 'public face', taking several pages for advertising features, publishing notices and posting business results.[9] Although Elsbeth remembers Ett as a great perfectionist,[10] there were also times when the magazine's layouts required

a little extra. Elsbeth recalls one occasion when her husband and Kidman were struggling over a particularly tricky spread. Hans suggested that they down tools and go out to catch a Jean Lurçat exhibition that was on at the time. Inspired, they returned to the office loosened up, and found a solution to the spread in no time.

By the end of the 1940s Elsbeth was in regular employment as Jay, *The Ambassador*'s in-house photographer. Although eventually becoming the magazine's associate editor, she kept up with a regular stream of freelance work, engaged in what she often described as the prosaic 'job lot' photography of commercial advertising and company brochures, but also finding work with some of the most important magazines of the period, including the British *Harper's Bazaar*.

THE BALLET IS DRESSED

The Ambassador gained a reputation for successful international promotions, collaborating with retailers in important foreign territories and developing close relationships with the leading players – for example, Stanley Marcus (president of the luxury retailer Neiman Marcus), who became a personal friend of the Judas. Marcus would later credit *The Ambassador* as the catalyst for resuming trade with

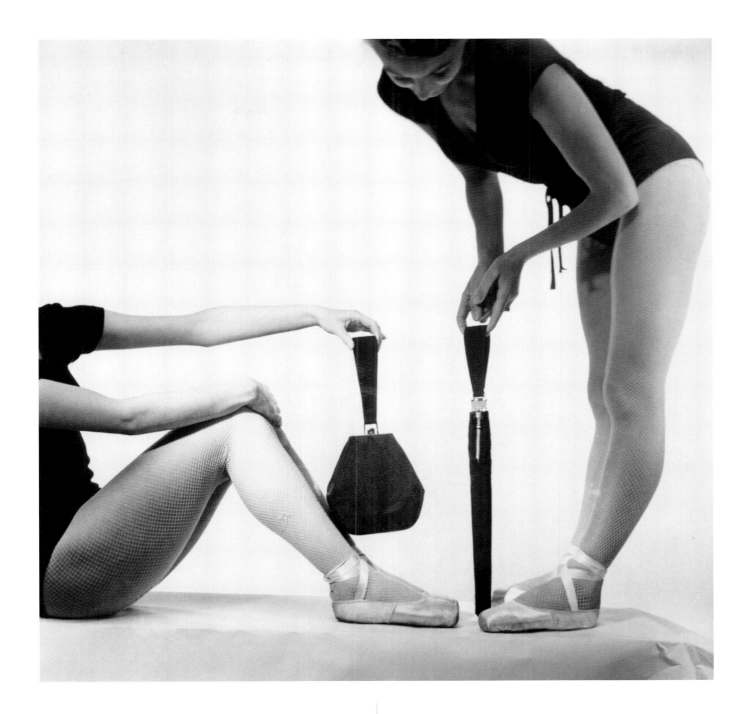

Europe (see page 24).[11] The 'Ballet' promotions of 1949 and 1950 were early examples of this pioneering coupling of editorial and retail. A fire at Sadler's Wells had destroyed the company's costumes. In response *The Ambassador* signed up a number of British manufacturers to sponsor a stylish off-stage wardrobe for the soloists and corps de ballet of the Sadler's Wells Ballet on their first North American tour. The unenviable task of coordinating this extensive collection of outfits was given to Laurie Newton-Sharpe, a well-known buyer and style adviser for the shoe retailer Lilley & Skinner, and profiled in the press at the time as 'Mrs Pompadour'. Newton-Sharpe described how the idea for this ambitious project 'came into shape at a dinner party: asking the most graceful girls in Britain to show America our loveliest clothes during their dancing tour of the States'.[12] No doubt aided by the Judas' own industry contacts, she spent a month visiting 'between sixty and seventy firms', convincing wholesalers and couturiers of the prestige of the project. Having sourced everything that the Company might need for their tour, from cocktail dresses, hats and stockings to sweaters, gloves, handkerchiefs and umbrellas, Newton-Sharpe instructed the dancers to 'wear the clothes like you would dress for the ballet, caring for every detail of costume and make-up as you would for the stage'. Elsbeth recalls that they hired a flat for fitting sessions, since many of the dancers were smaller than the average woman, and needed tailored adjustments to their outfits. The issue of *The Ambassador* of October 1949 was devoted entirely to this promotion. Complete with a gold cover, 'London Fashions for the English

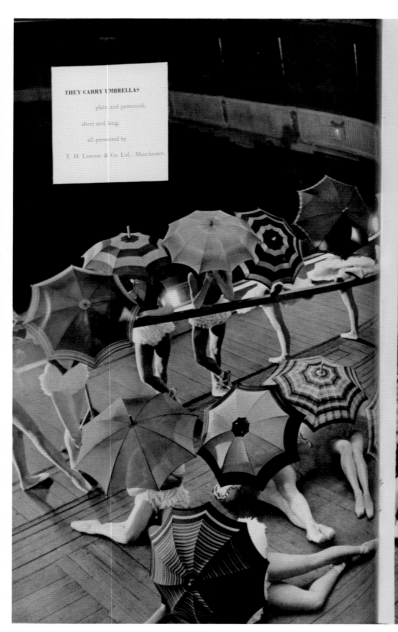
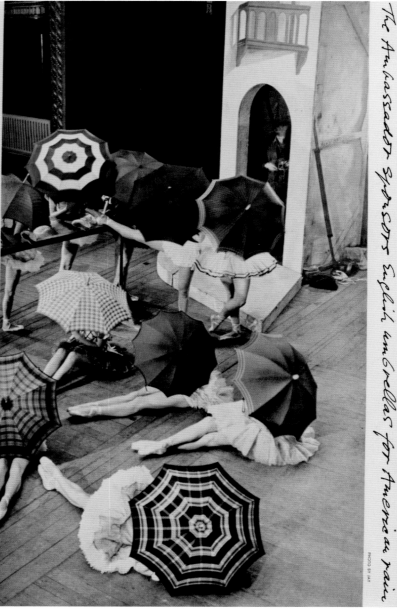

THEY CARRY UMBRELLAS

plain and patterned,

short and long,

all presented by

T. H. Lawton & Co. Ltd., Manchester.

The Ambassador Sponsors English umbrellas for American rain

PHOTO BY JAY

'London Fashions for the English Ballet'

1949, no.10

Opposite: Daniels & Fisher window display of Liberty scarves, Denver, Colorado. Promotion for 'The Ballet is Dressed' feature, 1950

AAD/1987/1/208

Ballet' was designed to resemble a theatre programme. The images by Jay illustrating the tour wardrobe were all taken in London prior to the trip. The fire resulted in the Sadler's Wells Ballet becoming the resident company at the newly reopened Royal Opera House and Elsbeth decided to commemorate this new home by using the stage, rehearsal spaces, backstage corridors, and even the surrounding streets of Covent Garden, as makeshift backdrops for her photographs. Some of the strongest images are those depicting accessories, again perhaps drawing on European modernist principles of 'objective' photography. Elsbeth's witty nature, however, is revealed in one particular double spread entitled 'They Carry Umbrellas', where the assembled dancers (supplied with umbrellas courtesy of T.H. Lawton & Co. of

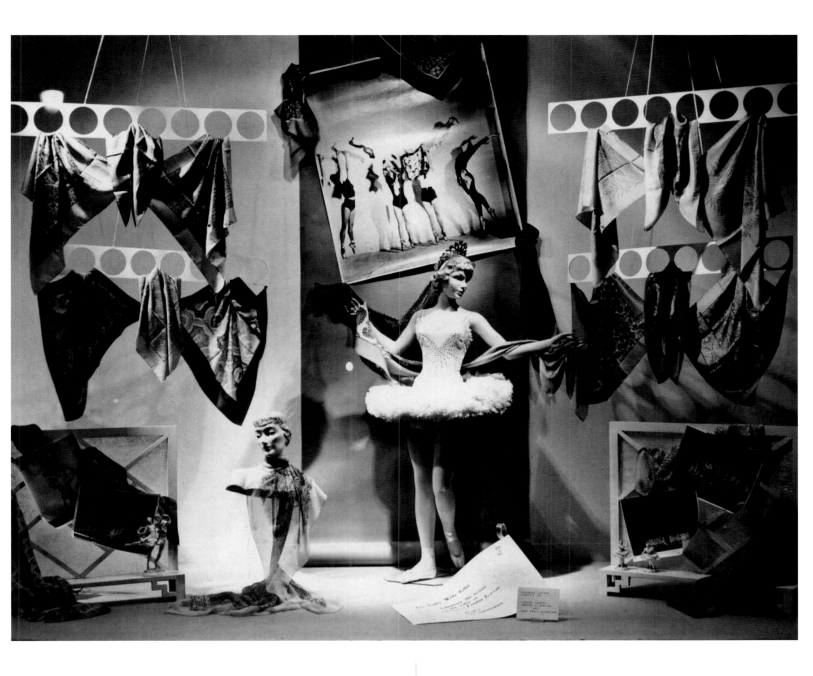

Manchester) appear on the verge of breaking into a fantastical Busby Berkeley sequence. The promotion was repeated the following year to coincide with a second North American tour. This feature, entitled 'The Ballet is Dressed', included a 'coast-to-coast tie-up with all the principal wholesale and retail outlets' (see pages 190–91). The intention was for these editorial features to be used by stores across the United States as pull-out brochures and mailing pieces for their customers. Large-scale blow-ups of Elsbeth's photographs were specially printed and sent to stores all over the country as a basis for associated window displays. The V&A's *Ambassador* archive contains photographs of these displays, including one arranged for the Daniels & Fisher department store in Denver, Colorado (above). Designed around a promotion related to the

Liberty scarves supplied on the tour, the display was centred on Elsbeth's iconic photograph capturing the dancers, mid-leap, flinging the scarves into the air. The image is a fascinating record of *The Ambassador*'s photographs applied in the context of a three-dimensional retail space.

CONSPICUOUS DISPLAY

In fact, there is evidence of a wider impact of *The Ambassador*'s photography on the design of retail spaces, in particular the effectiveness of shop window displays. As part of their 'How To Do It' series, *The Studio* published an instructional manual in 1954, written by Natasha Kroll, entitled *Window Display*. Kroll, a German émigré designer who arrived in London a few years after the Judas, had a teaching job at the

Opposite: 'Milling around Lancashire'
Marked-up photograph
1952, no.9
AAD/1987/1/113/73

Overleaf: 'Milling around Lancashire'
1952, no.9

Reimann School (re-located from Berlin in the 1930s) and worked as display manager at Simpson's in Piccadilly.[13] In her guide to window display (which featured line drawings by a young Terence Conran), Kroll included a section dedicated to fabrics dominated by photographs from *The Ambassador*. Kroll used Jay's 'still-life' images of strategically arranged textiles to support the opinion that 'merchandise should always be treated and presented so as to enhance its quality and character . . . the display should suggest a certain amount of improvisation, an illusion of spontaneity'. She noted that 'cloth will naturally behave according to its qualities – do not force it . . . let the material fall naturally, lending the occasional helping hand here and there'. Photographs of textiles from *The Ambassador* were also appropriated by *The Studio*'s annual survey of trends in architecture and design, the *Year-Book of Decorative Art*. The 1961 edition included an *Ambassador* arrangement of textiles that featured cottons by David Whitehead and a hand-screen-printed chintz by Turnbull & Stockdale.

Elsbeth was good friends with Sally Kirkland, the fashion editor of *Life* magazine who previously had been fashion editor at American *Vogue*. In 1945, during a visit to New York, Elsbeth accompanied Kirkland to a number of editorial meetings at which she had the opportunity to meet Carmel Snow, the legendary editor of *Harper's Bazaar*. Elsbeth remembers that these meetings always took place at lunchtime, but that 'no food was ever served, just Martinis'. It was during these sessions that Elsbeth also met photographers such as Richard Avedon and Irving Penn, who had developed under the watchful eye of dynamic art directors such as Alexey Brodovitch and Alexander Liberman. Although these photographers benefited from a great deal of creative freedom, Elsbeth recalls that Snow could still be 'vicious', telling her photographers in no uncertain terms that 'you can't just show the hems *swaying*, you need to show what the clothes actually *do*. The advertisers *demand* this.' This was, of course, familiar territory for The *Ambassador*, a trade journal that relied on advertising for its survival. Snow once declared to Elsbeth that 'you can photograph anything as long as you can accessorise it and as long as you can choose your setting'.[14] This advice seems particularly prescient in relation to an *Ambassador* feature of 1952 entitled 'Milling Around in Lancashire', organized in conjunction with the Calico Printers Association. The article was originally intended as a simple layout consisting of fabric swatches spread over a few pages. At a time when commercial photography was only just beginning to creep out of the studio to occupy streets and other locations drawn from everyday life, it seems remarkable that *The Ambassador* team decided to shoot with a model on location in the mills of Lancashire. As Elsbeth explained,

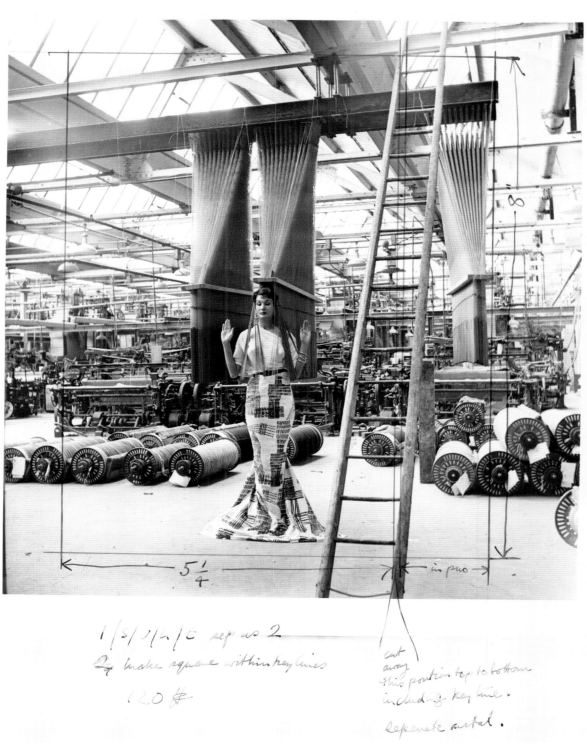

1/5/1/4/E sep as 2

2) make square within key lines

120 #

5 1/4

in pro

cut
away
this portion top to bottom
including key line.
Separate metal.

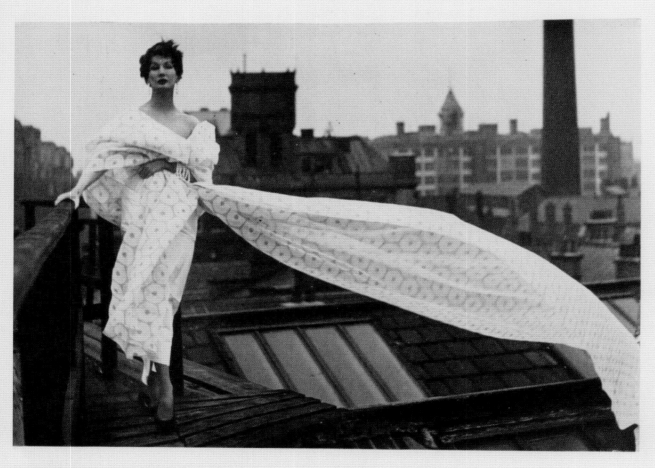

T HERE seems to be no limit to the things a young lady can get up to if she tries (as evidence, our pictures), and at Whitworth & Mitchell's Manchester Showroom Barbara got out on the roof in an organdie print which had the astonishing effect of making the warehouse next door send over to ask us to stop, as we were " interfering with production " . . .The rest of the pictures speak for themselves ; the fabrics are " Tricoline " and " Wemco ".

On the opposite page, Barbara is all mixed up in a men's shirting and pyjama fabric display—of course it's " Tricoline ".

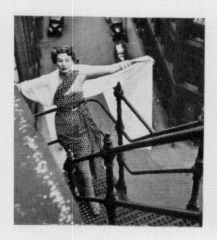

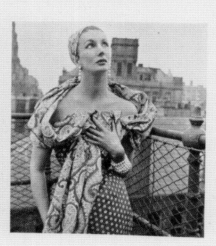

'when it was really absurd, it always tempted me'.[15] She also gave credit to the model, Barbara Goalen, whom she described as 'the Kate Moss of her day'. 'Barbara was very creative, she loved acting, she loved *producing* herself.' They had only one day in Lancashire, and it seems that an inspired joint decision was taken to model the CPA's products as swathes of unsewn cloth. As the editorial copy explained, 'all Barbara's costumes are spontaneous Goalen-Jay creations from fabrics straight off the loom'.

The 'Milling' feature is populated with numerous understated witticisms, such as the caption for the opening spread: 'Barbara makes an Egyptian of herself by getting wound up in black and white furnishing fabric for the lower half, and a jacquard loom for the head-dress' (see page 59),

or that for a memorable image of Goalen precariously balanced on top of the Whitworth & Mitchell showroom in Manchester with a wave of billowing cloth behind her: 'Barbara got out on the roof in an organdie print which had the astonishing effect of making the warehouse next door send over to ask us to stop, as we were "interfering with production".' This ambitious shoot seems reminiscent of a feature entitled 'The Big Coat' that had appeared in *The Ambassador* the previous year. Goalen was again the model, but this time she was photographed against the mammoth water settlement tanks at Fawley, an oil refinery recently opened by Esso Petroleum, which was described in the editorial as 'Europe's largest, and one of the world's greatest'.

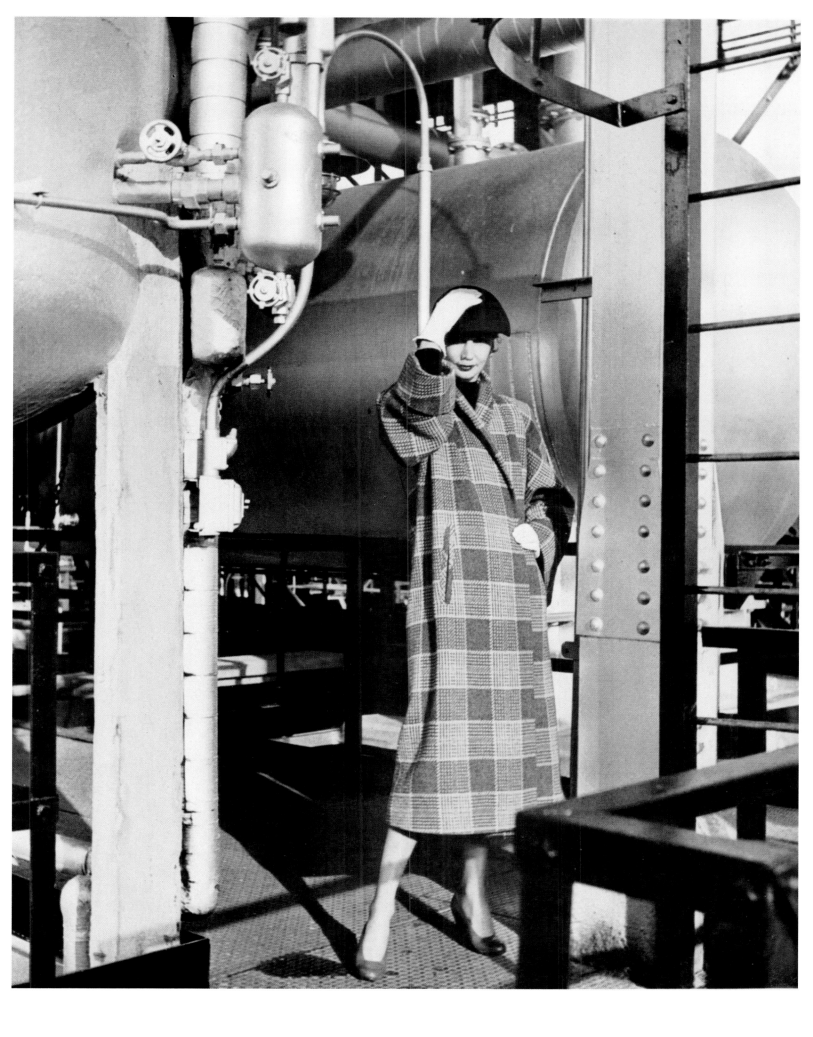

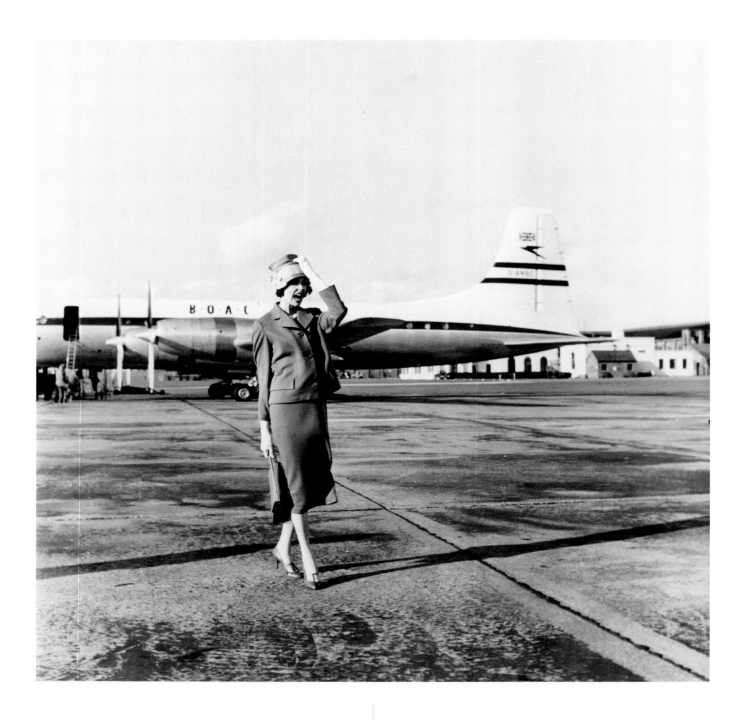

'Airborne with the Whispering Giant'
1957, no.5
Photograph
AAD/1987/1/192/3

Opposite: 'Airborne with the Whispering Giant'
1957, no.5

A SHOWCASE FOR BRITISH INNOVATION

A distinct *modus operandi* at *The Ambassador* was to feature wider aspects of British industry and ingenuity alongside the latest examples of fashions and textiles. 'Airborne with the Whispering Giant' was a feature of 1957 promoting the recently constructed Bristol Britannia airliner. The editorial copy noted that the 'Whispering Giant' and *The Ambassador* 'share a similar function – that of presenting to the world the best of British design, workmanship and enterprise'. The models were photographed in front of huge technical drawings or suspended on gantry platforms looking out on the vast factory floor, and in one example modelling a 'very full-skirted sleeveless dress . . . appropriately photographed in the wind tunnel'.

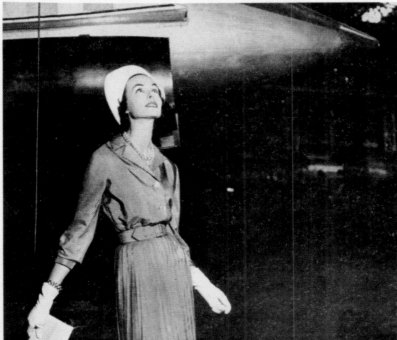

Pale blue 'Saharienne' suit
in 'Dorlinic' uncrushable rayon.
The matching chiffon scarf
is used to fill in the V-neckline.

A 'Dorville' model
Rose & Blairman Ltd., London W.1.

Easy shirtdress
with finely pleated skirt
in Debenham's honey-coloured
silk shantung.
The top of the dress
is slightly bloused and
the full $\frac{3}{4}$ sleeves are neatly cuffed.

Julian Rose Ltd., London W.1.

All hats from Otto Lucas Ltd.

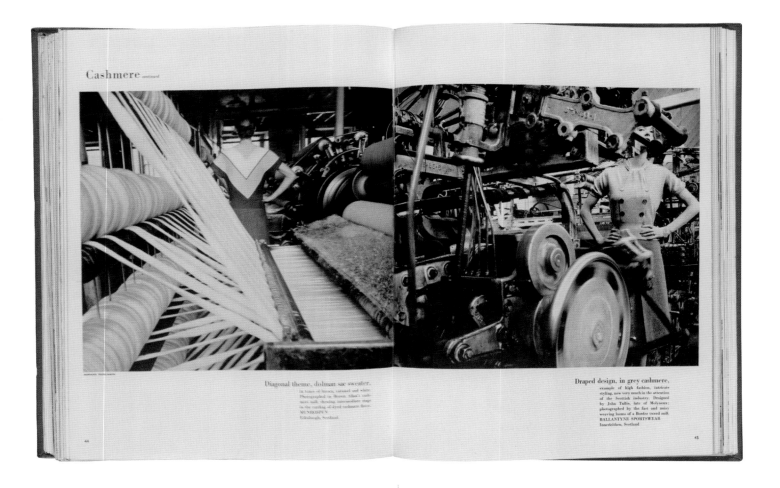

Diagonal theme, dolman sae sweater.
in tones of brown, caramel and white.
Photographed in Braun Allan's cash-
mere mill, showing intermediate stage
in the carding of dyed cashmere fleece.
MUNROSPUN
Edinburgh, Scotland.

Draped design, in grey cashmere,
example of high fashion, intricate
styling, now very much in the attention
of the Scottish industry. Designed
by John Tullis, late of Molyneux;
photographed by the fast and noisy
weaving looms of a Border tweed mill.
BALLANTYNE SPORTSWEAR
Innerleithen, Scotland

44

45

'Cashmere', *Vogue Book of British Exports*

1951, no.5

Photographed by Norman Parkinson

© Norman Parkinson Limited/Courtesy Norman Parkinson Archive

Opposite: 'The Inventive Spirit', *Vogue Book of British Exports*

1953, no.3

Model with the de Havilland Comet II, photographed by
Norman Parkinson

© Norman Parkinson Limited/Courtesy Norman Parkinson Archive

Overleaf: 'Eight Belles / Ship Shape'

1964, no.2

Photographed by [Peter?] Cockrell, Elsbeth's assistant

An interesting magazine in comparison to *The Ambassador* was the *Vogue Book of British Exports*. Regular contributor Norman Parkinson was commissioned in 1951 to photograph his wife, the model Wenda Parkinson, for an editorial feature on cashmere. They were sent to Hawick in the Scottish Borders to 'absorb the atmosphere of sweater production and to photograph as inspiration led them'. As with Jay's photographs of the dainty Barbara Goalen set against the heavy-duty machinery of the Lancashire cotton factories, so too here we see Parkinson juxtaposing his model next to 'the fast and noisy weaving looms of a Border tweed mill'. A similar feature, 'The Inventive Spirit', appeared in the *Vogue Exports* Coronation special issue two years later, showcasing British technical innovation. Parkinson's wide-angle photograph captured a model in a Hardy Amies suit and coat, standing under the looming tail shadow of a brand-new de Havilland Comet Mark II jet airliner, due to go into production with B.O.A.C. the following year.

The 'Eight Belles / Ship Shape' feature of 1964 provided *The Ambassador* with an opportunity to support the British shipbuilding industry. At the Earls Court Boat Show an 'on-shore view of fashion for beach and boat' was illustrated with outfits by Emcar and Ascher, modelled in the hull of a 'Dinky Shell' – manufactured by Fairey Marine Co. Ltd, a shipbuilding company based in Southampton.

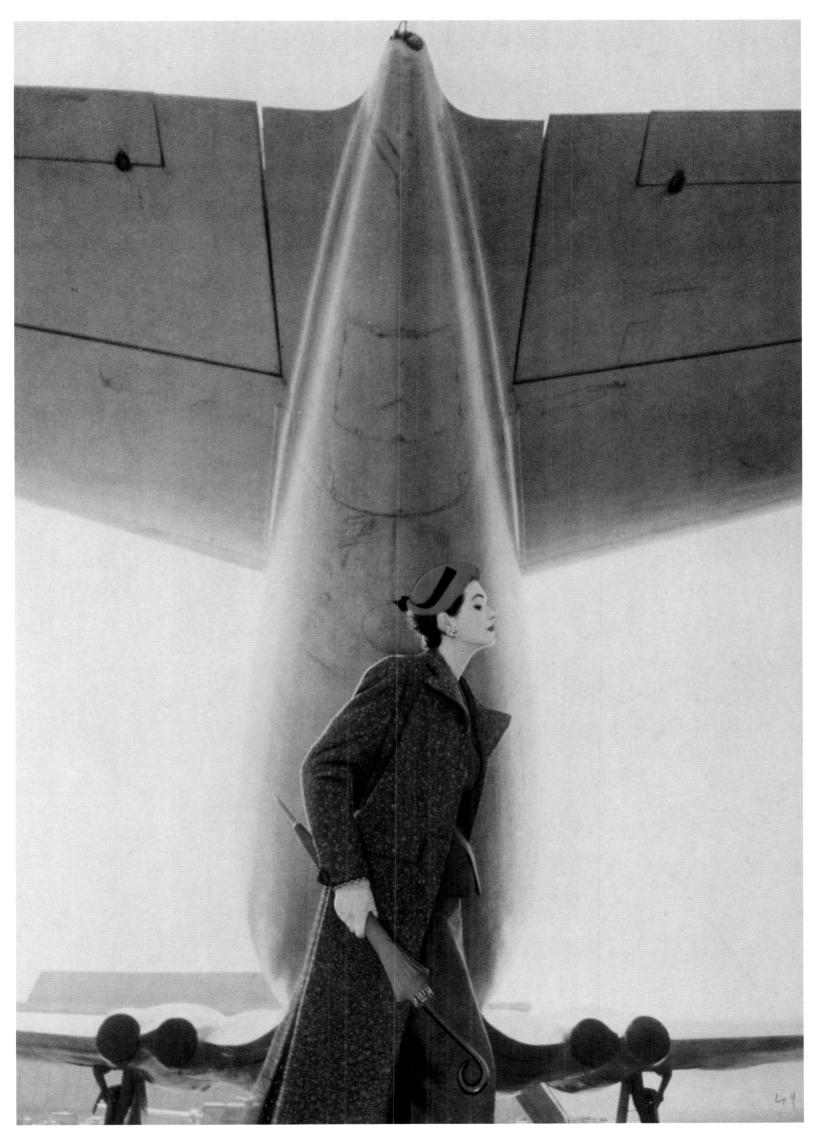

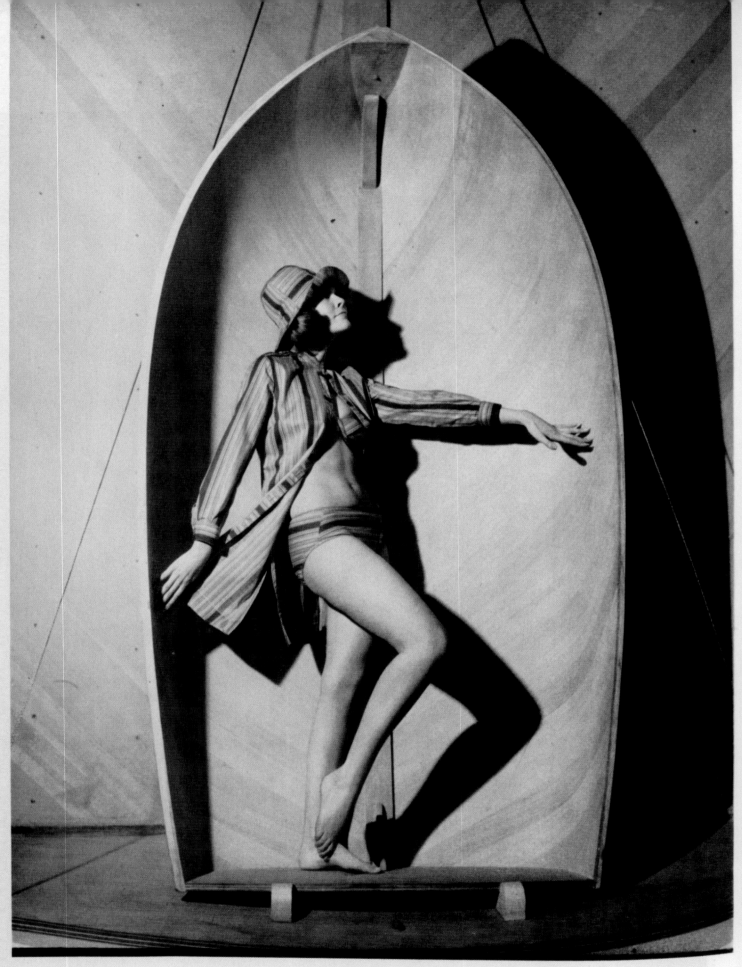

Shirt, bikini and matching hat in striped cotton by Emcar Casuals, London W.1
'Dinky Shell' by Fairey Marine Co. Ltd., Hamble, Hampshire.

EIGHT BELLES/SHIP SHAPE

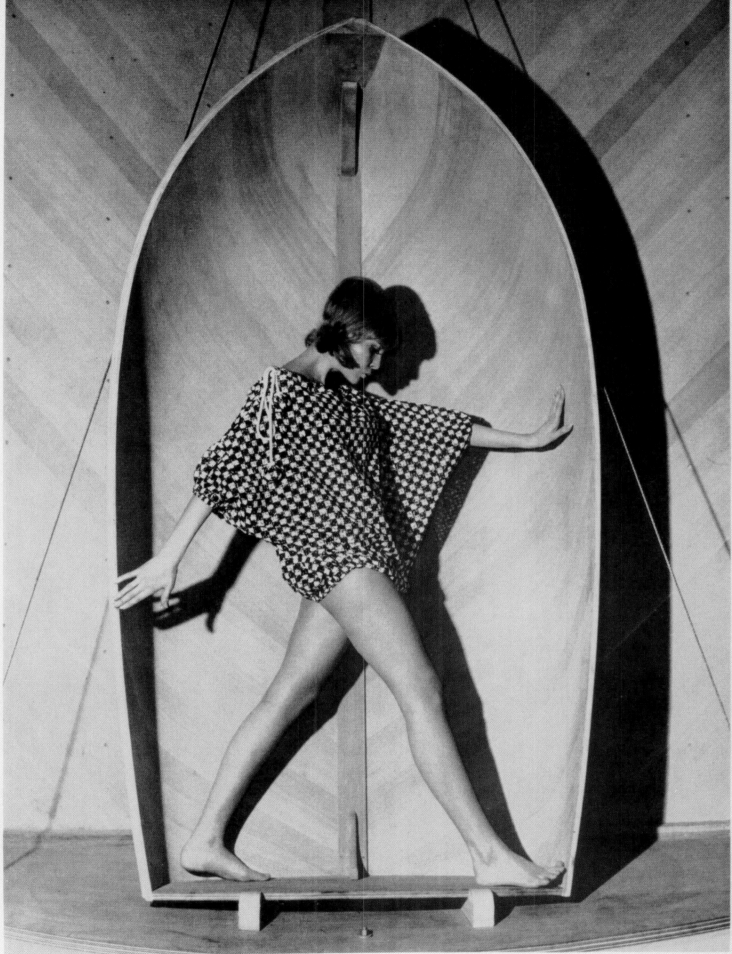

AMBASSADOR PHOTOS (COCKERELL)

'Carpet Bag' in Ascher's cotton lace designed by Ronald Lickman at 'inFashion' Ltd., London W.1.

continued

'The Alchemist's Dream Comes True: Calder Hall'
1957, no.1
AAD/1987/1/143/34

Overleaf: 'Pattern in Contrast', collaboration between Elsbeth Juda
and Louis le Brocquy.
1955, no.10

In 1957 *The Ambassador* accompanied the British sculptor Kenneth Armitage on an expedition to the recently completed Calder Hall, the world's first nuclear power station. Representing national aspirations for a bright new future, the feature was evocatively entitled 'The Alchemist's Dream Comes True'. Highlighting texture and shadow, these snatched glimpses of mysterious tunnels, wiring and pipes offer a fascinating, abstracted view into a machine-dominated underworld. The intention was for Armitage to make sketches during his visit, in the hope of inspiring a new work. Another example of *The Ambassador* providing new sources of visual material for British practitioners was the feature of 1955 'Pattern in Contrast'. This exploration of Spain was presented as a collaboration between a photographer, Jay, and a painter, Louis le Brocquy, who had recently been appointed to the School of Textile Design at the Royal College of Art. The agenda was established immediately with this bold opening statement: 'Textile design has been feeding off its own body far too long. Abstract design too often is merely derived from abstract design . . . We knew the time was ripe to go and find a new immediacy and excitement of pattern – a

new vitality of colour.' Elsbeth described the feature as one of *The Ambassador*'s regular 'integration pieces' where the concept was 'pre-sold' to crucial manufacturers, in this case Horrockses, Sekers, Heathcoat and Whitehead:

I said to Louis, let's go to Spain and make a feature . . . so I found four manufacturers willing to trust! We photographed Spanish lanes, Spanish windows . . . we had a car, and the chauffeur couldn't believe it when we stopped at a little shadow in the street or a piece of wrought-iron, when he wanted to show us the mosque in Granada.

The article further explained Jay's and le Brocquy's collaboration: 'Together with camera and sketchbook, recording and noting an immensely wide variety of impressions derived from peasant and Moor, castle and white-washed village, they worked with an eye peeled for pattern.'

The photographs, which were considered 'as varied as Moorish tiles', were translated by le Brocquy into design drawings that were then 'produced as furnishing fabrics by David Whitehead, cotton dresses by Horrockses, and woven as

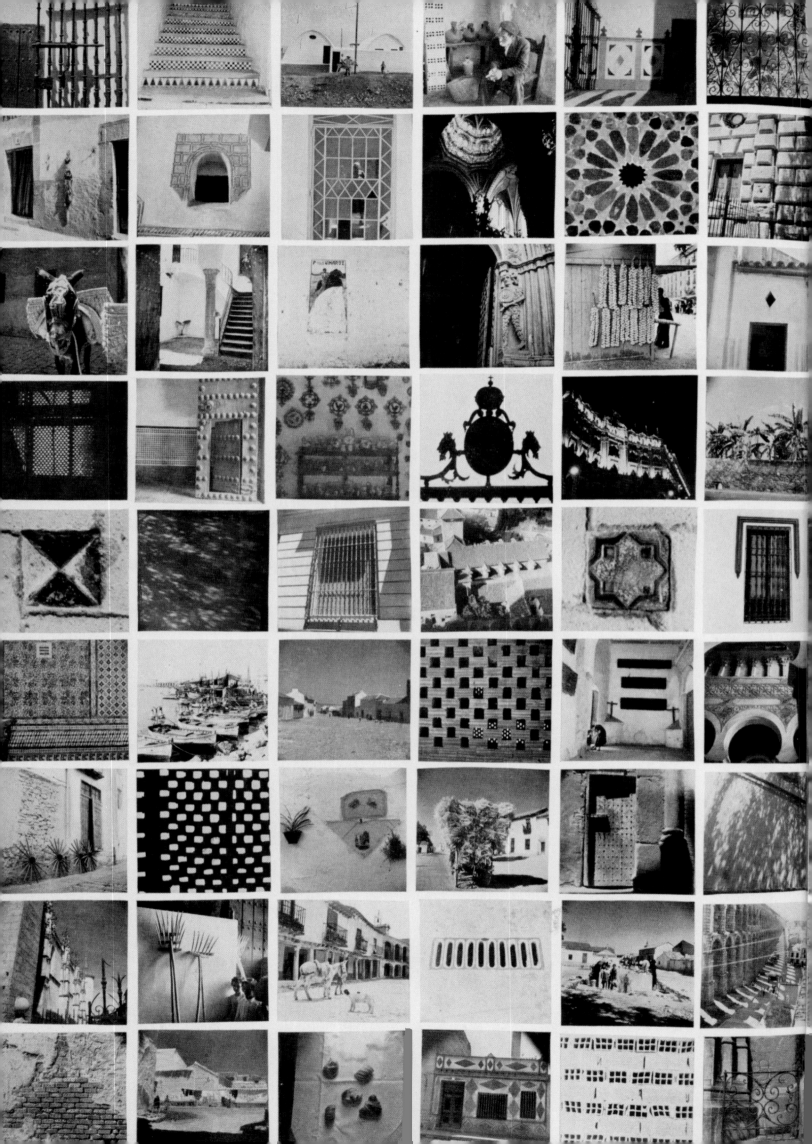

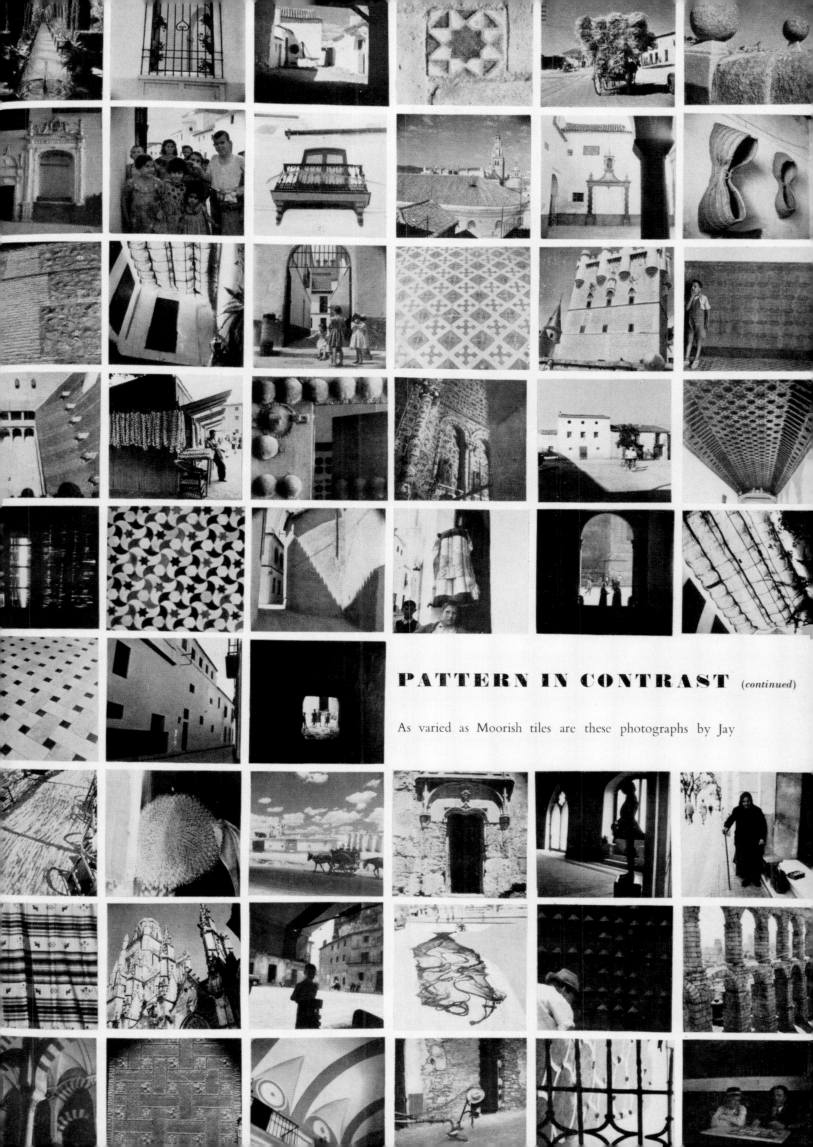

PATTERN IN CONTRAST (continued)

As varied as Moorish tiles are these photographs by Jay

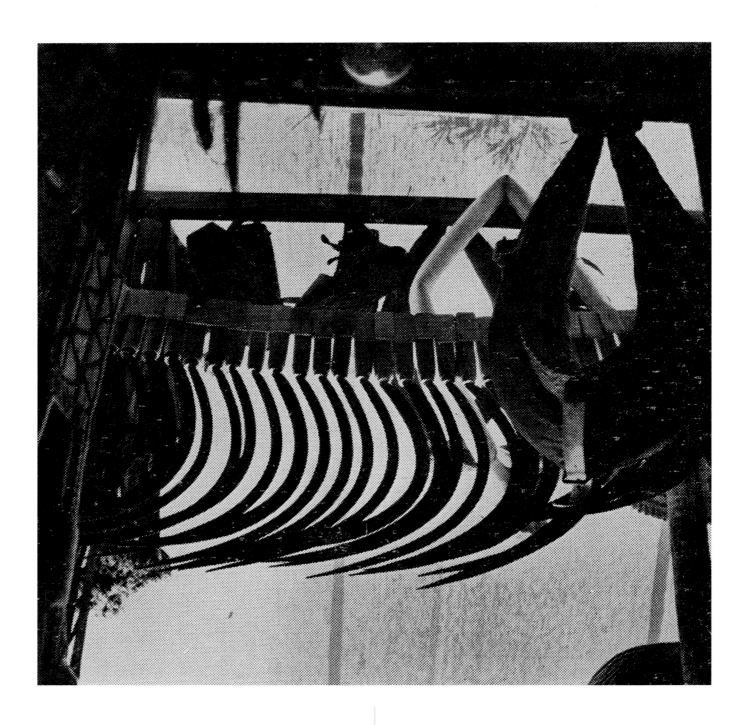

'Pattern by Contrast', sickles photographed by Jay in a shop doorway in Andujar.
1955, no.10

Opposite: Printed textile by Louis le Brocquy, for David Whitehead
V&A: CIRC.644–1956

Overleaf: 'Stripes + Dots', *Design Elements* series
Compiled by F.H.K. Henrion, written by Douglas Newton
1948, no.1

dress fabrics by Sekers'. One particular photograph depicting 'sickles, discovered by Jay in a shop doorway in Andujar . . . a pattern of exciting possibility' emerged as a fabric by David Whitehead. A sample was acquired for the V&A's textiles collection the same year (see also pages 150–51).

INSTRUCTION AND INSPIRATION

Graphic design was often a topic for discussion and debate within the pages of *The Ambassador*, as demonstrated by the *Design Elements* series, an instructional feature in the magazine during the late 1940s. Written by Douglas Newton, using images compiled by the graphic designer F.H.K. Henrion, the series examined themes such as 'Colour', 'Shape', 'Stripes + Dots' and 'Textures', in dialogue with related examples of British textiles. Henrion, an early pioneer of corporate identity, had started his career as a textile designer. Newton, a BBC journalist, later moved to New York where he received critical acclaim for his ground-breaking exhibition designs at the Museum of Primitive Art, and eventually became curator emeritus at the Metropolitan Museum of Art.[16]

The cluster of strings stretched from bar to bar in the device pictured below has the appearance of a shower of rain, when a gust of wind strikes it and the straight diagonal lines waver for an instance. In fact, however, they have been arranged to illustrate a geometrical principle, the **principle of the hyperbolic paraboloid.** It is a small masterpiece of theory; but simultaneously it has a practical application, for it can be used to calculate the ideal shape and function of such instruments as plough-shares.

Dots are not involved in this figure, unless we revert to the Greek idea that the lines were generated by the movement of dots. **The smiling lady is composed entirely of dots** : dots generated, strangely enough, by lines. These dots are not on any account to be taken for spots; they cover also the smooth grey complexion of the postage-stamp sized girl. If you examine the small face under a magnifying glass, you will find it to be as broken up as the larger portrait : and if you retreat to a suitable distance from the large picture, you will find the dots integrate, and tone to the greys of the smaller. Both pictures are printed from blocks made by the half-tone process, in which photographs are themselves photographed through sheets of glass engraved with a lattice of cross-lines. As water pouring through a sieve breaks up, the tones of the original photograph break up into dots which mass together to form black areas, or thin out into lighter and lighter greys and disappear altogether in white areas. As long as the pull of gravity lasts, the plumb will provide as nearly absolute a vertical line as we need for practical purposes. It is the standard from which the subtle lines of architecture diverge.

(continued on page 90)

The straightness and accuracy
of the plumb-line

OPPOSITE : *Halftone reproduction of a photograph,*
enlarged to show its component dots

Inset : the same photograph reproduced on a normal scale (120 screen)

A mathematical model : the hyperbolic paraboloid.

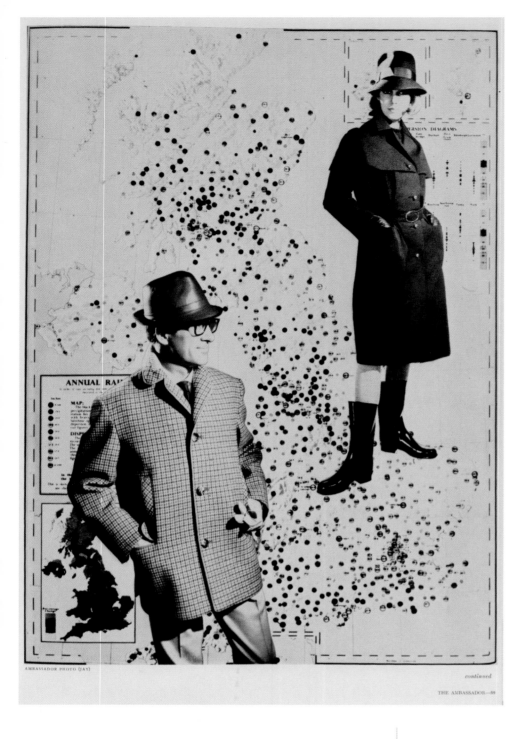

'Rain Fashion'
1964, no.1

Opposite: Cover by John Piper
1964, no.1
Based on endpapers for *Atlas of Britain and Northern Ireland*

Overleaf: 'A Feeling For Stripes'
1953, no.8

Alongside the *Design Elements* series *The Ambassador* was populated with occasional graphics-led features such as 'A Feeling For Stripes' in 1953. Illustrated with examples of trousers, socks, ties and luggage, the editorial championed the use of stripes 'because they can accentuate, vary and enrich the new silhouette', adding that their strength 'depends on more than our delight in the geometric pureness of a straight line'. John Piper supplied one of the most graphically striking *Ambassador* covers in 1964 when the magazine reproduced his endpapers for a recent edition of the *Atlas of Britain and Northern Ireland,* published by Oxford University Press. The cover was chosen to coordinate with the lead article, 'Rain Fashion', which featured models juxtaposed against rainfall maps of the British Isles. The reader was informed that there was 'no need for a Dietrich or a Bardot to prove that the Trenchcoat is "with it", weather – and fashion-wise'.

THE AMBASSADOR

no. 1-1964

*T b f f p 6 1 *

A FEELING FOR STRIPES

We believe that stripes are "in" because they can accentuate, vary and enrich the new silhouette. That is the reason for this feature in which the recurring stripe in to-day's fashion forms the theme.

A fashion as old – and as new – as the stripe does not attract the eye alone; its strength depends on more than our delight in the geometric pureness of a straight line. It depends almost as much on overtones and undertones, qualities which arouse emotional as well as visual response.

What overtones does the stripe suggest? Prison bars, railway lines, pedestrian crossings, for the fag at school "stripes" imply a beating; for the sixth former it means rugger vests, "colours" and ties only those who have fought upon the Waterloos of the playing fields may wear; for the ranker stripes denote a sergeant; a policeman wears striped cuffs when on duty; a frontier guard lowers a striped barrier before your car . . . but let's go back to our striped fabrics and fashions.

★

THIS PAGE: **1.** Humbug striped "Expanda" cufflinks. Jarrett, Rainsford & Laughton Ltd., Birmingham.

2. "Londonus" butcher-boy striped cotton jeans, buttoned at the calf. Louis London & Sons, London, E.1. Worn with a long-sleeved, candy-striped cotton voile blouse. Eric Hart Ltd., London, W.1.

OPPOSITE PAGE: **3.** The fancy striped silk tie exactly matches the wool socks. Turnbull & Asser Ltd., London, S.W.1.

4. Luggage from S. Noton Ltd., London, E.17, features stripe decoration. Made from compressed and coated fibre, they are welted round body and lid with contrasting plastic binding. Umbrella from T. H. Lawton & Co. (Manchester) Ltd.

5. TOP TO BOTTOM:
Tinsel striped organza and a coloured woven striped alpaca from James Sterling & John Brown & Son Ltd., London, W.1.
Zig-zag stripe on a wool and mohair coating from J. JL. & C. Peate (Guiseley) Ltd.
"Terylene" and tinsel stripe and a fringed rayon taffeta from Halle's (Overseas) Ltd., Macclesfield.

PHOTOS BY JAY

2

3

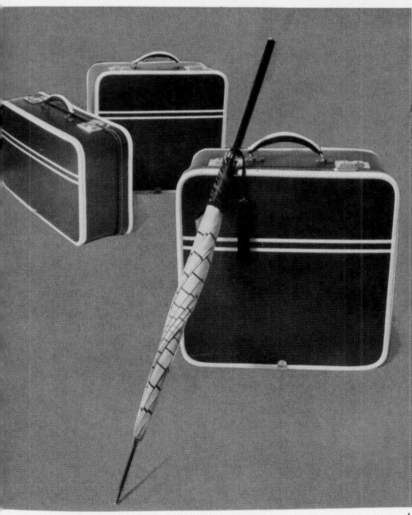

4

5

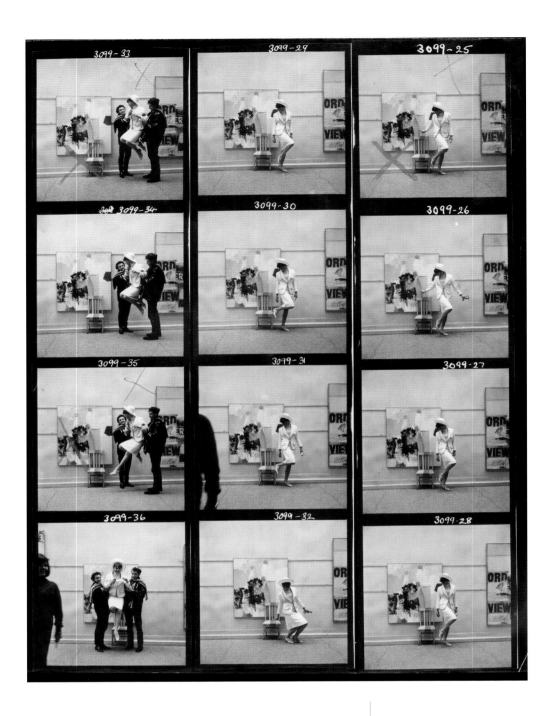

'Fab Pop Fash . . . For the Young'

1964, no.4

Photograph contact sheet

British ready-to-wear collections photographed at
Robert Rauschenberg exhibition at the Whitechapel Art Gallery

AAD/1987/1/162/1

Opposite: 'British Cottons for 1958'

1957, no.7

Photograph (Kenneth Armitage sculpture visible in background)

AAD/1987/1/145/3

ART AND CULTURE

As was noted earlier, the Judas maintained close links with
the art world. A number of *Ambassador* features testify to the
interest in appropriating these wider cultural contexts for the
purpose of textiles promotion. 'British Cottons' (1958) used
a contemporary sculpture exhibition organized by London
County Council in Holland Park to provide a novel backdrop
for the featured fabrics. A feature of 1964 entitled 'Fab Pop
Fash . . . For the Young' depicted 'Queenie', the wife of the
young Australian artist Brett Whiteley, modelling clothes by
Tuffin & Foale, Jean Muir and Mary Quant amongst works in
a Robert Rauschenberg exhibition at the Whitechapel Gallery.
As the editorial declared, 'the awareness and exhilaration
of modern city life in the Rauschenberg exhibition makes
London's Whitechapel Art Gallery the most relevant setting
for our fashion on the same wavelength' (see pages 212–17).

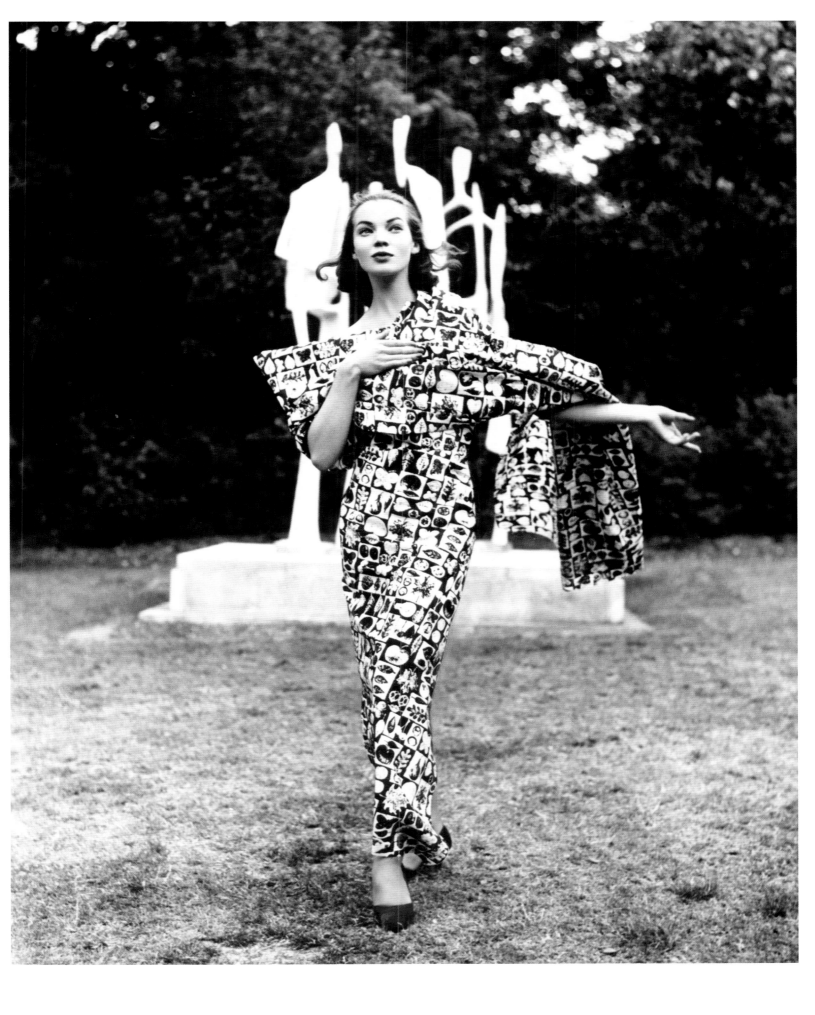

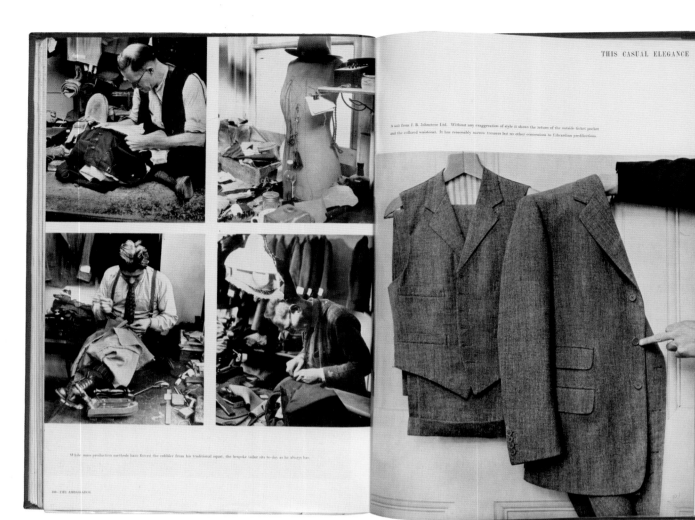

A suit from J. B. Johnstone Ltd. Without any exaggeration of style it shows the return of the outside ticket pocket and the collared waistcoat. It has remarkably narrow trousers but no other concession to Edwardian predilections.

While mass production methods have forced the cobbler from his traditional squat, the bespoke tailor sits to-day as he always has.

Left. Wool waistcoat with fly front and zipper closing; ribbed waistband. Right. Sports sweater with deep sleeves for easier movement. Designed with horizontal ribbing, decorated with white bands at neck and waist. Both from Knit Knitwear Ltd., London, W.1.

On these pages when perhaps the amusement should reach its peak we venture to offer nothing but studies in cause and effect, the details of elegance and the mode of charm. **1.** The corduroy trousers and the "sawn off" gown talking, you will note, to the Chinese coat. Perfect for one who is in his way back after bottoms, the other on his way out. Ease and charm are matched by smartness. **2.** The fancy waistcoat and the flower, the modern version of the velvet tie — and Chopin himself could not have been more evocative of nostalgia tempered with the fire of youth. **3.** The black tennis shirt — now that's new if you like, and smart enough for any king. White shoes, white socks, a white cigarette-holder and — crème de la crème — a black cigarette. **4.** Just this time — at the piano the fraye collar, the thin bow tie, and another fancy waistcoat of a most delicate style. "Rip-zip-de Hottie. Get me a beauty, I'm on the beam." **5, 6 and 7.** These men we have not met before in the clothes they wear here, and only that deep nostalgia so prevalent on a summer evening at Magdalen (pronounced Maud'in please) brings them back. Our friend who plays Bach in ruffs and jabot reads in his own and only wonderful fairisle, a fashion of yesteryear immensely up to date because he chooses to make it so. Chopin and the velvet tie look gently out of the window where the head of deer sleep in the sun, and our friend with the winged collar — none other than our host Thomas Potworthy — points out the nicety of the view, while showing to perfection that the trappings of university life to-day are hardly less splendid than the Elizabethans' and much, much more practical. As a final thought it is worth remembering that most of these clothes are obtainable wherever London suits are sold — and that is everywhere.

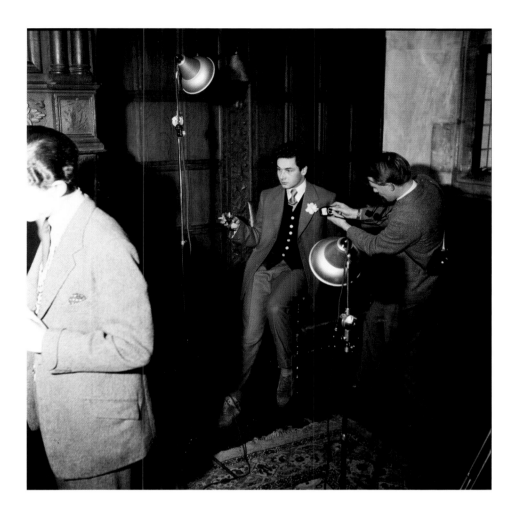

The Ambassador was also a great champion for traditional skills and craftsmanship, knowing full well that these were important selling points for British textiles abroad. The high standards of British tailoring were an area of particular focus. 'This Casual Elegance' was a feature of 1951 that offered the reader 'a sidelong glance at London tailoring', casting a spotlight on the masters of Savile Row:

There is an idea that the well-dressed Englishman is the epitome of studied disarray . . . This is an inversion of the truth. It is not a planned disorder but an unconscious elegance . . . While mass production methods have forced the cobbler from his traditional squat, the bespoke tailor sits to-day as he always has.

Echoing these themes of 'Britishness' and effortless sophistication, 'Style and Scholarship' appeared the following year, offering a glimpse into the hallowed portals of the University of Cambridge, and examining tailoring from the point of view of an idyllic student existence. The article described debonair members of the Cambridge Photographic Society as 'still smart, still leaders of fashion, and still as ever willing to enjoy something out of the usual'.

Opposite, top: 'This Casual Elegance'
1951, no.3

Opposite, bottom: 'Style and Scholarship'
1952, no.7
Men's fashions modelled by students from the Cambridge Photographic Society

Above: 'Style and Scholarship'
1952, no.7
Men's fashions modelled by students from the Cambridge Photographic Society
ADD/1987/1/110/1–69

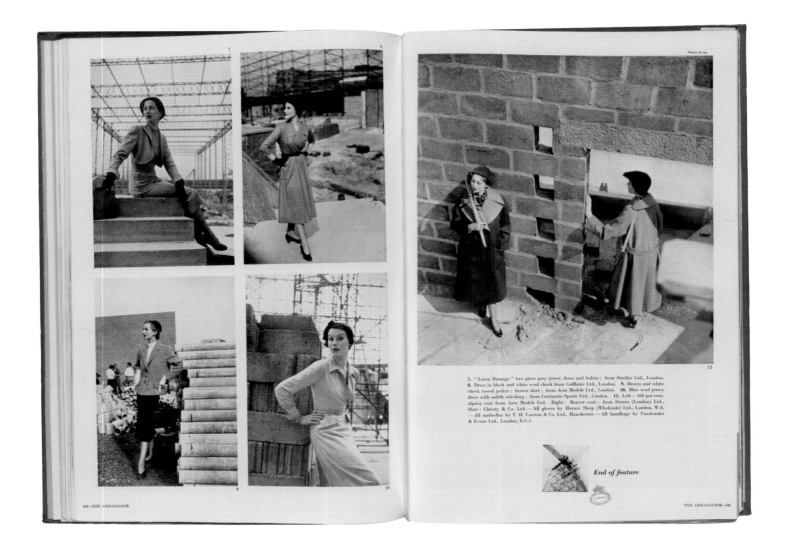

7. "Lacta Ramage" two piece grey jersey dress and bolero ; from Steelitz Ltd., London. 8. Dress in black and white wool check from Golllaine Ltd., London. 9. Brown and white check tweed jacket ; brown skirt ; from Asta Models Ltd., London. 10. Blue wool jersey dress with saddle stitching ; from Cortinette Sports Ltd., London. 11. Left : 100 per cent. alpaca coat from Asta Models Ltd. Right : Beaver coat ; from Dereta (London) Ltd., Hats : Christy & Co. Ltd. — All gloves by Horace Sleep (Wholesale) Ltd., London, W.8. — All umbrellas by T. H. Lawton & Co. Ltd., Manchester. — All handbags by Fassbender & Evens Ltd., London, E.C.1.

End of feature

'Exhibition 1951 as Fashion Background'
1950, no. 7
The Festival of Britain construction site is used as the setting for this fashion feature.

Opposite: 'Festival Nights'
1951, no.7
AAD/1987/1/98/17

ARCHITECTURE AND DESIGN
The wider role and impact of architecture and design is a recurring theme in *The Ambassador*, and was a subject close to the Judas' heart. The Festival of Britain of 1951 was pertinent to the magazine's ideals of celebrating British culture and innovation. The summer before the festival opened, *The Ambassador* took a group of models to the South Bank where they 'posed against the background of the site where Britain's 1951 Exhibition rises fast'. It was noted that the in-progress construction 'already looks exciting in its ribby, bony, bareness. The workmen only stopped for an occasional whistle at our girls.' The following summer, with the Festival in full swing, one of the models from the construction site fashion shoot, Barbara Goalen, returned to the South Bank for an eveningwear feature entitled 'Festival Nights'. As with the 'Milling' feature, Elsbeth recalls that Goalen again 'revelled in acting to the camera'. The angular lines, dramatic lighting and sculpted volumes of the Festival's pavilion buildings provided a perfect foil to the diaphanous cloth of Goalen's dress. As the editorial copy described, the scene was set with 'the soft air of a June night, the splash of innumerable fountains, the lapping of water on the prow of a river bus, the bright glow of reflection from the new buildings'.

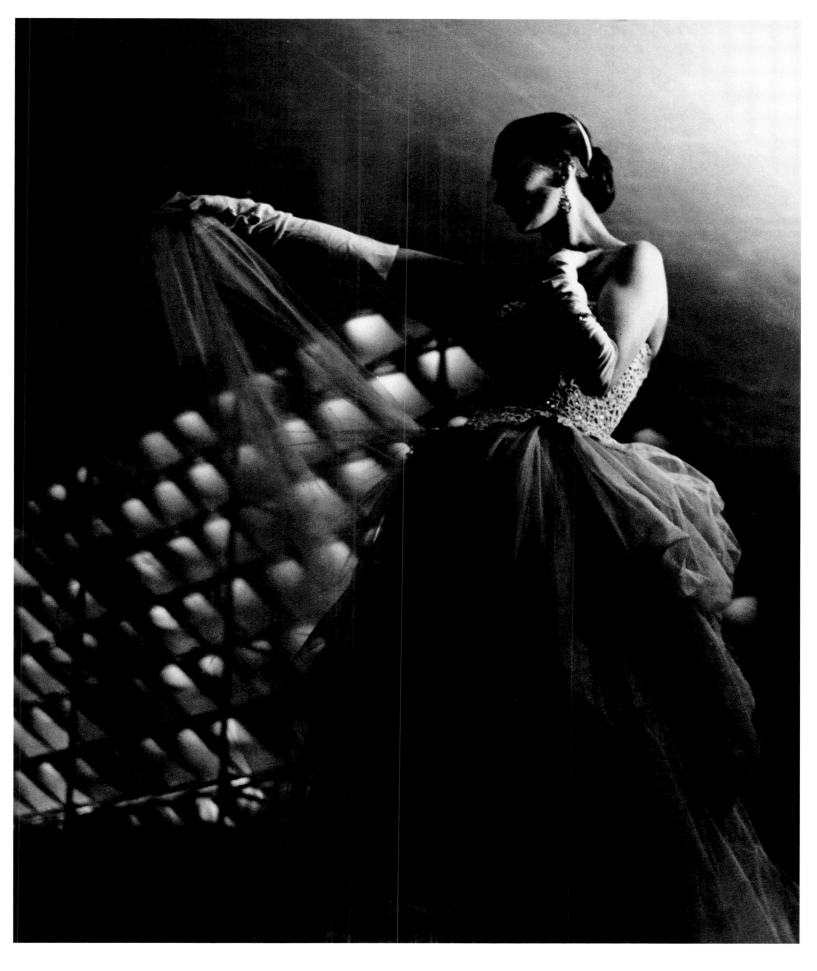

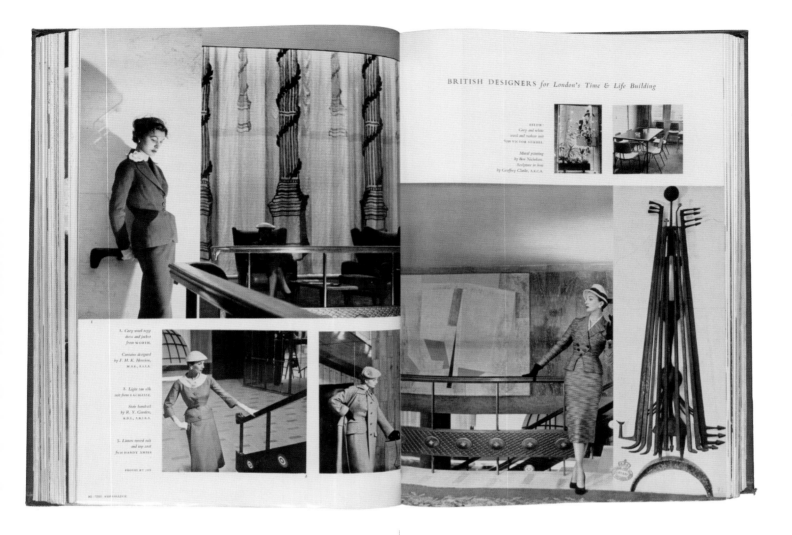

'British Designers for London's Time & Life Building'
1953, no.3

Opposite: 'It's Supposed To Be a Simple Business', front cover
1951, no.2

The opening of the new Time & Life Building in London in 1953 offered an opportunity for *The Ambassador* to highlight the contribution of British designers to a landmark architectural project. Coinciding with the Coronation, the building was a gift from the American publishing company Time Inc. to an optimistic post-war London. Hugh Casson (recently engaged as director of architecture at the Festival of Britain) was appointed to lead a team of British designers to devise an interior scheme in consultation with the building's architect, Michael Rosenauer.[17] *The Ambassador* photographs positioned models wearing outfits by Worth, Lachasse and Hardy Amies against a backdrop of curtains by F.H.K. Henrion, a sculpture by Geoffrey Clarke and a mural painting by Ben Nicholson. The building was widely acclaimed at the time of its opening, and was described as the 'first post-war example . . . of a forthright contemporary office interior: a new vernacular'.[18]

Architecture was a central element in one of *The Ambassador*'s most ambitious foreign promotional trips, an excursion through South America, documented in the feature 'It's Supposed To Be a Simple Business' of 1951. The team was minimal, consisting of Elsbeth, the model Shelagh Wilson and Elsbeth's secretary Fiona Wylie, who could also model, and therefore doubled up as the second mannequin.[19] The photographs from Rio de Janeiro were accompanied by the tag-line 'Business and Architecture Go Hand in Hand'. The Brazilian architect Oscar Niemeyer, with whom Elsbeth managed to engineer a lunch meeting, was described in the article as 'the architect whose every new building is a new idea'. As the editorial explained, 'there is a heavy accent on architecture in this story. It is not to be avoided. Rio is one of the few places where the adventurous contemporary architect comes into his own'. In addition to capturing Wilson's silhouette in a Horrockses dress against the stark geometric grid lines of Niemeyer's Ministry of Education and Health building, the photographs include other examples of Brazilian modernism, such as the São Paulo Museum of Art, a municipal housing settlement by Lucio Costa and the undulating glass brick walls of Niemeyer's Rio branch for Banco Boavista.

the Ambassador
the British Export Magazine

our flying
visit to
South America
(pages 71-110)

no. 2 - 1957

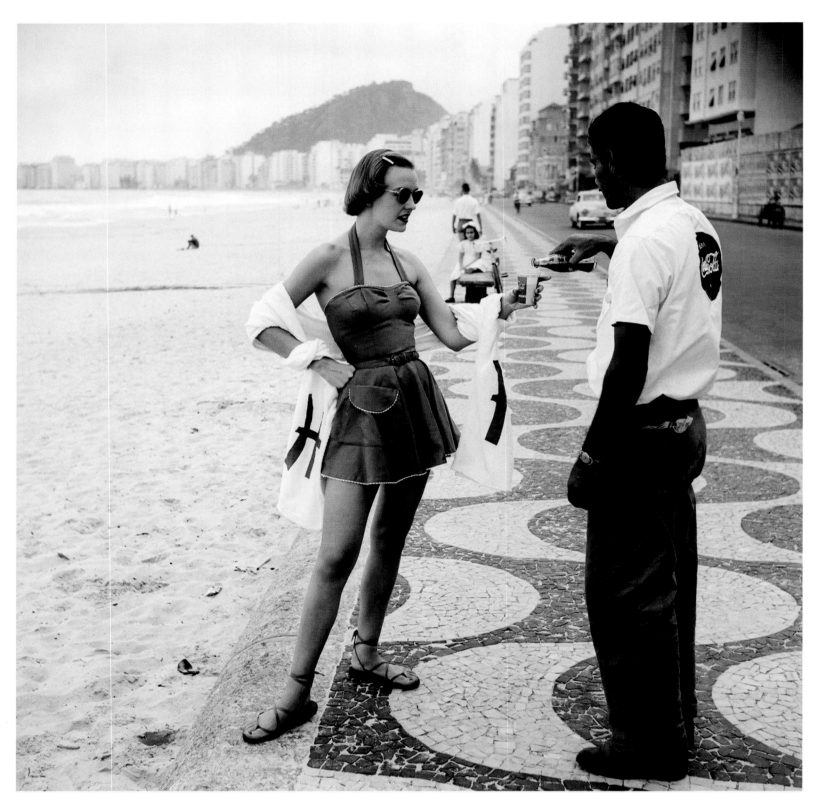

'It's Supposed To Be a Simple Business'
1951, no.2
AAD/1987/1/94

Opposite: 'It's Supposed To Be a Simple Business'
1951, no.2
AAD/1987/1/94

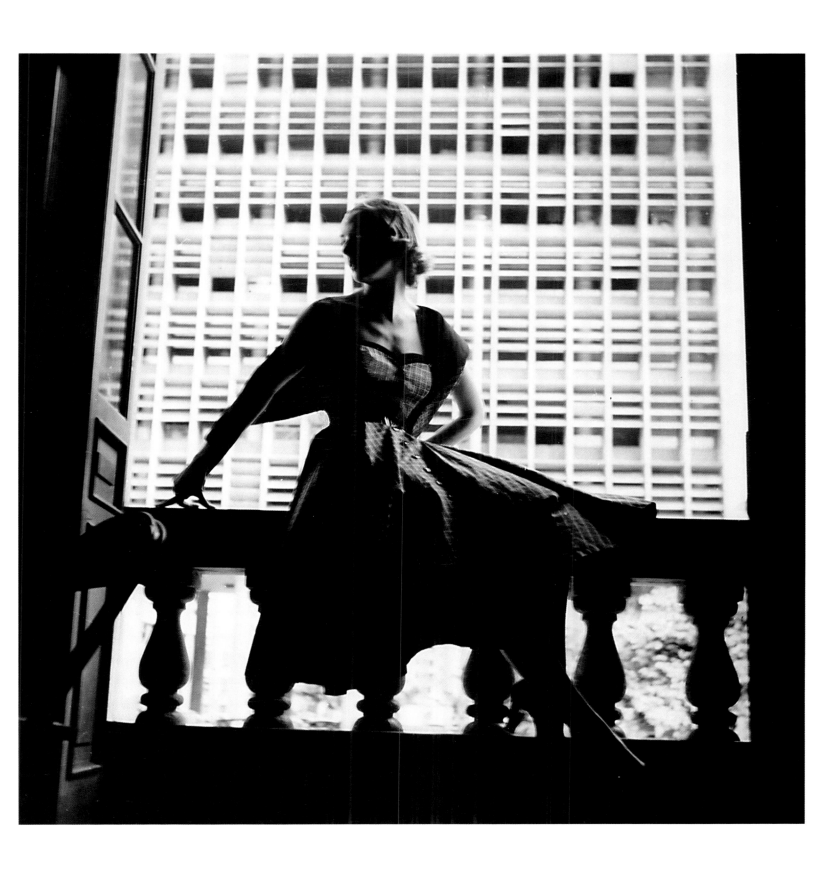

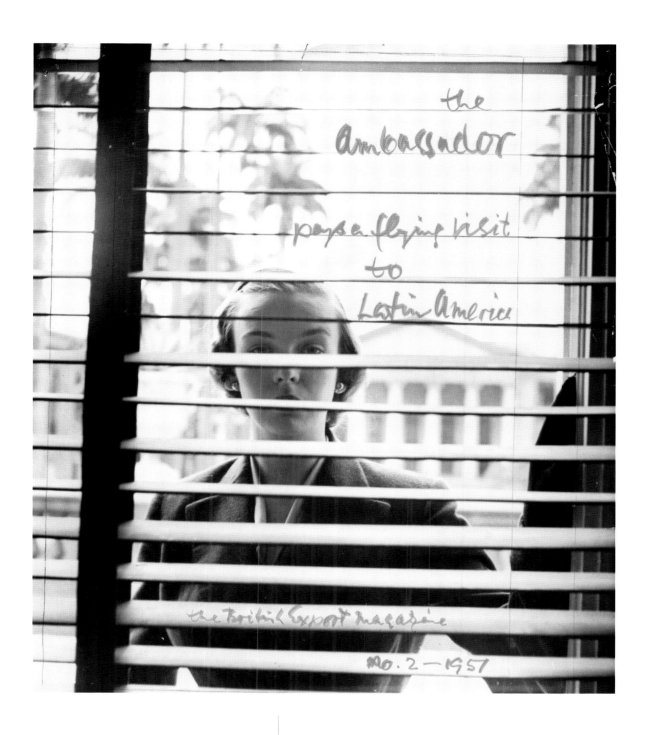

A mock-up for an alternative cover for the 'Simple Business' issue uses the horizontal lines of the Foreign Office's window grille as a series of guidelines for the cover text.

ON TO THE STREET

The South America article offered *Ambassador* readers a compelling glimpse of street life in Brazil. Similar promotional features in other foreign countries displayed Elsbeth's aptitude for documenting the details of local colour in the host city. The energy of these location shoots is explained by Elsbeth's admission that she would sometimes dream

'It's Supposed To Be a Simple Business'
1951, no.2
Front cover mock-up, photograph
AAD/1987/1/94

Opposite: 'It's Supposed To Be a Simple Business'
1951, no.2
Photograph contact sheet
AAD/1987/1/94

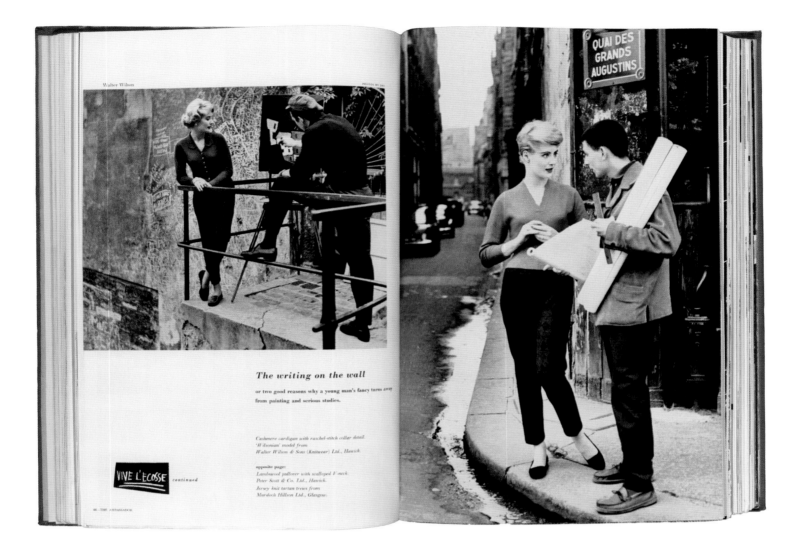

The writing on the wall

or two good reasons why a young man's fancy turns away
from painting and serious studies.

Cashmere cardigan with ruched-stitch collar detail.
'Wilsonian' model from
Walter Wilson & Sons (Knitwear) Ltd., Hawick.

opposite page:
Lambswool pullover with scalloped V-neck.
Peter Scott & Co. Ltd., Hawick.
Jersey knit tartan trews from
Murdoch Hilton Ltd., Glasgow.

VIVE L'ECOSSE *continued*

'Vive L'Ecosse'
1957, no.8

Opposite: Elsbeth Juda assisted by Fiona Wylie during a photo shoot
for 'It's Supposed To Be A Simple Business', 1951
AAD/1987/1/190/48

up these projects since 'it was the only way I could travel,
there was always too much work'. The 'Vive L'Ecosse' feature
(1957) presented another opportunity for Elsbeth to work with
her former secretary, now professional model, Fiona Wylie.
Temporarily transplanting Scotland to Paris, these cashmere
cardigans, jersey knit tartans and lambswool pullovers were
set against the artistic milieu of the Left Bank backstreets.

The Ambassador used its role in the promotion of British
textiles as an opportunity to inject fashion and advertising
imagery with a renewed sense of vitality. Avoiding
conventional clichés of product placement, *Ambassador*
layouts become known for a novel approach that employed
thoroughly modern techniques of presentation. In a world
of trade journals where the communication of information
often came at the cost of creative expression, *The Ambassador*
arrived 'steeped in revolutionary ideas about industrial design
. . . remaining fresh and alive and disconcerting'.[20] Assessing
Elsbeth's invaluable contribution to the photography in the
magazine, Mark Boxer – perhaps the most famous graduate
of *The Ambassador* family – wittily observed that 'she would
have gone even further, if she hadn't been married to the
boss'.[21]
end of feature

THE VILLAGE OF WESTON FROM AN OLD QUARRY TIP.

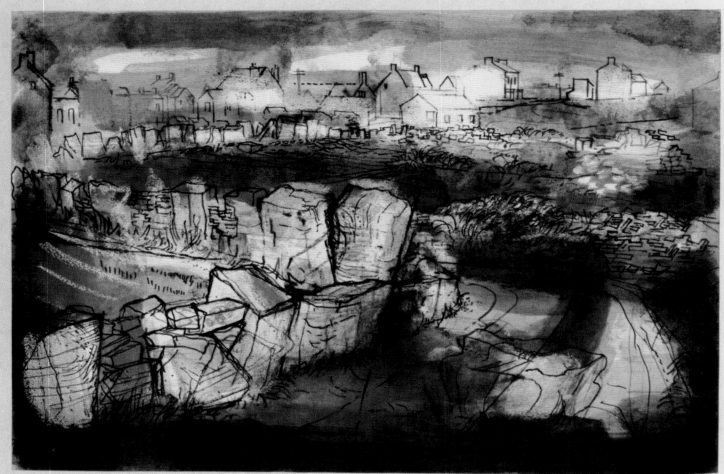

FIELD ROAD AT WESTON.

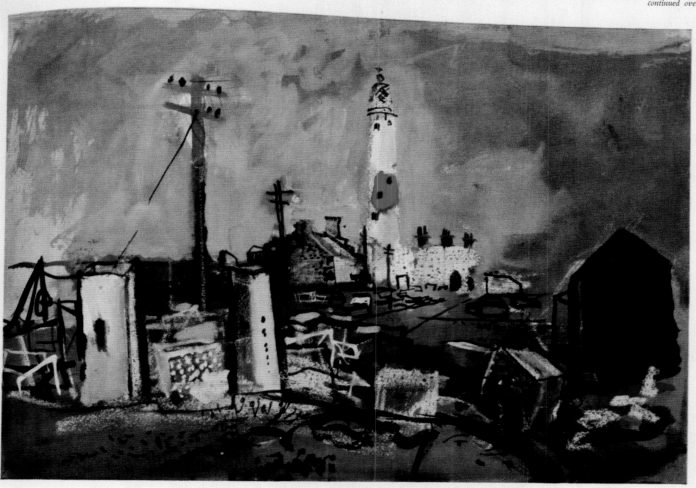

LIGHTHOUSE, STONE GATEPOSTS AND FISHERMEN'S HUTS AT THE BILL.

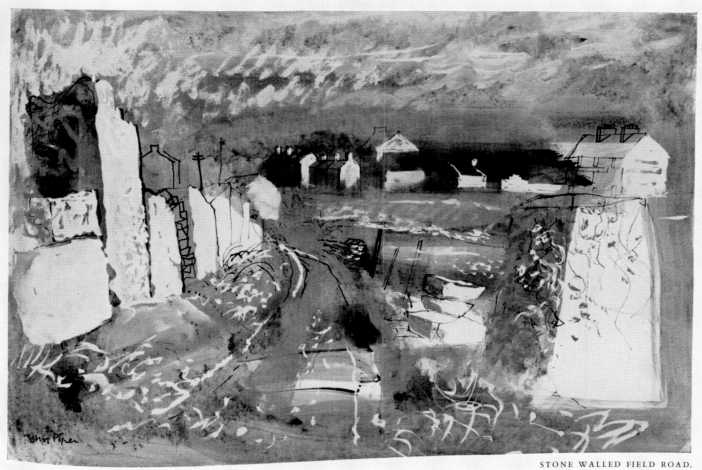

STONE WALLED FIELD ROAD.

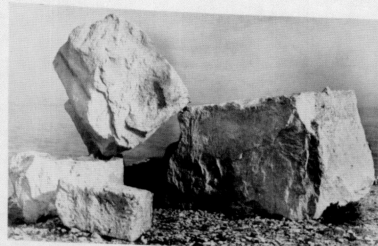

Opposite Page:
MARKS OF THE AXE AND WEDGE
MAKE EXCITING PATTERNS AND TEXTURES
ON THE BLOCKS OF STONE.

QUARRYMAN'S SCULPTURE.

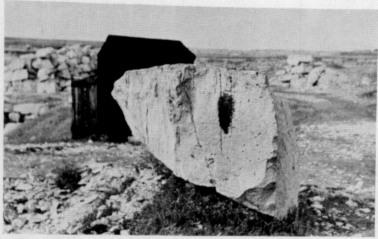

A BLOCK OF WEATHERING STONE, SEEN AGAINST A TARRED FISHERMAN'S HUT.

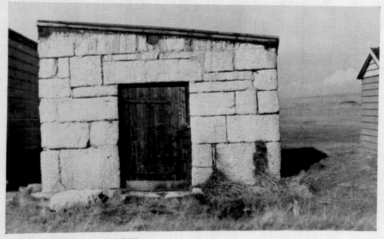

THIS FISHERMAN'S HUT WILL LAST FOREVER.

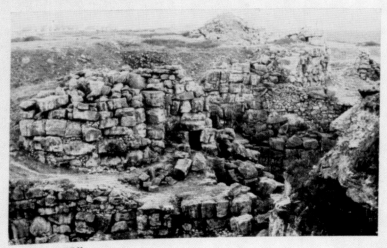

PHOTOS BY JAY DISCARDED STONE IN A QUARRY.

cut and packed away and hidden there by men in the first place, and has been waiting all this time for other men to unpack it and take it out again. And among the debris of the whole island, among the half-humanized blocks thrown out, stand the equally miraculous-looking consolidations of blocks into neat dwellings, low and solid among the strips of common land, with new crazy-paved villas here and there, and newer collections of pre-fabs and concrete and brick houses, and another crazy tangle of electricity wires overhead, the skyline cut by television aerials, and by more distant derricks and radar masts. And in the quarries among the newly exposed stone are the primitive and traditional tools (Twibel, Kivel, Pig, Wedge, Sledge) either in use or lying where work stopped yesterday. Quarry-men toss out petrified trees, ammonites, fossil oysters and Roman coffins as rubbish. They lie; or they are collected together into garden grottoes with alyssum and aubrietia growing between them. Waste blocks are used for walls, lintels, gateposts and gigantic stable and store-house entrances fit for giants' chariots and groceries. When they lie among grass and brambles they fill the mind sometimes with a dream-like architecture of massive simplicity – it grows out of them, a parody or glorification of the use better men might put them to. Or one can read into them, and out of them, enormous stylized carvings.

continued on page 91

FANTASTIC AND IMAGINATIVE LOCAL SCULPTURE
IN ST. GEORGE'S CHURCHYARD:
SOME IN IMPORTED MARBLE, MOST IN LOCAL STONE,
ALL INSPIRED BY PORTLAND IDEAS
AND EXECUTED BY PORTLAND CRAFTSMEN

Art and
The Ambassador

Gill Saunders

WIDELY ACKNOWLEDGED AS 'A STRIKINGLY BEAUTIFUL publication',[1] *The Ambassador* (and its predecessor *International Textiles* in the period under Hans Juda's management) gave a prominent place to fine art, not only in the design of the covers but also through the extended articles and features in its pages. The British art critic Robert Melville described it as 'probably the most daring and enterprising trade journal ever conceived . . . no other magazine . . . has so consistently and brilliantly demonstrated the relevance of works of art to the problems of industrial design'.[2] This striking alliance of art and industry had its roots in Hans's and Elsbeth's passion for contemporary art. When their 'Panoramic Penthouse' (at 10 Palace Gate, London) was featured in *House & Garden* it was described as 'elegant enough to house the Juda's enviable collection'; in a view of the entrance hall a fine painting by Miró and two by Graham Sutherland figured prominently.[3]

Cover, unsigned but probably by Graham Sutherland
Special Coronation issue, 1953

AN EXTRA-ORDINARY EDITION

THE AMBASSADOR

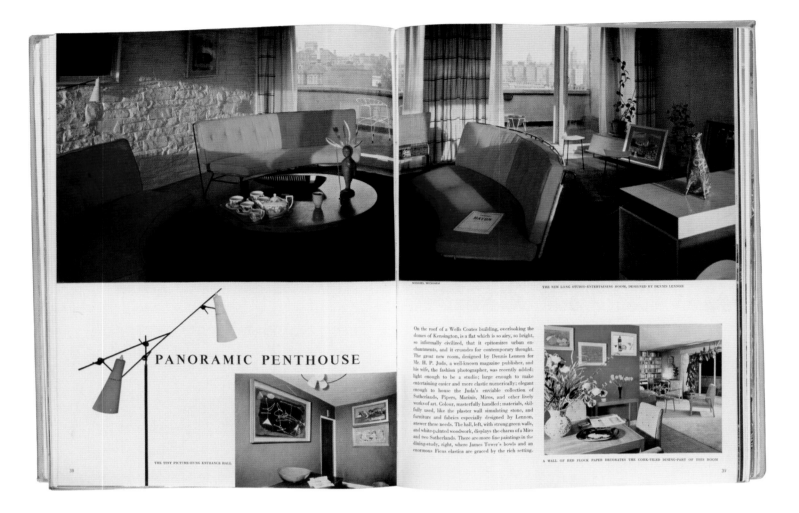

PANORAMIC PENTHOUSE

THE TINY PICTURE-HUNG ENTRANCE HALL

THE NEW LONG STUDIO-ENTERTAINING ROOM, DESIGNED BY DENNIS LENNON

On the roof of a Wells Coates building, overlooking the domes of Kensington, is a flat which is so airy, so bright, so informally civilized, that it epitomizes urban enchantments, and it crusades for contemporary thought. The great new room, designed by Dennis Lennon for Mr. H. P. Juda, a well-known magazine publisher, and his wife, the fashion photographer, was recently added: light enough to be a studio; large enough to make entertaining easier and more elastic numerically; elegant enough to house the Juda's enviable collection of Sutherlands, Pipers, Marinis, Miros, and other lively works of art. Colour, masterfully handled; materials, skilfully used, like the plaster wall simulating stone, and furniture and fabrics especially designed by Lennon, answer these needs. The hall, left, with strong green walls, and white-painted woodwork, displays the charm of a Miro and two Sutherlands. There are more fine paintings in the dining-study, right, where James Tower's bowls and an enormous Ficus elastica are graced by the rich setting.

A WALL OF RED FLOCK PAPER DECORATES THE CORK-TILED DINING-PART OF THIS ROOM

The Judas' London flat, *House & Garden*
September 1953

Opposite, left: Cover by John Piper
International Textiles
1944, no.8
This cover was a design for a textile. With its rich tones and architectural motifs it served to advertise Piper's eight-page feature in the same issue, entitled 'The Colour of English Houses', illustrated with a number of his bold pen and wash drawings of country house facades.

Opposite, right: Cover by John Piper
1954, no.6

COLLECTORS OF FINE ART

The Judas were enthusiastic collectors who 'consistently followed their own taste', buying pictures and sculpture not only by 'established and celebrated artists' but also from those 'relatively unknown' at the time, many of whom went on to find renown.[4] The best of their collection was exhibited at the Graves Art Gallery, Sheffield, in 1967 (see also pages 36–7). With the title *In Our View*, the exhibition presented the collection as a distinctly personal enterprise, in which the art historical significance and monetary value of the works were incidental. The Judas stressed that, despite accumulating a group of works 'remarkably representative of the contemporary English school',[5] they never had any pretensions to building a 'Juda Collection' and were unconcerned by what might be seen as omissions – no 'all-white Ben Nicholson or an early Francis Bacon *Pope*'.[6] What the collection *did* reflect was the network of friendships the Judas enjoyed with artists, sculptors and other art-world luminaries. And as Melville's foreword to the catalogue made abundantly clear, there were direct connections between the art collection and the content and cover art of *The Ambassador*. Indeed, the Sheffield exhibition gave space to a number of the original designs for the magazine covers, including examples by John Piper,

Henry Moore,[7] Graham Sutherland and *The Ambassador*'s in-house designer, the prolific pseudonymous 'Ett'. Also featured were several Piper watercolours that had appeared as illustrations to his extended articles on such subjects as the Cotswold wool country (1946, issue no.5) and Portland stone (1954, issue no.6)(see pages 96–101).

The exhibition prompted interest in the collection from the art trade, and Hans was approached to see if he might be interested in selling. After some initial resistance he came round to the idea, and only a few months later (on 1 November 1967) the Judas sold a large proportion of their collection in a dedicated sale at Sotheby's in London. Comprising a total of 128 lots, the sale included some of the most important works they had amassed in more than 30 years of collecting – notably Graham Sutherland's painting *Gorse on Sea Wall* (1939), an important early masterpiece (now in the Ulster Museum, Belfast), and *Palm Palisade* (1947), one of the first pictures to be inspired by his life in the south of France. Also sold were some of the designs used as covers for *The Ambassador*. Given the very personal nature of their collection, the decision to sell might seem surprising, but in fact it was further proof of the Judas' passionate but practical commitment to contemporary art – and to the artists themselves – for the proceeds were dedicated to 'establishing a fund for British artists and also to provide travelling scholarships' (see page 37).[8] As Elsbeth later explained, Hans was 'terribly committed to the Royal College, the Central School and all the other schools'.[9] Two years later, in recognition of his sustained generosity towards British artists and art education, Hans was appointed a senior fellow of the Royal College of Art.[10]

COMMISSIONS FOR COVERS

The practice of inviting artists to design covers for *The Ambassador* was evidence of a productive cross-fertilization between fine art and fabric design in the period, and the burgeoning relationship between artists and industry was something that Hans did much to foster. But these commissions, as well as invitations to write for the magazine – extended to John Piper, Louis le Brocquy and others – were also a practical supportive strategy that Hans established early on. Piper seems to have been the first to benefit. In 1944 he supplied a cover for issue no.8 of *International Textiles* and continued his collaboration with the Judas and the magazine at intervals through the 1940s, '50s and '60s. The 1944 issue also included an article by Piper, 'The Colour of English Country Houses', illustrated with his own lithographs.

Cover by John Piper
1946, no.5

By this date, Piper had abandoned his earlier attachment to modernist abstraction and reverted to a peculiarly British neo-Romanticism which found a focus in architecture and, in particular, historic buildings characterized by what he called 'pleasing decay'. By contrast his later covers (see 1954, no.6, p.91) show the revived influence of abstraction, and that of collage, a regular feature of his prints and watercolours.

Opposite: Cover by John Piper
1948, no.9

This cover was inspired by the feature on English slate engravings within; the design was based on rubbings made from gravestones and funerary monuments.

By this date Piper had established a strong professional interest in architecture. He had been writing regularly for the *Architectural Review* since the 1930s, again often supplying his own distinctive illustrations, and he had compiled *Shell Guides* to Oxfordshire (1938) and Devon (1939). In 1940 he had also contributed a number of striking watercolours of architectural subjects – churches, tombstones, tithe barns and the landscaped gardens of country houses – to the wartime documentary project 'Recording Britain'.[11] Piper's focus on colour and texture in his articles for *The Ambassador* was apt, for his illustrations found an echo in the various fabrics featured in and promoted by the magazine, especially the distinctively British tweeds and woollens. Two years later, for issue no.5 in 1946, he explored this correlation more explicitly in 'A Wool Country: Colour in the Cotswolds', a feature that reproduced a number of his watercolours of the areas around Northleach, Gloucestershire (one of the towns made wealthy by the mediaeval wool trade). His study of the church at Northleach was used on the cover – a dark and frankly rather dreary image lacking visual impact. Much stronger and more vibrant is his cover to issue no.9 in 1948, which is printed in rich colours and adapted lettering and ornamental motifs from the English slate engravings that he discussed within, and illustrated with a series of rubbings; equally effective is that for issue no.6 in 1954, with three bold landscape images, reproducing collages, illustrating his 14-page article 'Portland Stone – Portland Colours'.

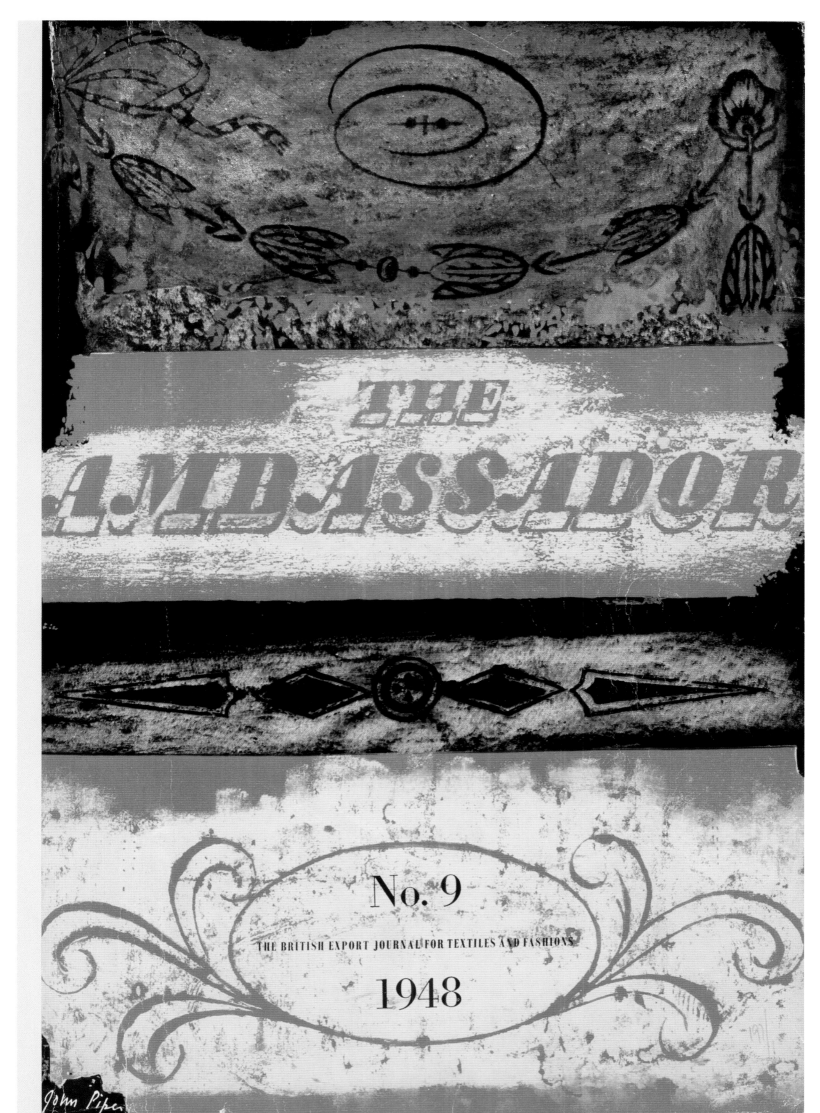

THE

AMBASSADOR

No. 9

THE BRITISH EXPORT JOURNAL FOR TEXTILES AND FASHIONS

1948

John Piper

Cover by Edward Wadsworth, *International Textiles*
1945, no.8
© Estate of Edward Wadsworth. All rights reserved,
DACS 2011

Wadsworth was working during a period of rapid
technological advance and invention, and he found
man-made objects, industry, and machinery fascinating
subjects for compositions which are often characterized
by a sense of arrested movement, and inflected by the
spirit of Surrealism. This picture, commissioned by Hans
Juda for the cover of the magazine, demonstrates these
qualities.

Opposite: Cover by Henry Moore
1953, no.11
Reproduced by permission of The Henry Moore
Foundation

Hans Juda was uniquely placed to foster productive
links between artists and the textile industries. In his
editorial to issue no.11, 1953, which included as
an insert the catalogue of the exhibition *Painting into
Textiles*, he emphasized the value of this relationship:
'Little but good can come from a closer association
between the Arts and textiles. The sketches and
paintings we commissioned were calculated to
stimulate everybody concerned – the designer, the
manufacturer, the converter – and provide a *starting
point* from which to develop saleable goods.'

This idea of allowing artists to present their work over several
pages of the magazine seems to have become established
practice early on. For issue no.8 in 1945 of *International
Textiles*, Edward Wadsworth was given a double-page spread
reproducing several works from a series that had been
commissioned by ICI (Imperial Chemical Industries), under
the heading 'A Modern Artist Visualizes Plastic Developments'.
Painted between 1942 and 1944, these pictures illustrated
some of the new materials that had been developed by ICI
as part of its contribution to the war effort. Extruded tubing,
injection mouldings, Perspex forms and nylon meshes and
brushes were presented in the same manner as the nautical
emblems and accessories in his characteristic still lifes, but
they also relate to works from the early 1930s, compositions
of ostensibly abstract forms that were actually tools such as
rulers, gauges, chains and spanners. The cover of this issue
was also by Wadsworth – a 'ballet méchanique' of bobbins and
shuttles reproduced from a painting entitled *Spinning and
Weaving*, dated 1941.[12]

PAINTING INTO TEXTILES

It was Henry Moore who produced what is perhaps the most
iconic of *The Ambassador* covers, for issue no.11 in 1953.
A design for a fabric – *Zigzag* (dated 1950)[13] – it was also
reproduced as the cover of the catalogue to the exhibition
Painting into Textiles (published as an insert to *The
Ambassador*, the design unchanged but for the substitution
of the new title, again in the bold autographic font supplied

Painting into Textiles

An exhibition sponsored by THE AMBASSADOR, the British Export Magazine

October 21st – November 14th

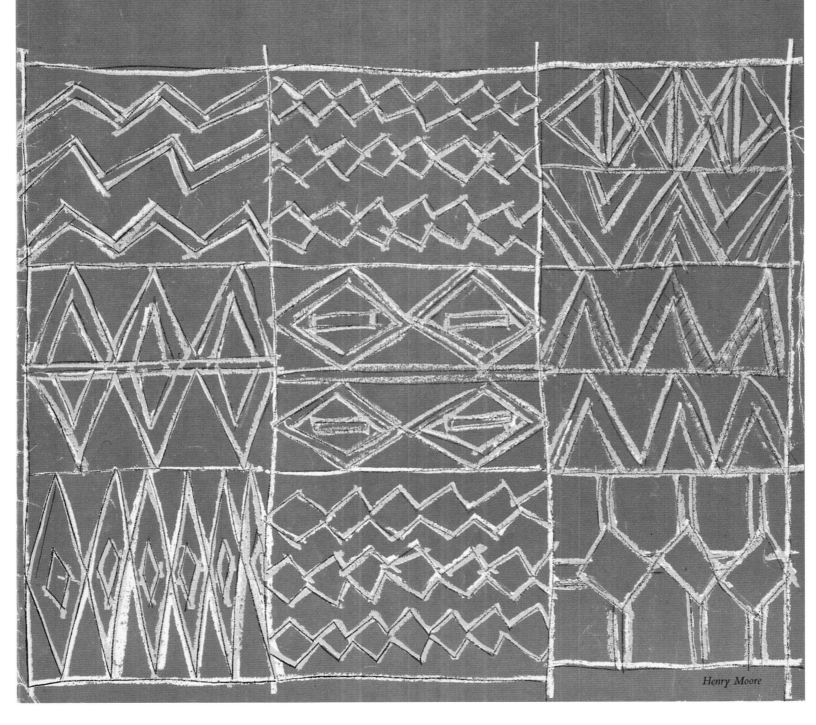

Henry Moore

Cover by Louis le Brocquy
1955, no.10
This cover design, by the Irish artist Louis le Brocquy,
was produced as a screen-printed cotton fabric by
David Whitehead in 1956.

by Ett). The exhibition was sponsored by the magazine and was held at the Institute of Contemporary Arts (21 October–14 November 1953), then in Dover Street, London. The aim of the exhibition was to promote a closer and more effective relationship between artists and textile converters. Hans and Elsbeth commissioned 25 artists, at a fee of £25 each, to produce a painting that might be translated into a textile, thereby introducing radical new ideas and, it was hoped, inspiring a new generation of design-conscious consumers. Hans in his editorial described the exhibited works as 'a *starting point* from which to develop saleable goods'.[14]

The list of participating artists reads like a 'Who's Who' of the contemporary British art world, and included Eileen Agar, Prunella Clough, Terry Frost, Ivon Hitchens, Peter Lanyon, Henry Moore, Victor Pasmore, Eduardo Paolozzi, John Piper, Ceri Richards, William Scott, Graham Sutherland, William Turnbull and Paule Vézelay. Though a handful of textile designers were also involved (notably Lucienne Day and Jacqueline Groag), most were painters or sculptors. In his introduction to the catalogue Hans acknowledged that 'some of the commissioned artists are not acquainted with the difficulties and techniques of textiles' but claimed this as 'an asset' that 'leads to an adventurous approach which may

create difficulties for the convertor [*sic*] but at the same time can be the spark for an unexpected and even startling design'.[15] Certainly, some reviewers found the concept challenging, but for the most part the exhibition was a critical and commercial success in that most of the exhibited works were taken up by the industry. Tom Mellor, acting for David Whitehead Ltd, developed works by six of the artists, including Moore, and the designs were commercially available by March 1954. The new fabrics were featured in an article, 'Whitehead's Contemporary Furnishings', in the following month's issue of *The Ambassador*. Moore's *Zigzag* design, one of the more conventional exhibits in terms of its potential as a repeating pattern, was one of these new fabrics.[16] Whitehead established a reputation for employing some of the most innovative artists and designers of the 1950s and '60s. In the words of Lucienne Day, the company 'broke with tradition and gave the mass market gay, colourful and imaginative designs . . . Whitehead became synonymous with the contemporary print, banishing forever the era of muddy floral and "folksy" print patterns.'[17] Another textile design subsequently produced by Whitehead featured on the cover of issue no.10 in 1955: a vivid abstract comprising slivers of primary colour on a black ground, by the Irish-born artist Louis le Brocquy.[18] This was one of a series of

THE AMBASSADOR

THE BRITISH EXPORT MAGAZINE

NUMBER 10 – 1955

IN THIS ISSUE:

● BRITISH COTTONS FOR 1956

● 'PATTERN IN CONTRAST' A NEW TREND IN TEXTILE DESIGN

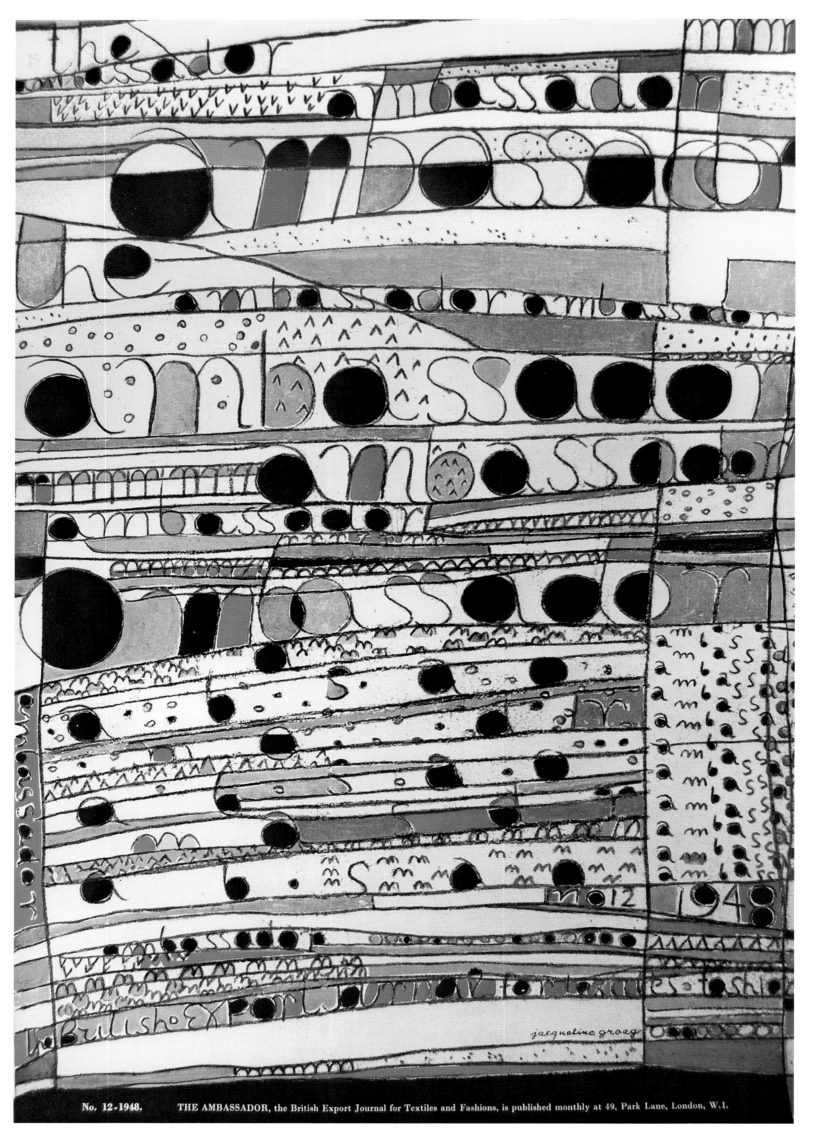

jacqueline groag

No. 12-1948. THE AMBASSADOR, the British Export Journal for Textiles and Fashions, is published monthly at 49, Park Lane, London, W.1.

Cover by Jacqueline Groag
1950, no.8

Opposite: Cover by Jacqueline Groag
1948, no.12

Groag's cover designs share many of the characteristics of her textile patterns; they are playful, yet carefully structured. In both these covers she successfully introduced an element of repeat, treating it not as a constraint but as an opportunity for invention. The 1948 cover design was later adapted for a cotton dress fabric produced by the Calico Printers Association.

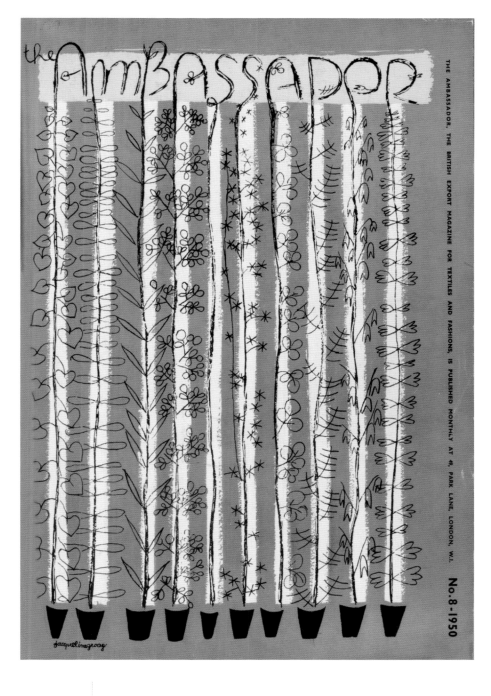

THE AMBASSADOR, THE BRITISH EXPORT MAGAZINE FOR TEXTILES AND FASHIONS, IS PUBLISHED MONTHLY AT 49, PARK LANE, LONDON, W.I.

No.8·1950

designs inspired by a research visit that Le Brocquy made to Spain in company with Elsbeth; his illustrated feature, 'Pattern in Contrast', in the same issue shows many photographs of tiles, architectural motifs and implements such as sickles (all taken by Elsbeth on this trip, see pages 72–3), alongside examples of how these images had been translated into textile patterns.

IN-HOUSE DESIGNS

Though a number of artists, illustrators and graphic designers drew covers for *The Ambassador*, it appears that only one professional textile designer – Jacqueline Groag – was invited to do so. Her lively whimsical compositions make a feature of the title, in each case playing with the typography, using the letters themselves as pictorial motifs. There was, of course,

a considerable cachet in having covers designed by renowned artists of the calibre of Sutherland, Piper and Moore, but in fact some of the most eye-catching, witty and exuberant cover images were the work of *The Ambassador*'s in-house designer 'Ett'. In an interview in 1992, Elsbeth described her as 'enormously perfectionist' and recalled that 'she would stay a whole night and make 50 covers and the first one was usually the best anyway, but she was never satisfied'.[19] Ett's cover designs suggest an encyclopedic knowledge of modern and contemporary art since she gestures to the work of masters such as Picasso and Miró without ever descending into pastiche. Her clever sophisticated designs have great visual impact, a confidence and verve. They were often inspired by articles in the magazine: the issue for July 1952, with her bold mosaic

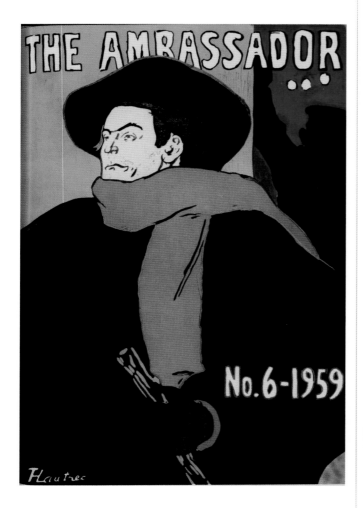

Left: Cover based on 'Les Ambassadeurs' by Toulouse-Lautrec

1959, no.6

Visual wit was often a feature of *The Ambassador* covers and this sly pastiche of a poster by Toulouse-Lautrec is a good example. It is unusual only to the extent that it adapts an existing artwork rather than being an entirely original design.

Right: Poster for 'Les Ambassadeurs' by Toulouse-Lautrec
V&A: Circ.551–1962

Opposite: Cover by Ett
1952, no.7

design on the cover, included a feature on the Arts Council's touring exhibition of replicas of Ravenna mosaics. Hans cited the exhibition as an inspiration to industry and wrote: 'At a time when texture and surface interest continue to play an important part in fabric design, we venture to suggest that Mosaic Prints are a logical and successful link in this trend.'[20] Indeed, he went on to mention a 'Ravenna range' of furnishing fabrics from David Whitehead Ltd, already in production.

Although he mostly commissioned new work for the covers, Hans was not above blatant appropriation of an iconic historic image on occasion – notably for issue no.6 in 1959, when he had Ett rework Toulouse-Lautrec's famous 1892 poster of the singer Aristide Bruant for the Parisian nightclub 'Les Ambassadeurs'; Hans had been given an impression of this lithograph (signed by Bruant) by his uncle, and the coincidence between its title and that of his magazine proved irresistible, so he published it with the English neatly substituted for the French.

FRIENDSHIPS WITH ARTISTS

Hans and Elsbeth enjoyed lifelong friendships with several of the artists whose work they collected and promoted – notably with John Piper and his wife Myfanwy. In 1946

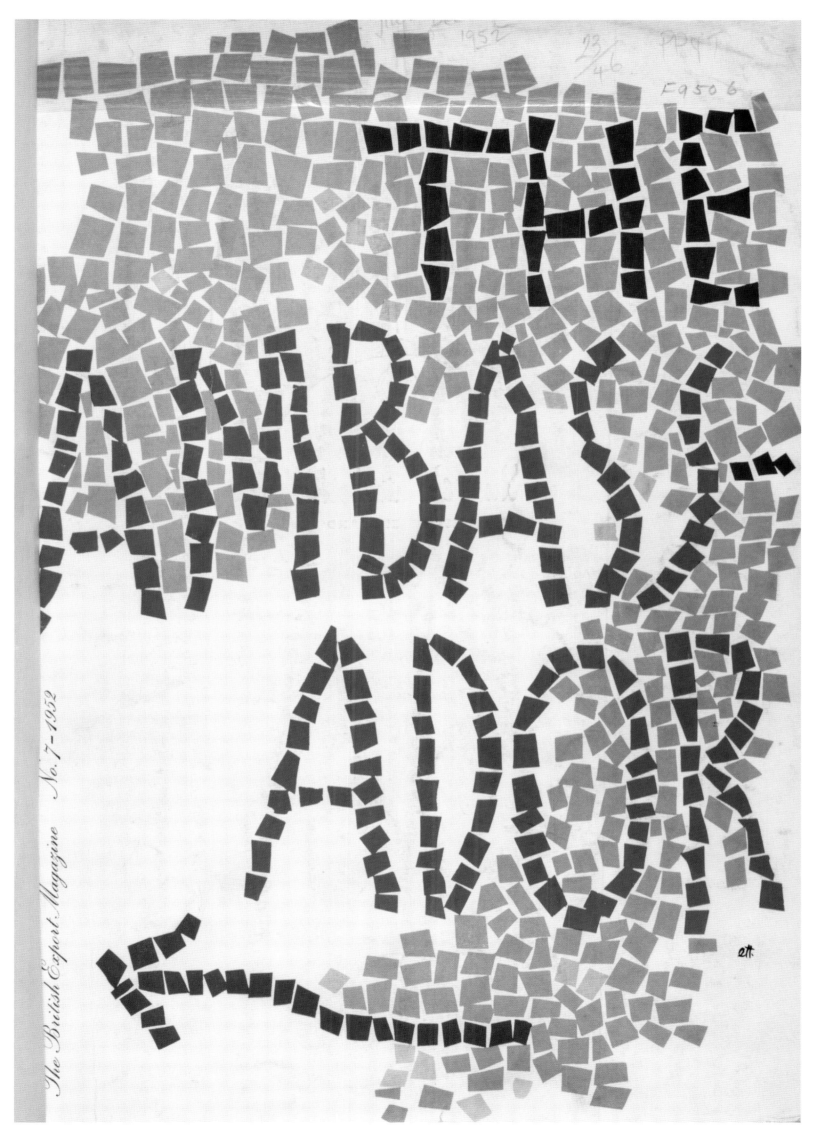

The British Export Magazine No. 7 - 1952

Winston Churchill with Graham and Kathleen Sutherland
Collection of Elsbeth Juda

Opposite: Cover by Graham Sutherland
1949, no.7
The original of this was a design for a tapestry. It was subsequently
included in the exhibition *Painting into Textiles* in 1953.

Hans funded a short-lived art journal, *Pavilion*,[21] edited by
Myfanwy, and in the early 1960s he and Elsbeth bought land
and built themselves a country house at Fawley Bottom, the
Buckinghamshire hamlet where the Pipers had been living
since the mid-1930s. But perhaps the warmest and most
enduring friendship was with Graham Sutherland and his wife
Kathleen as already suggested. Surviving correspondence
between the couples records regular meetings – lunches,
weekends, holidays, in London, and later the south of France,
when the Sutherlands established themselves there. The
friendship extended to professional collaborations beyond
Sutherland's work for *The Ambassador*; a small gouache,
Pergola (1954), in the Juda collection is inscribed 'to Elsbeth in
gratitude to you for Oct 17 1954'.[22] This was by way of thanks to
Elsbeth for her support when she accompanied Sutherland on
a visit to Chartwell where he was painting the ill-fated portrait
of Sir Winston Churchill;[23] then aged 80 and unwell, Churchill
was a difficult sitter. Elsbeth took photographs of the sitting
as aide-memoires for Sutherland, as well as several pictures of
Graham and Kathleen with Sir Winston (see page 12).[24]

The Judas amassed a 'very formidable number of
Sutherland paintings, gouaches, sketches etc'[25] and promoted
his career in various ways, not least by lending to exhibitions,

THE AMBASSADOR

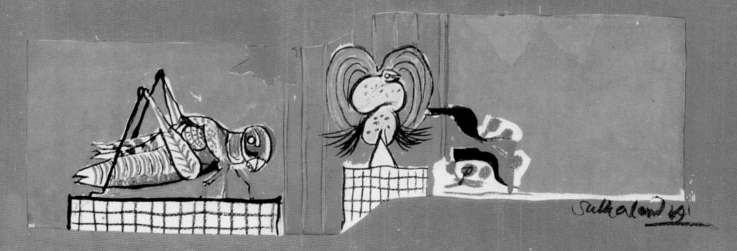

Cover by Graham Sutherland
1960, no.7
This was painted in 1940, and intended as a textile design. It had
been in Hans Juda's possession for some years before he decided to
use it on the cover of the magazine in July 1960.

Overleaf: Duncombe Park, Yorkshire, by John Piper
Special Coronation issue, 1953
Piper contributed a number of features to *International Textiles* and
The Ambassador, illustrated with his own drawings and watercolours.
Like his contributions to magazines such as *Architectural Review* in
the same period, his illustrated articles for *The Ambassador* were
heartfelt and intelligent celebrations of the distinctive virtues of English
architecture and landscape.

including a group show in the British Pavilion for the Venice Biennale in 1952, and a major show of Sutherland's work that toured to Munich, Berlin, Cologne and The Hague in 1967. A Sutherland image first appeared on the cover of *The Ambassador* in 1949 (issue no.7); this was a design, made the same year, for a tapestry. Vividly coloured, it incorporated several motifs that recur in his paintings – the rose, the grasshopper or cricket ('la cigale') and a stork-like bird. This image was reproduced again as a full-page colour plate in a sumptuous book on Sutherland, with an introduction by Robert Melville, published the following year by Ambassador Editions.

Great care was taken with the production of this book; copious correspondence in the archive discusses the choice of paper, the design and colour of the binding, and so on. It seems that Hans was equally attentive to the quality of the reproduction of *The Ambassador* covers; for the Sutherland cover in 1949 he sent a 'first pull' (proof) of the cover to the artist for his comments, stressing that 'there is still time to improve'.[26] Sutherland's work was the focus of several features in *The Ambassador* – including one written by Sir Kenneth Clark with pictures of roses (the rose being 'the symbol of a nation') for the special Coronation issue in 1953 – but his work

did not appear on the cover again until 1960. On 10 May 1960 Hans wrote to Graham as follows:

I have a beautiful rose sketch of yours which has been hanging in my office for many years . . . Have I your permission to reproduce the print? If so, I might put it on the July cover of 'The Ambassador' which features new British cottons. Your print has always been new and fresh but never so up to date than fifteen or twenty years after you created it.[27]

In a memo about the reproduction of this image Hans instructed: 'We must mention that this design was done many years ago but somehow the sensitive artist has created something which is eternal. (One must not overdo the write-up but one can be very outspoken and appreciative).'[28] In the event the write-up was laudatory and respectful but not overblown, describing the design as having 'a timeless quality and an intensity of vision', and concluded with a reference to the fact that Sutherland had recently been awarded a significant public honour, the Order of Merit. On publication, Hans sent a copy of the magazine to Sutherland, declaring: 'We are all thrilled with the cover and I can only hope you approve of it.'[29]

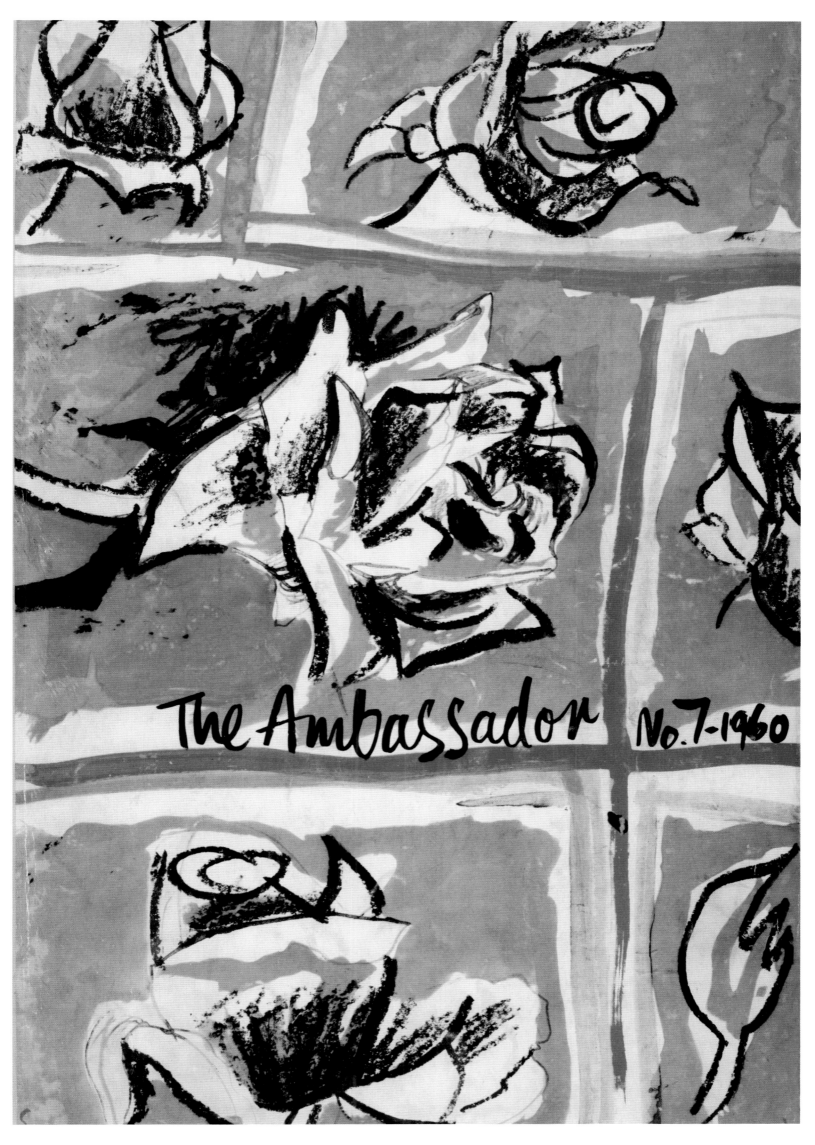

The Ambassador No. 7-1960

DUNCOMBE PARK, YORKSHIRE.

John Piper

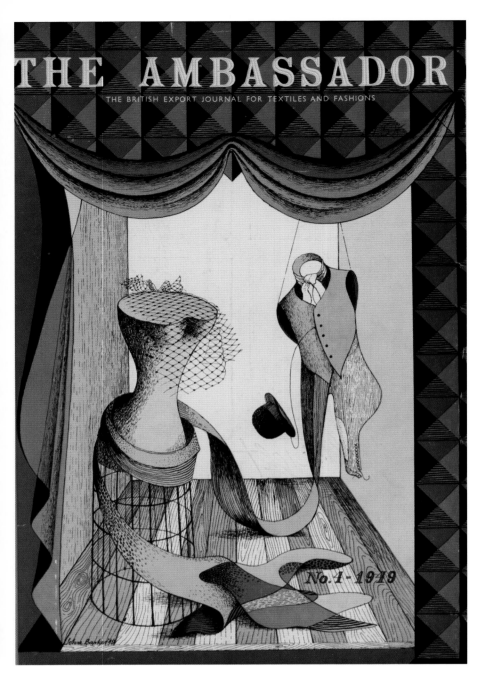

THE AMBASSADOR

THE BRITISH EXPORT JOURNAL FOR TEXTILES AND FASHIONS

No. 1 - 1919

Cover by John Barker

1949, no.4

Barker's cover brings together several motifs and stylistic devices – the headless tailor's dummy, the theatrical space and oddly tilted perspective – familiar from the work of such artists as Giorgio de Chirico and René Magritte, to create a dated but charming composition with a flavour of Surrealism.

Opposite: Cover by Osbert Lancaster

1956, no.4

By permission of Clare Hastings

The most famous cartoonist of his generation, Osbert Lancaster was a brilliant social satirist with a passion for architecture and for fashion, both frequently the subjects of affectionate mockery in his books, and in the pocket cartoons he contributed to the *Daily Express*. He was also a noted illustrator and a designer of book jackets and magazine covers.

AT THE CUTTING EDGE

The Ambassador covers showcased the art of their time – beginning with John Piper's antiquarian-style architectural studies in the 1940s, and his bolder, more abstracted landscapes in the 1950s and '60s. In 1949 a cover by the little-known John Barker[30] served up a rather tame and distinctly British rehash of Surrealism, albeit a charming, pastel-coloured version. The illustrator John Farleigh supplied the cover for issue no.5 in 1953 – with fluent swathes of colour divided by broad black lines, it resembles an abstract design for stained glass; very much of the moment, it is quite unlike the more controlled linear work for which he is best known. 'Britishness' – and a playful humour – often flavour the designs, perhaps most explicitly so in the cover by the cartoonist Osbert Lancaster

(1956, issue no.4), in which a gentleman reads a copy of *The Ambassador* in a room accessorized by discreet signs of wealth and good taste: a Roman portrait bust, an eighteenth-century portrait of a man and his lugubrious dog, and a Wedgwood vase on a Neoclassical mantelpiece. Lancaster had earlier been commissioned to produce a series of eight satirical illustrations for the special Coronation issue showing 'The Englishman's Profound Horror of Any Form of Sartorial Ostentation'.

Thanks no doubt to his connections with the RCA and other art schools, Hans remained *au courant* with the rising stars in contemporary art, and commissioned *Warm Glow*, a painting by Joe Tilson, for the cover of issue no.4 in 1960,[31] one of a small number of issues that promoted a new colour

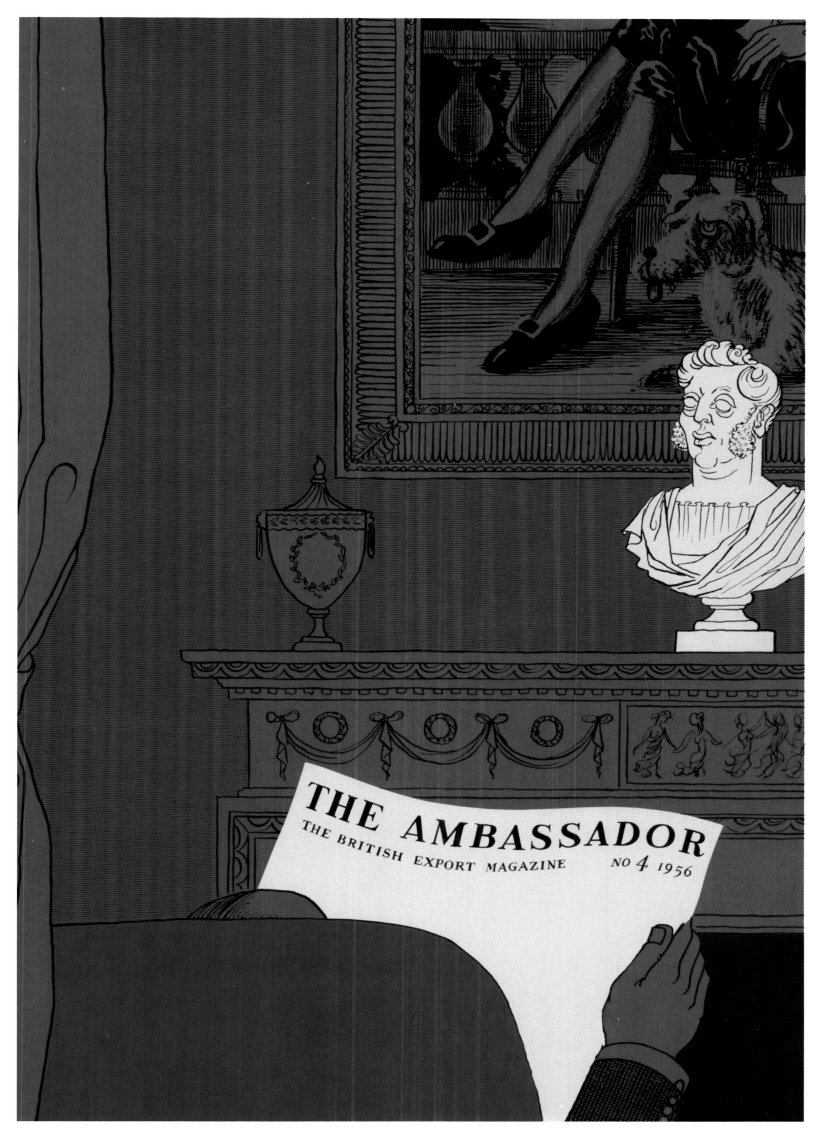

THE AMBASSADOR
THE BRITISH EXPORT MAGAZINE NO 4 1956

THE AMBASSADOR No. 4 - 1961

in this issue: THE WARM GLOW

Cover by Joe Tilson

1961, no.4

© Joe Tilson. All rights reserved, DACS 2011

Tilson was one of the founding figures of British Pop Art in the 1960s, but his early work was abstract and had a defiantly hand-made character which was evident in his emphasis on surface and texture. This painting, *Warm Glow*, was specially commissioned by Hans Juda for the cover of *The Ambassador*.

Opposite: Cover by Max Bill

1967, no.1

© DACS 2011

In the editorial to this issue, the magazine applauded Max Bill's achievements in a 30-year career. It concluded: 'Bill's art and that of others like him, has had a profound effect, and has helped to create a world where colour and design are increasingly significant in our environment.'

(other colours included Venice Red in issue 7 and Bristol Blue in issue 9, both in 1961). However, the artist-designed covers appeared less frequently as time went on. Perhaps the last of note was for the issue of January 1967, by the influential Swiss graphic designer Max Bill, who had recently exhibited in London. A clean, elegant, geometric design, it was characteristic of his work, which explored the optical and emotional effects of colour and engaged with modern science and mathematics. It was by association with such artists that Hans so successfully aligned the magazine with the cutting edge, both in art and design, and in industry.

end of feature

The Ambassador No.1-1967

'THE AMBASSADOR' IS PUBLISHED MONTHLY AT 49, PARK LANE, LONDON W1

TEX for the kitchen TILES

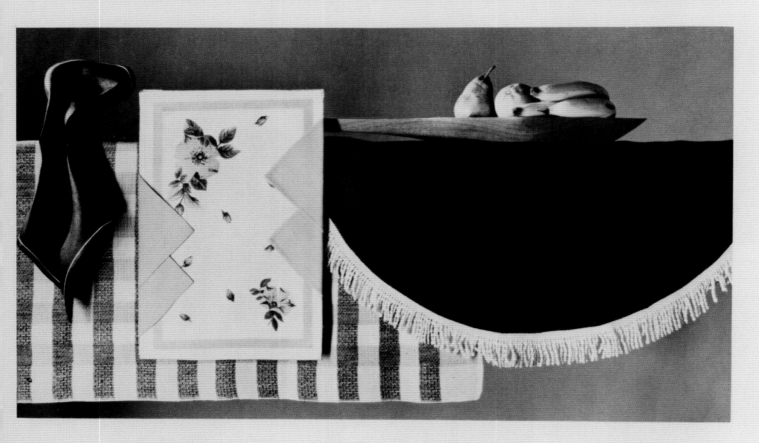

The complementary selection of tiles and household textiles on these pages reveals the wide-ranging relief and mural applications of tiles for interior design. The British tile industry, with its long tradition of ceramic skills, is becoming increasingly specialized, with its production ranging from plain tiles with the newest finishes, to decorative tiles in geometrical and abstract patterns.

ABOVE: FROM LEFT TO RIGHT:
Heavyweight linen check tablecloth. Samuel Lamont & Sons Ltd., Belfast.
Black linen napkin, from Fragonard Ltd., London E.C.2.
Printed pure Irish linen luncheon set, by
The 'Old Bleach' Linen Co. Ltd., Randalstown, Northern Ireland.
Charcoal grey Irish linen tablecloth with white cotton fringe.
Webb & Co., London W.1.

OPPOSITE:
A three dimensional profile tile, from H. & R. Johnson Ltd., Stoke-on-Trent.
Geometrical pattern wall tiles from the 'Integral' series, by
Pilkington's Tiles Ltd., Manchester.
Plain glazed wall tile in gloss finish from Carter Tiles Ltd., Poole, Dorset.
Handprinted Irish linen teacloth, designed by Laura Ashley,
from Ashley Mountney Ltd., London W.1. (Available at Heals.)
Stainless steel frying pan, with copper-clad base, from the 'Prestige' range of cookware.
The Prestige Group Ltd., London E.C.1.
'Kenwood Chefette' food mixer and liquidizer.
Kenwood Manufacturing (Woking) Ltd., Havant, Hampshire.

continued

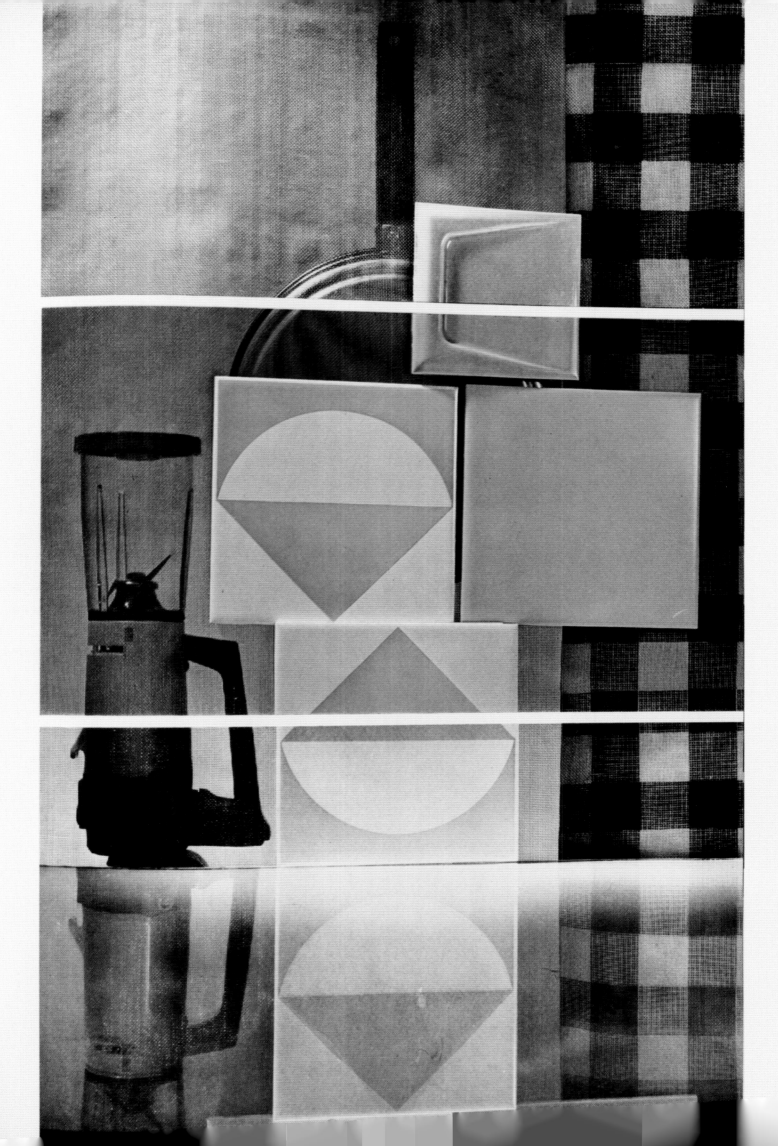

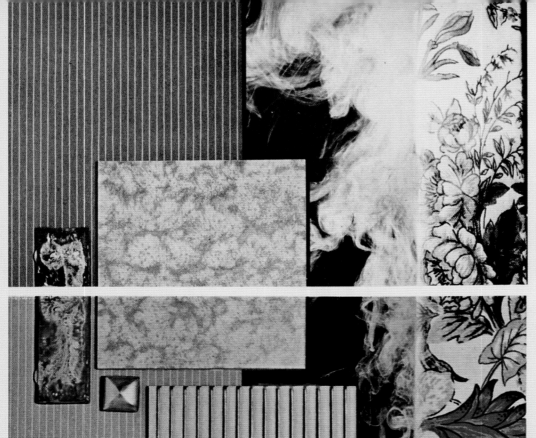

TEX TILES

for living room

Upper and lower: mottled fireplace tiles,
by Richard Tiles Ltd., Tunstall, Stoke-on-Trent.

'Rustic' textured surround tiles and
embossed fireplace tiles, from
The Campbell Tile Co. Ltd., Stoke-on-Trent.

Stripe wallpaper from the 'Palladio Mondo' range, by
Lightbown Aspinall Branch of
The Wallpaper Manufacturers Ltd., London W.1.

Traditional design screen-printed linen.
Simpson & Godlee Ltd., Manchester.

'Borgeisha' 'Imperial Ochre' rug in 'Acrilan'/'Dynel'
from the Borg range of deep-pile rugs, by
Amphenol-Borg Ltd., Whitstable, Kent.

OPPOSITE:

Plain glazed tiles in gloss finish, from
H. & R. Johnson Ltd., Tunstall, Stoke-on-Trent.

Textured tiles with a rough hewn
hand-made look, from the 'Turinese' range, by
Malkin Tiles (Burslem) Ltd., Stoke-on-Trent.

'Elkington' silver ice bowl, from
British Silverware (Export) Ltd., London W.1.

and terrace . . .

continued

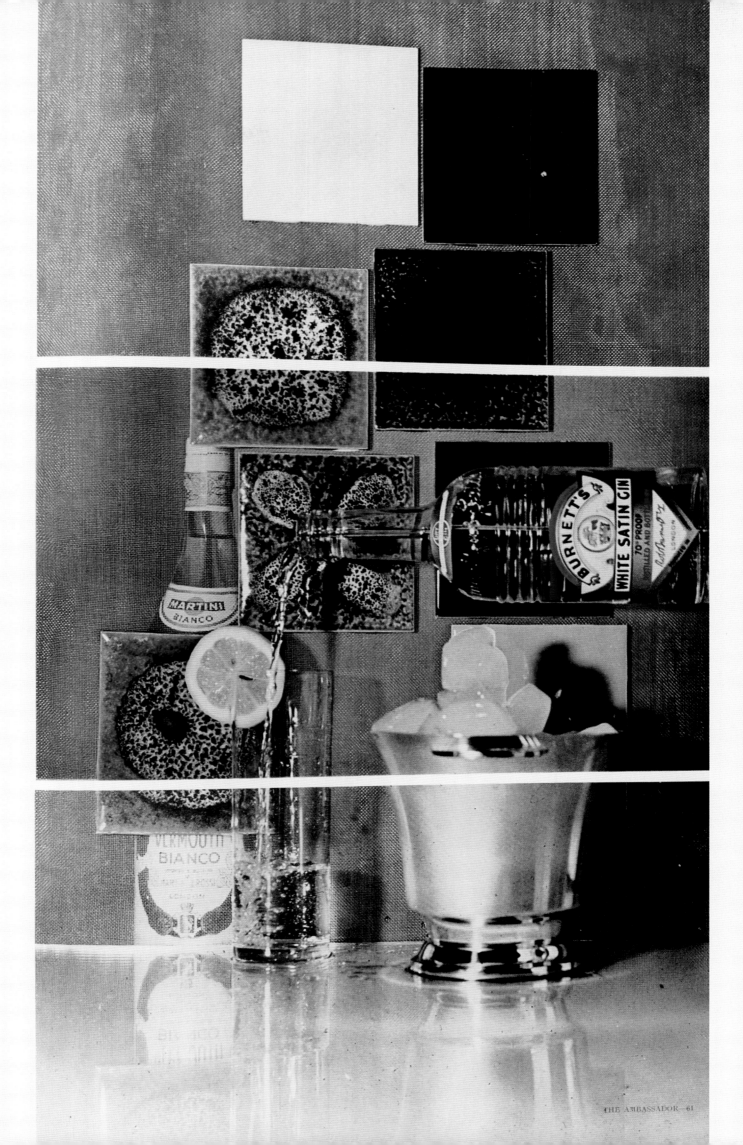

TEX TILES

for the bathroom

continued

OPPOSITE:

'Floral Dutch' decorated tiles from T. & R. Boote Ltd., Stoke-on-Trent.

'Cerne blue' wall tile with eggshell finish and 'Blue Cloud' mottled floor tile from the 'Dorset' range. Both by Carter Tiles Ltd., Poole, Dorset.

All-cotton fancy jacquard towel. W. M. Christy & Sons Ltd., Manchester.

Glass bathsalt jars from Woollands of Knightsbridge.

'Red roses' bath soap from Yardley & Co. Ltd., London W.1.

FROM LEFT TO RIGHT:

'Chequers' all-cotton towel, from W. M. Christy & Sons Ltd., Manchester 2.

'Roses' ice blue all-cotton hand towel set, by Finlay Shields Sales Organisation, London W.1.

'Wavecrest' turkish towel, from W. T. Taylor & Co. Ltd., Horwich, Lancs.

Toiletries, from left to right:
Deodorant perfumed with 'Passport' cologne. Goya Ltd., London W.1.

'Beauty Magic' skin cream from Yardley & Co. Ltd., London W.1.

'Lady Manhattan' perfume, from Fields of Bond Street, London W.1.

'Cedar Wood' after-shave gel by Goya Ltd.

'French Pink' bath cubes and talcum powder, from Fields of Bond Street.

'Gardenia', perfumed soap and talcum powder, from Goya Ltd.

Furnishing Fabrics: 'A Brilliant Story'

Mary Schoeser

*T*HE *AMBASSADOR* PROVIDES AN UNPARALLELED insight into British furnishing fabrics for three decades after 1940, when its publication – still under the title *International Textiles* – transferred to London.

Before 1940, *International Textiles* documented significant trends pertinent to British furnishings, even if obliquely. Little was written about British cloths destined for interiors between 1933 and mid-1940, although there is ample contextual information concerning the state of the industry, particularly the once world-dominating cotton sector situated in and around Lancashire. There, as throughout Britain, clothing textiles accounted for two-thirds of cloth production, so unsurprisingly a tacit agreement among the editors of *International Textiles* was reached, that the magazine would promote British suitings and fashion fabrics while highlighting the furnishing fabric production of Continental manufacturers, particularly German and Swiss firms.

Detail from advertisement for Heal's
1967, no.1

Welsh tweeds designed by Marianne Straub
under the auspices of the Welsh Rural Industries Bureau
International Textiles, 27 November 1935

Yet announcements about the development of new yarns and changes in trade barriers and currency values, as well as summaries of stylistic trends, were equally relevant to the British furnishing fabrics industry.[1] What is more, after 1940 the magazine documented not just the shift to London and thus to a British bias in its coverage of furnishing fabrics, but also the fundamental changes within that industry: woven fabrics initially set the stylistic trends, but as screen-printed cottons came to prominence in the mid- to late 1950s weaves became more specialized, while the promotion of designers grew commonplace. These changes can all be linked to the legacy of the Second World War itself, namely the need for manufacturers to retool and to re-establish export markets, with the opportunistic hope to fill the void left by a much-reduced Central European textile sector.

Among the notable examples of the few British furnishing fabrics illustrated in *International Textiles* before the war were two 'moderne' cotton fabrics printed by Simpson & Goodlee (June 1934) and curtain fabrics printed by J.F. & H. Roberts ('British Made' supplement, April 1935), both Manchester firms.[2] Annual illustrated reports on the British Industries Fair (BIF) focused on fashion fabrics, despite the fact that the BIF was an important vehicle for the promotion of furnishings; among those occurring pre-war, only the event of 1938 prompted the illustration of machine-net curtains made by T.J. Birkin & Co. of Nottingham (and it is interesting to note that two years later the magazine reported both Nottingham and Ayrshire furnishing lace manufacturers as still able to produce and export cloth).[3] Despite being few in number, such examples recognize British strengths in cotton processing, making, finishing and merchanting, which reminded readers, as an earlier BIF review noted, of 'the high standard of a [British] textile industry, the products of which very often lead the way for the rest of the world'.[4]

Upholstery fabrics, however – as opposed to curtain fabrics – were at this date usually woven rather than printed, and of silk (for the most costly interiors), wool (especially for furniture requiring form-fitting cloth), or a mixture of wool and linen or jute, but very seldom cotton, which does not tolerate abrasion well and, untreated, is highly flammable. For the upholstery sector *International Textiles* illustrated only one British example before 1940, a group of Welsh tweeds. This was late in 1935, when the Welsh industry was being reorganized under the supervision of the University of Wales and the Rural Industries Bureau

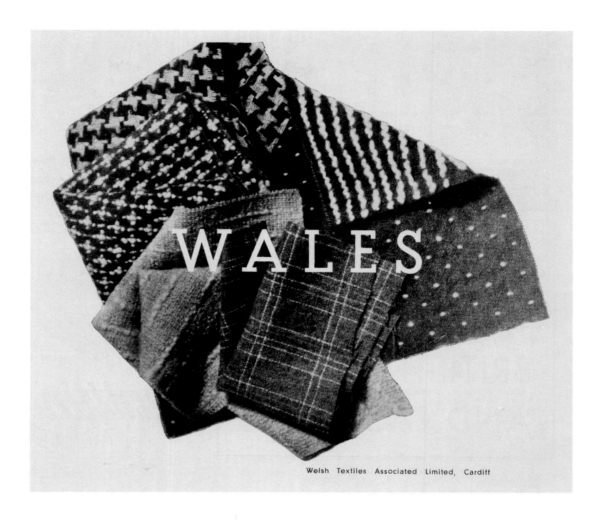

Welsh Textiles Associated Limited, Cardiff

(RIB), which appointed an unnamed 'experienced designer' to control production.[5] Nearby are shown a group of hand-woven cloths from Gospels, the studio of Ethel Mairet in Ditchling, Sussex. These two illustrations give a glimpse of the future for woven upholstery cloths: Mairet fostered links with European designer-weavers, visiting their studios and offering short-term residencies at her own.[6] Among these was Swiss-born Marianne Straub, already trained in hand weaving in Zurich and power weaving in Bradford, and at Gospels in 1933–4 learning hand dyeing and spinning and maintaining close contact thereafter. The RIB's Welsh tweeds were by Straub, employed there from 1934 to 1937 at the suggestion of Mairet.

And there were other harbingers of the absorption of Europeans that so characterized developments in mid-twentieth-century British design. In its issue of August 1934 the pre-war magazine featured a single textile artist, Otti Berger, in her 'weaving laboratory' in Berlin, illustrating the results of her hand-woven prototypes for mass production, in this case manufactured under licence by Wohnbedarf AG, the Zurich firm founded in 1931 and now famous for its collaborations with Alvar Aalto, Marcel Breuer, Ludwig Mies van der Rohe and other like-minded modernists.[7] Bauhaus-trained and

then also a designer for de Ploeg in the Netherlands, Berger emigrated to Britain in 1937. Straub, who was by then head designer for Helios, employed Berger both on a freelance basis and as her temporary replacement, but could not persuade her to remain in England.[8] While Straub cloths appeared – mainly unattributed – in later volumes of *The Ambassador* – the next designer to be featured was Czech-born Jacqueline Groag, who left her successful practice in Vienna in 1939; Juda devoted three pages of colour illustrations to her in 1946, and promoted her consistently thereafter.[9]

THE AMBASSADOR PROMOTES BRITISH TWEEDS

Mairet, Straub and Berger produced weaves dependent for their character on colour and texture, cloths often called 'tweeds' despite that term's more precise meaning, of a cloth composed from blended-colour yarns. Tweeds were world-renowned British suiting cloths; their transition to upholstery fabrics is linked to the development of modernist furniture in Britain (leather was the favoured upholstery for European furniture makers) and the work of Gordon Russell, Marcel Breuer and Ernest Race, among others.[10] Little wonder, then, that *The Ambassador*, among its articles promoting art as inspiration for design – and with an eye to

textile is of supreme importance, and it is in the capacity of a colour consultant to the textile designer that Mr. Cooper declares the modern artist — even the abstract artist, hitherto regarded as not remotely connected with industry — can play an extremely worth-while part. His natural sensibility and imagination will outweigh much of the factual knowledge accumulated by practical experience. In any multi-coloured design, each colour must be good, not only in itself, but also in its relation to the other colours of the range. Colour combinations, in conjunction with the

DUNCAN GRANT: ZURBARAN.

various types of weave available, offer the fullest scope to the creative powers of the designer and artist.

Possibly the most significant influence upon textile design to be found in modern art is in the work of the impressionist painters, who imparted a subtle brilliance and radiance of colour to their pictures by means of small touches of pure colour in close juxtaposition. Their technique was adapted by hand weavers, and for a time a close relationship was established between artist and craftsman. However, this

72—THE AMBASSADOR

Left: Cloths developed by David Cooper of Gledhill Bros & Co., Huddersfield, their colouration inspired by a painting by Duncan Grant
1946, no.11

Right: Upholstery and curtaining fabrics designed by Elsa Gullberg on a handloom and power-woven by Norman Scatchard
1951, no.9

Opposite, left: Advertisement for Holdsworth's moquettes (a woven cloth today familiar as bus and train upholstery), run in 1953 and 1955
1955, no.6

Opposite, right: This advertisement on the inside back cover presents the work of Tibor Reich in an editorial format
1955, no.9

promoting the modern British upholstery style as much as fashionable outerwear cloths – devoted ten pages in late 1946 to a 'new approach to the design of woven textures . . . based on a combination of impressionist and abstract painting techniques'. Describing the principles developed by David Cooper of the woollen manufacturer Gledhill Bros & Co., Huddersfield, the feature declares woven textile design to be 'architectural art in miniature', juxtaposing works by Paul Nash, Henry Moore, Graham Sutherland, Duncan Grant, Matthew Smith, Frances Hodgkins, Victor Pasmore and John Piper with herringbone and other suiting weaves coloured by Cooper to 'express fully the rhythmic vitality'.[11] The significance of fashionability created by colour in essentially timeless woven cloths (whether tweeds, flannels, tartans, estate checks or Savile Row-destined worsteds) was a point well made by *The Ambassador* on many occasions.

In their making British manufacturers were masters, but Juda was quick to seize opportunities to demonstrate that where tradition held sway, insularity did not. Thus in 1951, under the heading 'International Co-operation', the hand-woven designs by Elsa Gullberg of Sweden, created for the power looms of Scatchards of Halifax (whose parent company was Grays Carpets and Textiles), were emphasized

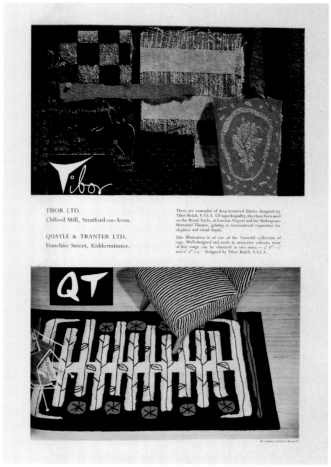

as a range of colour-related fabrics rather than a collection of individual cloths, 'from which furnishing schemes may be chosen to give the home the proper atmosphere of harmony and peace to counter the tempo of modern life'.[12] Juda even praised a firm that did not reveal the names of its designers, for his yardstick was modernity, functionality and a measure of overseas success. Thus 'Contemporary Moquettes' of November 1952 challenged the notion that such cloths were *passé* by illustrating moquettes by Holdsworth's, whose extensive overseas trade was attributed to their creation of new designs and colourways to order, and to the use and popularization of their moquettes by Scandinavian furniture manufacturers.[13]

Straub, certainly, became one of the Judas' many friends within the industry, and it is interesting to witness in the pages of *The Ambassador* other Mairet Straub connections with Europe that proved fruitful over the long term. In 1938 they travelled together to Berlin and met the Bauhaus-trained Margaret Leichner. At the end of that year both also established close working relationships with R. Greg & Co. of Stockport, then one of the most innovative yarn spinners in the world, convincing Greg's sales director, Stoppford Jacks, that adventurous yarns would be best sold in fabric form. In 1944 Leichner, by now in London, was supplied with handlooms by

Greg's, on which she wove their yarns, work that later passed to graduates of Leichner's weaving course at the Royal College of Art (RCA).[14] The success of Leichner's prototypes may well have contributed to Greg's financial support for Hungarian-born Tibor Reich, who had studied textiles in Vienna and, after his immigration in 1937, at the University of Leeds. His firm, Tibor Ltd, was established near Stratford-upon-Avon in 1945. Although he also designed carpets for Quayle & Tranter Ltd of Kidderminster and in 1954 introduced screen-printed fabrics, Tibor became best known for fabrics using Greg's yarns to create deeply textured cloths, often featured in *The Ambassador*. Equally prominently featured were Edinburgh Weavers, whose post-war artist-designed cloths, woven under the direction of Alistair Morton – who knew Jacks well and who himself designed avant-garde cloths – had a surface vitality derived from the incorporation of the innovative Greg's yarns.[15] Texture thus came to represent quality, whether in yarns or cloths, and became the signature of the designer-weaver, among them Ronald Grierson, reportedly still happy to weave single rugs, but, as Juda clearly understood and appreciated, whose 'craftsman's approach . . . gives to his industrial work the merit of being completely appropriate to the product'.[16]

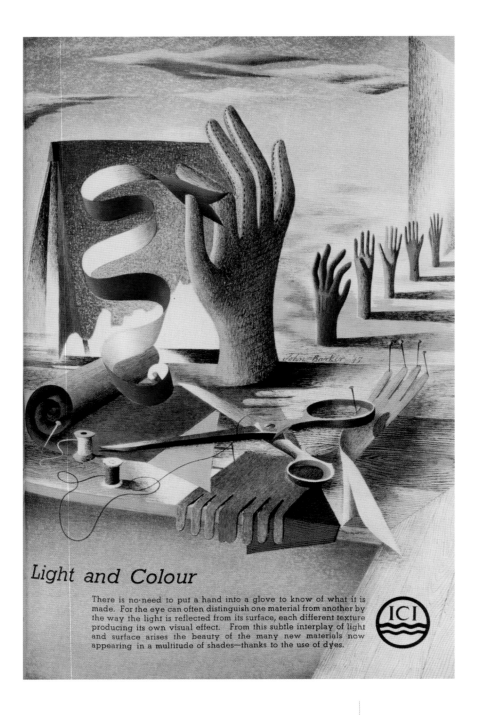

Light and Colour

There is no-need to put a hand into a glove to know of what it is made. For the eye can often distinguish one material from another by the way the light is reflected from its surface, each different texture producing its own visual effect. From this subtle interplay of light and surface arises the beauty of the many new materials now appearing in a multitude of shades—thanks to the use of dyes.

Advertisement for ICI, drawn in ink and gouache by John Roland Barker, who also designed posters for London Transport

1947, no.10

Opposite: Warriors, designed by Elisabeth Frink, an all-wool tapestry weave by Edinburgh Weavers, 1961, was photographed close up to emphasize the character of the yarn. It is shown alongside a Frink plaster maquette

1961, no.1

© Estate of Elisabeth Frink. All Rights Reserved, DACS 2011

NEW FIBRES AND PLASTIC PRODUCTS

That close-up illustrations were important aspects of the promotions provided by *The Ambassador* derived from the fact that Britain still maintained a large number of fibre-dependent industries, yarn manufacturers as well as firms producing constituent materials. Among the latter was ICI, which not only produced dyestuffs, but had also developed Perspex (in 1932) and polyethylene (1937, today familiar as plastic bags). After the war the company pioneered the development of polyamide (nylon) fibres in Western Europe and, branded as Terylene, developed the polyester fibre that had first been isolated in the laboratory of the Calico Printers Association in 1941.[17] For the still-large British net curtain industry, nylon, and then polyester (highly resistant to rotting

LEFT:
'Taro', a 'Time Present' fabric designed by Craven,
on heavy cotton satin.
Hull Traders Ltd., London N.W.10.

BELOW:
'Warriors', designed by Elizabeth Frink,
an all-wool tapestry weave.
Edinburgh Weavers, London W.1.

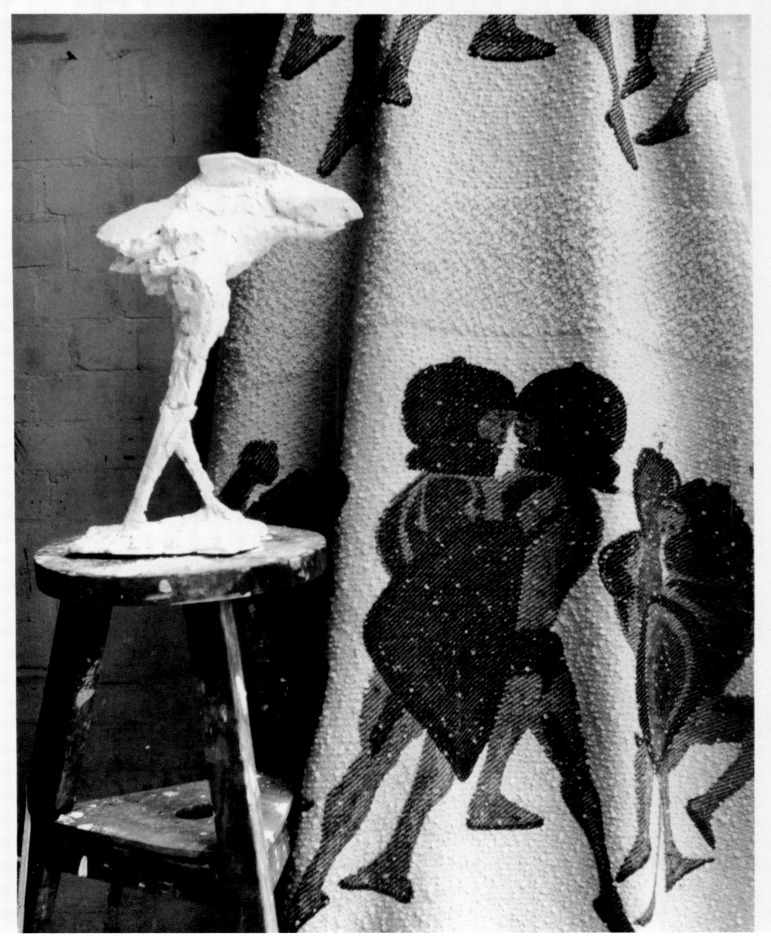

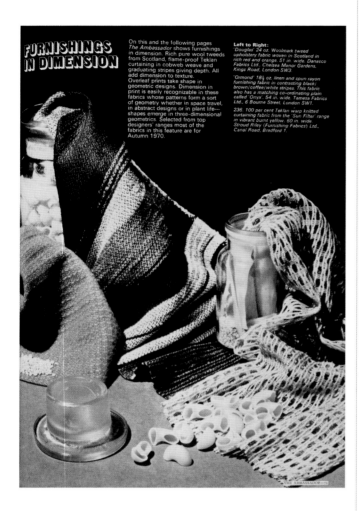

FURNISHINGS IN DIMENSION

On this and the following pages *The Ambassador* shows furnishings in dimension. Rich pure wool tweeds from Scotland, flame-proof Teklan curtaining in cobweb weave and graduating stripes giving depth. All add dimension to texture. Overleaf prints take shape in geometric designs. Dimension in print is easily recognizable in these fabrics whose patterns form a sort of geometry whether in space travel, in abstract designs or in plant life—shapes emerge in three-dimensional geometrics. Selected from top designers' ranges most of the fabrics in this feature are for Autumn 1970.

Left to Right:
'*Douglas*' 24 oz. Woolmark tweed upholstery fabric woven in Scotland in rich red and orange. 51 in. wide. Danasco Fabrics Ltd., Chelsea Manor Gardens, Kings Road, London SW3

'*Ormond*' 18½ oz. linen and spun rayon furnishing fabric in contrasting black/brown/coffee/white stripes. This fabric also has a matching co-ordinating plain called '*Onyx*'. 54 in. wide. Tamesa Fabrics Ltd., 6 Bourne Street, London SW1.

236. 100 per cent Teklan warp knitted curtaining fabric from the 'Sun Filter' range in vibrant burnt yellow. 50 in. wide. Stroud Riley (Furnishing Fabrics) Ltd., Canal Road, Bradford 1.

'Furnishings in Dimension'

1969, no.10

Showing rich textural effects are, from left, a Scottish woollen tweed upholstery cloth, in rich red and orange (retailed by Danasco Fabrics, London); Ormond, a Tamesa linen and spun rayon fabric with brown/coffee-coloured stripes (designed by Marianne Straub and woven for Tamesa by Warner & Sons, Braintree); and a vibrant burnt yellow Teklan warp-knitted curtain fabric by Stroud Riley (Furnishing Fabrics) of Bradford

Opposite: 'Contemporary Nets'

1953, no.1

Furnishing net designed by Terence Conran, manufactured by A. & F.H. Parkes of Nottingham, and photographed by Jay

by the sun through glass), were soon to become standard fibres. A product largely neglected in histories of the period, net curtains were essential elements in post-war International Style interiors, attracting investment in modern patterns, as demonstrated by the 'contemporary nets' featured by the magazine in 1953, designed by the young Terence Conran and photographed by Jay.[18] British firms making sheer curtain fabrics also forged ahead with new manufacturing techniques such as warp knitting. Although first developed in 1775 by the British firm Crane, it was the introduction of the compound-needle machine in 1946 that brought about phenomenal growth in this field between 1950 and 1970, initially led by the British-built FNF tricot machine, which was most widely applied to clothing textiles. Nevertheless, the surge in warp knitting had great impact on interiors with the reassessment of Raschel machines that arose in tandem with the development of new fibres such as the modacrylic Teklan, available from Courtaulds' Coventry factory from 1962. By the mid-1960s the resulting weighty and often vibrantly coloured net curtains were defining characteristics of large walls of glass in educational, corporate and civic buildings, maintaining the British tradition of furnishing cloths with depth and dimension.[19]

New fibres – and more plentiful supplies of natural fibres – were essential to meet both rising consumption and population expansion, and articles in *International Textiles* and, later, Juda's 'Thinking Ahead' sections often included reports on this topic from worldwide sources. So many options existed after the war that the editorial of November 1946 included a chart classifying man-made and synthetic fibres by origin, spinning techniques and methods of coagulation. By 1952 the magazine noted a textile world 'noisy with a rush of new names', adding that the 'man-made fibres have given new words to the language, new possibilities to the industry, new superlatives to advertising'.[20] Apart from showing cross-sections of nylon and Terylene, in recognition of its international readership the article also featured the American innovations Orlon and Dynel, acrylics by now becoming widely available (and, with wool-like characteristics combined with moth resistance, destined to become important in upholstery cloths and, especially, in carpeting).[21] Four years later, 'A Brilliant Story' highlighted

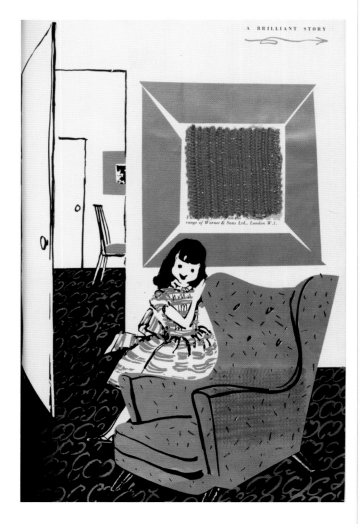

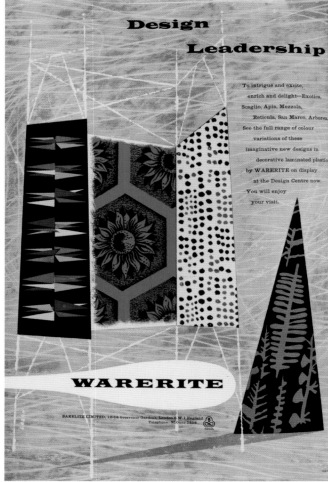

Left: 'A Brilliant Story'

1956, no.5

This page of an editorial on Lurex combines a sketch of a chair by
E. Gomme Ltd upholstered in a Tibor fabric with a framed swatch of
Silverton, a Warner & Sons fabric designed by Marianne Straub
in 1952 to launch Lurex in the UK.

Right: Advertisement for Warerite

1957, no.6

the versatility and stability of Lurex, an aluminium thread
encased in transparent plastic and developed by Karl Prindle
at Dobeckmun, in Cleveland, Ohio, in 1946 – granted, the
Dobeckmun overseas headquarters were in London and the
cloths depicted all emanated from British firms.[22] The rapidly
developing plastics industry, largely propelled by textile
chemists, resulted in products seemingly unrelated, given
their rigidity. As advertisements such as that for Warerite
demonstrate, however, the readership of *The Ambassador* was
eager for interior decorative products of all types, including a
brilliantly patterned thermoset resin developed soon after the
war by Bakelite Ltd, which commissioned designs from Zika
Ascher and Jacqueline Groag, among others.

NEW DYESTUFFS AND THE RISE OF SCREEN PRINTING
The large number of colour illustrations in *The Ambassador*
was equally important for the many other household
textiles featured in the magazine, which included blankets,
carpets and what had once been called 'white goods', namely
sheets, towels and table linens. While two-toned checked linen
glass cloths were near-universal by the nineteenth century,
the introduction of colour to bathroom towels appears to
coincide with the more widespread introduction of indoor

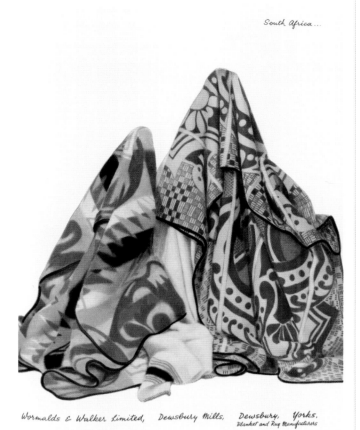

South Africa...

Wormalds & Walker Limited, Dewsbury Mills, Dewsbury, Yorks.
Blanket and Rug Manufacturers

THE AMBASSADOR—73

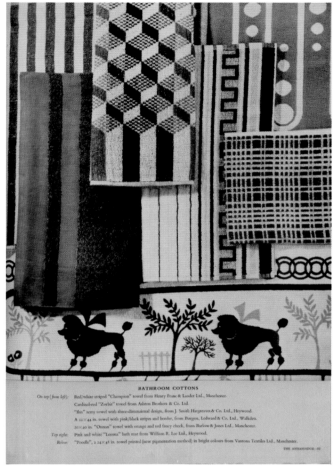

BATHROOM COTTONS

On top (from left): Red/white striped "Champion" towel from Henry Franc & Lander Ltd., Manchester.
Cardinal-red "Zorbic" towel from Ashton Brothers & Co. Ltd.
"Bas" terry towel with three-dimensional design, from J. Smith Hargreaves & Co. Ltd., Heywood.
A 22½ x 44 in. towel with pink/black stripes and border, from Burgon, Ledward & Co. Ltd., Walkden.
20 x 40 in. "Osman" towel with orange and red fancy check, from Barlow & Jones Ltd., Manchester.
Top right: Pink and white "Lenona" bath mat from William R. Lee Ltd., Heywood.
Below: "Poodle", a 24 x 48 in. towel printed (new pigmentation method); in bright colours from Vantona Textiles Ltd., Manchester.

THE AMBASSADOR—81

plumbing and were thus not commonplace until the 1920s. As with the other cloths discussed thus far, colour was dyed into the woven cloth, or into the yarn, to create woven patterned effects. And as is true today, the weave may stay the same for years, with the colour alone providing fashionable changes. British firms successful in exporting also recognized that at any one time different markets preferred different shades. In 1951 Vantona, the very large Lancashire-based integrated household textile manufacturer (that is, spinning, weaving, bleaching, dyeing *and* merchanting), declared peach and rose tones as the preferred British colours – as opposed to the pre-war popularity of pale blues – but noted how the woven construction of some towel designs 'show a small neat pattern on one side, while on the reverse it appears as a brightly coloured stripe . . . the bright, jazzy sides being particularly popular in Australia and other countries of bright sunshine'.[23] Consulting an architect to keep abreast of bathroom design, by 1955 Vantona had pioneered towelling printed with fast pigment colours, transforming the bathroom, as an *Ambassador* feature on cotton put it, 'into one of the gayest places in the house, with towels and bathmats in bright, stimulating colours and designs'.[24] Soon, it became commonplace for terry towelling

Left: Advertisement for blankets
1947, no.8
Like many British firms with a tradition of exports, products were tailored to certain markets in the patterning and colouring, as these blankets inspired by South African tastes illustrate.

Right: 'The 24 Hour Fabric'
1955, no.10
This page from a feature on bathroom towels and mats makes a point of noting that the poodle pattern has been produced by the new pigment-printing method, while all the others are of traditional colour-woven construction.

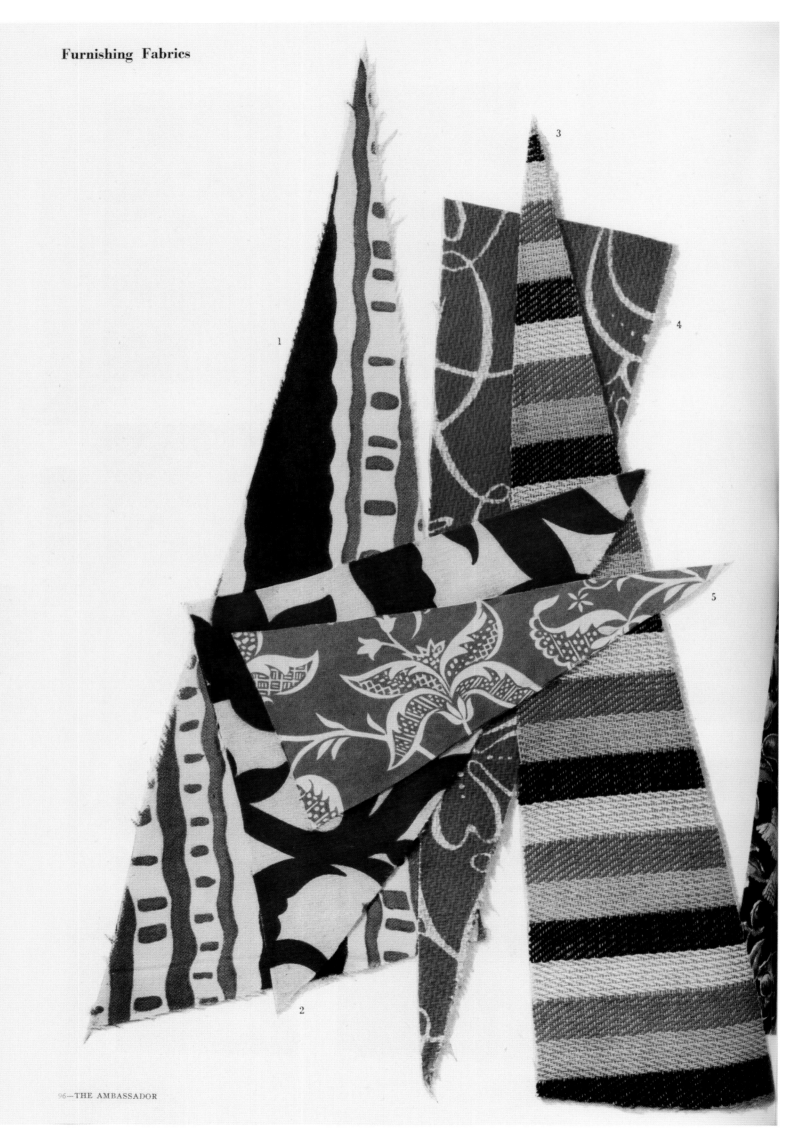

'Furnishing Fabrics'

1948, no.10

On the left are two spun rayon fabrics, the larger hand-block printed by Graftons and the smaller by Davies & Luke, both of Manchester. To the right are two heavily textured fabrics, one a screen print by Turnbull & Stockdale and the other a stripe from Hill Brown, woven with a new plasticized Barlow & Jones' cotton yarn called 'Vinolite'. In the centre is a Margaret Simeon design hand-screen printed by Weyvale Fabric Printworks, Godalming.

to sport vivid patterns, a possibility that transformed the beach towel into the fashionable accessory it remains today.

Pigment colours were developed in tandem with screen printing, a technique in use as a hand and then semi-automatic process in the 1930s but, in its fully mechanized form, just beginning to be widely installed in the mid-1950s. Soon to become the dominant method of textile printing, rotary screen printing revolutionized interior textiles (and, with machine knitting, was the only textile sector to experience continuous growth into the late twentieth century). An additional boost to screens came because, compared to engraved rollers – since the 1820s the basis of Britain's dominance in the supply of printed cottons – screens printed textured cloths more easily, thus eliding both with the post-war design leadership of 'tweedy' fabrics and post-war constraints regarding what was available to print on. A snapshot of the situation is provided in a feature of 1948 on furnishing fabrics, which confirmed that in prints, 'close attention is paid to texture and much of the charm of these new printed effects depends upon the care which has gone into the weaving of the ground fabrics'. This happy spin on the struggle to maintain supplies of ground (or 'grey') cloths is reinforced by the comment that 'the Furnishing Fabric industry did not debase itself by producing cheap trash

immediately after the war. On the contrary, the tendency was for producers to "trade-up" in quality, thereby obtaining the best value from materials which were in short supply, hence we had a surfeit of high-class printed linens.'[25] One colour spread encapsulates the results (see opposite). A highly textured woven stripe sits amid two screen-printed textured cloths, one of linen and the other of heavily textured cotton, alongside two prints on delicately textured spun rayon cloths. One of the latter was hand-block printed, but this old method, still maintained in a few firms for complex or 'limited edition' production, was also eventually to lose out to rotary screens, which were far cheaper to originate and by about 1963 (thanks to improvements in the printing cylinders) could mimic the look of a block print. And as screen printing took off, so prints on textured grounds declined. This was partly because screen-printed marks could be – and were – used to suggest the appearance of those more expensive texture-woven grounds. More importantly, grey cloths ceased to be the province of British weavers, whose livelihoods faltered as the 1960s progressed. Imported, standardized and smooth cottons became the norm for furnishing-print 'greys'. *The Ambassador* did its best to promote the declining suppliers of British pattern-woven furnishings, but whereas its illustrations of the 1940s typically divide relatively equally between prints and

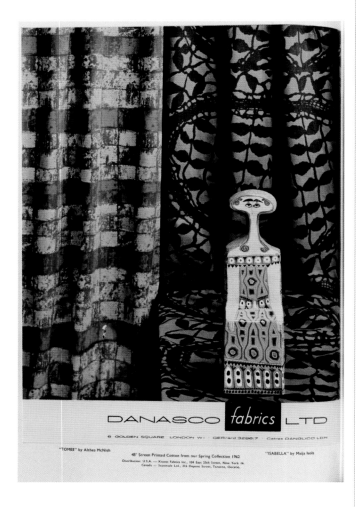

Danasco advertisement
1962, no.2

Opposite: Roses designed by Graham Sutherland for Courtaulds
1944, no.5

weaves, by the 1960s the proportion of woven fabrics shown had fallen below 30 per cent, and as the 1970s approached, it was often much less. Those weaves shown typically offered tonal effects, rather than striking designs.

SUPPORTING BRITISH DESIGNERS

Despite troubling signs, until the end of 1964 – in other words, as long as *The Ambassador* was under Juda's direct control – it presented an optimistic, even defiant, picture of the British textile industry.[26] Juda's understanding of economics privileged his stance, for example in an editorial of 1957, which trumpeted his adopted country's creative and technical skills.[27] Clearly adept at promoting British goods abroad, Juda seemed just as aware of an important audience in the captains of industry at home. They were equally the target of his consistent promotion of good design, including the insistence on innovative advertising imagery. The post-war shortage of experienced designers was as critical to Britain's furnishing industry as was the real shortage of materials.[28] Much was done by industrial and national agencies to publicize Britain's creative talents and to direct manufacturers towards artists as designers, beginning with the establishment in late 1940 of the Colour, Design and Style Centre in Manchester,

which after 1942 operated under the aegis of the Cotton Board. The first exhibition, orchestrated by Gerald Holtom, included designs by Eric Ravilious, Graham Sutherland, John Piper, Edward Bawden, Duncan Grant and Vanessa Bell. Although many were purchased, Sutherland's design, called 'Rose', was one of the few put into production, by Helios (it was shown in 1946 at the first post-war national exhibition, *Britain Can Make It*, and produced into the 1950s) (see also pages 108–9). Sutherland designs were prominent among those shown at the exhibition, and he was included – with Ravilious, Piper and now, also, Henry Moore – in a subsequent artist-designs exhibition mounted by the Style Centre in 1944, where he showed a similar rose design, which was taken up by Courtaulds.[29] This exhibition received extensive coverage in *International Textiles* in May 1944. Thereafter, Juda's promotion of both the Style Centre and artists as designers – notably the magazine's own *Painting into Textiles* exhibition and the frequent commissions from British artists – even included what were essentially 'how to' features, notably one of 1955 on Spain featuring Louis le Brocquy artwork, photographs by Jay from which these were derived, (see also pages 72–5) and resulting cloths, primarily by David Whitehead, who took Juda's principles to heart.[30]

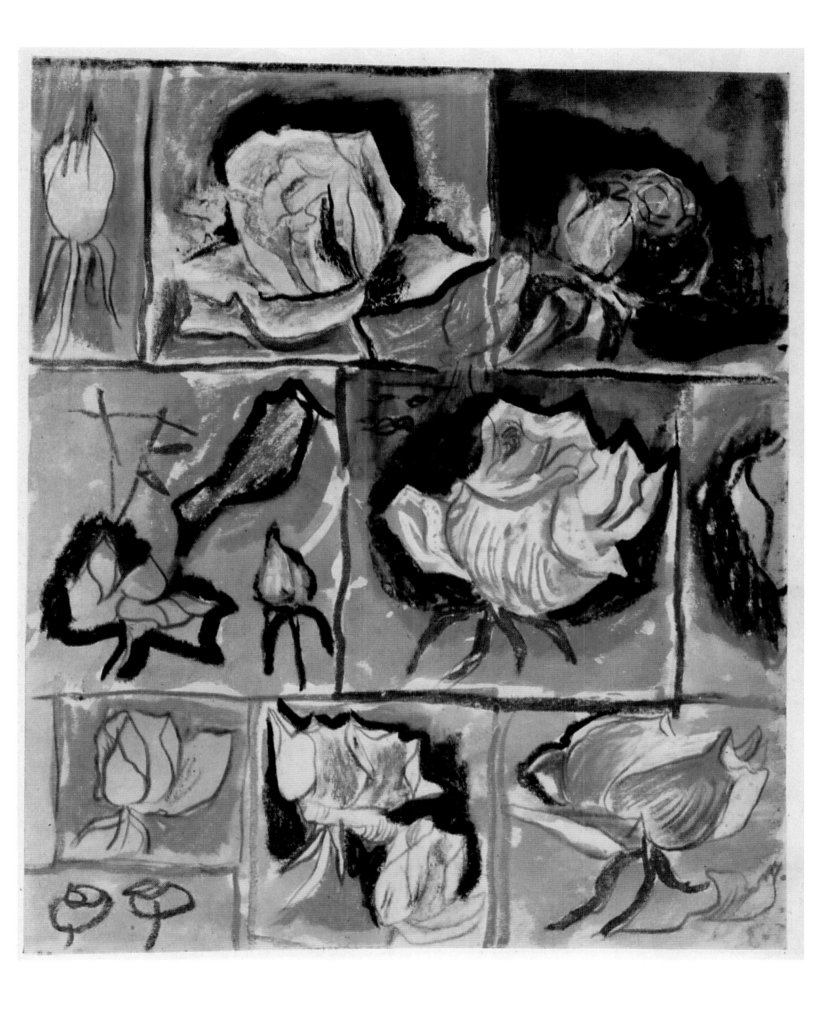

Jimmy Cleveland Belle, then director of the Style Centre, strove for 'a reconciliation of the traditional genius of England in the designing and making of beautiful textiles, with the mechanical genius which gave us the leadership in the mass production of cloth in the nineteenth century'. Writing this in 1943, he imagined a time when 'textile firms will boast of the designers . . . before they mention the number of their machines'.[31] Juda clearly shared the same vision. Nine months later, when Alastair Morton stated that the best designs in terms of sales were often not those his firm was most proud of, Juda added an editorial note, describing Morton as an artist and manufacturer but 'probably not a salesman. . . . We are less pessimistic about a more general acceptance of new fashions and good designs.'[32] Juda was clear: 'Because good design involves risk, and because business men very often feel that they must hedge risk, commercial design frequently involves fatal compromise.' This, in 1951, was followed by his observation that, on the other hand, 'we see that manufacturers who seek a successful design policy are bold, discerning, positive – and successful'.[33] Accompanying these words were illustrations of contemporary designs from a range of sources including Foxton's, David Whitehead and Story's of London, intermingled with floral designs

'Cool Abstracts – Hot Colours'
1963, no.1
From left: A Grafton screen print by Stewart Black, a Hull Traders hand-screen print by Peter Perritt, a Bernard Wardle machine-screen print, and a Morton Sundour print by Verena Junker, all on smooth cottons bar the last, which was printed on a slightly textured matt cotton or cotton-mix fabric called cretonne.

from Bernard Wardle and Simpson & Goodlee. Juda saw no conflict in such juxtapositions; they accurately represented British textile production and underpinned the potential for renewed exports. But with something to suit every taste, '"What", Juda asked, "is wrong?"' In an outspoken response to his own question, Juda concluded that for both traditional and contemporary designs there were now, in 1952, 'any number of young designers whose freshness of outlook will ensure no bad copying in the future'.[34] And, true to his word, he subsequently promoted student work from the RCA, the Huddersfield School of Art and the Central School in London, as well as recent graduates, such as Pat Albeck.[35] By 1963 he rightly boasted that enlightened post-war British art education and 'a new direction from industry is now bearing fruit with a crop of young designers whose work has given British textiles

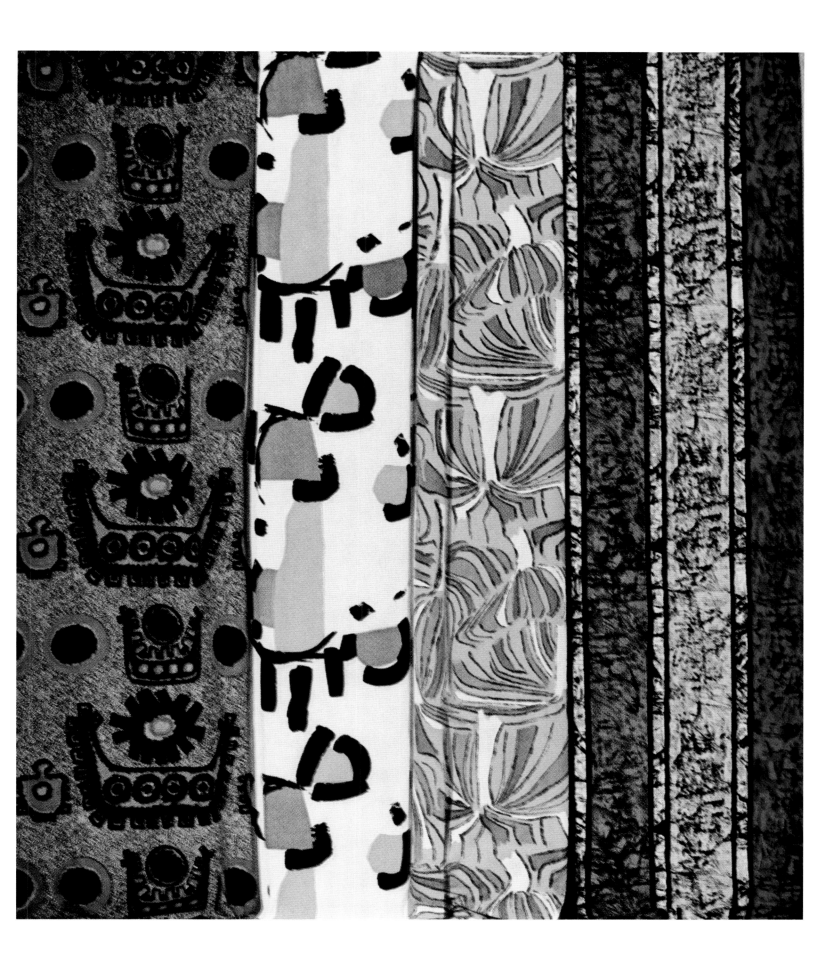

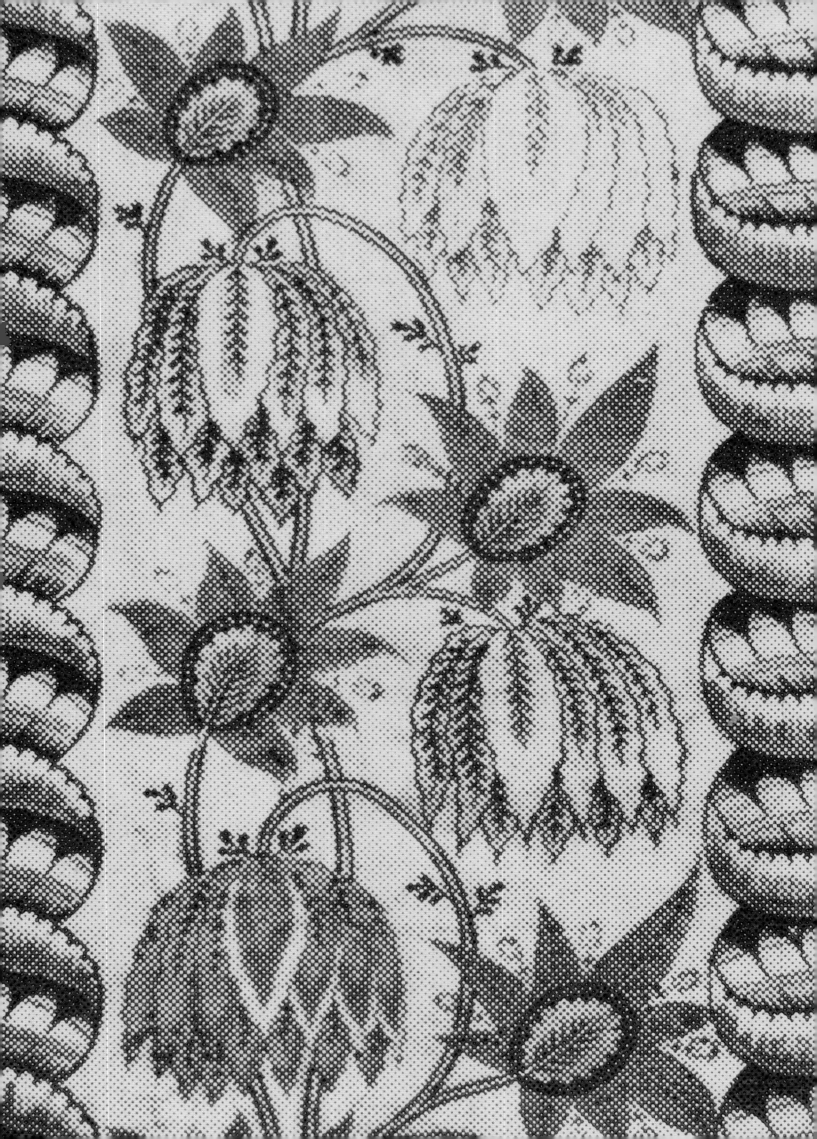

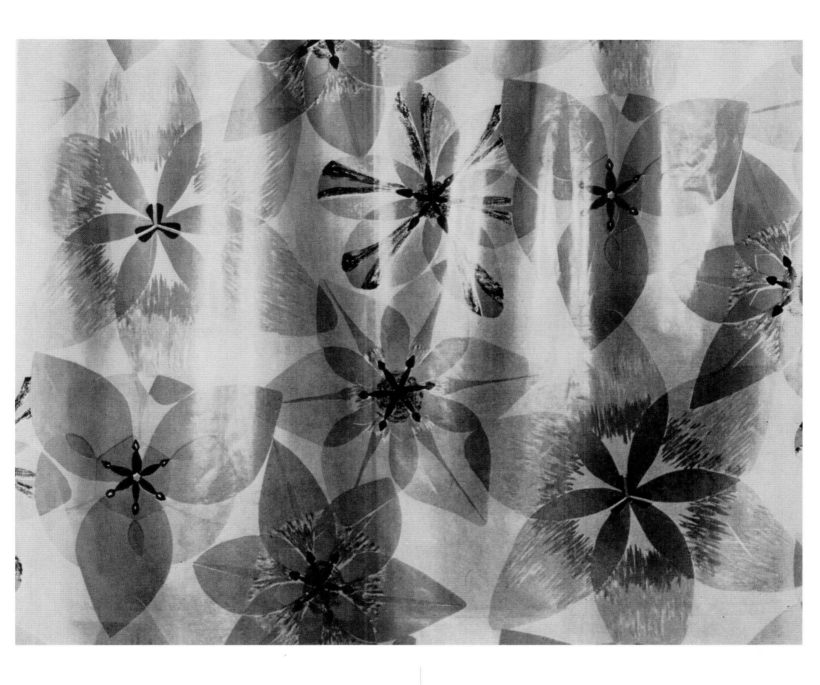

'The New Chintz Tradition'

1960, no.5

Kaleidoscope, above, was designed by Mary Harper for Edinburgh Weavers for the 1960 Style Centre exhibition, *The New Chintz Tradition*. It was inspired by and displayed with an English hand-block printed cotton of 1790, opposite, lent to the exhibition by the Henry Francis DuPont Winterthur Museum, Delaware.

a fresh impetus', illustrating contemporary designs, as well as what one of Europe's top store buyers called 'the best modern florals in the world'.[36] *The Ambassador* credited this achievement in large part to the work of the Cotton Board's Style Centre, which not only promoted artists but also young graduates as designers: RCA work in 1958, for example, and final year and recent graduates in 'Inprint in Procion' in 1966.[37] It also consistently collaborated with the Victoria and Albert Museum to present fine examples of British eighteenth- and nineteenth-century cottons. That this could prompt modern florals is well illustrated when, in 1960, when the Museum mounted its *English Chintz* exhibition and the Style Centre simultaneously exhibited new fabrics inspired by the old, bannered under the title *The New Chintz Tradition*.[38]

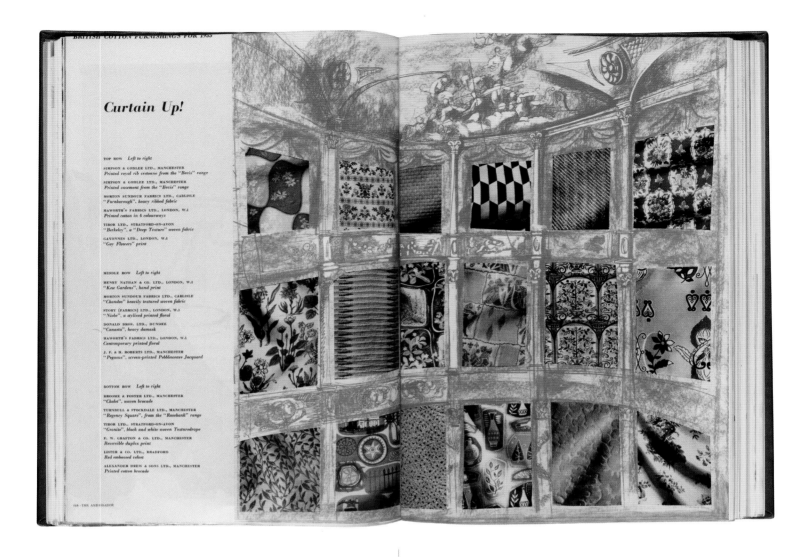

Curtain Up!

TOP ROW *Left to right*
SIMPSON & GODLEE LTD., MANCHESTER
Printed raval rib cretonne from the "Bevis" range
SIMPSON & GODLEE LTD., MANCHESTER
Printed casement from the "Bevis" range
MORTON SUNDOUR FABRICS LTD., CARLISLE
"Furnborough", heavy ribbed fabric
HAWORTH'S FABRICS LTD., LONDON, W.1
Printed cotton in 4 colourways
TIBOR LTD., STRATFORD-ON-AVON
"Berkeley", a "Deep Texture" woven fabric
GAYONNES LTD., LONDON, W.1
"Gay Flowers" print

MIDDLE ROW *Left to right*
HENRY NATHAN & CO. LTD., LONDON, W.1
"Kew Gardens", hand print
MORTON SUNDOUR FABRICS LTD., CARLISLE
"Chandos" heavily textured woven fabric
STORY (FABRICS) LTD., LONDON, W.1
"Niobe", a stylised printed floral
DONALD BROS. LTD., DUNDEE
"Canasta", heavy damask
HAWORTH'S FABRICS LTD., LONDON, W.1
Contemporary printed floral
J. F. & H. ROBERTS LTD., MANCHESTER
"Pegasus", screen-printed Pebbleweave Jacquard

BOTTOM ROW *Left to right*
BROOME & FOSTER LTD., MANCHESTER
"Chalet", woven brocade
TURNBULL & STOCKDALE LTD., MANCHESTER
"Regency Square", from the "Rosebank" range
TIBOR LTD., STRATFORD-ON-AVON
"Granite", black and white woven Texturdrape
F. W. GRAFTON & CO. LTD., MANCHESTER
Reversible duplex print
LISTER & CO. LTD., BRADFORD
Red embossed velvet
ALEXANDER DREW & SONS LTD., MANCHESTER
Printed cotton brocade

'Curtain Up!'
1954, no. 10
This spread typifies the range of textile styles promoted by the magazine through innovative presentation.

Opposite: 'Design in Harmony'
1959, no.4
Shown in a feature devoted to Heal's are two roller-printed geometric designs by Paule Vézelay displayed either side of a roller print designed by Jane Daniels. The teak veneer desk with ebonized drawer carcasses is from a range of desks and filing cabinets by the Nicholson brothers; the office chair with metal swivel base and leather upholstery is by Henry Long.

COLLABORATIONS WITH FURNITURE MAKERS AND SHOPS

On more than one occasion, Juda also stressed the need for designs to be sympathetic to particular types of interiors or furniture: 'Too many furnishing fabric designs go straight from the drawing board to the loom or printing plant, without ever being tried at a window or seen on a chair or sofa; thus too many patterns are seen on inappropriate chairs, and too many windows are graced or disgraced, by unsuitable curtains.'[39] In this instance of September 1955, sketches of chairs and windows suggested a range of furniture styles and

historical interiors, and the clever integration of fabrics and sketched furniture or interiors, often by Ett, was part of the distinctive style of the magazine throughout the 1950s.[40] As the 1950s progressed, however, more often than not fabrics were photographed against real props – such as fireplaces – or within real interiors.[41] Although lighting, mirrors, ceramics and other examples of British decor were also incorporated, increasingly the emphasis was on new British furniture, especially that made by Hille, Ernest Race and Heal's. An entire feature of 1953 showed both traditional and contemporary fabrics with Hille furniture.[42] In 1957, while declaring a new level had been set by that year's Earls Court furniture exhibition, the editorial confirmed the magazine's intentions: 'By photographing the new range of British furnishings in their natural habitat – contemporary furniture – we show how complementary they are to each other.' And in keeping with the editor's knowledge of modern British art, he added that the 'suave shapes are emphasised by the rough textures and muted patterns of the covering cloths and in particular by the ubiquitous deployment of contrasting colours for the external and internal contours – a device strongly reminiscent of some of Barbara Hepworth's earlier sculpture'.[43] Here the fabrics are still a mixture of contemporary and – if not truly traditional,

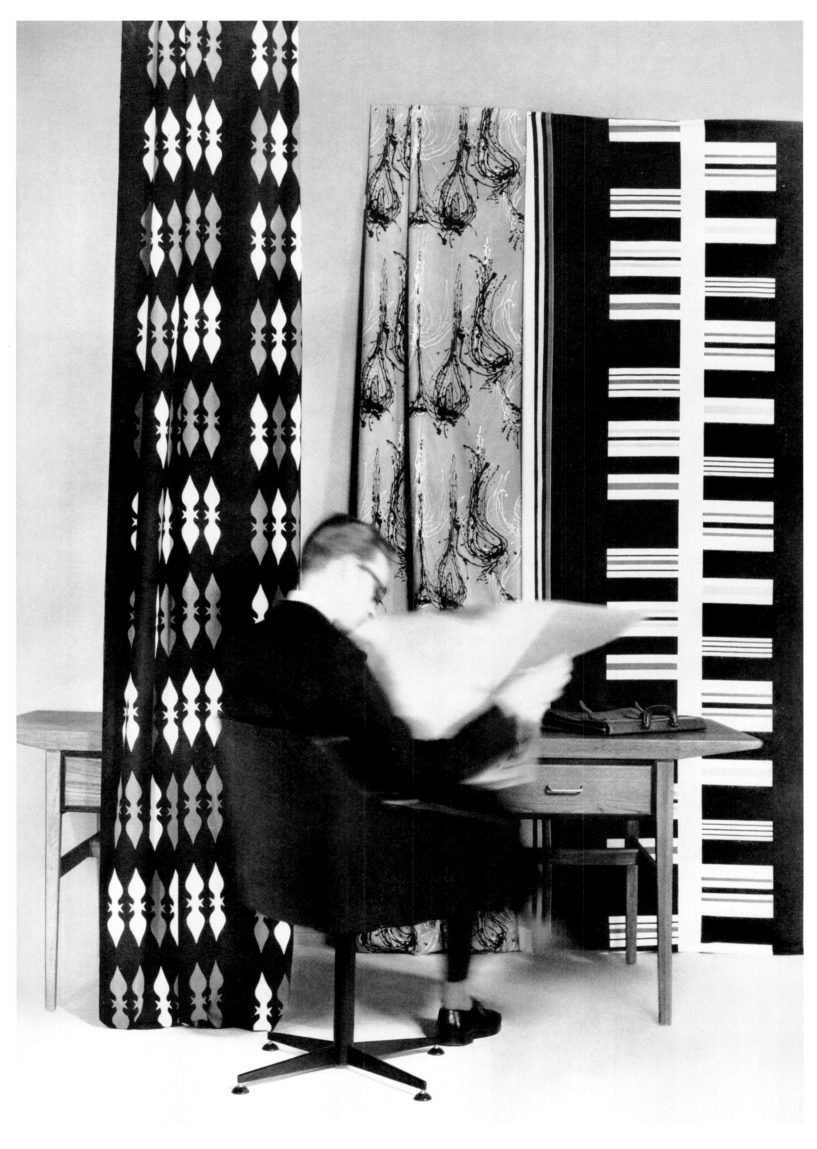

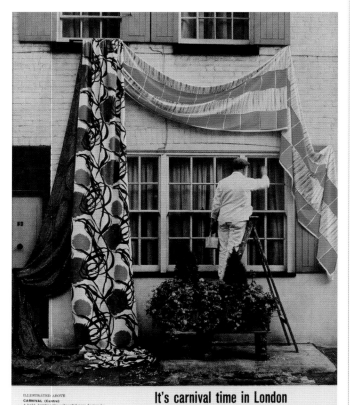

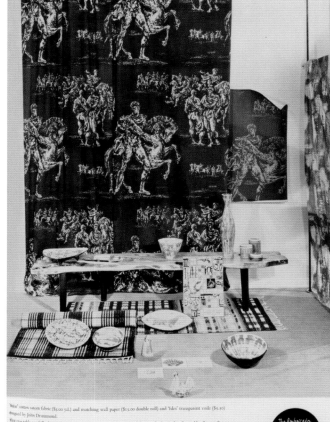

Left: Advertisement for Rosebank 'Futura' collection

1963, no.1

Fabrics designed, from left, by June Locke, Hilda Durkin and John Blackburn feature in this advertisement for the Futura Collection by Rosebank, the own-brand of Turnbull & Stockdale.

Right: Lord & Taylor British Fortnight

1958, no.9

Included in Lord & Taylor's 'British Fortnight' are Hull Traders textiles and a wallpaper designed by John Drummond, a table by Arthur Reynolds, ceramics by Kenneth Clark and Ann Wynn-Reeves, rugs by Peter Collingwood and a mosaic panel by Nigel Henderson and Eduardo Paolozzi. Lord & Taylor is the oldest upscale speciality retail department store in the USA, founded in Manhattan in 1826.

Opposite: Advertisement for Hill Brown showroom, London

1948, no.7

then 'transitional' – as were the fabrics in a feature of 1958, all photographed at Heal's (but with textiles by more than twenty other firms), whereas by 1959, in a feature devoted solely to Heal's, every fabric was decidedly up-to-the minute.[44] Taking the concept of 'natural habitat' even further, and in response to the increasingly large scale of many furnishing fabric designs, *The Ambassador* in 1962 took fabrics to Hide Tower, London, then the highest block of flats in the country, and two years later displayed Heal's fabrics within and around London County Council schools, highlighting the international recognition that British school architecture had gained at the Milan Triennale of 1960.[45] Advertisements indicated that British manufacturers pressed home similar messages.

The collaboration with furniture makers and shops thus did as much to promote British furniture as it did British fabrics. *The Ambassador* had strong views on this topic too, stating in 1952: 'The shops who have made it almost their exclusive business to deal in . . . modernity are legion; but the good ones could be counted on the fingers of one hand', citing Dunn's of Bromley and Heal's as exemplary.[46] And just as Juda made his own premises a 'home away from home' for overseas visitors, he also saw the benefit of well-appointed showrooms, which from the late 1940s were

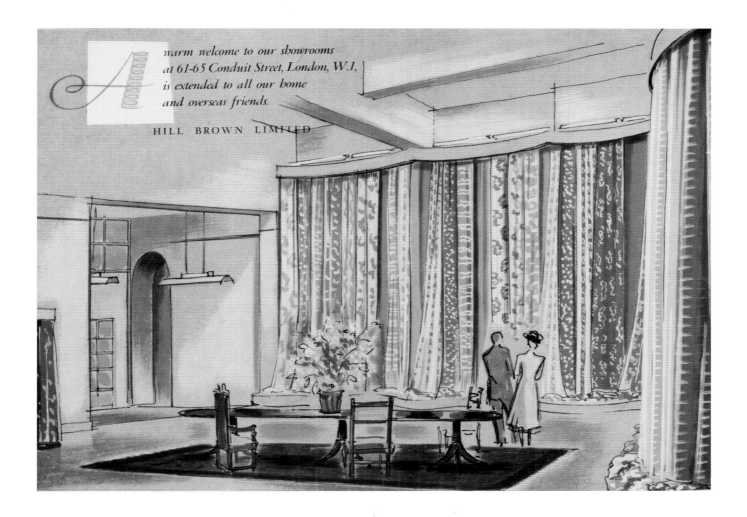

warm welcome to our showrooms
at 61-65 Conduit Street, London, W.1,
is extended to all our home
and overseas friends.

HILL BROWN LIMITED

being rebuilt and refitted. Edinburgh Weavers' new London showroom was given a two-page spread in 1956, while a much larger spread showed the magazine's selection of fabrics for autumn 1960 in 'the lavish new showroom designed by Dennis Lennon for Greaves and Thomas [which, with] rich decoration and accessories setting off the simple lines of modern furniture . . . makes an ideal background for fabrics'.[47] Other shops and showrooms illustrated between 1955 and 1960 alone include Hamilton House (exhibiting furnishings by the British Man-Made Fibres Federation), a carpet showroom designed by Heal's, the 'G Plan' Gallery by Anthony Denney for E. Gomme Ltd, and the Crown Wallpaper Style Centre designed by Roger and Robert Nicholson – for wallpapers were also covered in the magazine. The interior of the Design Centre in London was shown in 1957, when it presented the *Design in Cotton* exhibition staged by the Cotton Board's Style Centre.[48] These images not only indicated the sort of welcome and informative environments awaiting overseas buyers, they also suggested methods of displays themselves. And as the last example indicates, that the Style Centre was by 1957 mounting exhibitions outside Manchester presaged its influence – parallel to that of *The Ambassador* – in orchestrating the manner of presentation

of British fabrics when shown overseas. Thus the magazine went from reporting events such as Lord & Taylor's *British Fortnight* in 1958, the *British Fortnight* in New York in 1960, and the large-scale promotion of British furnishings by Myer Emporium Australian stores in 1961, to coverage of international events in which the Style Centre had a direct hand.[49] These, orchestrated by Donald Tomlinson (director 1948–64), included contributions to the Rand Easter Show in Johannesburg in 1962 and, in 1963, the Melbourne International Trade Fair, the Central African Trade Fair, Bulawayo, and a joint Cotton Board and Scottish Council of Industrial Design presentation in Manchester and Glasgow that was later to travel to New Zealand and South Africa.[50]

SHIFTS IN INTERNATIONAL TRADE

While the examples just given illustrate collaborations with countries closely associated with Britain through colonial, cultural and linguistic ties, *The Ambassador* did not overlook other nations. In 1961 the magazine noted that British furnishings 'find their way increasingly into world markets from Scandinavia to Japan. It is proof of their versatility that they blend so successfully into these contrasting environments.' Placing British fabrics with Japanese,

CONTEMPORARY CLASSICS

The Marcel Breuer plywood long chair, like the tables opposite designed in the early 1930s, outlined against three fabrics which hint at the new forms that came with the Modern Movement. Also from John Alan Designs.

Left to right

Cachou flavoured pink, yellow, blue and mauve print on a white cotton ground. A Parkertex design by Natalie Gibson. G. P. & J. Baker Ltd., Berners Street, London W.1.

'Archway', a Stereoscopic print in a build up of grey/green, Royal blue and brown dots on white cotton. Designed by Eddie Squires for Warner's Studio Range. Warner & Sons Ltd., Winsley Street, London W.1.

'November' hand printed abstract in clear multi-colours on white cotton. Designed by Shirley Craven. Hull Traders Ltd., Sedley Pl., London W.1.

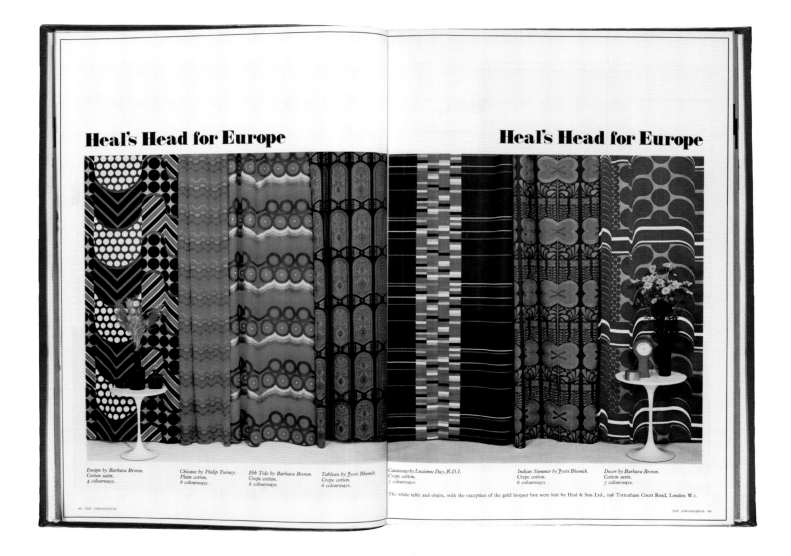

Heal's Head for Europe

Ensign by Barbara Brown.
Cotton satin.
4 colourways.

Chicane by Philip Turney.
Plain cotton.
8 colourways.

Ebb Tide by Barbara Brown.
Crepe cotton.
6 colourways.

Tableau by Jyoti Bhomik.
Crepe cotton.
6 colourways.

Causeway by Lucienne Day, R.D.I.
Crepe cotton.
5 colourways.

Indian Summer by Jyoti Bhomik.
Crepe cotton.
6 colourways.

Decor by Barbara Brown.
Cotton satin.
5 colourways.

The white table and objets, with the exception of the gold lacquer box were lent by Heal & Son Ltd., 196 Tottenham Court Road, London W.1.

Italian, Norwegian, German, Austrian, Swedish and French objects, ranging from a folding screen to a grand piano, this feature – and another entirely graced with Danish furniture and accessories also available to purchase in the UK – demonstrated the breadth of British trading, both as exporters and, increasingly, as importers.[51] By January 1969, when the magazine revisited the concept of fabrics foregrounded with furniture, furniture was also now often imported, with the incorporation of Thonet's bentwood rocking chair (made from 1860 in Moravia), as well as Breuer 1930s furniture then being manufactured by John Alan Designs in London. With regard to this trend, most telling, perhaps, is that when *The Ambassador* featured British fabrics displayed in Pesch, Cologne, 'a large and distinguished new furniture and furnishing store, incorporating all contemporary architectural, design and display facilities', it was within months of the first meeting of representatives of the Common Market (the European Economic Community: EEC), in January 1958.[52] The creation of the EEC, composed of Germany, Belgium, France, Italy, Luxemburg and the Netherlands, was a landmark moment for trading among European nations. The UK, with Ireland, Norway and Denmark, were not to join until 1972, having been refused entry in 1960. Some long-established furnishing

Opposite: 'Contemporary Classics'
1969, no. 1
This was one of the last features to cite the names of the designers.

Above: Advertisement for Heal's
1967, no.1
Triumphant over its success in Europe, Heal's advertised its 1967 range which included designs by Barbara Brown (from left, numbers 1,3,7), Philip Turney (2), Jyoti Bhomik (4,6) and Lucienne Day (5).

textile firms got around EEC duties on imported goods by amending existing relationships with agents in EEC countries. Heal's took a different route, establishing Heal Textil GmbH in Stuttgart in September 1964 and, in less than two years, doubling its turnover in Germany, a feat announced in *The Ambassador* in early 1967.[53] For many other firms, however, there was no comparable success; exports fell, and in parallel so did the magazine's number of pages and advertisements.

In retrospect it is clear that 1965 was a watershed year, for both *The Ambassador* and the furnishing textile industry, equally altered by takeovers and the changes in mass-market styles and selling techniques.[54] Coming to an end were the post-war 'designer decades'. Firms such as Heal's and David Whitehead continued to name and promote artists and

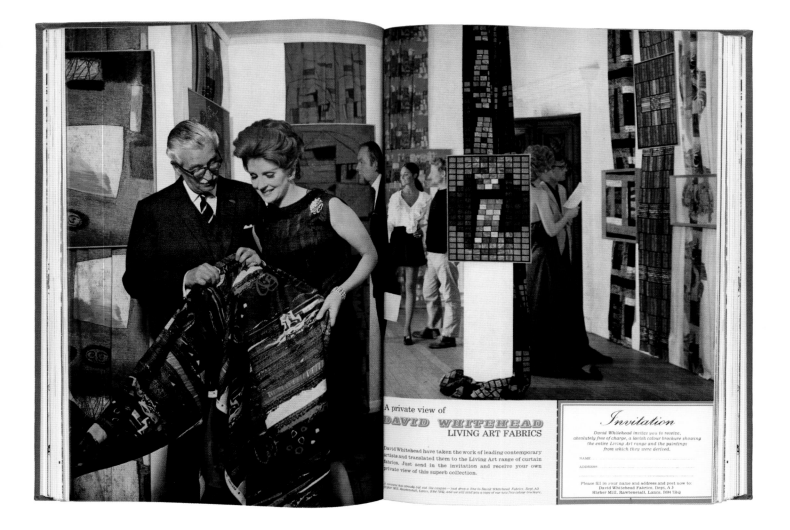

A private view of

DAVID WHITEHEAD
LIVING ART FABRICS

David Whitehead have taken the work of leading contemporary
artists and translated them to the Living Art range of curtain
fabrics. Just send in the invitation and receive your own
private view of this superb collection.

Invitation

David Whitehead invites you to receive,
absolutely free of charge, a lavish colour brochure showing
the entire Living Art range and the paintings
from which they were derived.

NAME

ADDRESS

Please fill in your name and address and post now to:
David Whitehead Fabrics, Dept. A J
Higher Mill, Rawtenstall, Lancs. BB4 7RQ

1970, no.8
David Whitehead's *Living Art Fabrics* exhibition featured work by artists
such as John Pakenham, George Campbell and John Piper.

Opposite: 'Furnishings in Motion'
1970, no.1
This feature omits the designer's names.

Overleaf; left: 'Light on New Furnishings' **1955, no.1**;
Right: **1970, no.10**
A full-page 1955 editorial spread on Tibor woven cottons, left, most
probably styled by Jay, seems to be the inspiration for a 1970 photograph
of Moygashal contract prints, right, showing one design by Margit Steiner
followed by others by Arno Thoner. The key difference is that the latter is
but one-tenth the size of the former.

designers, but only for a time. (Lost too was the credibility the
magazine in its heyday had lent to its advertisers, who most
consistently were Heal's and Whitehead's, both young firms in
search of overseas markets.)[55] Whitehead's *Living Art Fabrics* of
1969 was the final expression of director Tom Mellor's complete
accord with the concept of 'painting into textiles' proposed by
the Style Centre and that had been transported across the world
by Juda's magazine; in 1970 the Whitehead Group was taken
over by Lonrho and the introduction of new fabrics ceased.

By then the naming of designers was rare in the pages of the
magazine. In the same year the Textile Centre was opened in
London by the Textile Council, a statutory body established
in 1967 to centralize and unify export drives across the diverse
British textile industry and 'help it to face future conditions
competitively' (including the still-vexing question regarding
whether or not the UK would enter the EEC). Absorbing the
Style Centre's design library (and causing the closure of the
Cotton Board's exhibition centre in Manchester in 1969), it
was introduced with some fanfare in *The Ambassador* but was
not successful, foreseeing its own demise in the government
reviews that made clear 'that in one form or another there will
be many more mergers and further groupings in the British
textile industry'.[56] The bold graphic and editorial approach
associated with Juda's tenure gradually faded away, and with
it the focus on fabrics and designers, and the up-beat point of
view.[57] What remained was a legacy of collaborations with the
Cotton Board's Style Centre, notably the creation of the 'Brit
Week' concept, which still provides a focal point for overseas
in-store and Design Centre shows, and the propulsion of many
young British designers to global fame. Its adventurous visual
style also altered forever the presentation of furnishing textiles,
whether in showrooms, at trade fairs or in photographs.

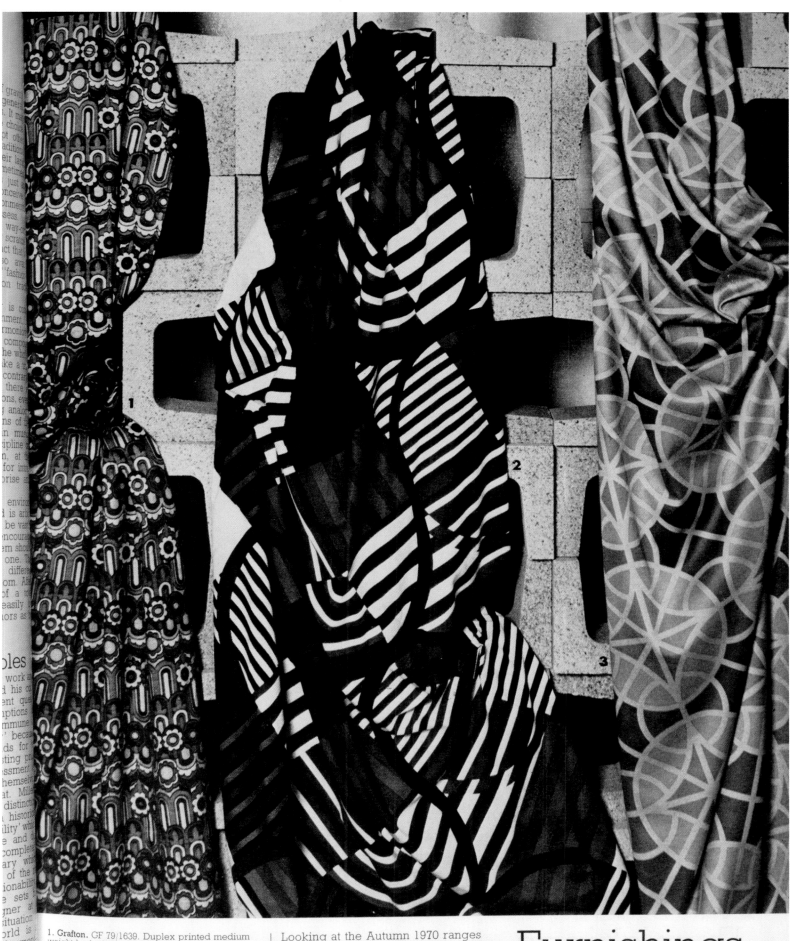

1. **Grafton.** GF 79/1639. Duplex printed medium weight bark cloth with the Calpreta fully shrunk finish. Interesting Art Déco design interspersed with flowers in tones of yellow and gold. Cepea Furnishings—English Calico Ltd. (Household Division), 56 Oxford Street, Manchester.

2. **Moldova.** Bold abstract design in purple, blue, black and claret on white ground in pure cotton with shrink resistant finish. McKinnon & Jenkins Ltd., Textra (International) Ltd., 15/16 Newman Street, London W1.

3. **Louisiana.** Inter-relating circles form geometric shapes in gold, orange and red in pure cotton. Bernard Wardle Fabrics, Chinley, Stockport, Cheshire.

Looking at the Autumn 1970 ranges from leading furnishing fabric manufacturers, it is interesting to see that the current Art Déco inspired designs—sweeping through from printed dress fabrics to tweeds—have hit this section of the industry. We have chosen several of these '30's prints and mixed them with a host of exciting florals, graphic reliefs, semi-traditional patterns and sheers as well as heavy brocades and surface relief textures for upholstery.

Furnishings in Motion

continued

PHOTOS BY HEPHER

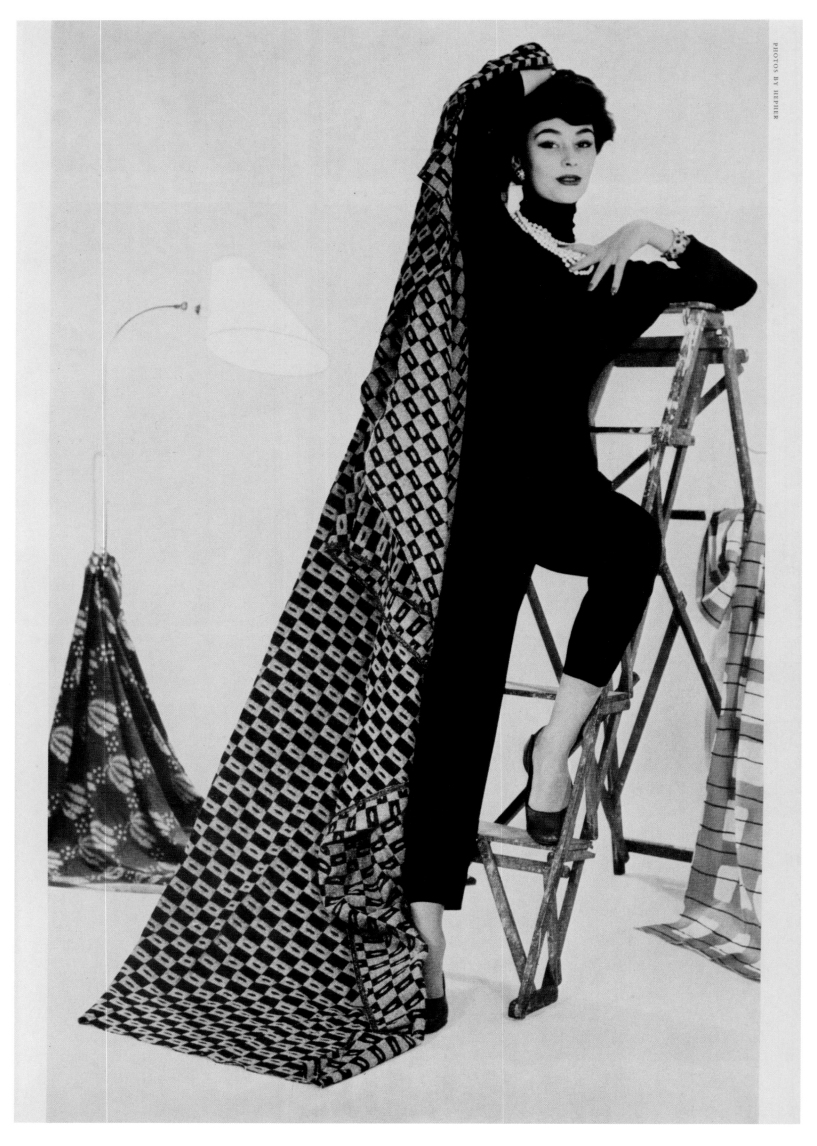

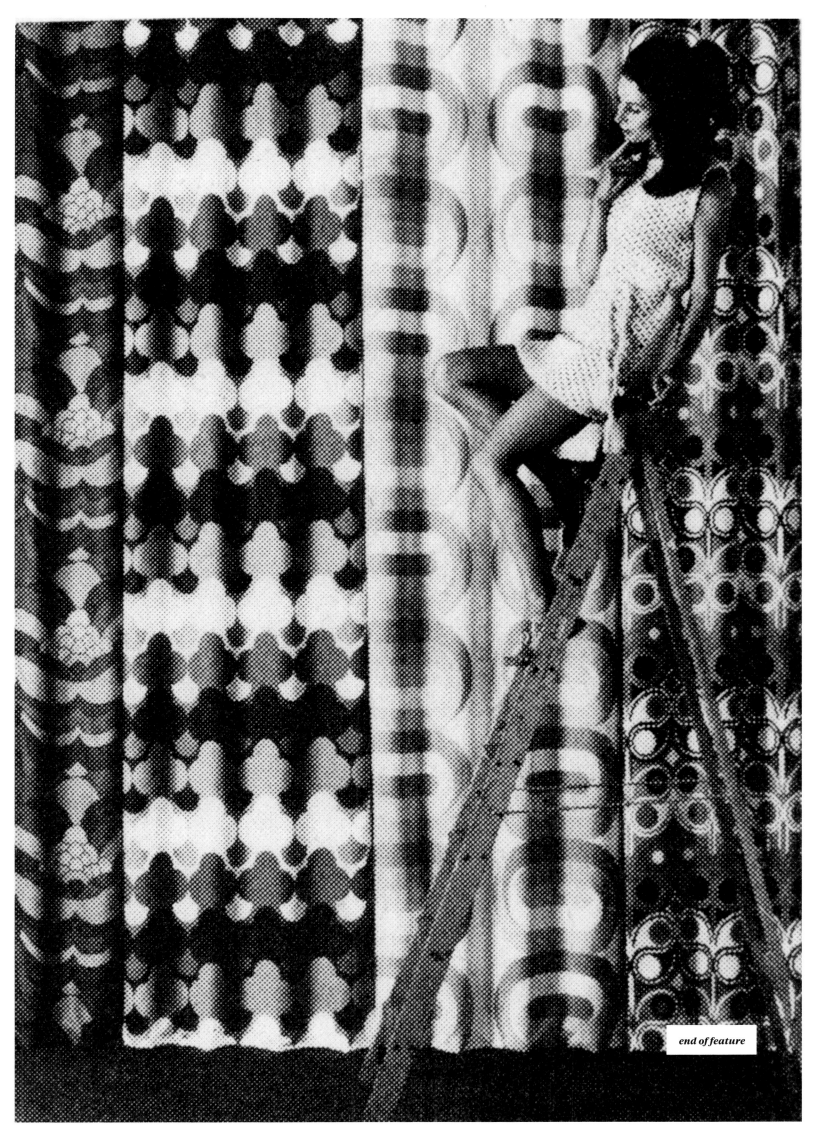

end of feature

On Friday evening when they arrive
from town, Geoff is wearing
a short tweed overcoat in proofed
West of England tweed from
Aquascutum Ltd., London, W.1.
His grey felt hat is from
Battersby & Co. Ltd., London, E.C.1.
Super cape gloves with pure silk lining
from Taunton & Thorne Ltd., Montacute,
Somerset.
Shelagh wears a "Harella" camelhair coat
from L. Harris Ltd., London, E.C.1.
Her suede hat with button-on brim
in wool ribbing is
from Agmar (Hats) Ltd., London, W.2.
Her super cape—suede gloves
with pure silk lining are also
from Taunton & Thorne Ltd.
Shelagh's handbag and all their luggage
is from C. Greatrex & Son Ltd., Walsall.

Recovering from their long drive, we find
Geoff in a three-piece lounge suit in
Scotch tweed (from Reid & Taylor Ltd., Langholm)
tailored by Sumrie (Export) Ltd., London, W.1.
His "Rocola" shirt is
from R. H. & S. Rogers Ltd., London, E.C.1.
Shelagh's "Braemar" twinset in lilac cashmere
with black scalloped edge is
from Innes, Henderson & Co. Ltd., Hawick, Scotland.
Her "Harella" skirt is in red gabardine
(from Salts (Saltaire) Ltd., Saltaire).

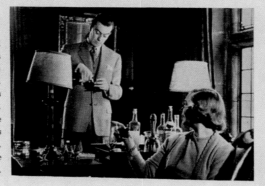

For Friday night's informal dinner Geoff wears a plum velvet smoking jacket
from Simpsons (Piccadilly) Ltd., London, W.1.
Evening trousers made to measure by Hector Powe Ltd., London, W.1.
and a "Radiac" evening shirt from McIntyre, Hogg, Marsh & Co. Ltd., London, E.C.2.
Shelagh's cashmere evening sweater is from Robert Pringle & Son Ltd., Hawick,
and her pleated taffeta evening skirt from Ian Meredith Ltd., London, W.1.

SATURDAY

Well protected for their rainy morning's shopping!
Geoff in a fawn Garbardine raincoat
from Dannimac Ltd., Manchester, 3,
and a brown "Country Mixture" hat
from Battersby & Co. Ltd.
Shelagh in a silver grey
Rubberized satin mackintosh
and matching cap from
Alligator Rainwear (Export) Ltd., Manchester, 3.

To kiss Shelagh good morning
Geoff wears a camel dressing gown
from Jaeger Co. Ltd., London, E.C.1.
Shelagh in a
pink chiffon bed jacket and matching nightie
from D. W. Davies Ltd., London, W.1.

Photos by Jay

Then it cleared up, so, for golf, Shelagh wears
a blue cashmere twinset from Barrie & Kersel, Hawick, Scotland,
and a "Festival" skirt from Gor-ray Ltd., London, W.1.
Geoff dons a reversible windbreaker
of Egyptian cotton poplin,
and "Dunlop Gabardine" sports trousers,
both from Dunlop Clothing & Weatherproofs Ltd., London, N.18.

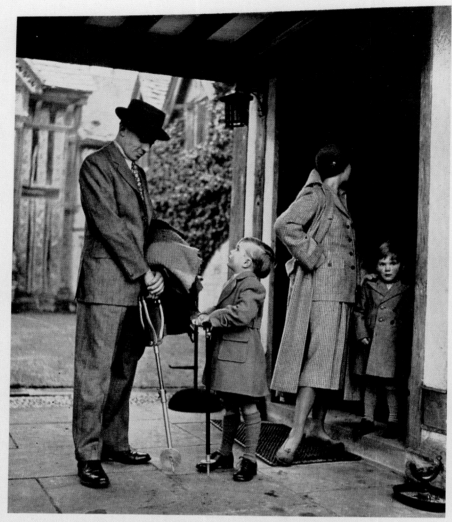

Starting off after lunch for a
point-to-point with the children,
Geoff wears a two piece country suit
in Scotch tweed (from R. B. Neil & Sons Ltd., Langholm)
made by Sumrie (Export) Ltd.;
Shelagh wears a "Stolas Tweedcraft" model,
consisting of a suit and matching topcoat
in natural 100% Shetland tweed,
from Euan Douglas & Co. Ltd., London and Edinburgh.
Her suede and wool hat
from Agmar (Hats) Ltd.
Simon and Shaun's "Minimode" tweed coats
with velvet collars are
from Sydney Benskin & Co. Ltd., London, N.19.

Bedtime story for the boys
is read by Geoff in a long sleeved
pure cashmere cardigan from Barrie & Kersel,
while Shelagh looks on in
a grey flannel dress with a yellow suede belt
from W. & O. Marcus Ltd., London, W.1.
The boys' yellow sweaters
are hand knitted in wool
from J. & W. Bastard Ltd., Leicester.

SATURDAY

Shelagh wears an evening dress with
a full white grosgrain skirt,
black velvet strapless bodice and fringed stole
from Susan Small Ltd., London, W.1.
Geoff sips his brandy
in a dinner jacket tailored by Hector Powe Ltd., London, W.1,
his "Radiac" evening shirt is
from McIntyre, Hogg, Marsh & Co. Ltd.

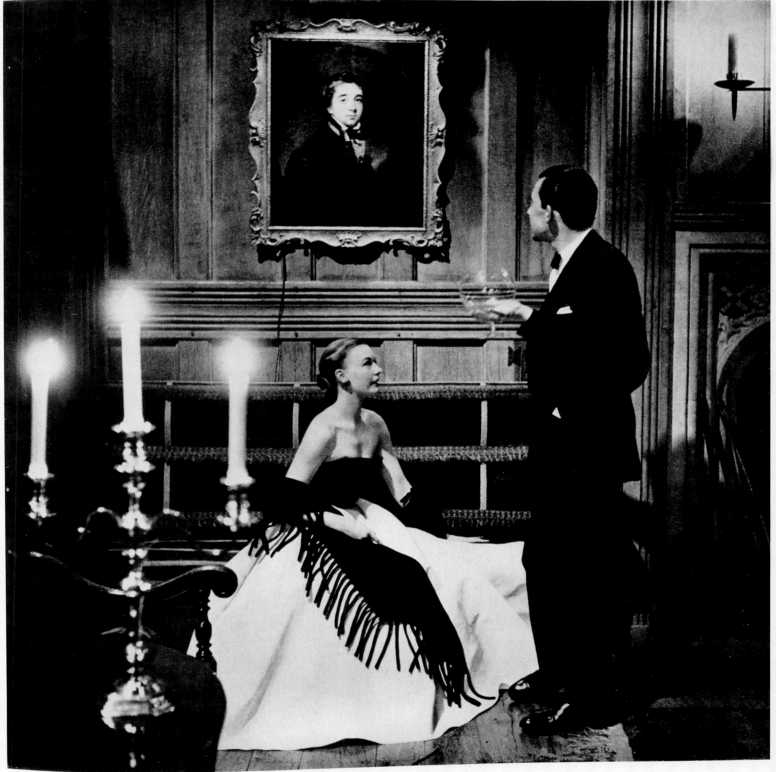

Photos by Jay

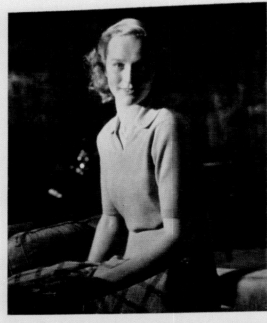

Jacqueline, who lives next door, wears,
for a neighbourly call, a green cashmere
"Braemar" sweater with
open neck and turn down collar.

To inspect the farm, Shelagh
dons a green reefer jacket (corduroy
from Nathaniel Williams & Co., London, W.1.)
from Charleon of Grosvenor Street, London, W.1.
Holland & Lewis (Ladies Fabrics) Ltd.,
London, W.1, supplied the beige wool with
a brown overcheck for her skirt
from Ian Meredith Ltd., London, W.1.
The calf seems interested in Geoff's
medium weight tweed sports jacket
in houndstooth design
and sports trousers, both
from Dunlop Clothing & Weatherproofs Ltd.

After lunch the whole family
go to the Children's Service.
Geoff in a fine overcheck "Londonus" suit
from Louis London & Sons, London, E.1.
Shelagh's grey wool jersey suit is
from Bery Ltd., London, W.1.
Her wooden hat from Agmar (Hats) Ltd.
Her Hitchin gloves are in cotton
from Frymann & Fletcher, Ltd., Nottingham.

In the evening neighbours come in to drinks.
For this
Shelagh wears a navy rayon
halter necked dress
(which has a matching jacket)
from Linzi (Exports) Ltd., London, W.1.
while Geoff wears his
three piece lounge suit
from Sumrie (Export) Ltd.

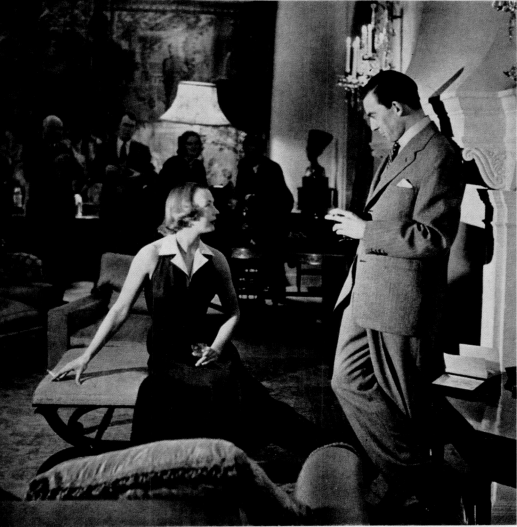

Photos by Jay

After Church, Geoff cleans
his gun in a camel
and lambswool sleeveless
cardigan from
Turner, Rutherford & Co. Ltd., Hawick, Scotland,
over a sports shirt
from McIntyre, Hogg, Marsh & Co. Ltd.,
and "Dunlop Gabardine" sports trousers.

All Geoff's ties
and both his and Shelagh's scarves
are from Michelsons Ltd., London, E.C.2.
Shelagh's belts are from
the Cromwell Manufacturing Co. Ltd., London, W.1.

When all the guests
have gone they fix
themselves some supper
in the kitchen,
Shelagh in an everglaze chintz
dress in blue and white print
from Loroco Ltd., London, W.1.
Geoff's green sports shirt
is from
McIntyre, Hogg, Marsh & Co. Ltd.

. . . and sorry to say it's Sunday night.

Fashion and *The Ambassador*: 'The World is the Customer of Fashion'

Claire Wilcox

International Textiles
1942, no.4
Sketches by Ett

AS 'THE BRITISH EXPORT JOURNAL FOR TEXTILES AND fashions', *The Ambassador* enthusiastically promoted fashion in all its manifestations, from the latest London collections to traditional British products such as Harris tweeds and Irish linens. *The Ambassador* was unique among trade magazines. It was not exclusively a fashion magazine, and fashion was rarely depicted on the front cover. Yet, with its heavy glossy pages and quality colour reproduction, the magazine had the 'feel' of fashion, its tactile qualities enhanced by the samples of fabric affixed to the lavish advertisements that filled the magazine's pages. Sophisticated fashion sketches by the in-house artist Trudie Ettinger ('Ett') often printed on matt inserts resembling watercolour paper, quirky fashion shoots by Elsbeth Juda and an innovative typographical approach set *The Ambassador* apart. As Elsbeth recalled, 'it was unusual for a trade paper to have an independent editorial policy and it was unusual for a trade paper to apply a kind of aesthetic standard.'[1]

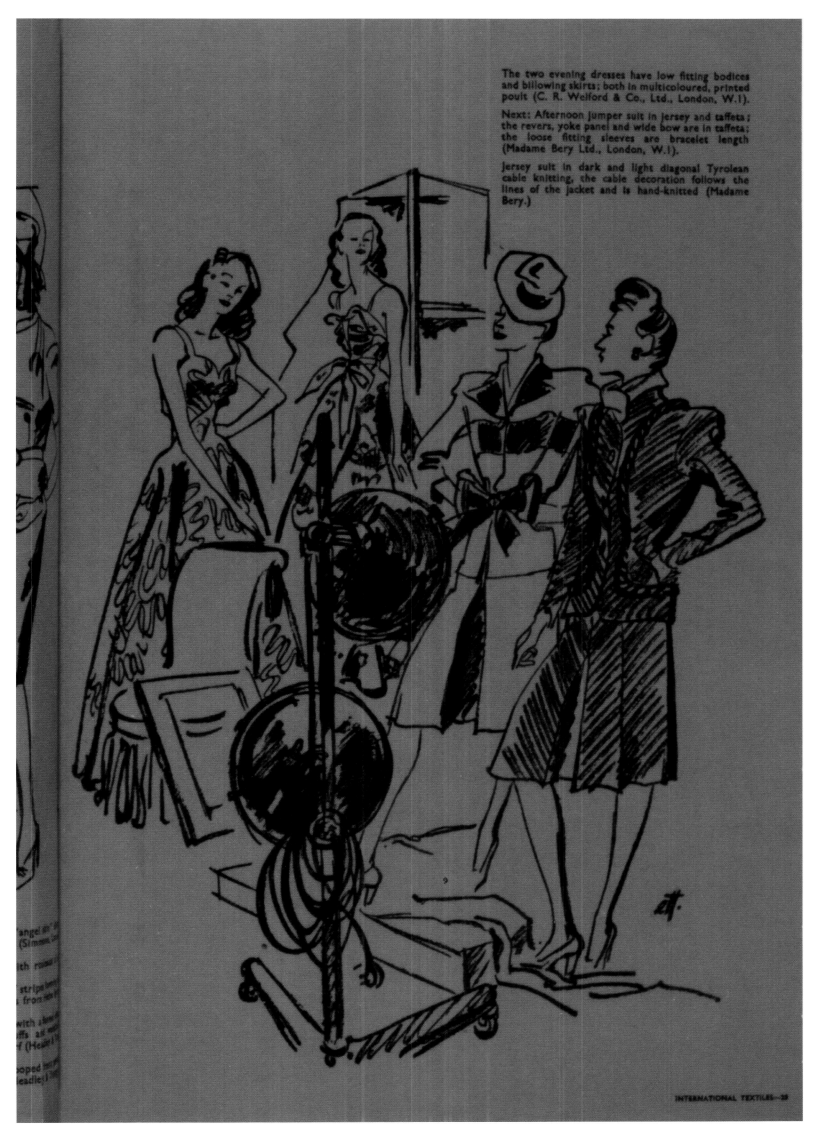

The two evening dresses have low fitting bodices and billowing skirts; both in multicoloured, printed poult (C. R. Welford & Co., Ltd., London, W.1).

Next: Afternoon jumper suit in jersey and taffeta; the revers, yoke panel and wide bow are in taffeta; the loose fitting sleeves are bracelet length (Madame Bery Ltd., London, W.1).

Jersey suit in dark and light diagonal Tyrolean cable knitting, the cable decoration follows the lines of the jacket and is hand-knitted (Madame Bery.)

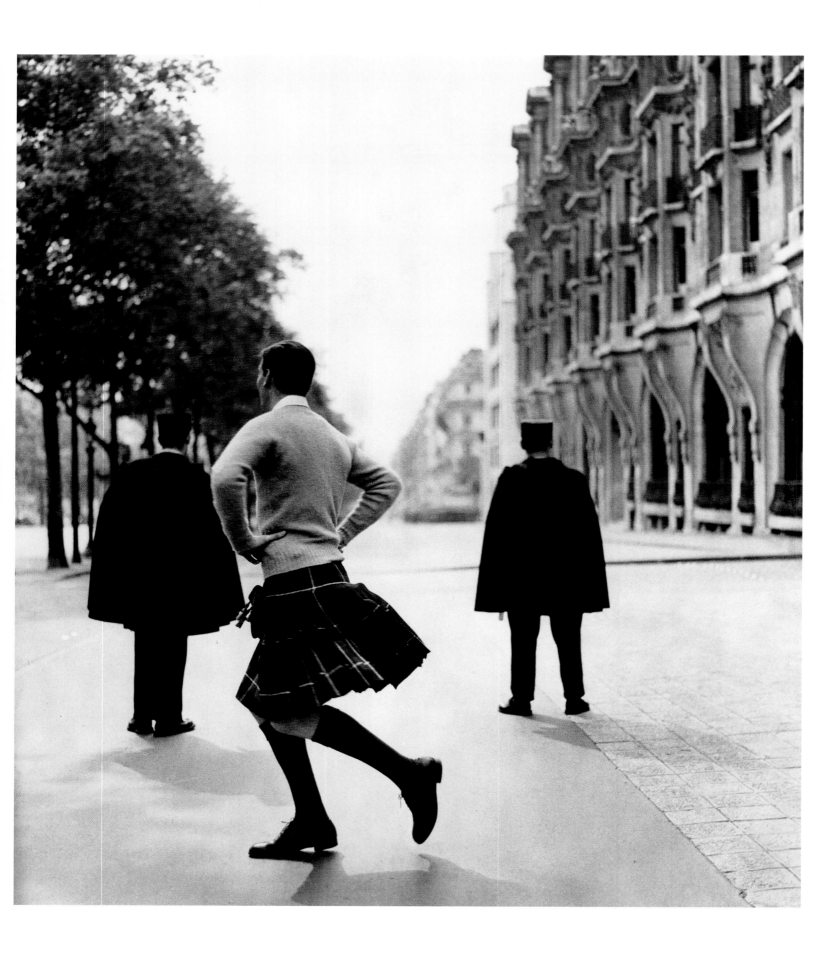

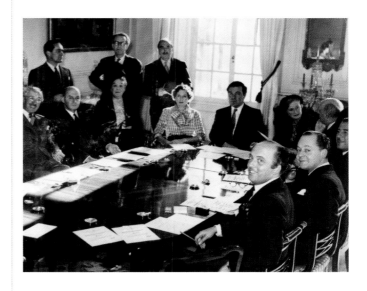

Members of INCSOC, October 1949
V&A Archives

Opposite: 'Vive L'Ecosse'
1957, no. 8

The *Ambassador*'s innovative approach was driven by Hans Juda's global vision, for world trade was his passion. The pages of the magazine typically included coverage of the Paris haute couture, supplements on British textiles and fashion, 'Thinking Ahead' features and regular articles on historical fashions by V&A curator James Laver. Astute editorials by Hans, and detailed financial updates on the status of the textile export markets provided ballast. One of the particular challenges for *The Ambassador* (as for fashion magazines such as *Vogue*) was to present familiar merchandise, much of which varied little from season to season, in a fresh light. The key to the magazine's success in achieving this was Elsbeth Juda's approach to photography for, as the photography critic Francis Hodgson observed, 'the essence of her style was to take the products to be promoted . . . out into the world and there to heap glamour upon them'.[2] This principle was applied to categories as diverse as knitwear, accessories, leisure wear and tartan kilts, the last memorably photographed by Jay on the streets of the Champs Elysées.

THE ECONOMICS OF FASHION

The Ambassador was built upon a network of relationships within the industry, from suppliers to advertisers, retailers and, importantly, its global subscribers. The magazine was committed to improving and modernizing the British textile and fashion industry and, to that end, the Judas acted not only as publishers and commentators, but took on a more strategic, advisory role, providing promotional material and brokering relationships between wholesalers and retail outlets in Europe, Australia, New Zealand, Japan and the USA. While advertising and editorial were clearly differentiated, the Judas introduced promotional merchandise features, which benefited from their insistence on quality of design and presentation. One of the magazine's most effective tools to promote British design abroad were the 'British Weeks' and 'British Fortnights', the first of which took place in conjunction

with the leading New York department store Lord & Taylor and subsequently with stores all over the world.

The Ambassador maintained a close relationship with both the Board of Trade, which supported the magazine during the Second World War, and the Cotton Board, which was established in 1940 for the purpose of 'performing, with a view generally to the benefit of the industry and in particular to the maintenance and extension of export trade therein, and advising on questions relating to the industry which may be referred to them by any Government Department'.[3] In January 1942 *International Textiles* celebrated the opening of the Cotton Board's Colour, Design and Style Centre in Manchester in an editorial entitled 'For Happier Days To Come'. Despite the fact that exports were officially rationed because of the war, the Centre's activities – which included exhibitions of fashion – were intended to promote Lancashire cotton cloths and help in planning for post-war trade.

The year 1942 was a crucial one for fashion. The launch of the Centre coincided with the instigation of the Board of Trade's Utility Scheme for clothing and textiles, devised to ensure a uniformity of quality clothing for the population nation wide, with prototypes designed by members of the recently formed Incorporated Society of London Fashion Designers (INCSOC). Sir Thomas Barlow, Director of Civilian Clothing, explained: 'The basis of the Government's programme is to produce and create a range of goods in various materials, in cotton, rayon and wool, which will conform to certain specifications the experts consider sound, and which have a maximum selling price . . . there is now an exceptional opportunity for work on textiles and clothing on a mass basis, on a scale not previously possible'.[4]

Christian Dior
La ligne corolle
Jaquette cintrée en shantung,
jupe longue finement plissée.

Left: Utility day dress, possibly Edward Molyneux, 1942
V&A: T.57–1942

Right: 'Bar' suit by Christian Dior
Vogue (French edition) May/June 1947
Illustration by Christian Bérard
© ADAGP, Paris and DACS, London 2011

Opposite: right: Suit, Hardy Amies, 1947
V&A: T.38–1966

Overleaf: 'London Haute Couture'
1948, no. 2

The notion of mass production caused some anxiety amongst quality-conscious textile manufacturers. The Chairman of the Fine Cotton Spinners' and Doublers' Association Ltd was quoted by *The Ambassador* as declaring: 'The decisive factor in our export trade must be not price, but quality. That's how we got the trade, and that is how we shall keep it.'[5] The tension between bespoke and ready-to-wear fashion remained a topic of importance throughout *The Ambassador*'s duration. The clothing industry was one of the last to be fully mechanised, in part due to the challenges of sizing; however, innovations in the USA and new production models introduced by the Utility scheme helped to pave the way for a more efficient means of manufacture and distribution. While many figures in the industry agreed that ready-to-wear was the future of British fashion, equally, the role of the creative designer could not be ignored, for as the journalist and government adviser Madge Garland wrote, 'The more mass production there is – the more often a model is copied – the more important is the original design and the more significant the role of the designer.'[6]

The French haute couture system provided a model of excellence that was emulated in London. Paris was regarded as the originator of style, with top fashion houses such as Balenciaga and Balmain influencing fashion world-wide.

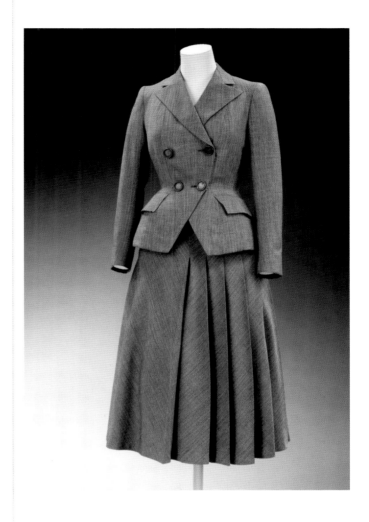

While the essence of the couture trade was based on the creation of exquisite hand-made garments for wealthy clients, the sale of ideas in the form of patterns and sketches based on the latest couture styles to the 'making-up' or wholesale trade was increasingly lucrative. During the war, *International Textiles* was not alone in expressing the hope that the German occupation of Paris would challenge France's dominance of the global fashion industry. However, Christian Dior's 'New Look', launched in February 1947, dashed this completely. As Bettina Ballard, American *Vogue*'s fashion editor wrote, 'We were witnesses to a revolution in fashion'.[7] This triumph for Paris immediately rendered practical wartime styles out of fashion (it was said that during Dior's fashion show, journalists and buyers were tugging on their skirts to make them seem longer). The London couturier John Cavanagh described Dior's vision as 'a total glorification of the female form'.[8]

Fearing that the new fashion would render existing Utility stocks un-saleable, or create demands on the textile industry when most fabric was needed for export, the government stepped in. The British journalist Alison Settle recalled: 'We were forbidden by the Board of Trade to mention his styles in case they engendered a desire for more fabrics, pretty styles, some trace of elegance. Dior's "New Look" was supposed to be completely unknown in Britain.'[9] However, by 1948 *The Ambassador* reported that the London haute couture collections featured 'tiny waists, skin-tight bodices, normal shoulders, narrow sleeves top the swirl or ballerina skirt . . . hips are still emphasized, often by clever pleating or by minimizing the waist'. The feature included elegant sketches by 'Ett' of designs by Victor Stiebel, Charles Creed, Bianca Mosca, Peter Russell, Digby Morton and Hardy Amies (all members of INCSOC) and was copiously illustrated with colourful printed cottons and smooth, light-weight woollens, ideally suited to shape the crisp lines of New Look tailoring.[10]

Dior's success revived French haute couture, and generated world-wide publicity for his fashions; it equally helped to renew Paris's dominance of the ready-to-wear industry. By 1948 Dior had opened premises in New York to produce wholesale versions of his designs for the American ready-to-wear market and the London couturiers were quick to follow with collections specifically designed for the international markets. The increased fabric required for Dior-esque full skirts was a great boon to the textile trade. However, despite this stimulus, Britain's industrial infrastructure was disappointingly slow to recover. *The Ambassador*'s August 1948 editorial 'The Better New Look' cited Paul Hoffman,

Three pure silk prints specially designed by Arnold Lever for Jacqmar,
London, W.1. The 15/16 oz. woollen bouclé coating is also a
Jacqmar material, used by Victor Stiebel

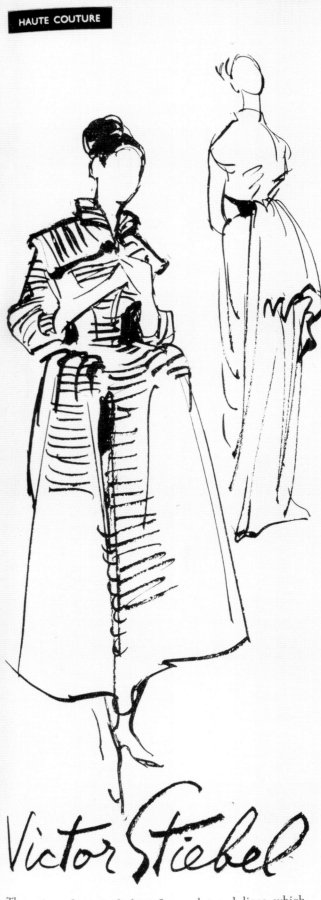

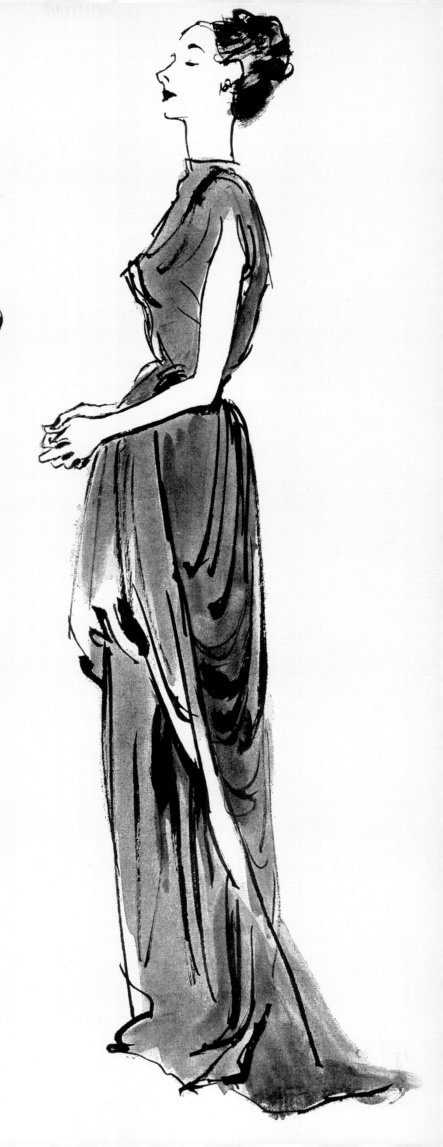

Victor Stiebel

There is a distinct feeling for sculptured lines which reveals itself in the moulded, skin-tight bodices that top all Victor Stiebel's skirts. His very full-skirted print dresses are worn under basque jackets made in the same material. Skirts are hippy—whether pleated or plain. Ingenious use is made of two skirts to create a new fulness and introduce a " Milkmaid " line.

the US administrator of the Marshall Plan, a financial aid programme to support the regeneration of Europe between 1948 and 1952. 'The goal of European recovery cannot be brought about by old ways of doing business or old conceptions of how a nation's interests are best served. New patterns of intra-European trade and exchange must be found and new directions in the use of European resources.'[11]

Hans Juda could not agree more. Going on to describe the 'failure of our mission to Paris' following a visit to the haute couture collections he wrote:

We inspected thousands of models during those openings without discovering any British materials. We were told by everybody concerned that he or she would have loved to buy and use British fabrics. We remembered the London Couture shows, where French prints had been lavishly displayed only a few weeks earlier. Then we discovered the list of 'token exports' of British goods to France which contained anything from disinfectant products, mustard, Christmas cards to canned soups – but no woollen textiles . . . And we have the horrifying suspicion (and inside information . . .) that the amount of imports of British woollens and worsteds into France will be hardly more than what one or two British firms alone used to export to France in better days![12]

Hans's frustration at delays in getting UK fabric manufacturers mobilized was shared by Elsbeth, who became increasingly involved in brokering relationships between buyers and manufacturers after the war, 'knowing what was required

from a customer's point of view which you could then communicate to designers . . . I found it terribly frustrating because it was a lot of work, of course, and a lot of fine detail and a lot of imagination needed in order to see the slight difference and care enough to make it work'. One of her self-appointed functions was to visit every manufacturer at least once a year 'two weeks to Manchester, two weeks to Yorkshire, two weeks to Scotland':

I was very concerned with styling . . . I remember going to a firm . . . I said show me the whole range, they said they were doing so badly and I worked, I took the range away. I took samples of 200, 300 fabrics and . . . made a range for shirts, women's shirts, men's shirts, because it was a wonderful product and just by varying the colour and making a colour range, this was another thing British manufacturers did not like to do!

Elsbeth took the range to Susan Small, a successful ready-to-wear company (that regularly purchased the rights to reproduce Dior designs) which placed an order. To her disappointment the fabric company decided it was 'too much trouble, they were shutting down and that was it'.[13]

THE PHOTOGRAPHER'S VISION

Elsbeth's role on *The Ambassador* was complex. A one-woman powerhouse, she progressed from doing interviews with master tailors in the early years, despite not knowing what a lapel or turn-up meant (see page 22), to becoming assistant editor and resident photographer.

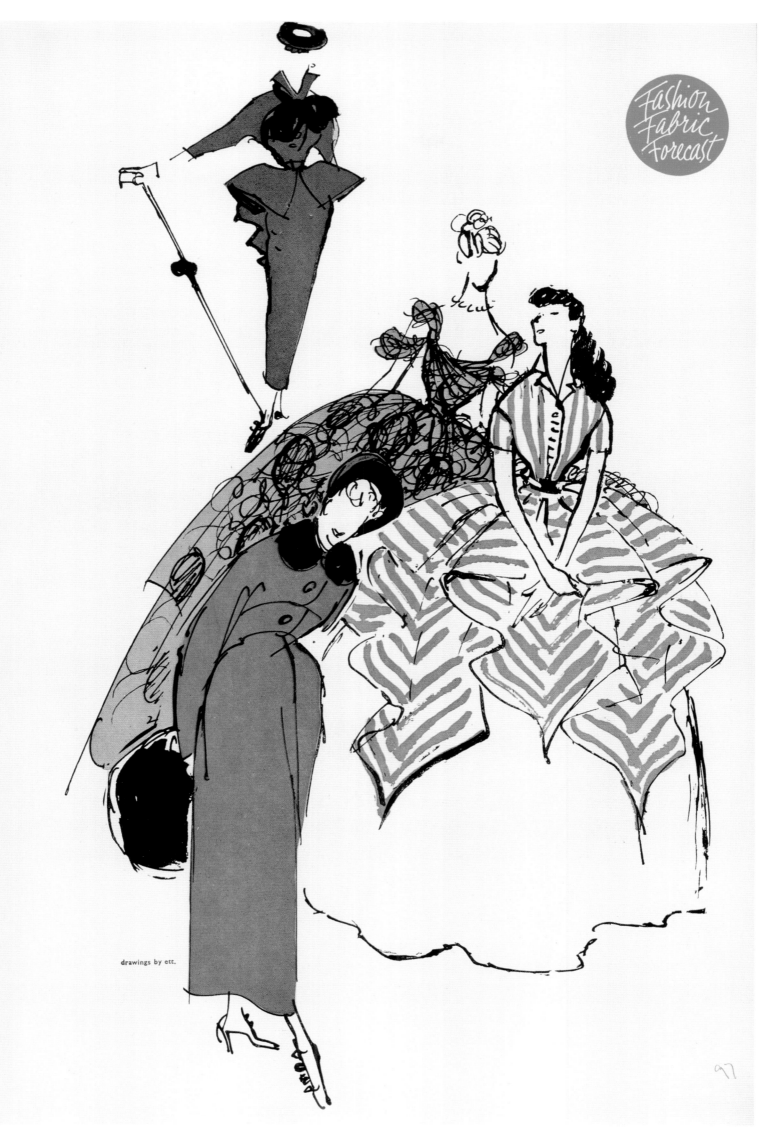

drawings by ett.

'A Model Photographer'
1951, No.5
AAD/1987/1/97/1–27

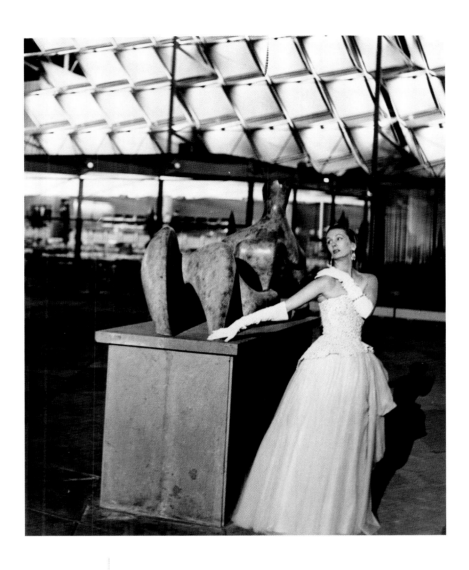

Immediately after the war Elsbeth travelled to New York where she met the photographers Irving Penn and Richard Avedon, and Carmel Snow, the editor of *Harper's Bazaar*. Snow told Elsbeth that as long as she chose the accessories and location carefully, she could photograph anything. Taking this to heart, in the next two decades she masterminded a series of extraordinary fashion shoots, many on location, and arguably invented the role of 'stylist'. Elsbeth photographed fashions amongst the abandoned lots of the Olympic Stadium at White City in 1948, tartans amongst the castles and coastlines of Scotland and cashmeres in Italy, where the biggest markets lay. She persuaded the photographer Norman Parkinson to model the latest men's fashions in his home, snapped rowdy Cambridge students in their halls wearing tweeds and ties, and posed the leading model Barbara Goalen in Norman Hartnell evening dresses balancing on the walls of the Embankment, amongst the Henry Moore sculptures at the 1951 Festival of Britain and even at 10 Palace Gate, the Judas' own art-filled flat (see page 188).

In 1949 Hans Juda decided that the first Sadler's Wells Ballet tour to America and Canada would be an opportunity to launch an export promotion 'presenting the Ballerinas and the Corps de Ballet as Ambassadresses of British Fashion' (see also pages 54–7).[14]

'Festival Nights'
1951, no. 7
AAD/1987/1/98/1–29

Opposite: 'Style and Scholarship'
1952, no. 8

Overleaf: 'Festival Nights'
1951, no. 7
The image on the left was not reproduced in the magazine.
AAD/1987/1/98/19

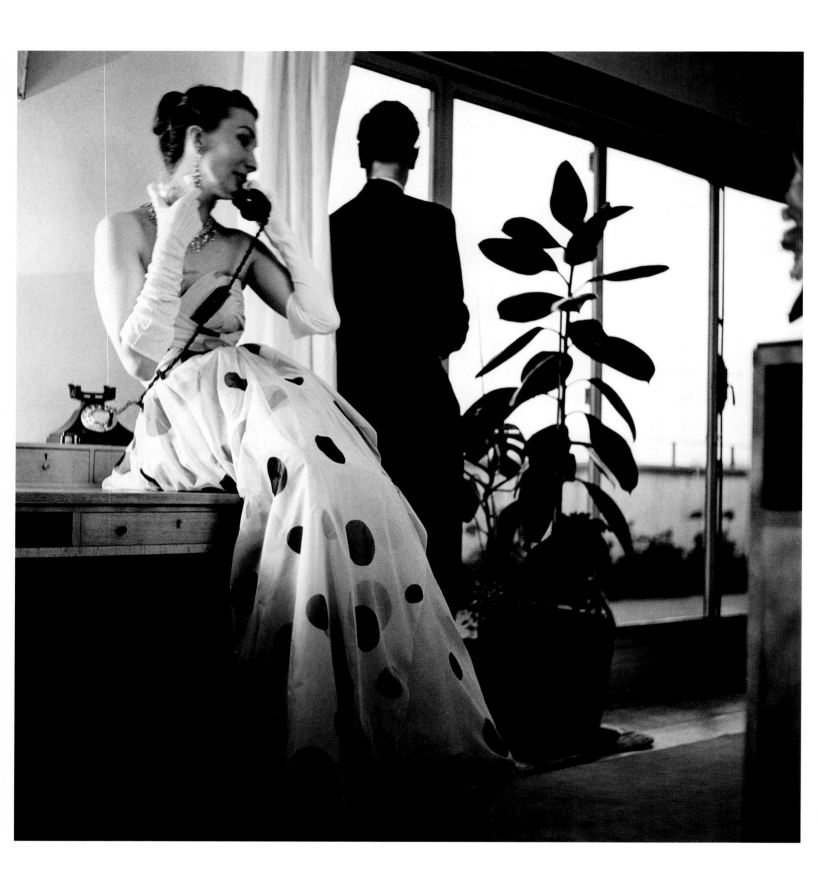

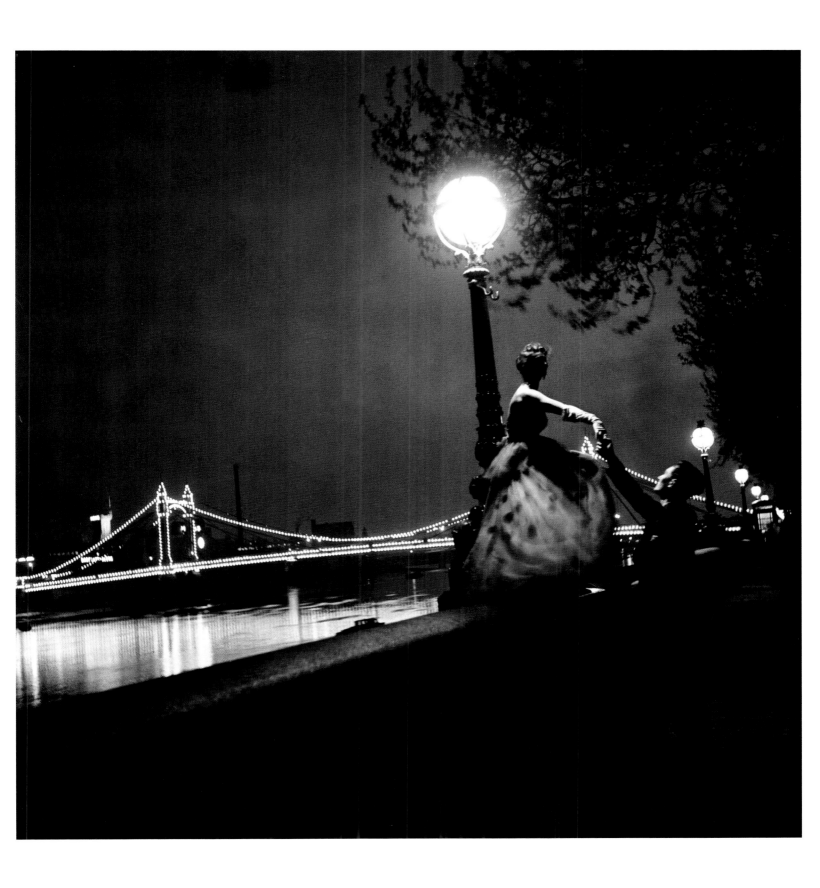

'London Fashions for the English Ballet'
1949, no. 10

Overleaf: 'London Fashions for the English Ballet'
1949, no. 10

Elsbeth recalled:

we sponsored the off-stage wardrobe of these wonderful dancers. We were obviously in love with the wonderful ballet and the people who danced were fabulous artistes . . . my husband had the idea that they should all be kitted out by British industry and we would produce an editorial feature which would then enable American stores right across the USA to use it as a mailing piece to their customers, as a basis for window displays and general British promotion, and it worked quite well.[15]

The idea was in fact inspired. Deftly bringing together many of Hans's passions – world trade, travel and culture, the project was featured over three consecutive issues, while the tour received an enormous amount of press coverage.

'London Fashions for the English Ballet' was launched with a special issue designed to resemble a theatre programme which introduced 'The Cast', 'The Fabrics' and 'The Clothes', followed by listings of suppliers of hats, gloves, handkerchiefs, sweaters, umbrellas, shoes, stockings, blouses and leather goods, all of which were supplied gratis to the dancers. Sixteen pages of coverage of textiles followed, with sketches by Ett. 'Smooth, smooth suitings, competent and exuberant checked woollens, quietly elegant worsteds, glamorous silks . . . we feature these fabrics, chosen to go to America and Canada with the English ballet as being representative of the textile Britain is famed for.' Importantly, *The Ambassador* reminded

its readers: 'The Ballet wears the fashion in the fabric, the fabric in the fashion.'

The promotion included both the work of the London couturiers and 'off-the-peg' fashions and 'off-the-counter' textiles. The idea of creating a realistic wardrobe for the young ballerinas was practical, because there would be no need for couture fittings, and inclusive, drawing on a large range of manufacturers with which *The Ambassador* had professional links. The wardrobe also suited the dancers who, although young and graceful, were not professional models; as the magazine explained, 'We present them not as an official shop window specially dressed for an export drive'. Instead, the clothes the girls wore 'are those they might have chosen and bought for themselves for a trip such as this'.[16]

The sheer number of photographs Elsbeth took for the Sadler's Wells features, single-handed, is impressive, and is reflected in the pages of thumbnail shots that anticipate today's fashion 'look books'. Colourful charts like those used by couture houses to plan their catwalk shows reflect the complexity of the undertaking and reflect with fascinating precision London's fashion landscape of the time. Each column recorded in forensic detail the names of the dancer, cloth manufacturer, textile, model house, and supplier of hat, bag, gloves and shoes. The final photo shoot before the company's departure took place at London Airport. Air travel in the immediate post-war period was glamorous and modern, and none of the company had flown before. Standing in a row before a gleaming plane, the dancers seem as if about to take their bows (see pages 210–11).

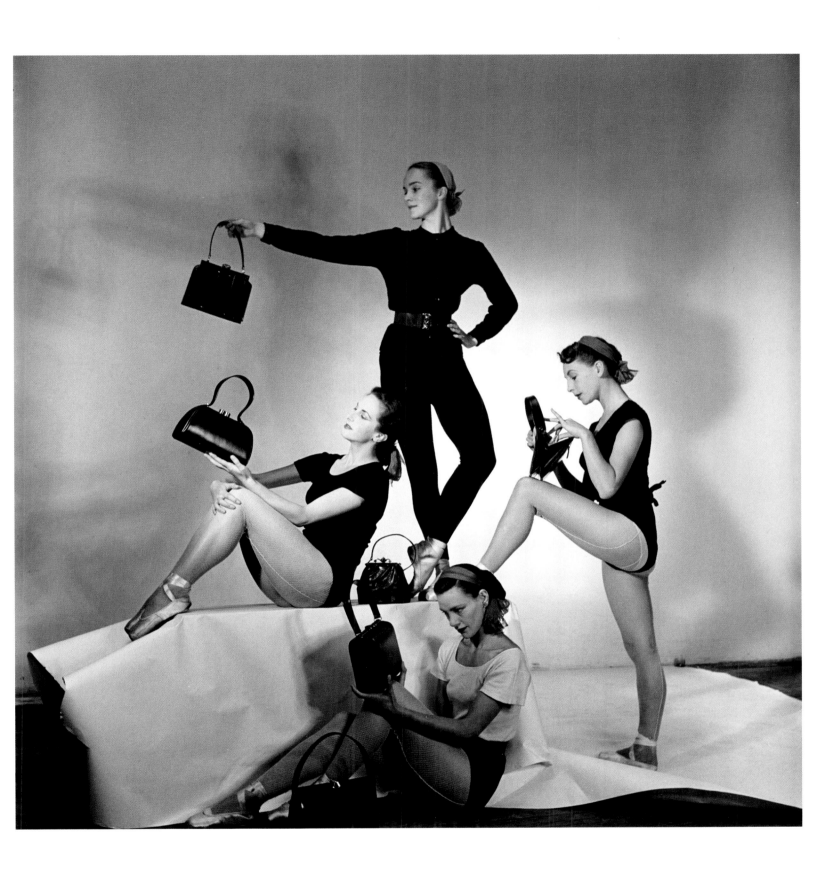

NAME	CLOTH MANUFACTURER	PATTERN	MODEL HOUSE	HAT	BAGS GLOVES SHOES
Margot Fonteyn	WEST CUMBERLAND SILK MILLS		BIANCA MOSCA	6to Lucas	Kenneth Rouse, Bentwoss, lilley & Skinner
Moira Shearer			DIGBY MORTON	Radoep	Kenneth Ruster, lilley and Skinner
Pamela May	WEST CUMBERLAND		WORTH	Worth	Kenneth Rouse, lilley & Skinner
Beryl Grey	GARDINER OF SELKIRK		HARTNELL	torker	morley's, lilley & Skinner
Nadia Shin			Starke	Hugh Beresford	morleys, lilley & Skinner
June Brae	A.C. KAY		LOUIS LEVY	6to Lucas	morleys, lilley & Skinner
Pauline Clayden	WEST CUMBERLAND		SUSAN SMALL	THAARUP	"
Margaret Dale	MANCHESTER VELVET CO.		JULIAN ROSE	MHp Lansing	Mary Bagcraft, morley, lilley & Skinner
Christian du Boulay	PETER McARTHUR TARTAN		DORVILLE	Hugh Beresford	morley, lilley & Skinner
Paula Dunning	WEST CUMBERLAND SILK MILLS		DORVILLE	S. Cook	morley, Bagcraft, lilley & Skinner
Anne Gilroes	ZURRER SILKS		SUSAN SMALL	THAARUP	morley, lilley and Skinner
Ted Gregory	SILK VELVET MANUFACTURING CO.		ERIC HART	S. Cook	"
Mary Skeaping			LADY IN BLACK		"
Greta Hamby	STUNZI		MARCUS	Dorothy Carlton	"
Anne Heaton	WEST CUMBERLAND		SUSAN SMALL	THAARUP	morleys, lilley & Skinner
Pirmin Jackson	DRIVER HARTLEY		LADY IN BLACK	6to Lucas	Black Bagcraft, morley, lilley & Skinner
Pirella Brane	WEST CUMBERLAND		MARY BLACK	MHp Lansing	lilley & Skinner
Elizabeth Kennedy	STANDARD MILLS		LADY IN BLACK	S. Cook	morleys, lilley and Skinner
Gerd Larsen	JOHN KNOX, STUNZI (TRIMMING)		SUSAN SMALL	THAARUP	lilley and Skinner
Rosemary Lindsay	ZURRER SILKS		FRANK USHER	MHp Lansing	lilley and Skinner, morley
Gillian Lynne	STUNZI SILKS		MARCUS	Dorothy Carlton	
Lorna Mossford	MARTIN & SAVAGE		MERCIA	Dorothy Carlton	
April Parame	QUALITEX SILKS — COLNE		SELITA	6to Lucas	lilley & Skinner, morleys
Anne Negus	BERNE SILK		LADY IN BLACK	S. Cook	morley, lilley and Skinner
Elaine Fisher			HENRI GOWNS	6to Lucas	morley, lilley & Skinner
Nadia Nerina	DRIVER HARTLEY		SUSAN SMALL	THAARUP	morley, lilley and Skinner
Pamela Rye	S. ASHTON OF BRADFORD		MASCOTTE	S. Cook	morley, lilley and Skinner
April Olrich			NETTIE VOGUES	Edwin Poh	morley, lilley and Skinner
Thekla Russell	ZURRER SILKS		FRANK USHER	6to Lucas	Black Bagcraft, morley, lilley & Skinner
Jean Gilbert			HENRI GOWNS	York	morley, lilley and Skinner
Margaret Stah			JULIAN ROSE	S. Cook	morley, lilley and Skinner, Bagcraft
Jean Stokes	WEST CUMBERLAND SILK MILLS		DORVILLE	Hugh Beresford	morleys, lilley and Skinner
Valerie Taylor	ZURRER SILKS		FRANK USHER	6to Lucas	morley, lilley and Skinner
Rosemary Tabure	WEST CUMBERLAND		MERCIA	Dorothy Carlton	morleys, lilley and Skinner
Pauline Wadsworth	WEST CUMBERLAND SILK MILLS		MARY BLACK	S. Cook	morley, lilley and Skinner
Wendy Winn	A.C. KAY		LOUIS LEVY	S. Cook	morley, lilley and Skinner
Dorothea James	ZURRER SILKS		SUSAN SMALL	THAARUP	Black Bagcraft, lilley and Skinner

THE AMBASSADOR initial charts—the basis for

NAME	CLOTH MANUFACTURER	PATTERN COAT	SUIT	MODEL HOUSE	BLOUSE OR SWEATER	HAT	GLOVES BAGS SHOES UMBRELLAS
MARGOT FONTEYN	COLEMAN – SHIELANA			Hardy Amies		Otto Lucas	Morley's Black / Black Burrman Kelly Skinner
MARGOT FONTEYN	DUMAS & MAURAY			Michael Sherard		Assot and Pavy	Black Black / T.H. Lawton
MOIRA SHEARER	Wilson + Glenny			Mattli		Rudolf	Howarth Royce Kelly Skinner
PAMELA MAY	Dumas & Mauray			Charles Creed	Bella Grey	Vernier	Morley's Grey Kays L.S.
BERYL GREY	JACQMAR			Victor Stiebel	Ballantyne Wing	Youman	Morley's Grey Kays L.S.
VIOLETTA ELVIN	GARDINER OF SELKIRK			Frederick Starke		Vernier	L.S. T.H. Lawton
JUNE BRAE	Brown Bros.			Rosher	Finestone Brown Jersey	Assot and Pavy	Nigger L.S.
PAULINE CLAYDEN	Middlemost / HUNT AND WINTER BOTHAM			DERETA		Assot and Pavy	Black L.S.
MARGARET DALE				Matita	Sylph Cye	Aage Lovise	Grey Black
CHRISTINE DU BOULAY	HEATHER MILLS			DORVILLE / WINDSMOOR		McCracken and Bowen	Tan
Paula Dunning	CUMBERLAND MILLS			BRENNER SPORTS	Sylph Cye	Paget &	Nigger T.H. Lawton
Anne Gilmour	E.R. MATTHEWS SHIELANA			Mascotte		Paget	Ginger T.H. Lawton
Jill Gregory	JOHN KNOX			Ian Meredith			Black
Mary Steaping	STUBLEY RAWNSLEY			IAN MEREDITH	Finestone Emerald		Navy
Anita Hamby	GIBSON AND LUMGAIR			MARCUS	Sylph Wing Cye	McCracken and Bowen	Wine Black Peskin
Anne Naten	MUNRO SPUN SALTS (Saltaire) Ltd.			COUNTRY LIFE	Munro Spun Turquoise Angora	Jay Hats	Black
Thelma Jackson	JAMES PORTEOUS SHAW BROS.			TRAVELLA	Finestone Sky Crepe Sky Jersey		Brown
Fiorella Keane	SHIELANA			SILHOUETTE LUXE		Aage Lovise	Black
Elizabeth Kennedy	WILSON AND GLENNY			DERETA	Tan Pringle		Ceru
Enid Lister	HUNT AND WINTER BOTHAM GEORGE HARRISON – COAT			REVILLE / WINDSMOOR	Finestone Grey Green Yellow		Black
Rosemary Lindsay	JOS. KING OF KEIGHLEY – SUIT			KOUPY		Otto and Amie	Black
Julia Lynas	LINTON TWEEDS			SPECTATOR SPORTS / RODEX / ASTA	Lennox Black Jersey	Otto and Amie	Black
Lorna Mossford	M.O.T. TEXTILES			WINDSMOOR	Finestone Pring Ballantyne	Pavy	Nigger
Anne Navarre	JAEGER			JAEGER		McCracken and Bowen	Brown
Anne Negus				IAN MEREDITH		McCracken and Bowen	
Brenda Nelson	WILSON AND GLENNY			DERETA	Pringle Cocoa		Nigger
Nadia Nerina	JERSEYCRAFT – DRESS JOB BEAUMONT – COAT			SPECTATOR SPORTS / HORINSKY		Jay Hats	Nigger
Palma Nye	SHIELANA STIBBE			POSNER	Ballantyne Scarf	Assot	Black
Anne Oldrich				LADY IN BLACK / WINDSMOOR		Assot and Vy	Black
Julia Russell	GARDINER OF SELKIRK			KOUPY			Black
Jean Gilbert	RICHARD PETTY – BRADFORD			DORVILLE		York	Navy
Margaret Star	HOLLAND AND LEWIS M.O.T. TEXTILES			REVILLE	Finestone	Assot and Pavy	Nigger
Jean Stokes	CUMBERLAND MILLS			DORVILLE		Berkertex Niss	Nigger
Anne Taylor	DICK AND GOLDSCHMIDT CUMBERLAND MILLS			SILHOUETTE DE LUXE / HORINSKY		McCracken and Bowen	Nigger Peskin
Rosemary Tapure	CUMBERLAND MILLS			KOUPY			Black
Pauline Southworth	JOHN KNOX of SILSDEN MACLORITEX – GALASHIELS			DORVILLE		Francis	Beige / Brown
Wendy Winn	CUMBERLAND MILLS			SPECTATOR SPORTS	Lennox Knitwear Black	McCracken and Bowen	Black
Dorothea James	LINTON			DORVILLE		Paula Wallace	Black

our correlation of cloth, clothes and accessories

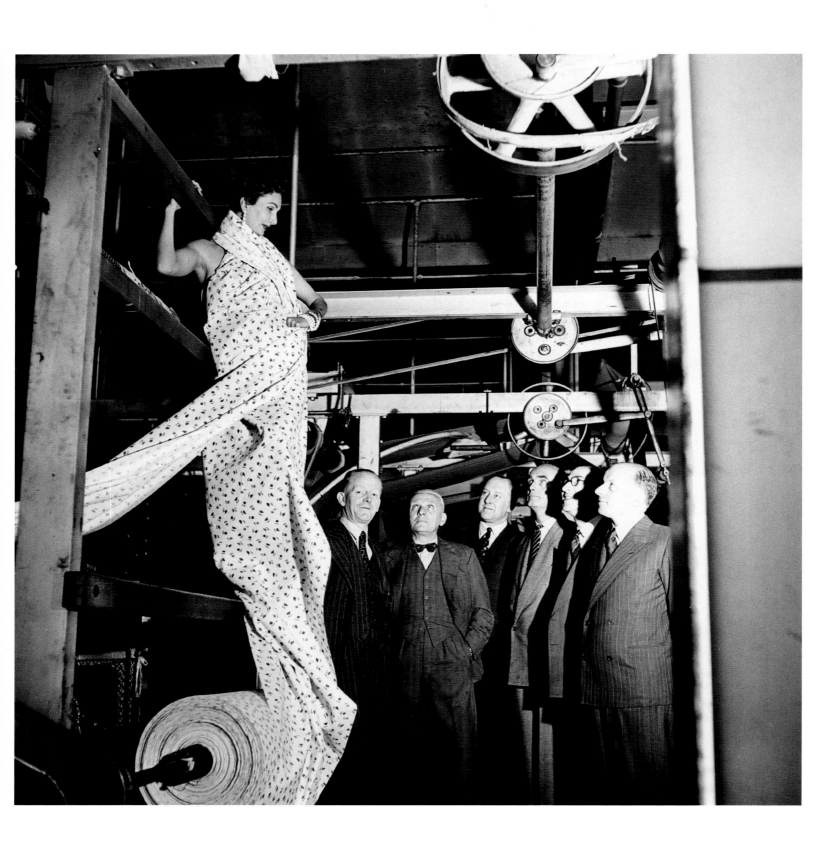

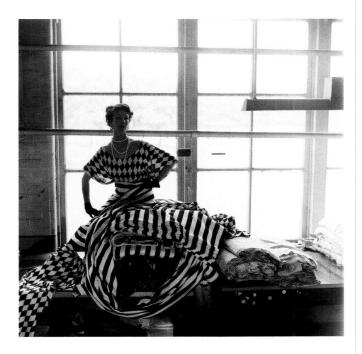

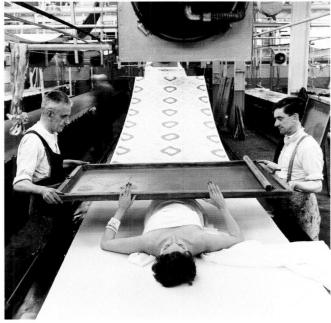

The Ambassador magazine continued to situate the design and export of fashion ideas within the wider context of production and industry. Nowhere is this more explicit than in the juxtaposition of model, cloth and heavy machinery in the feature 'Milling around Lancashire' of September 1952. What started off as an 'improvised whirlwind' became 'an impressive and serious business tour'. In an interview in 1992 Elsbeth recalled: 'my job was to … use mainly intuition based on experience and just think up things that made The Ambassador different from other magazines'. In this shoot, Elsbeth photographed Barbara Goalen amongst the mill engines, spools, dye vats and printing screens of heavy industry, wearing nothing but her jewellery and 'spontaneous Goalen-Elsbeth Juda creations from fabrics straight off the loom' (see page 53). Goalen was draped in towelling, men's shirting and pyjama fabric as if she was wearing the most expensive haute couture, and her insouciance triumphed in the final shot where she stands like a figurehead on the steep roof of Whitworth & Mitchell's Manchester showroom, fabric billowing in the wind. While the feature demonstrated the translation from flat textile to fashion, it also imbued

'Milling around Lancashire'
1952, no.9

Overleaf: 'At St Moritz'
1953, no. 3

furnishing fabrics and industrial synthetics such as Tygan and Tyglass with the glamour of fashion. Goalen, Britain's top model at the time, asked for no luxury other than a mirror during the four-day shoot.[17]

The lead fashion feature of March 1953 again featured Barbara Goalen, this time on the glamorous ski slopes of St Moritz. 'Coronation on Ice' played to international interest in the forthcoming Coronation, which would be televised to more than 20 million people around the world. Elsbeth chose the most incongruous site possible. Theatrical, absurd and arresting, the images feature the ever-game Goalen in high heels on skis, and in full Coronation robes, including crown, standing on a carpet laid on a ski slope. A final group shot resembles a mediaeval pageant on ice, complete with model in full evening dress sitting on a horse.

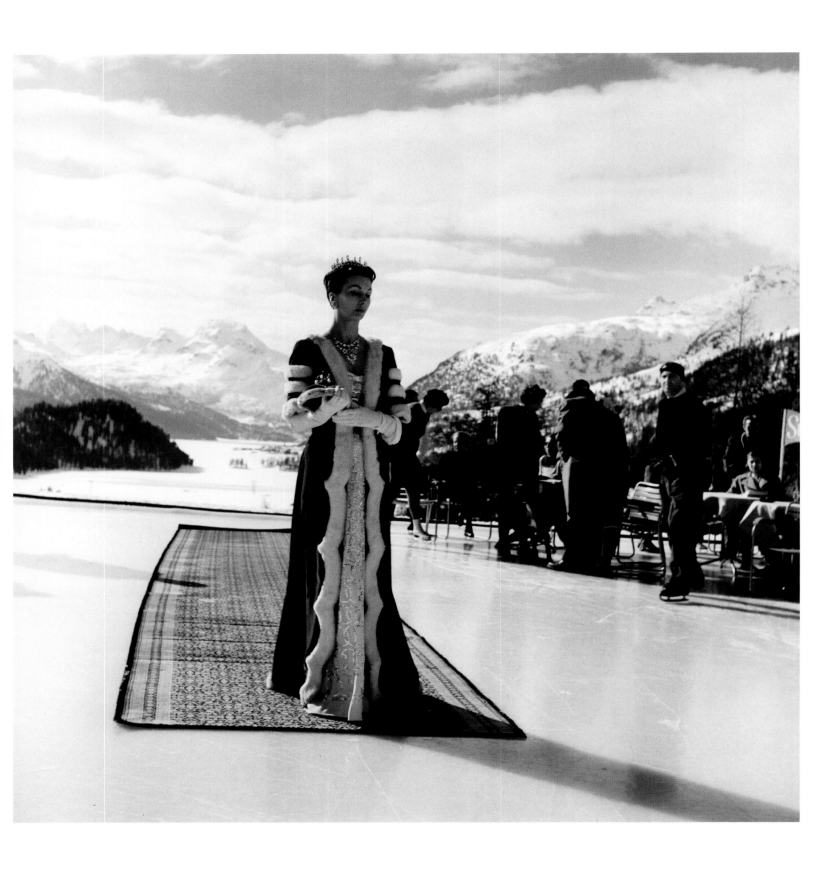

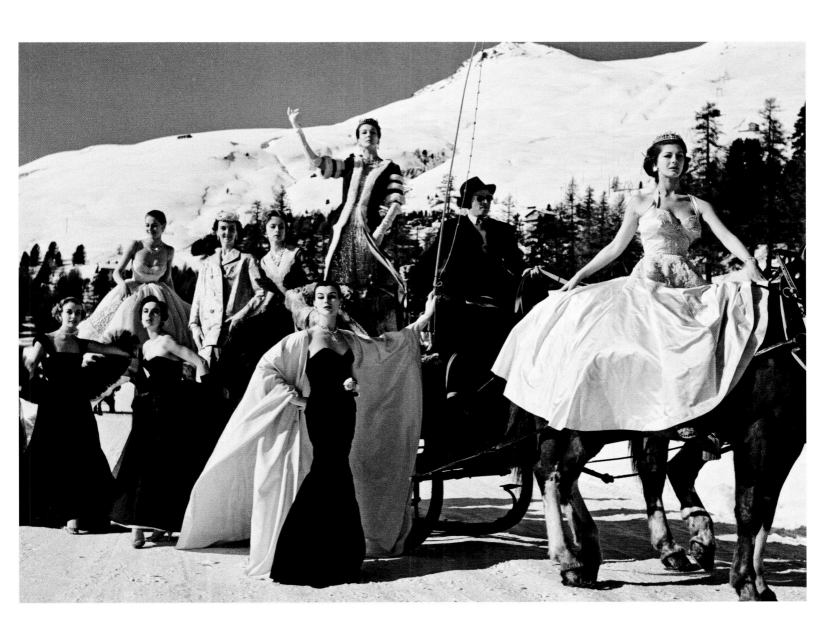

'Lord and Taylor's British Fortnight'

1958, no. 9

Mr Boden of *The Ambassador* staff dressed up as a policeman
for this photograph.

Overleaf: 'London Looks Up'

1961, no. 9

A NEW BRITISH FASHION ERA

The gradual recovery of the British fashion and textile
industry after the war was in no small part due to the efforts of
the INCSOC couturiers, who continued to show their London
couture collections while creating high quality ready-to-wear
designs for both export and home. Christian Dior's success
had also stimulated world-wide fashion trade and attracted
international buyers back to Europe, including London, but
his sudden death in 1957, only ten years after launching his
fashion house, caused turmoil in Paris, which feared that the
entire couture system would collapse. Dior's successor Yves
Saint Laurent lasted barely two years at Dior before setting up
his own couture house, but his *prêt-à-porter* line was soon in
the vanguard of couture's move towards the democratization
of fashion. By the 1960s British fashion had also begun to find
a new momentum as distinctly youthful fashions and the
emergence of the high street boutique challenged established
patterns of consumption. 'Young British Fortnights' were
added to *The Ambassador*'s 'British Weeks' and 'British
Fortnights' and were staged all over the world, while at home,

in 'Tribute to British Fashion' in July 1960, *The Ambassador*
reported the new London Fashion Week event to be an
unqualified success:

The initial result of this joint promotion produced £500,000
of additional export orders. The success is felt, not only by the
Fashion House Group of London, but also by the members of
AFIA (Apparel & Fashion Industry's Association), who showed
their collections at the same time, and by a great number of
other fashion exporters. These orders should raise the collective
total to several million pounds sterling.[18]

Other optimistic features followed. 'London Looks Up'
featured a fashion shoot taken at temporary exhibition halls
on London's South Bank built for the sixth Congress of the
International Union of Architects in 1961. The buildings were
designed by the multidisciplinary architect Theo Crosby and
combined dramatic architecture and striking graphics. The
modernist environment provided a fitting backdrop for the
sharp tailoring of the London designers, while the graphic

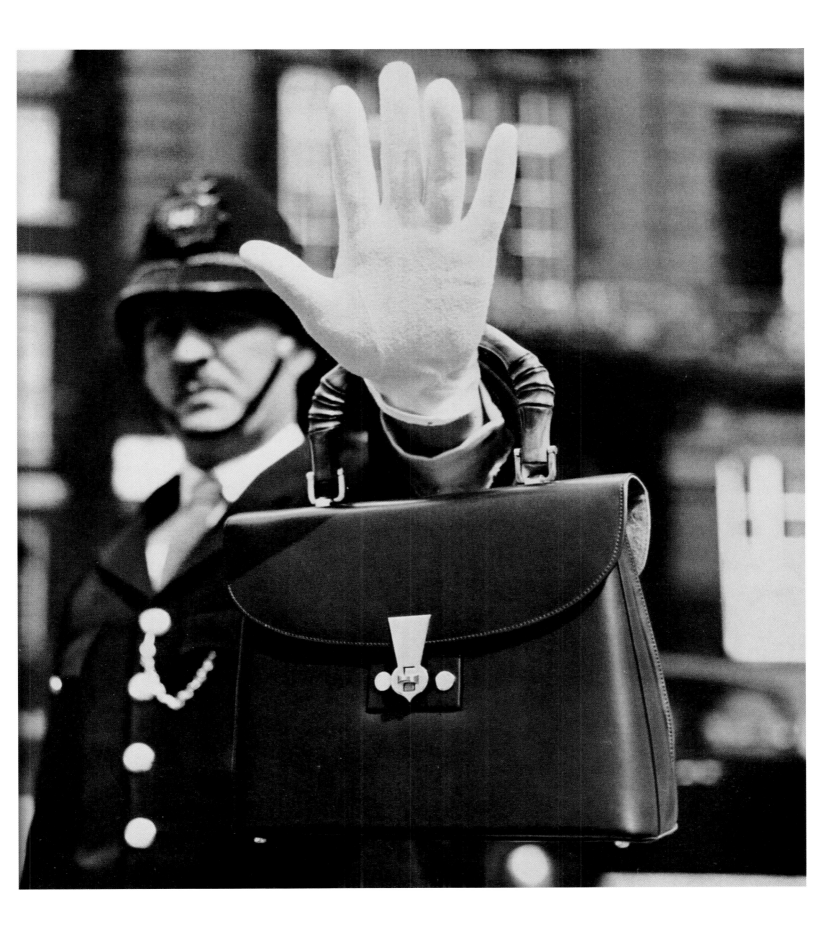

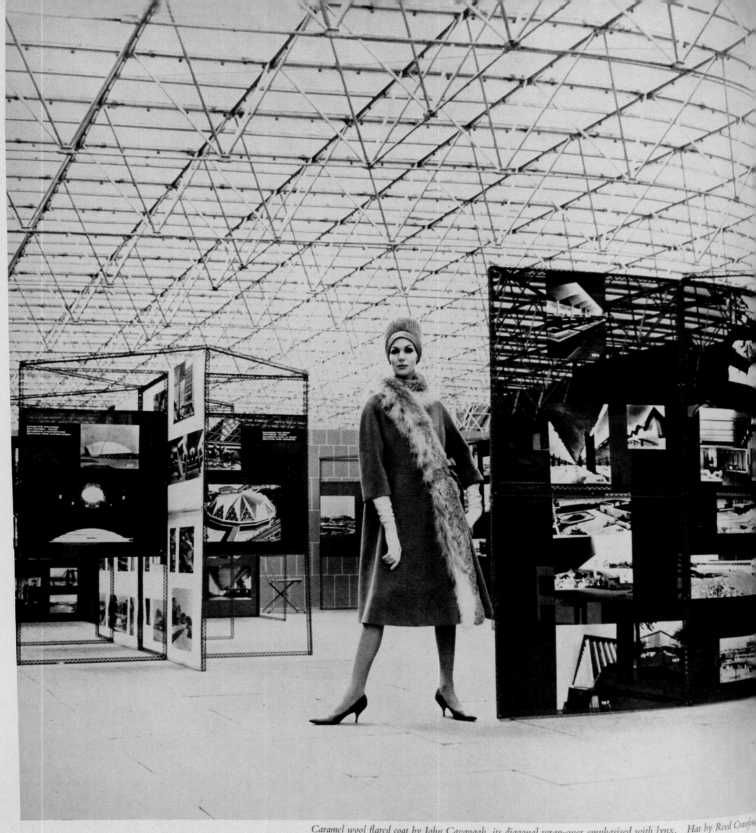

Caramel wool flared coat by John Cavanagh, its diagonal wrap-over emphasised with lynx. Hat by Reed Crawfor

LONDON LOOKS UP

London couture has had a face lift all round. If it can keep up the creative impulse that clearly comes through this season, it deserves to rank higher than it does in world fashion. There is no doubt, that in the past, London has played safe and has trod warily behind other capitals. But this autumn, members of the Incorporated Society of London Fashion Designers show that they are well in line with current trends; they are up to date; and, most important of all, they are original. Although London does not,

and does not try to, produce the gimmick news lines of Paris, it does have a valuable contribution to fashion, offering the sort of clothes that will be echoed in the ready-to-wear industry over the next year. And what was shown in London this July was in no way contradicted by the Paris collections which took place the following week.

Most welcome of all, is the change that has come over the little-afternoon-dress. Tight skirted, fitted at the bodice with

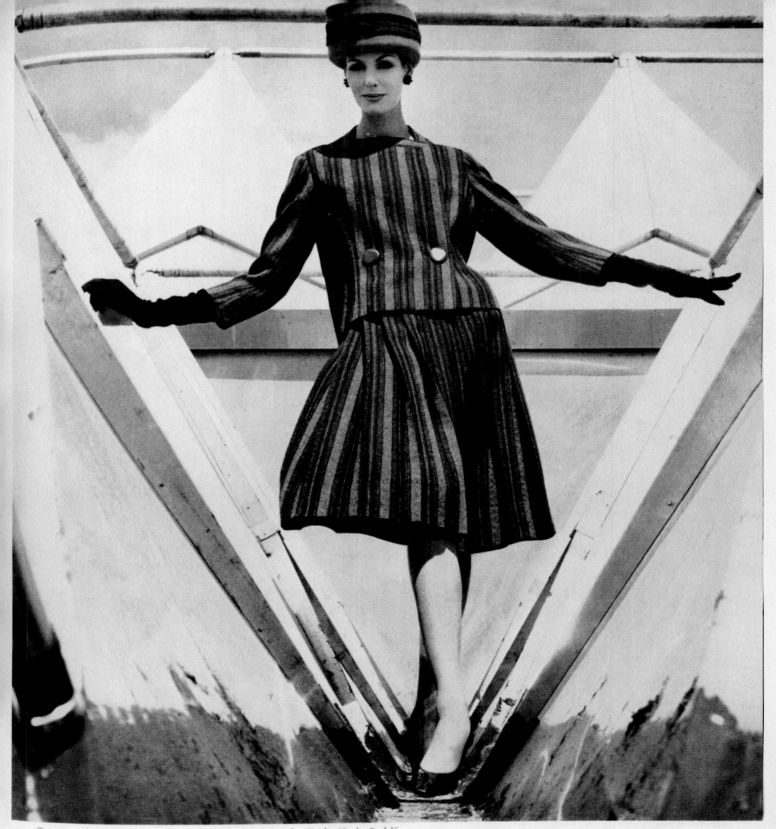

Turquoise and grey blazer-striped tweed suit with pleated skirt, by Mattli. Hat by Rudolf.

set-in sleeves, its inflexibility has let down English collections time and time again. Now it has been emancipated. Even the most conservative of couturiers have adopted freer flowing lines which offer both more variety of expression and greater ease.

From an export angle, tailoring still is the big attraction in English couture (we have, therefore, confined our illustrations to coats and suits although an evening dress by Hardy Amies is included in our lace feature on pages 80–81).

There is a general movement towards more fitting suits. The midriff is flattened towards the body and from there the line flares out towards the hem. Waists, although acknowledged, are not stressed and in dresses and coats particularly they may be raised or lowered. Fabrics are still soft – lacy tweeds and wool chiffons for day; fine silks, heavy crêpes and silk chiffons for evening, rich brocade being the late day exception. New interpretations of Paisleys are seen everywhere in a multitude of different fabrics.

There are also some deep stained glass effects.

Colours are individually expressed. They vary from electric shocks at Cavanagh, through Mattli's violets and Michael's Bristol Blues, to dark sombre tones at Charles Creed. Black, of course, is everywhere. The official fashion colour promoted by the Society is bronze green, a subtle seaweed colour, and the accessory show given by Associate Members showed mineral tones–brown, red, copper, pewter and so on – to team with it.

continued ▶

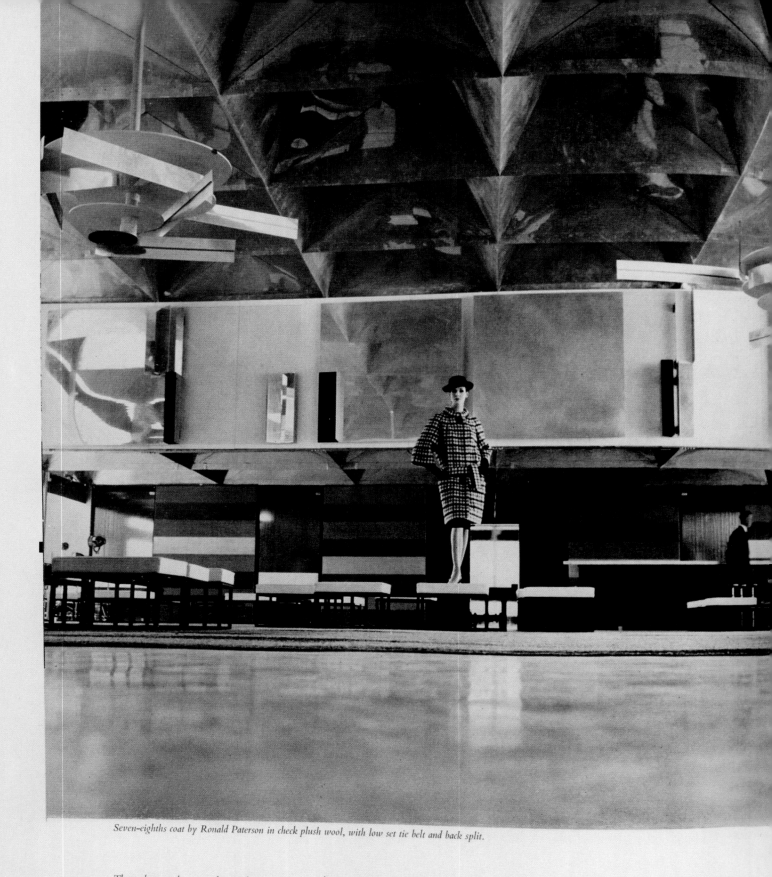

Seven-eighths coat by Ronald Paterson in check plush wool, with low set tie belt and back split.

These photographs were taken at the two temporary buildings, designed by Theo Crosby and erected specially for the 1961 congress, in London, of the International Union of Architects. The main one was sponsored by British Aluminium, Cape Building Products and Pilkingtons; the other, which served as an exhibition hall, by Taylor Woodrow. Murals and other works of art were commissioned, some making exciting use of the structural materials.

CHARLES CREED shows a sharply defined waist and swinging skirt, often with unpressed pleats flowing out from mid thigh – all strictly tailored. Colours are dark and dense, fabrics smooth with a silky sheen. He is at his most dramatic in a dark alpaca and worsted plush tweed coat with turned-up leopard collar; at his most typical in a double-breasted over-coat with high lapels; at his most fanciful in combined suede and velvet or leather and velvet suits.

MATTLI, although less publicised than most, has one of the best collections in London. His clothes show a real under-standing of fashion and a sensitive use of fabrics. They are original, but at the same time dateless. This season, he con-centrates on the cooler colours of the spectrum – violet, lilac, turquoise blue. Suits, in soft tweeds, often with bold blazer stripes, are collarless with rounded shoulders and a back dip. Coats have matching skirts and wool overblouses, with inset bands in contrasting or cross-cut material. Fur is used as a lining. For

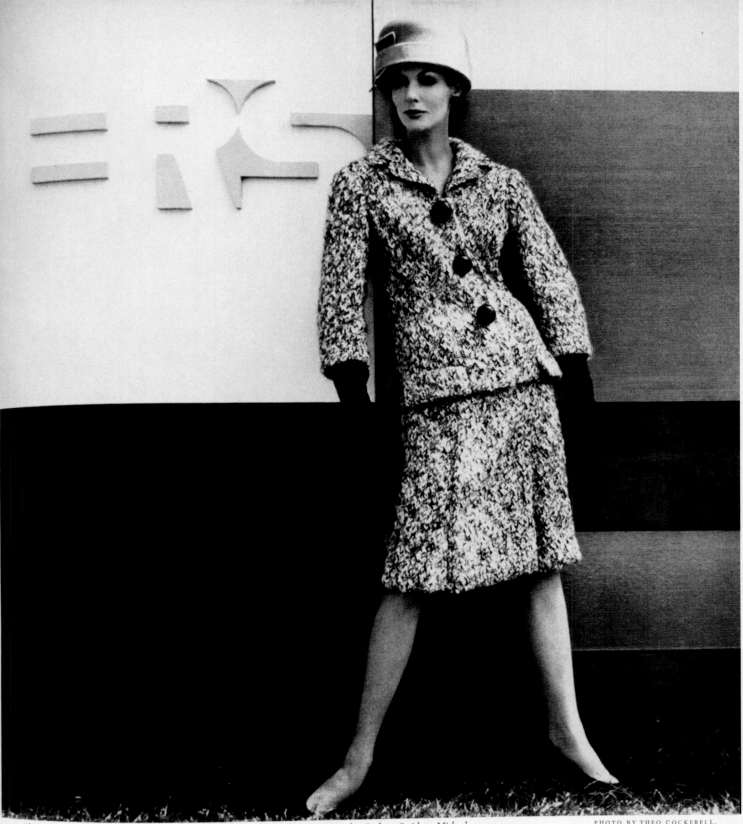

Black and white knitted suit by Michael, with long jacket and panelled skirt. Hat by Graham Smith at Michael.

PHOTO BY THEO COCKERELL.

cocktails and theatre wear, Mattli offers chic brocade suits with finely pleated blouses, while the sculptured simplicity of his evening dresses, ankle length and slender with a flattened midriff, is sheer perfection.

An ensemble called 'Giant Stride' – country style checks, pleated skirt and cape – opened HARDY AMIES' collection and was the key to his 'long body conscious' line, which both looks, and must feel, comfortable to wear. Yet in many ways, his dresses and late day clothes

were the stars of this collection. These had a new freedom and simplicity which took well to the long-bodied look. A simply panelled metal lamé dress showed the fabric to full advantage, while an emerald silk shantung collarless coat, cut straight with no adornment whatsoever, was in its very simplicity one of the most memorable garments in all the collections. Hardy Amies has a well weathered export eye and many of the clothes in this collection have already been bought by Stix, Baer and Fuller and Carson Pirie

Scott for showing in St. Louis and Chicago. He has also designed a special cruise collection for the maiden voyage to Australia of the 'Bretagne'. Three models will sail out from Britain to show the clothes at gala charity parades in Melbourne and Sydney.

JOHN CAVANAGH is well on form – highly colourful and original. Emerald, jade, red, pink, orange are some of his colours, lightest weight open tweeds (one woven on a silk backing), face cloth, silk crêpe, chiffon, embroidered organdie and lace,

continued on page 118

Peter Blake in his studio with the model Marie-Lise Gres
1961
National Portrait Gallery, London

Overleaf: 'The Colour of Form'
1968, no. 6

stripes of the wools and tweeds were reflected in the geometric structure of the buildings. *The Ambassador* commented: 'London couture has had a face lift all round. If it can keep up the creative impulse that clearly comes through this season, it deserves to rank higher than it does in world fashions.'[19]

During the 1960s the London look went from strength to strength. Features in *The Ambassador* continued to show fashion in the context of modern innovations in living. A colour promotion for the textiles and furniture manufacturer Form International entitled 'The Colour of Form' juxtaposed space-age fashions, including a metallic silver mini skirt with tight mesh top and white sunglasses against revolutionary moulded plastic and metal chairs.[20] Items on fashionable menswear became increasingly frequent, as Carnaby Street and a new generation of tailors such as Tommy Nutter fuelled the peacock revolution. Developments in new synthetics such as Crimplene, Bri-Nylon and Terylene led by innovative companies such as ICI saw an increasing boldness in colourful prints and surface treatment and, helpfully, 'drip dry' qualities, while traditional textile manufacturers such as Heathcoat also embraced new technologies, making a variety of fabrics 'in the modern mood of gay young people'. These included 'flock-printed nets for whirling skirts' and 'whipcords woven with restricted stretch for jazz-happy chic skinny pants.'[21] Leather became increasingly fashionable for clothes, helped by new tanning techniques that rendered it supple and allowed for an increasing variety of colours. As *The Ambassador* reported in 'The Language of Leather' of 1966: 'The language of leather is new, bright and bold . . . The leather look is definitely today's look.'[22] Fashion became intertwined with art, with Jay photographing Pop artist Peter Blake with model Marie-Lise Gres in front of his collage construction 'Love Wall' at his studio in 1961.

From the war years up to the departure of the Judas in 1964 *The Ambassador* maintained a balancing act, encouraging and promoting new design while managing not to alienate a traditional manufacturing sector that still had its roots in

the nineteenth century. In the post-war years, exports of British textiles remained strong. During the 1960s, however, at a time of radical change in fashion, textile manufacturers were increasingly unable to adapt. Elsbeth recalled: 'I was terribly thrilled when the Bibas and Mary Quants emerged and I thought here was a new force . . . it made British-style, world-style which was terribly important.' However, many companies began to shut down: 'clothing manufacturers of the sort of Matito, Dorville, Rima, could no longer compete because people wanted quick in, quick out fashion and the working girl bought a new outfit every week and quality went by the board. This meant that fabrics got cheaper, the textile industry was not innovative enough to understand it.'[23]

Perhaps the compensation for the Judas was the success of another of their passions, education, for they were fervently committed to the belief that 'our young designers are our capital', even going to the extent of selling their art collection to create a scholarship fund in the 1970s. As patrons and governors at the Royal College of Art and the Central School, they had the satisfaction of a new generation of graduates, including Ossie Clark and Foale & Tuffin, going on to gain international recognition. Madge Garland, the first Professor of Fashion at the RCA and long-time contributor to *The Ambassador* wrote: 'To-day a Fashion Designer must not think parochially, but internationally . . . the open-sesame of export has revealed a wide world hitherto taken into little account by the Fashion Industry, but which offers the astute designer not only a market for the best he can produce, but an international school in which he can learn.'[24]

The Ambassador magazine's commitment to promoting British exports was matched by an innovative approach to publishing that drew on the Judas' internationalism, broad knowledge of art and belief in the value of world trade as a civilizing tool, for, as Hans wryly commented, 'the world must exchange goods otherwise they'll exchange weapons'. They imbued fashion with modernity by situating it within the context of the new architecture, and a revolution in travel. Cars, ocean liners and planes were used as a backdrop while

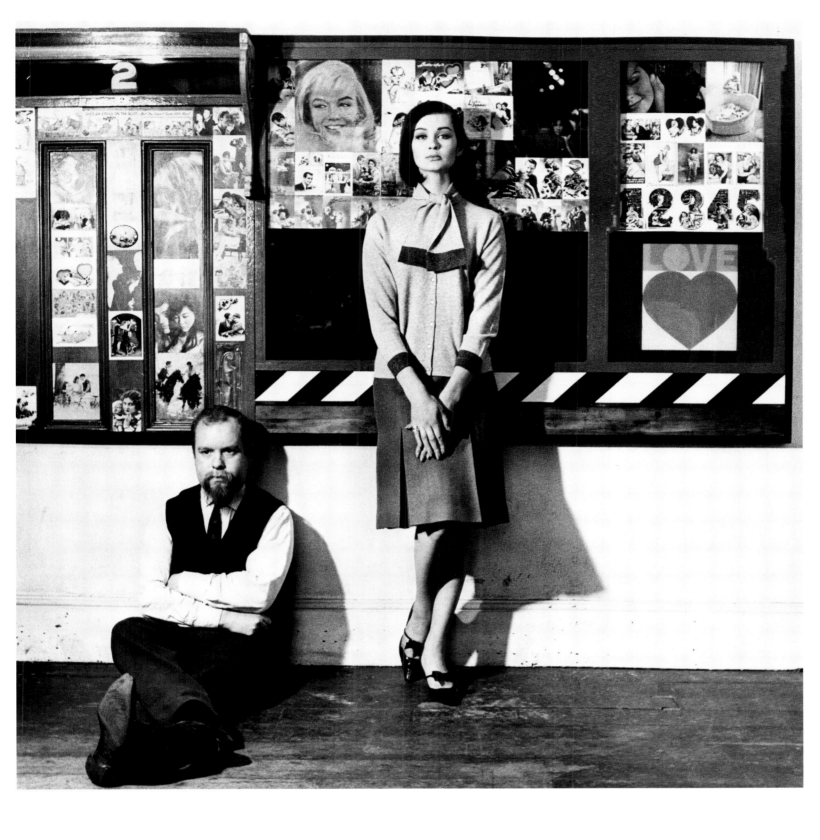

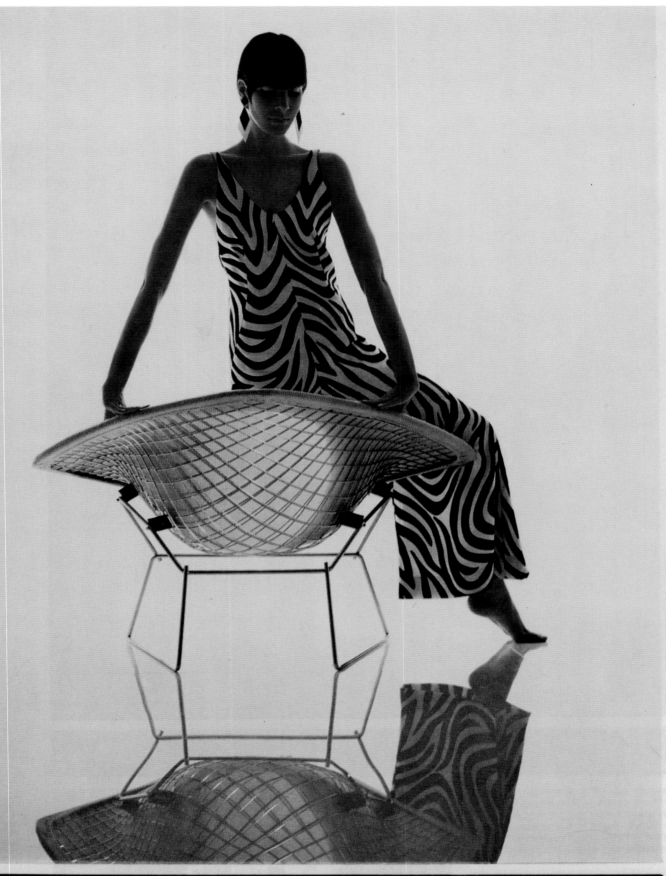

tine conference hall in Nairobi if tests are successful. 'We are very keen to stimulate the use of natural resources there; the handicraft industry requires an outlet, it needs resuscitating. I have offered one of our textile designs to the East African Federation, through UNESCO, and have also offered to market it.' In addition, Form International, because of their technological advances, are fast becoming basic suppliers to their associate companies in Europe,

'. . . but the next big breakthrough is in Eastern Europe' thinks Monty Berman. Form International are thus taking space at the Belgrade Fair in September to introduce themselves there.

In his trip to the East, Monty Berman will take with him enough determination and knowledge for three wise men, and the gifts he carries are timeless examples of designers' and manufacturers' skill. We wish him well.

the colour of Form

Form International, 28 Avon Trading Estate, Avonmore Road, London W14.

the colour of Form . . .

International is a purveyor of a way of life. Its
... is conducted in the belief that first class
... should be made available to as many people as
..., and integrated with the building into which it
... – creating a total environment.
...company's promotional material reflects the high

order of its textiles and furniture: functional yet visually
dramatic, immediately distinctive yet classical. So well
does it capture the tone of Form International that we
were moved to collect together these three recent
examples and then we talked to the managing director,
Monty Berman about 'the colour of Form . . .'

PHOTOGRAPHS CLIVE BOURSNELL

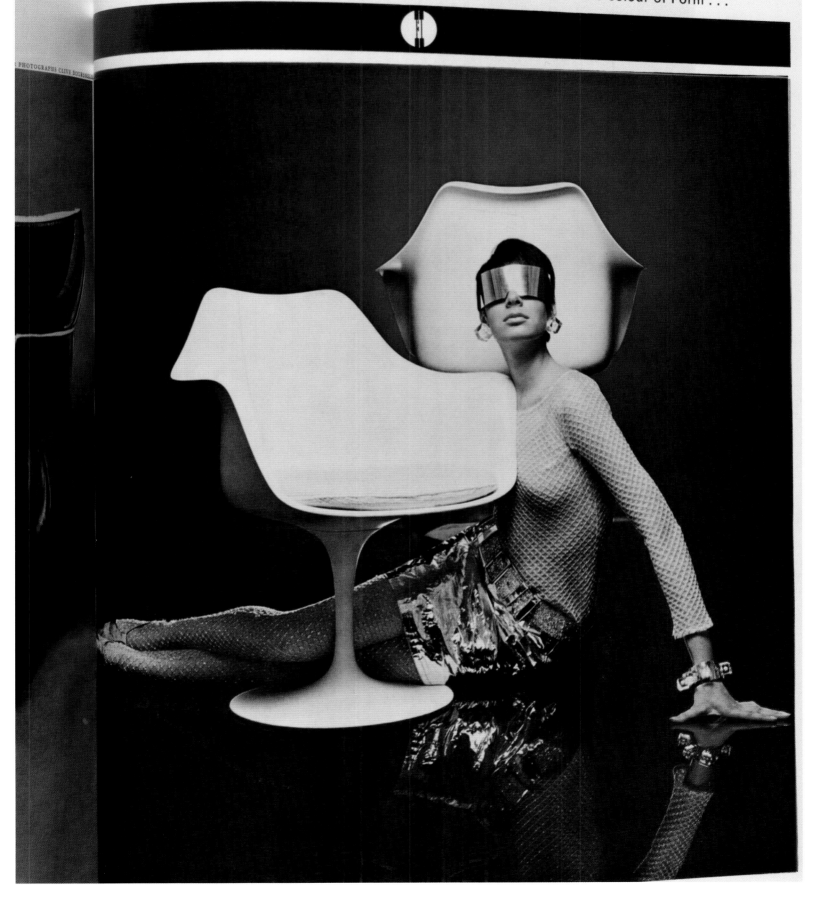

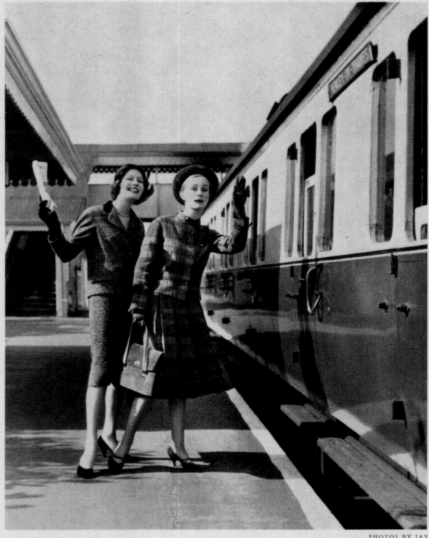

The Ambassador features Lord & Taylor's British Fortnight

OPPOSITE:

Photographed at Little Kimble's
Point-to-Point race meeting:
semi-fitted suit in heavy corduroy,
hand-tailored and lined throughout
in taffeta with matching coat.
Leslie Kaye at Harry B. Popper Ltd.,
London W.1.
Suit $185.00, coat $165.00.

*(Classic felt helmet by Hilhouse of London;
country suede tie shoes by Lady Iles of Mayfair.)*

ABOVE RIGHT:

Commuter's suits, formal and informal:
semi-fitted in Galloway Reels' hand-woven
Scottish tweed, trimmed with velvet collar.
Leslie Kaye at Barry B. Popper. $185.00.
For sentimental good-byes,
blanket plaid suit from Digby Morton,
in soft Shetland tweed.
The young box pleated skirt has a
brief jacket with collar band. $145.00.

RIGHT:

Suit with pleated skirt in
Prince of Wales' black and white worsted;
the short open jacket is worn
with cross-over silk shirt.
Hardy Amies Ready-to-Wear. $185.00.

(Hat by Otto Lucas.)

THE COUNTRY CLOTHES SHOP.

PHOTOS BY JAY

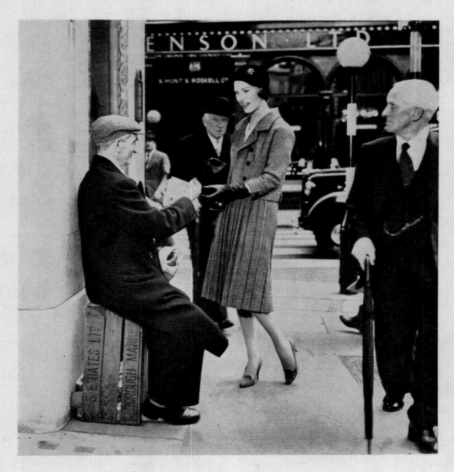

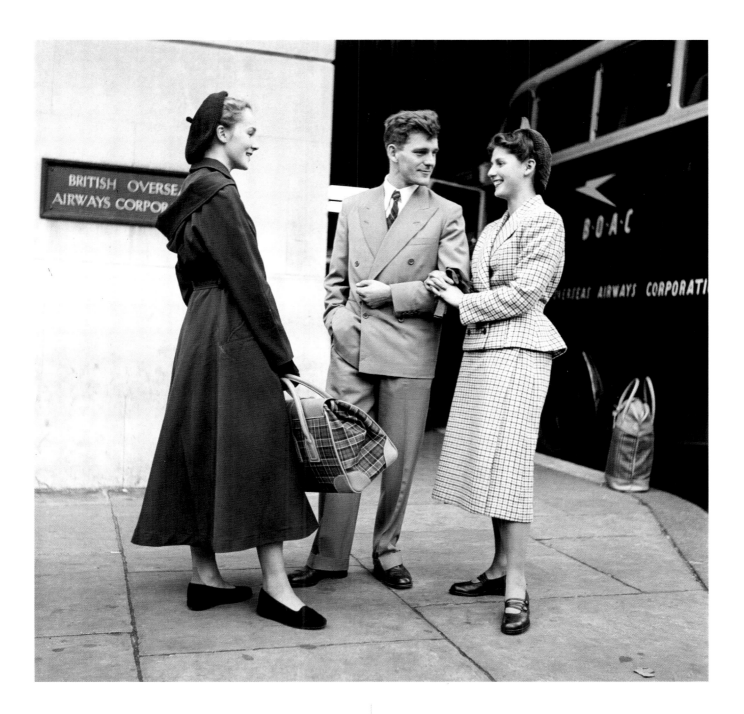

the 'Ready to Fly – Ready-to-Wear' feature of October 1956 employed a BOAC flight to South Africa as the setting for an airborne fashion show. The magazine played on fashion's relationship with contemporary art from early on, showing the collections of London's Wholesale Model Houses at an exhibition of modern sculpture in Battersea Park in July 1948, and the work of young British designers at a Rauschenberg exhibition at the Whitechapel Art Gallery in April 1964 (see pages 82–3). Playing on tradition, cricket, riding and polo outfits were posed before paintings by George Stubbs, while the Windsor Horse Trials were used as a background for sportswear and accessories. On-location shoots took place all over the world, from the Outer Hebrides to the ski slopes of St Moritz and the beaches of Rio de Janeiro. Accessories were styled like still lives, nylons imbued with glamour and the staples of British fashion presented as timelessly chic. While

'The Ballet is Dressed'
1950, no.9
AAD/1987/1/93
This image was not reproduced in the magazine.

Opposite: 'Lord and Taylor's British Fortnight'
1958, no. 9

Overleaf: 'London Fashions for the English Ballet'
1949, no. 10

The Ambassador employed and anticipated the principles of marketing and styling that fuel the fashion industry today, the Judas' distinguishing vision was to present British fashion as part of an international design landscape.[25]

end of feature

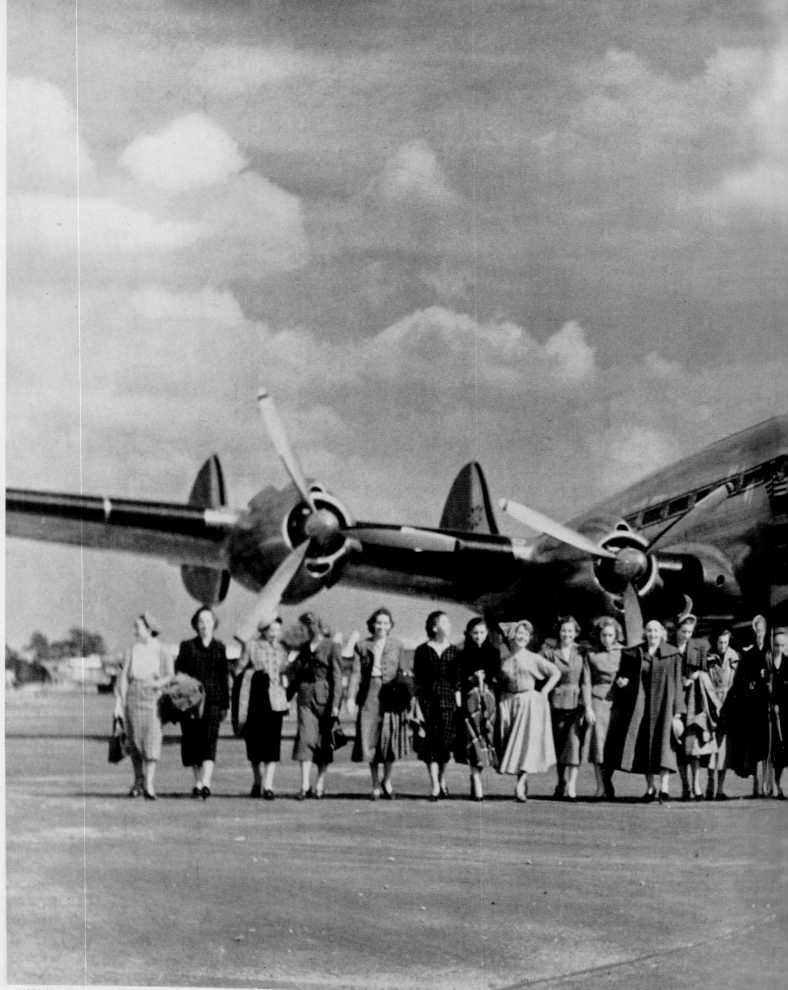

PHOTO BY JAY

The Ambassador rehearses

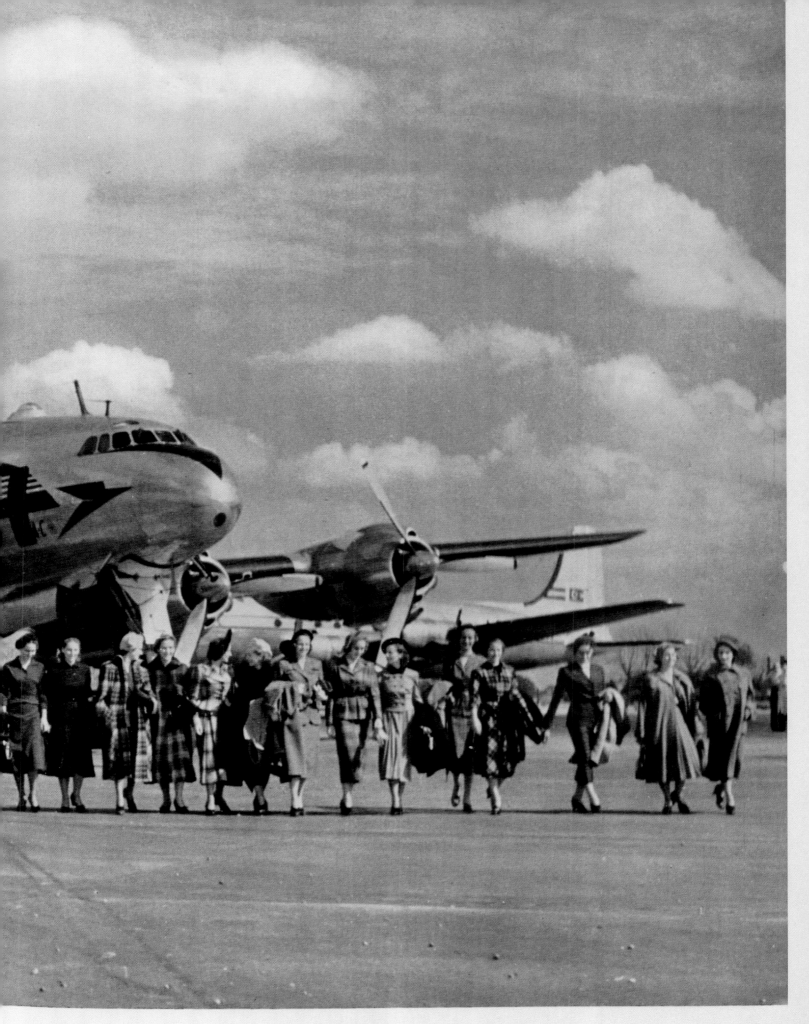

the departure...

our photo-call at London Airport assembles the Corps de Ballet
for a dress rehearsal. Close-ups of these travel clothes
are shown on the following pages.

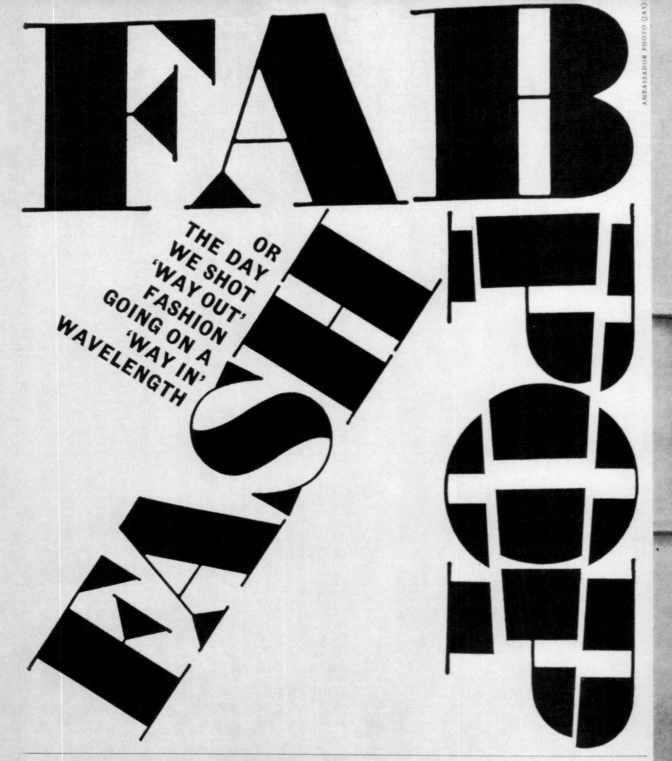

FAB FASHION

FASH

OR THE DAY WE SHOT 'WAY OUT' FASHION GOING ON A 'WAY IN' WAVELENGTH

The awareness and exhilaration of modern city life in the Rauschenberg exhibition makes London's White-chapel Art Gallery the most relevant setting for our fashion on the same wavelength. It is this awareness which produces the group identity of young British fashion designers, and gives our ready-to-wear additional impetus all over the world. The acceptance of social and other shifts is interpreted with wit and enthusiasm -- if not always with the complete professional finish so characteristic of the more experienced British Ready-To-Wear.

We have photographed 'The Queen', wife of Brett Whiteley, one of our foremost young painters, who personifies this spirit, also evident in her choice of these clothes. More of her is usually seen through her husband's eyes -- as in the painting on the left, which forms part of his exhibition at the Marlborough–New London Gallery during May.

Woman in the Bath 4, by Brett Whiteley

Linen/viscose blazer suit, with piping and silver link buttons. Ken Sweet, London W.I.

Rauschenberg's Pilgrim 1960 (right) and Hazard 1957 (far right)

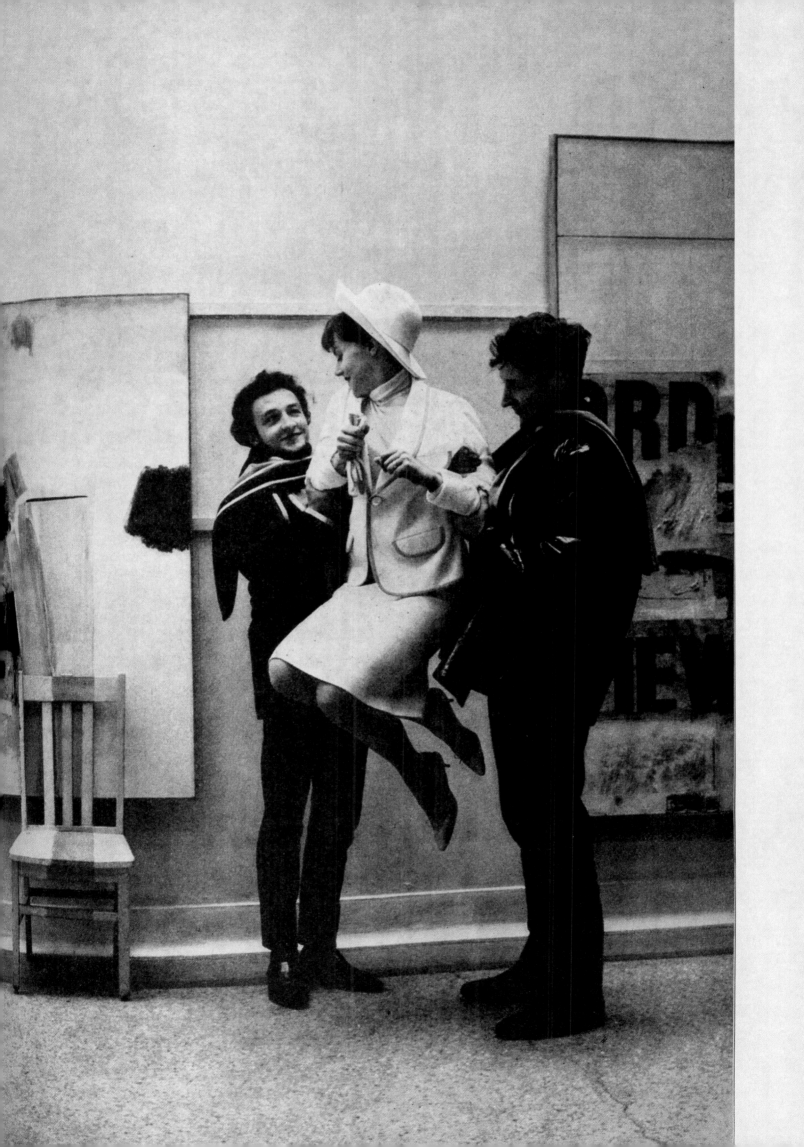

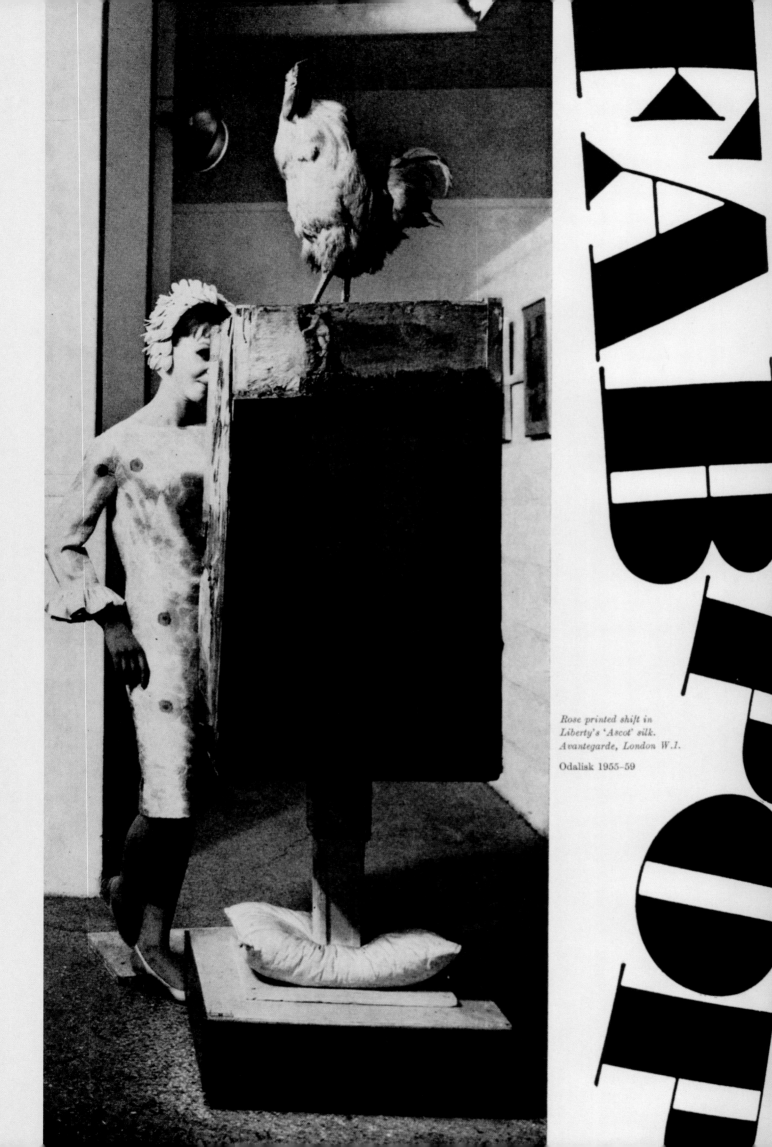

*Rose printed shift in
Liberty's 'Ascot' silk.
Avantegarde, London W.1.*

Odalisk 1955–59

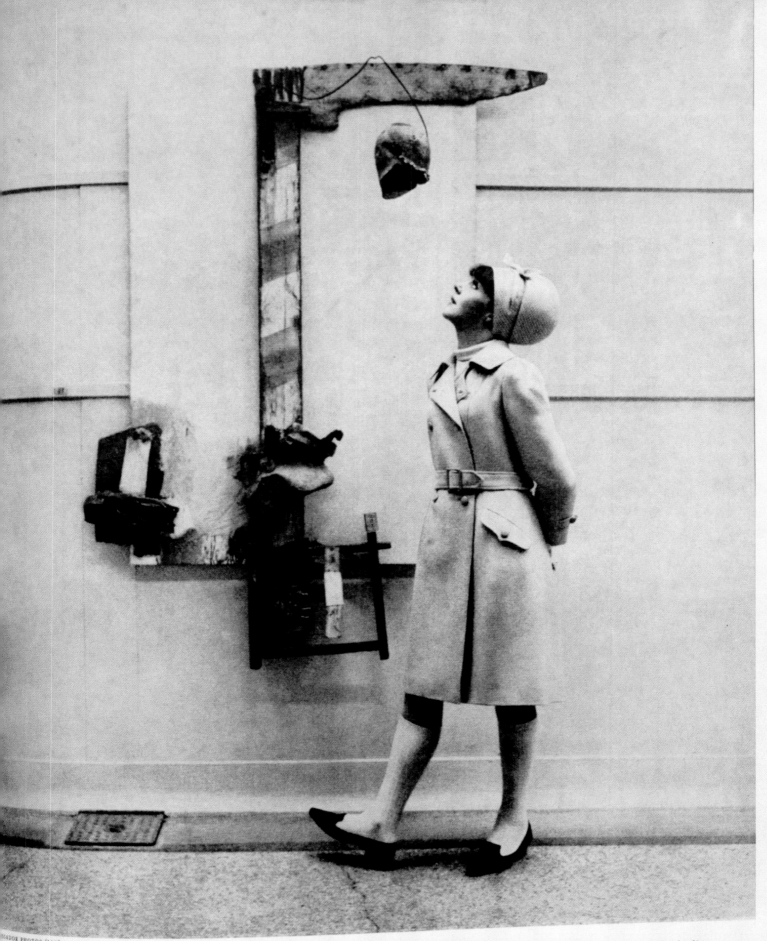

BASSADOR PHOTOS (JAY)

FASH
FASH

Double-breasted coat in wool/gaberdine,
inverted back pleat.
Designed by Emmanuelle Khahn for
Cojana, London W.1.

Aenfloga 1961

continued

POP

Norfolk suit in needlecord,
lining and shirt in
Liberty's Tana lawn.
Tuffin & Foale, London W.1.

Kickback 1959

'Ruffle' wool suit with ruffled
neckline and sleeves.
Designed by Maggie Shepherd for
Caron (Carol Freedman Ltd.),
London W.1.

Curfew 1958

AMBASSADOR PHOTOS (JAY)

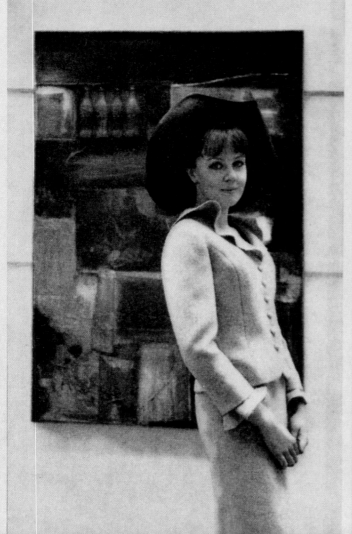

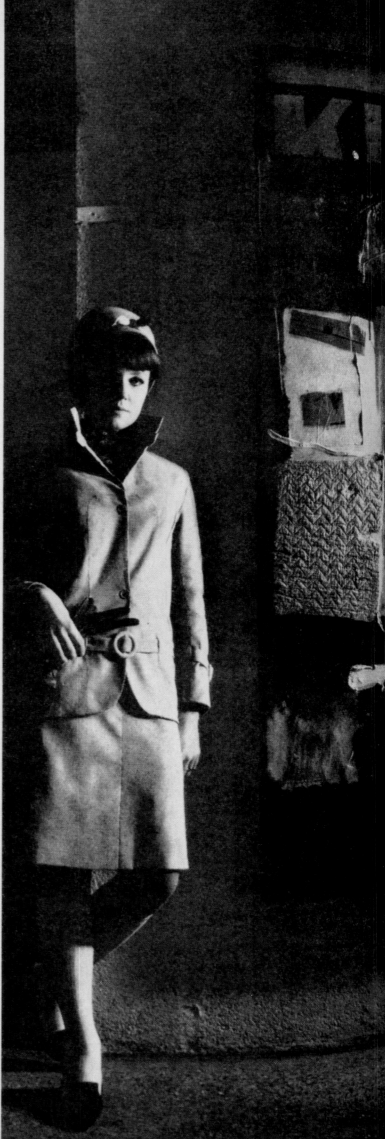

FAB

*Shift in linen/'Terylene' with organza frilled
neck and sleeves.
Designed by Jean Muir for Jane & Jane, London W.1.*
Barge 1963

*Low-backed terrace dress in printed rayon, with side slits.
Colin Glascoe Ltd., London W.1.*
Dylaby II 1962

*Hats by James Wedge, London W.1.
Gloves by Miloré Glove Co., Worcester.
Shoes by Bally of Switzerland.
Hairstyle by Michael at Raphael & Leonard.* continued

*Shift in linen/'Terylene' with organza frilled
neck and sleeves.
Designed by Jean Muir for Jane & Jane, London W.1.*
Barge 1963

*Low-backed terrace dress in printed rayon, with side slits.
Colin Glascoe Ltd., London W.1.*
Dylaby II 1962

The Ambassador
Archive
at the V&A

Alexia Kirk

THE AMBASSADOR ARCHIVE WAS PRESENTED TO the V&A by Elsbeth Juda in 1987. It includes an almost complete set of *International Textiles* (1933–46) and *The Ambassador* magazine (1946–70). It also contains photographs and negatives from photography shoots (1945–64); correspondence between Elsbeth and Hans Juda and some of the artists they worked with, including Henry Moore and Graham Sutherland (*c.*1945–64); and the tape and transcript of an interview with Elsbeth Juda (1987). The archive is now accessible to visitors in the V&A's Archive of Art and Design.

'In Harmony with Architecture': Henry Moore at work in his studio, and photographs of individual pieces of sculpture
The Ambassador (March 1953), Coronation issue, pp.34–37
39 black-and-white photographs, 87 contacts
AAD/1987/1/119/1–39 File 1

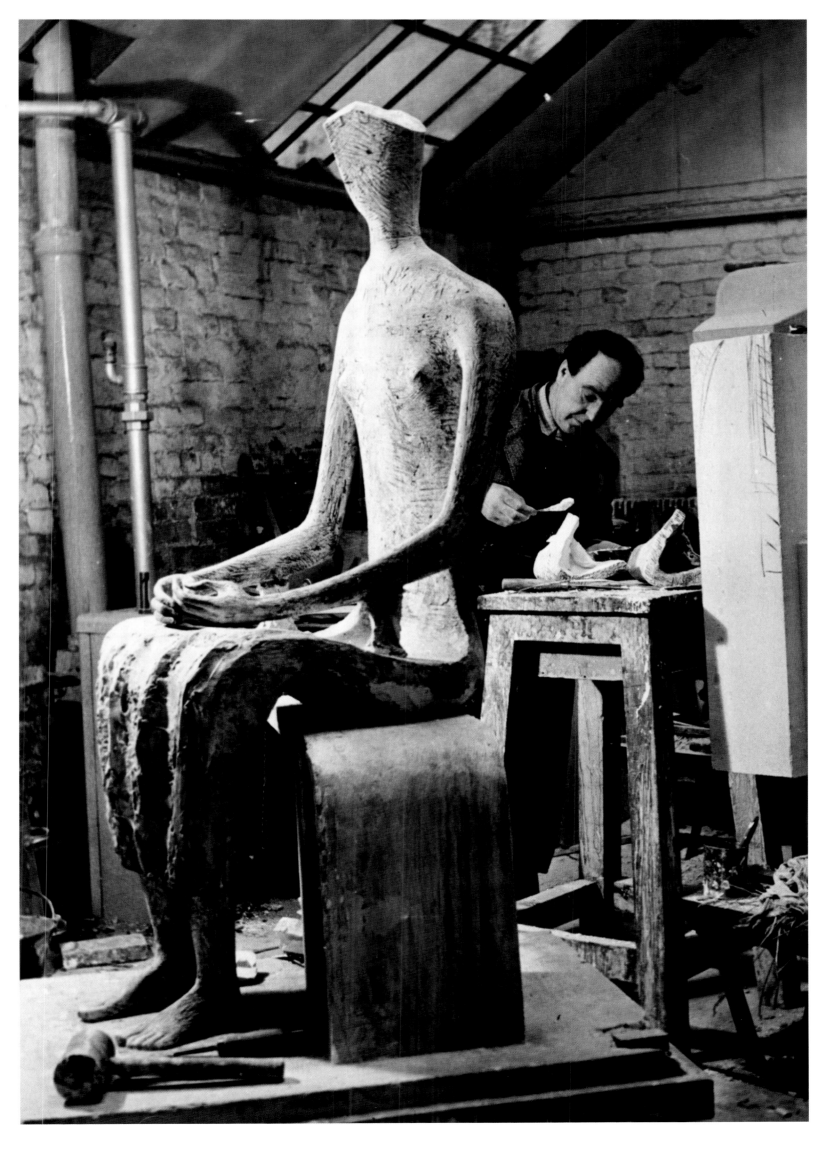

The *Ambassador* archive contains a remarkable record of Elsbeth Juda's photographic work for *International Textiles* and *The Ambassador*. The following pages provide an inventory of surviving records for more than 160 photography shoots.

'Typography': Arthur J. Cullen, part of a series of crafts features, the work of the Arts & Crafts Exhibition Society, introduced and arranged by John Farleigh
International Textiles (1945), no.6, pp.9–66
17 photographs, 1 offprint
AAD/1987/1/67/1–18

'Textile Printing': Margaret Simeon (Morton Sundour Fabrics Ltd), part of a series of crafts features, the work of the Arts & Crafts Exhibition Society, introduced and arranged by John Farleigh
International Textiles (1945), no.8, pp.A–H
5 photographs, 1 offprint
AAD/1987/1/67/19–24

Right: 'Pottery': Heber Mathews (pictured), Bernard Leach, part of a series of crafts features, the work of the Arts & Crafts Exhibition Society, introduced and arranged by John Farleigh
International Textiles (1945), no.9, pp.A–H
16 photographs, 1 offprint
AAD/1987/1/67/25–41

'Manuscript Writing': M.C. Oliver, W.M. Gardner, T. Wrighley, Edward Johnson, Irene Wellington, part of a series of crafts features, the work of the Arts & Crafts Exhibition Society, introduced and arranged by John Farleigh
International Textiles (1945), no.10, pp.A–H
2 photographs, 1 offprint
AAD/1987/1/67/42–44

'Silversmithing': Goldsmiths' Company, S. Hammond, Edward Maufe, part of a series of crafts features, the work of the Arts & Crafts Exhibition Society, introduced and arranged by John Farleigh
International Textiles (1945), no.11, pp.A–H
8 photographs, 1 offprint
AAD/1987/1/67/45–53

'Glass': Whitefriars Glass Works, part of a series of crafts features, the work of the Arts & Crafts Exhibition Society, introduced and arranged by John Farleigh
International Textiles (1945), no.12, pp.83–90
15 photographs, 1 offprint
AAD/1987/1/67/54–69

'Weaving': Cyril Kisby, Mrs Mairet, Lydia Pickering, part of a series of crafts features, the work of the Arts & Crafts Exhibition Society, introduced and arranged by John Farleigh
International Textiles (1946), no.1, pp.83–90
1 offprint
AAD/1987/1/67/70

'Bookbinding': Sydney Cockerell, Douglas Cockerell, Roger Powell, Sybil Pye, William Mathews, Anthony Gardner, part of a series of crafts features, the work of the Arts & Crafts Exhibition Society, introduced and arranged by John Farleigh
13 photographs, 1 offprint
AAD/1987/1/67/71–84

Opposite: Welsh wool feature
*c.*1945–6
12 photographs
AAD/1987/1/68

'Horrockses Clothes'. Villefranche, modelled by Pat Kenyon
The Ambassador (1948), no.4, pp.101–5
4 photographs
AAD/1987/1/69 – 2011FB0187

'Print Themes', designed, written and illustrated by De Holden Stone, Professor of Textiles
The Ambassador (1948), no.11, pp.82–99
5 offprints
AAD/1987/1/70

'Cottons in Capri'
The Ambassador (1949), no.6, pp.124–30
1 black-and-white photograph
AAD/1987/1/71

Eliette von Karahan, photographed in Madge Garland's flat for a lingerie feature, and other Jay photographs
1940s–1950s
1 packet of 12 colour negatives, 102 colour negatives
AAD/1987/1/72

Dorothy Cuff in Welsh feature
late 1940s–early 1950s
1 black-and-white photograph
AAD/1987/1/73

'A Galaxy of Sports Clothes'. Male sports clothes modelled by Russ Allen, orchestra leader, the Milroy nightclub
The Ambassador (1949), no.6, pp.104–13
9 black-and-white photographs
AAD/1987/1/74

Background material: Scotland, Yorkshire and London
Early 1950s
29 black-and-white photographs
AAD/1987/1/75

'Accent on Scotland'. Scottish feature: textiles and fashion
The Ambassador (1950), no.7, pp.108–31
26 black-and-white photographs, 6 negatives
AAD/1987/1/76

'Elegance of Fabric is Emphasised by Simplicity of Line'
The Ambassador (1950), no.8, pp.76–83
1 black-and-white photograph
AAD/1987/1/77

'The English Ballet in America': opening night party with photographs of guests
The Ambassador (1949), no.11, pp.71–6
27 black-and-white photographs [not taken by Elsbeth Juda]
AAD/1987/1/78

'The Ballet is Dressed': Sadler's Wells Ballet in America
The Ambassador (1950), no.9, pp.115–62
102 black-and-white photographs, 1 illustration
AAD/1987/1/79

'The Ballet is Dressed': fashion shoots
The Ambassador (1950), no.9, pp.115–62
55 contact sheets
AAD/1987/1/80

'The Ballet is Dressed': correspondence
1950
Copies of 21 letters
AAD/1987/1/81

'The Ballet is Dressed': ballet rehearsals
The Ambassador (1950), no.9, pp.115–62
51 black-and-white photographs, 168 contact prints
AAD/1987/1/82

'The Ballet is Dressed': ballet performances and rehearsals
The Ambassador (1950), no.9, pp.115–62
46 black-and-white photographs
AAD/1987/1/83

'The Ballet is Dressed': ballet performances and rehearsals
The Ambassador (1950), no.9, pp.115–62
59 black-and-white photographs
AAD/1987/1/84

'The Ballet is Dressed': fashion and accessories
The Ambassador (1950), no.9, pp.115–62
36 black-and-white photographs, 5 contact prints
AAD/1987/1/85

'The Ballet is Dressed': illustrations of samples of cloth and named manufacturers used for dancers' outfits, correspondence
The Ambassador (1950), no.9, pp.115–62
10 glass negatives, 1 item of correspondence
AAD/1987/1/86

'The Ballet is Dressed': photographs of Margot Fonteyn
The Ambassador (1950), no.9, pp.115–62
30 black-and-white photographs
AAD/1987/1/87

The Ambassador (1950), no.9, pp.115–62
104 black-and-white contact prints
AAD/1987/1/88

'The Ballet is Dressed': ballet performances and rehearsals
The Ambassador (1950), no.9, pp.115–62
58 black-and-white contact sheets
AAD/1987/1/89

'The Ballet is Dressed': ballet performances and rehearsals
The Ambassador (1950), no.9, pp.115–62
45 black-and-white contacts
AAD/1987/1/90

'The Ballet is Dressed': ballet performances and rehearsals
The Ambassador (1950), no.9, pp.115–62
126 black-and-white contacts
AAD/1987/1/91

'The Ballet is Dressed': ballet performances and rehearsals
The Ambassador (1950), no.9, pp.115–62
246 black-and-white contacts
AAD/1987/1/92

'The Ballet is Dressed': fashion shoots, performances and dancers
The Ambassador (1950), no.9, pp.115–62
99 black-and-white contacts
AAD/1987/1/93

'It's Supposed To Be a Simple Business': South American feature. Fashion shoots, photographs of textiles, architecture, scenic views
The Ambassador (1951), no.2, pp.71–107
273 black-and-white contacts
AAD/1987/1/94 File 1

'It's Supposed To Be a Simple Business': South American feature. Fashion shoots, photographs of textiles, architecture, scenic views
The Ambassador (1951), no.2, pp.71–107
261 black-and-white contacts
AAD/1987/1/94 File 2

'It's Supposed To Be a Simple Business': South American feature. Fashion shoots, photographs of textiles, architecture, scenic views
The Ambassador (1951), no.2, pp.71–107
442 black-and-white contacts, 2 copies of correspondence
AAD/1987/1/94 File 3

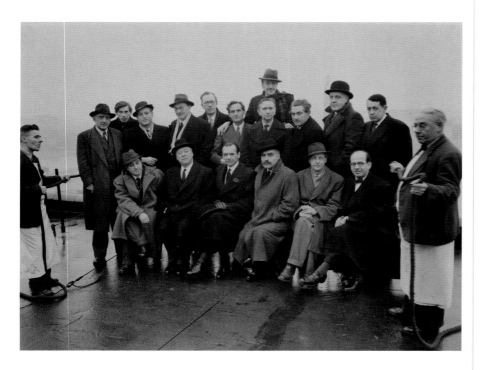

'It's Supposed To Be a Simple Business': South American feature. Fashion shoots, portraits, photographs of architecture

The Ambassador (1951), no.2, pp.71–107

309 black-and-white contacts, 10 negatives of portraits

AAD/1987/1/94 File 4

'It's Supposed To Be a Simple Business': South American feature. Fashion shoots, portraits, photographs of architecture

The Ambassador (1951), no.2, pp.71–107

80 black-and-white photographs

AAD/1987/1/94 File 5

'It's Supposed To Be a Simple Business': South American feature. Fashion shoots, portraits, photographs of architecture

The Ambassador (1951), no.2, pp.71–107

55 black-and-white photographs

AAD/1987/1/94 File 6

'It's Supposed To Be a Simple Business': South American feature. Fashion shoots, portraits, photographs of architecture, correspondence

The Ambassador (1951), no.2, pp.71–107

54 black-and-white photographs, 2 items of correspondence

AAD/1987/1/94 File 7

'This Casual Elegance': photographs of Savile Row tailors

The Ambassador (1951), no.3, pp.98–113

14 black-and-white photographs

AAD/1987/1/95/1–17

Above: Festival of Britain: photographs of architects and artists of the festival, including

Misha Blake, Osbert Lancaster, Feliks Topoloski, Gordon Russell and Hugh Casson on the roof of The Savoy Hotel.

The Ambassador (1951), no.4, pp.148–51

4 black-and-white photographs

AAD/1987/1/96/1–4

Below: 'A Model Photographer': photographs of Norman Parkinson, photographer for Condé Nast

The Ambassador (1951), no.5, pp.104–10

27 black-and-white photographs

AAD/1987/1/97/1–27

Opposite, top: 'Festival Nights': fashion shoot of evening gowns at the South Bank

The Ambassador (1951), no.7, pp.102–3

29 black-and-white photographs

AAD/1987/1/98/1–29

'Just Next Door': fashion shoot in Ireland

The Ambassador (1951), no.7, pp.87–105

44 black-and-white photographs

AAD/1987/1/99/1–44

'Just Next Door': fashion shoot in Ireland

The Ambassador (1951), no.7, pp.87–105

868 black-and-white contacts

AAD/1987/1/100

'Just Next Door': portraits of locals in Ireland

The Ambassador (1951), no.7, pp.87–105

2 large black-and-white photographic portraits

AAD/1997/1/101

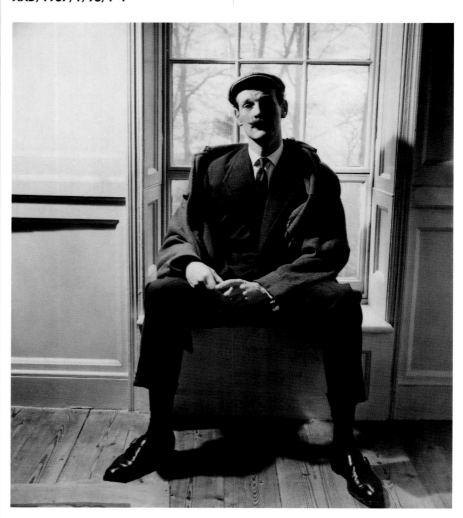

'Irish Linen': examples of Irish linen shot at Stormont and other Irish country houses
The Ambassador (1951), no.10, pp.127–46
40 black-and-white photographs
AAD/1987/1/102/1–40

'Irish Linen': examples of Irish linen shot at Stormont and other Irish country houses
The Ambassador (1951), no.10, pp.127–46
19 black-and-white photographs
AAD/1987/1/103/1–20

Below: 'Switzerland Buys British': fashion shoot set in Switzerland
The Ambassador (1951), no.11, pp.75–95
10 black-and-white photographs
AAD/1987/1/104/1–10

'The Man, The Detail, The Style': Peter Ustinov, Robin Darwin, Norman Hartnell, Cyril Lord, Ashley Havinden
The Ambassador (1951), no.12, pp.95–101
175 black-and-white contacts
AAD/1987/1/105/1–17

'*The Ambassador* Visits Australia'
The Ambassador (1952), no.3, pp.99–141
16 black-and-white photographs
AAD/1987/1/106/1–16

'Our Visit to New Zealand'
The Ambassador (1952), no.4, pp.79–98
17 black-and-white photographs
AAD/1987/1/107/1–17

'All the Queen's Horses and All the Queen's Men', part of the Background of Britain series. Men's country fashions shot at the Olympic Horse Trials at Badminton
The Ambassador (1952), no.6, pp.71–5
23 black-and-white photographs
AAD/1987/1/108/1–23

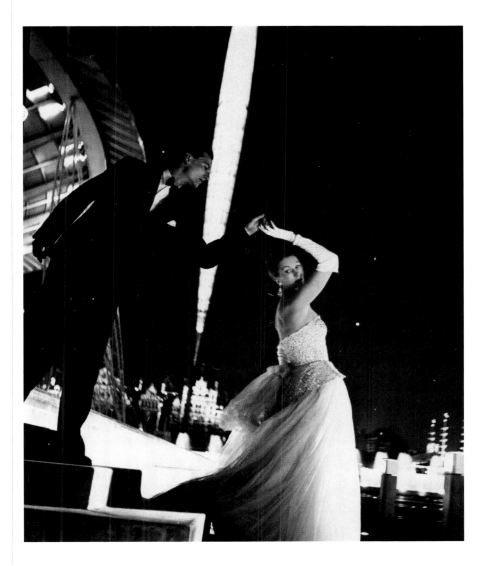

'All the Queen's Horses and All the Queen's Men', part of the Background of Britain series. Men's country fashions shot at the Olympic Horse Trials at Badminton
The Ambassador (1952), no.6, pp.71–5
252 black-and-white contacts
AAD/1987/1/109/1–37

'Style and Scholarship': men's fashions modelled by Rhys Evans and fellow students from the Cambridge Photographic Society
The Ambassador (1952), no.7, pp.7 and 101–11
69 black-and-white photographs
AAD/1987/1/110/1–69

'Style and Scholarship': men's fashions modelled by Rhys Evans and fellow students from the Cambridge Photographic Society
The Ambassador (1952), no.7, p.7 and pp.101–11
245 black-and-white contacts
AAD/1987/1/111/1–13

'Milling around Lancashire': Barbara Goalen modelling textiles in various Calico Printers Association mills and offices
The Ambassador (1952), no.9, pp.79–94
652 black-and-white contacts
AAD/1987/1/112/1–74

'Milling around Lancashire': Barbara Goalen modelling textiles in various Lancashire mills
The Ambassador (1952), no.9, pp.79–94
42 black-and-white photographs
AAD/1987/1/113/1–42

'Milling around Lancashire': Barbara Goalen modelling textiles in various Lancashire mills
The Ambassador (1952), no.9, pp.79–94
31 black-and-white photographs
AAD/1987/1/113/43–75

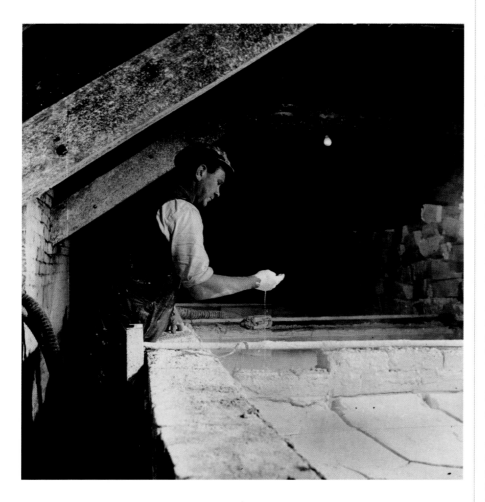

Above: 'Inspired Pottery': feature on the pottery industry in north Staffordshire

The Ambassador (1952), no.12, pp.76–91

24 black-and-white photographs

AAD/1987/1/114/1-24

'Couture at St Moritz': *Ambassador* promotion of British couture, fashion and textiles. Fashion shows photographed on ice, in flight, and at Suvretta House in St Moritz

The Ambassador (1953), no.3, pp.79–90

46 black-and-white photographs and complete sheets of contacts

AAD/1987/1/115/1-34 & 44-55 File 1

'Couture at St Moritz': *Ambassador* promotion of British couture, fashion and textiles. Fashion shows photographed on ice, in flight, and at Suvretta House in St Moritz

The Ambassador (1953), no.3, pp.79–90

9 black-and-white photographs

AAD/1987/1/115/35-43 File 2

'The Young Idea': feature on children's clothes and the development of new textiles

The Ambassador (1953), no.2, pp.84–89

2 black-and-white photographs

AAD/1987/1/116/1-2

'What They Stand For': John Piper and Patrick Reyntiens stained glass, John Piper at work in studio

The Ambassador (March 1953), Coronation issue, pp.40–52

8 black-and-white photographs, 7 black-and-white complete contact sheets, 7 black-and-white negatives, 25 colour negatives, 1 roll colour negatives

AAD/1987/1/117

'Pomp and Circumstance': Benjamin Britten

The Ambassador (March 1953), Coronation issue, pp.62–66

8 black-and-white photographs, 12 black-and-white contacts

AAD/1987/1/118/1-9

'In Harmony with Architecture': Henry Moore at work in his studio, and photographs of individual pieces of sculpture

The Ambassador (March 1953), Coronation issue, pp.34–37

39 black-and-white photographs, 87 contacts

AAD/1987/1/119/1-39 File 1

'In Harmony with Architecture': Henry Moore at work in his studio, and photographs of individual pieces of sculpture

The Ambassador (March 1953), Coronation issue, pp.34–37

9 black-and-white photographs

AAD/1987/1/119/40-48 File 2

'Mediterranean Fortnight': Rome, Athens, Cyprus and Istanbul. British fashion and textiles shot on location, photographs of local people and places of interest

The Ambassador (1953), no.9, pp.71–96

30 black-and-white photographs

AAD/1987/1/120/1-30 File 1

'Mediterranean Fortnight': Rome, Athens, Cyprus and Istanbul. British fashion and textiles shot on location, photographs of local people and places of interest

The Ambassador (1953), no.9, pp.71–96

26 black-and-white photographs

AAD/1987/1/120/31-57 File 2

'Mediterranean Fortnight': Rome, Athens, Cyprus and Istanbul. British fashion and textiles shot on location, photographs of local people and places of interest

The Ambassador (1953), no.9, pp.71–96

11 black-and-white photographs, 27 sheets of black-and-white contacts, 7 contacts

AAD/1987/1/121/1-39

'Mediterranean Fortnight': Rome, Athens, Cyprus and Istanbul. British fashion and textiles shot on location, photographs of local people and places of interest

The Ambassador (1953), no.9, pp.71–96

2 black-and-white photographs, 12 black-and-white contacts

AAD/1987/1/122/1-4

'Mediterranean Fortnight': Rome, Athens, Cyprus and Istanbul. British fashion and textiles shot on location, photographs of local people and places of interest

The Ambassador (1953), no.9, pp.71–96

10 black-and-white photographs, 24 sheets of black-and-white contacts

AAD/1987/1/123/1-35

'Mediterranean Fortnight': Rome, Athens, Cyprus and Istanbul. British fashion and textiles shot on location, photographs of local people and places of interest

The Ambassador (1953), no.9, pp.71–96

3 black-and-white photographs, 14 sheets of black-and-white contacts, 25 black-and-white contacts

AAD/1987/1/124/1-18

'Hobbies': John Cranko, ballet dancer, photographed at home

The Ambassador (1953), no.10, pp.88–95

4 black-and-white photographs

AAD/1987/1/125/1-4

'Painting into Textiles': work produced for the *Painting into Textiles* exhibition sponsored by *The Ambassador* and held at the ICA

The Ambassador (1953), no.11, pp.71–90

60 black-and-white photographs

AAD/1987/1/126/1–60 File 1

'Painting into Textiles': work produced for the *Painting into Textiles* exhibition sponsored by *The Ambassador* and held at the ICA

The Ambassador (1953), no.11, pp.71–90

36 black-and-white photographs

AAD/1987/1/126/61–99 File 2

'Festive Scotland': photographs taken at the International Festival of Music and Drama in Edinburgh

The Ambassador (1953), no.11, pp.112–16

4 black-and-white photographs

AAD/1987/1/127/1–4

'The Stars Above': fashion show shot at Greenwich Observatory and Museum

The Ambassador (1954), no.1, pp.59–67

26 black-and-white photographs, 249 black-and-white contacts

AAD/1987/1/128/1–27

'Portland Stone – Portland Colours': photographs by John Piper of Portland, Portland stone and local people

The Ambassador (1954), no.6, pp.80–94

19 black-and-white photographs

AAD/1987/1/129/1–19 File 1

'Portland Stone – Portland Colours': photographs by John Piper of Portland, Portland stone and local people

The Ambassador (1954), no.6, pp.80–94

26 black-and-white photographs

AAD/1987/1/129/20–45 File 2

'Portland Stone – Portland Colours': photographs by John Piper of Portland, Portland stone and local people

The Ambassador (1954), no.6, pp.80–94

583 black-and-white contacts, 12 colour negatives, 1 Ambassador envelope

AAD/1987/1/129/46 File 3

'*The Ambassador* from Scotland': Scottish textiles. Features include: hopsack weave, furnishing textiles and rainwear and 'Hopsack and Stout' colours for menswear

The Ambassador (1954), no.7, pp.71–99

8 sheets of contact prints

AAD/1987/1/130/1–10

'Canada – East to West': trade visit to Canada, including Canadian personalities, local people, architecture and British exports

The Ambassador (1954), no.8, pp.67–102

17 black-and-white photographs

AAD/1987/1/131/1–17 File 1

'Canada – East to West': trade visit to Canada, including Canadian personalities, local people, architecture and British exports

The Ambassador (1954), no.8, pp.67–102

46 black-and-white photographs

AAD/1987/1/131/18–63 File 2

'Canada – East to West': trade visit to Canada, including Canadian personalities, local people, architecture and British exports; rough design for *The Ambassador* cover

The Ambassador (1954), no.8, pp.67–102

50 sheets of 456 black-and-white contact prints

AAD/1987/1/132/1–50 File 1

'Canada – East to West': trade visit to Canada, including Canadian personalities, local people, architecture and British exports

The Ambassador (1954), no.8, pp.67–102

27 sheets of black-and-white contact prints

AAD/1987/1/132/51–76 File 2

'Canada – East to West': trade visit to Canada, including Canadian personalities, local people, architecture and British exports

The Ambassador (1954), no.8, pp.67–102

28 sheets of black-and-white contact photographs

AAD/1987/1/132/77–105 File 3

'Canada – East to West': trade visit to Canada, including Canadian personalities, local people, architecture and British exports

The Ambassador (1954), no.8, pp.67–102

75 sheets of black-and-white contact photographs

AAD/1987/1/133/1–75 File 1

'Canada – East to West': trade visit to Canada, including Canadian personalities, local people, architecture and British exports

The Ambassador (1954), no.8, pp.67–102

41 sheets of black-and-white contact photographs

AAD/1987/1/133/76–116 File 2

'Sybil Connolly Does Irish Linen Proud': Sybil Connolly's fashion collection made from Irish linen

The Ambassador (1955), no.3, pp.67–74

24 black-and-white photographs, 26 black-and-white contact sheets

AAD/1987/1/135/1–50

'Foundations of Artistry': foundation garments

The Ambassador (1955), no.3, pp.125–31

2 black-and-white photographs

AAD/1987/1/136/1–2

Overleaf: '*The Ambassador* at the Brussels Exhibition' and 'Summing-up on Brussels': designs for *The Ambassador* stand, photographs of the stand and exhibits, opening night of the Brussels Exhibition

The Ambassador (1955), no.6, pp.107–13; no.8, pp.92–96

97 black-and-white photographs, 32 black-and-white contact sheets, 1 photograph of newspaper article

AAD/1987/1/137/1–130

'Pattern in Contrast': Spanish architecture, design and form

The Ambassador (1955), no.10, pp.100–25

40 black-and-white photographs

AAD/1987/1/138/1–40 File 1

'Pattern in Contrast': Spanish architecture, design and form

The Ambassador (1955), no.10, pp.100–25

39 black-and-white photographs

AAD/1987/1/138/41–80 File 2

'Pattern in Contrast': Spanish architecture, design and form

The Ambassador (1955), no.10, pp.100–25

39 black-and-white photographs

AAD/1987/1/138/81–120 File 3

'Pattern in Contrast': Spanish architecture, design and form. Includes black-and-white photograph of textile design by Louis le Brocquy, 1 crayon and gouache original design on paper by Louis le Brocquy, 1 colour chart, as sourced in Spain by *The Ambassador*

The Ambassador (1955), no.10, pp.100–25

34 black-and-white photographs

AAD/1987/1/138/121–156 File 4

'Pattern in Contrast': Spanish architecture, design and form

The Ambassador (1955), no.10, pp.100–25

54 black-and-white contact sheets

AAD/1987/1/138/157–211 File 5

'Pattern in Contrast': Spanish architecture, design and form

The Ambassador (1955), no.10, pp.100–25

50 colour negatives

AAD/1987/1/138/212–274 File 6

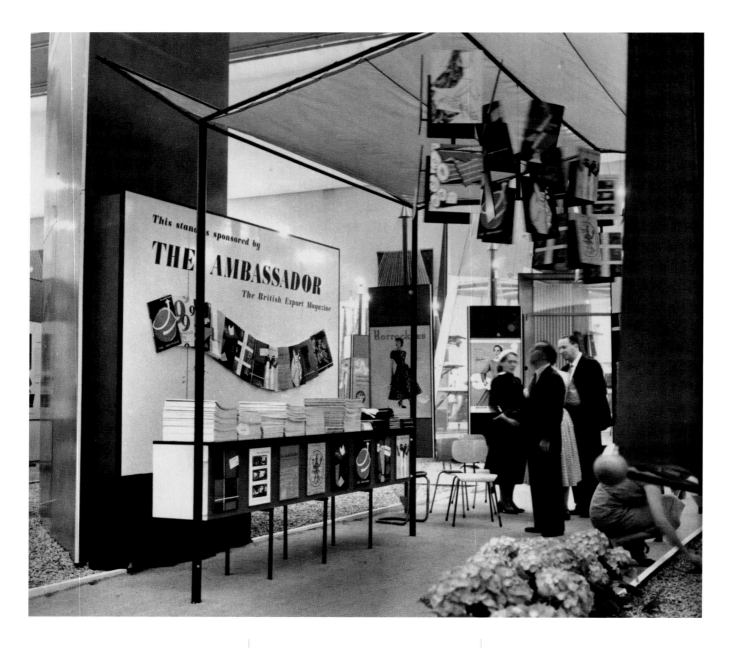

'London's Luxury Line': fashion spring collections of the Incorporated Society of London Fashion Designers

The Ambassador (1956), no.3, pp.76–83

7 black-and-white photographs

AAD/1987/1/139/1–7

'Osbert Lancaster and the English Look'

The Ambassador (1956), no.5, pp.76–83

6 black-and-white photographs, 3 black-and-white contact sheets

AAD/1987/1/140/1–9

'Mozart and his First Audiences': feature on Mozart and the Rococo fashions of his European audiences; pictorial sources from Vienna's historical museum and various departments of the Austrian National Library; photographs of eighteenth-century engravings of eighteenth-century opera designs, opera audiences and street vendors

The Ambassador (1956), no.5, pp.59–82

11 black-and-white photographs

AAD/1987/1/141/1–11 File 1

'Mozart and his First Audiences': feature on Mozart and the Rococo fashions of his European audiences, pictorial sources from Vienna's historical museum and various departments of the Austrian National Library, photographs of eighteenth-century textile samples from various volumes of the *Journal für Fabrik Manufaktur und Handlung*, photograph of fashion plate engraving from Gallery des Modes, Paris, 1778

The Ambassador (1956), no.5, pp.59–82

17 black-and-white photographs

AAD/1987/1/141/12–29 File 2

'Mozart and his First Audiences': feature on Mozart and the Rococo fashions of his European audiences, photographs of the engravings from various illustrated eighteenth-century fashion journals; many have contemporary descriptions documented in French

The Ambassador (1956), no.5, pp.59–82

39 black-and-white photographs

AAD/1987/1/141/30–69 File 3

'Mozart and his First Audiences': feature on Mozart and the Rococo fashions of his European audiences, typed notes, written in German, taken from the *Journal für Fabrik Manufaktur und Handlung* (1792–3); hand-painted colour ways probably taken from eighteenth-century fashion plates of male and female dress; ephemera relating to the history of Mozart, Vienna and Austria

The Ambassador (1956), no.5, pp.59–82

4 typed notes, 66 hand-painted colour ways, 20 items of ephemera

AAD/1987/1/141/70–90 File 4

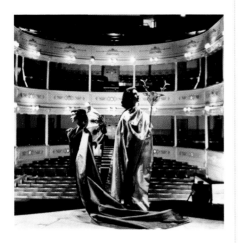

Top, left: '*The Ambassador* Plays Charades at the Theatre Royal': feature on new British textiles photographed at Bristol Old Vic Theatre
The Ambassador (1956), no.6, pp.84–90
13 black-and-white contact sheets, 18 black-and-white photographs
AAD/1987/1/142/1–31

Top, centre: 'The Alchemist's Dream Comes True: Calder Hall'
The Ambassador (1957), no.1, pp.115–30
37 black-and-white photographs
AAD/1987/1/143/1–16 File 1

'The Alchemist's Dream Comes True: Calder Hall'
The Ambassador (1957), no.1, pp.115–30
37 black-and-white photographs
AAD/1987/1/143/17–37 File 2

'The Alchemist's Dream Comes True: Calder Hall'
The Ambassador (1957), no.1, pp.115–30
37 black-and-white photographs
AAD/1987/1/143/38–59 File 3

'Town and Country: The Best of Both Worlds': feature on the dress and style of Anthony Wysard, editor of *Wheeler's Review*
The Ambassador (1957), no.3, pp.57–62
1 black-and-white photograph
AAD/1987/1/144/1

Top, right: 'British Cottons for 1958'
The Ambassador (1957), no.7, pp.73–108
19 black-and-white photographs
AAD/1987/1/145/1–19

'Scotland in Paris': feature on Scottish woollens modelled and photographed in Paris
The Ambassador (1957), no.8, pp.56–92
2 black-and-white photographs, 8 black-and-white contact sheets
AAD/1987/1/146/1–10 File 1

'Scotland in Paris': feature on Scottish woollens modelled and photographed in Paris
The Ambassador (1957), no.8, pp.56–92
98 black-and-white transparencies
AAD/1987/1/146/11 File 2

'Out of this World': feature on the conquest of Space and the colours evoked by Outer Space
The Ambassador (1957), no.12, pp.81–96
3 black-and-white photographs
AAD/1987/1/147/1–3

'*The Ambassador* Visits Holland': first in a European Common Market series, focusing on the Netherlands. British fashions and artefacts photographed in Dutch settings
The Ambassador (1958), no.3, pp.76–96
1 black-and-white photograph
AAD/1987/1/148/1

Below: 'British Cottons for 1959: Cotton is Fashion – Cotton Dresses in Scandinavia'
The Ambassador (1958), no.7, pp.47–106
9 black-and-white photographs
AAD/1987/1/149/1–9

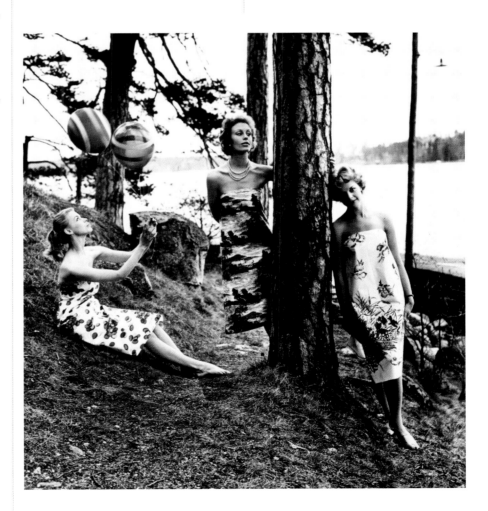

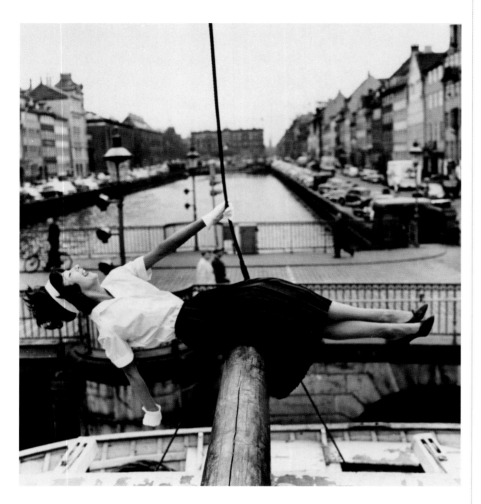

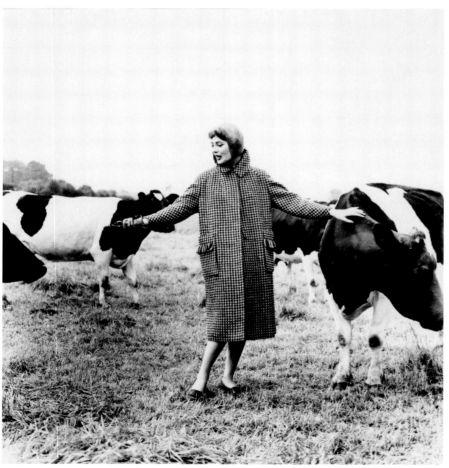

'Lord & Taylor's British Fortnight': review of Lord & Taylor's 'British Fortnight' reproduced for *The Ambassador*

The Ambassador (1958), no.9, pp.1–52

AAD/1987/1/153/85 File 4

'*The Ambassador* in Brazil: Our Pictures at the Palace': feature on editorial visit to Brazil and the gift of contemporary British modern art from *The Ambassador* to the museums of modern art in Bahia and Minas Gerais. Includes photograph of sculpture outside the Palácio de Alvorada, and transparencies of John Piper and his paintings

The Ambassador (1960), no.1, pp.47–66

1 black-and-white photograph, 24 colour transparencies

AAD/1987/1/154/1–20

'How New is Art Nouveau?': feature on Charles Rennie Mackintosh. Photograph of chair designed by C.R. Mackintosh

The Ambassador (1961), no.2, pp.77–84

1 black-and-white photograph [not taken by Elsbeth Juda]

AAD/1987/1/155/1

'*The Ambassador* Visits Japan': feature on the export of British woollens and worsteds to Japan. Photographs taken by Jay of textiles, textile merchandise, Japan and her people, architecture and the opera

The Ambassador (1961), no.12, pp.60–128

33 black-and-white photographs, 43 packets of black-and-white negatives

AAD/1987/1/158/1–33 File 1

'*The Ambassador* Visits Japan': feature on the export of British woollens and worsteds to Japan. Photographs taken by Jay of textiles, textile merchandise, Japan and her people, architecture and the opera

The Ambassador (1961), no.12, pp.60–128

32 black-and-white photographs

AAD/1987/1/158/34–65 File 2

'*The Ambassador* Visits Japan': feature on the export of British woollens and worsteds to Japan. Photographs taken by Jay of textiles, textile merchandise, Japan and her people, architecture and the opera

The Ambassador (1961), no.12, pp.60–128

43 black-and-white photographs

AAD/1987/1/158/65–108 File 3

'Foto-Finnish': feature on Anglo-Finnish promotional trade fairs held for the centenary of Finland's largest department store, Oy Stockmann Ab, in Helsinki. Photographs of Anglo-Finnish fashion, glassware, ceramics and textiles shot in Oy Stockmann Ab, at *Finlandia*, an exhibition of Finnish designs at the V&A, and in the city of Helsinki

The Ambassador (1962), no.3, pp.62–78

43 black-and-white contacts

AAD/1987/1/156/1–43 File 1

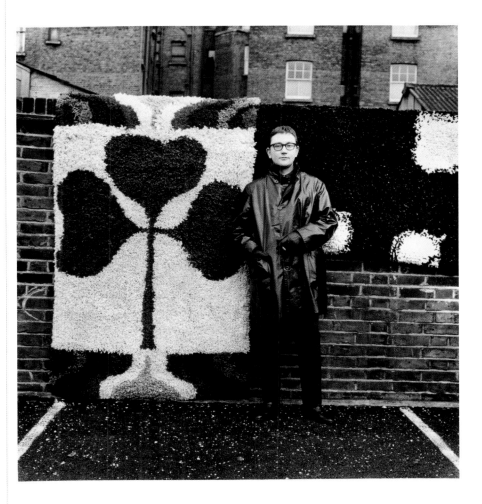

'Foto-Finnish': feature on Anglo-Finnish promotional trade fairs held for the centenary of Finland's largest department store, Oy Stockmann Ab, in Helsinki. Photographs of Anglo-Finnish fashion, glassware, ceramics and textiles shot in Oy Stockmann Ab, at *Finlandia*, an exhibition of Finnish designs at the V&A, and in the city of Helsinki

The Ambassador (1962), no.3, pp.62–78

24 black-and-white photographs

AAD/1987/1/156/44–68 File 2

Above: 'Limited Editions': photographic feature on rugs designed by contemporary artists and exhibited at the ICA. Artists include Anne Buchanan, John Plumb, Andrew Forge, Joe Tilson, Peter Stroud, John Ernest and William Scott (pictured)

The Ambassador (1962), no.6, pp.117–19

8 black-and-white photographs

AAD/1987/1/157/1–8

'The Ambassador Visits Hong Kong': editorial visit to Hong Kong. Photographs of the city and a tailor's shop

The Ambassador (1963), no.1, pp.85–100

3 black-and-white photographs, 1 printed ephemera

AAD/1987/1/159/1–4

'Great Men by Vivienne': portrait photographs of famous British men taken by the photographer 'Vivienne' (Madame Yvonde)

The Ambassador (1963), no.2, pp.43–46

6 black-and-white photographs

AAD/1987/1/160/1–6

'*The Ambassador* Awards Presentation': *The Ambassador* Awards for Achievement 1962 presented by HRH Princess Margaret

The Ambassador (1963), no.6, pp.5–7

14 black-and-white photographs

AAD/1987/1/161/1–14

'Fab Pop Fash': British ready-to-wear collections by young fashion designers, modelled by Queenie, wife of the painter Brett Whiteley. Feature photographed at the Rauschenberg exhibition at the Whitechapel Art Gallery

The Ambassador (1964), no.4, pp.52–58

6 black-and-white photographs, 5 black-and-white contact sheets

AAD/1987/1/162/1–12 File 1

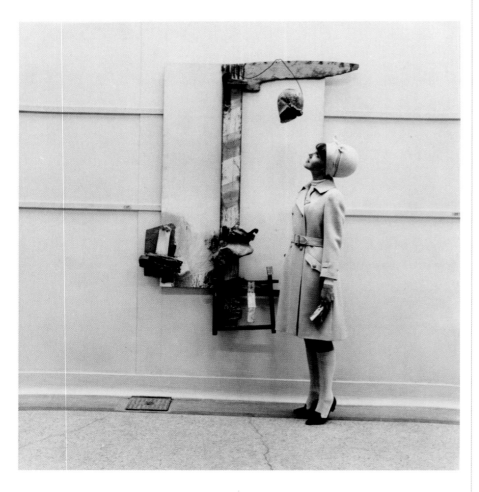

Above: 'Fab Pop Fash': British ready-to-wear collections by young fashion designers, modelled by Queenie, wife of the painter Brett Whiteley. Feature photographed at the Rauschenberg exhibition at the Whitechapel Art Gallery
The Ambassador (1964), no.4, pp.52–58
13 black-and-white photographs
AAD/1987/1/162/13–24 File 2

'Double Exposure': Jay's photographs of the British Nylon spinners in their Pontypool factory. Feature includes both photographs and Brett Whiteley's paintings of the factory
The Ambassador (1964), no.11, pp.149–78
12 black-and-white photographs
AAD/1987/1/163/1–12

'The Role of The Council of Industrial Design'
The Ambassador (1964), no.11, pp.184–6
50 black-and-white contact sheets
AAD/1987/1/164/1–50 File 1

'The Role of The Council of Industrial Design'
The Ambassador (1964), no.11, pp.184–86
22 black-and-white photographs
AAD/1987/1/164/51–72 File 2

'The Role of The Council of Industrial Design'
The Ambassador (1964), no.11, pp.184–86
24 black-and-white photographs
AAD/1987/1/164/73–96 File 3

Royal College of Art professors at lunch, 10 Palace Gate: photographs of Dr Assis Chateaubriand, Robert Godden, R.W. Baker, Madge Garland, Richard Gayatt, Frank Dobson, Hans P. Juda, Robin Darwin, Principal of the Royal College of Art
1958
16 black-and-white photographs, 4 black-and-white contact sheets
AAD/1987/1/165/1–20

Negatives for Sheffield catalogue and photographs of cover designs for *The Ambassador*: paintings exhibited in the 1953 *Painting into Textiles* exhibition at the ICA
[1953]
10 black-and-white photographs, 38 black-and-white negatives
AAD/1987/1/166

Background photographs for *The Ambassador*: Halifax, Kidderminster, Yorkshire, etc; photographs of cathedrals, steeples, factory towers and a Jacquard loom
undated
8 black-and-white photographs
AAD/1987/1/167/1–8

Royal College of Art Trafalgar Day dinner honouring the ambassador to London from Brazil, 21 October 1958, hosted by Hans Juda and Robin Darwin, the principal of the Royal College of Art. Photographs of Dr Assis Chateaubriand and guests at the dinner
1958
19 black-and-white photographs
AAD/1987/1/168/1–19

Barcelona: sculpture, Picasso mural at museum
undated
11 black-and-white photographs
AAD/1987/1/169/1–11

Francis Bacon exhibition at the Hanover Gallery; Peter Lanyon, Louis le Brocquy and William Gear at exhibition of Peter Lanyon's paintings; James Tower pottery; Mr Maggs, bookseller
undated
11 black-and-white photographs
AAD/1987/1/170/1–11

Oliver Messel with set design, possibly Figaro, at Glyndebourne
undated
2 black-and-white photographs
AAD/1987/1/171/1–2

Worksheets for Burton Photography prepared by Crawford's advertising agency; includes brief description of fashion shoot, name of model, style of dress and some samples of cloth
undated
2 worksheets
AAD/1987/1/172/1–2

Westminster Abbey, photographs taken of details of stone and wood carvings [not used for *The Ambassador*]
undated
24 black-and-white photographs
AAD/1987/1/173/1–24

Photographs of architecture and eighteenth-century tombstones relating to a feature, 'Cotswold Wool', commissioned from John Piper for *The Ambassador*
undated
11 black-and-white photographs [not taken by Jay]
AAD/1987/1/174/1–11

Thailand: shots of textile weavers and dyers, local art school, various social contexts [possibly never used for The Ambassador
undated
17 black-and-white contact sheets
AAD/1987/1/175/1–17

Robin Darwin and Elena with Hans Juda at Fairley
undated
2 black-and-white photographs
AAD/1987/1/176/1–2

'Marks & Spencer's Goes International'
The Ambassador (1964), no.2, pp.77–80
2 black-and-white contacts
AAD/1987/1/177/1–2

Tamayo, a Mexican designer in London to design for the ballet
undated
3 black-and-white contact sheets
AAD/1987/1/178/1–3

[number not used]
AAD/1987/1/179

Lynn Chadwick, sculptor: shots of Chadwick's work, the sculptor with his first wife
undated
14 black-and-white contact sheets
AAD/1987/1/180/1–14

Kenneth Armitage, sculptor: shipping sculptures to Château Mouton-Rothschild; photographs of Kenneth Armitage and his sculptures, including *The Ambassador* Award
undated
23 black-and-white contact sheets, 3 black-and-white photographs
AAD/1987/1/181/1–27

Photographs of Snowdon and guests taken by Jay Juda at a private view book party
undated
19 black-and-white photographs
AAD/1987/1/182/1–18

Sotheby's sale of Hans and Elsbeth Juda's collection of modern British and Continental drawings, paintings and sculpture, 1 November 1967; Sotheby's sale catalogue, press cuttings on the sale
1967
1 catalogue, 6 press cuttings
AAD/1987/1/183/1–7

John Piper, John Betjeman, Hans Juda and Piper family [not used in *The Ambassador*]
undated
4 black-and-white photographs, 18 black-and-white contact sheets
AAD/1987/1/184/1–32

Juda collection of paintings: Sheffield Exhibition, Graves Art Gallery, photographs mounted on card, photographs, black-and-white transparencies, colour transparencies
undated
15 black-and-white photographs
AAD/1987/1/185/1–15 File 1

Juda collection of paintings: Sheffield Exhibition, Graves Art Gallery, photographs, photographs mounted on card, black-and-white transparencies, colour transparencies
undated
39 colour transparencies, 8 black-and-white transparencies, 8 black-and-white photographs
AAD/1987/1/185/16–55 File 2

'New Faces – New Cloth'. Fashion feature on the personal choice of dress of three young men: The Hon. Robert Erskine, collector; Anthony Armstrong-Jones, photographer; and Neil Macmillan, writer
The Ambassador (1954), no.7, pp.108–18
2 black-and-white photographs, 1 black-and-white contact sheet
AAD/1987/1/186/1–3

[Number not used]
AAD/1987/1/187

'*The Ambassador* Features David Jones': feature on the David Jones store in Australia. Photograph of British men's casual fashions shot at the races
The Ambassador (1959), no.4, pp.1–44
1 black-and-white photograph
AAD/1987/1/188/1

Below: 'Britain – Nation of Conservative Adventurers' / 'Scotland – Vive L'Ecosse', feature on commercial industries.
The Ambassador (1959), no.12, pp.3–18
1 black-and-white photograph
AAD/1987/1/189/1

Notes

Introduction
Christopher Breward

1 *International Textiles* (1946), no.3, p.59
2 Brian Harrison, *Seeking a Role: The United Kingdom, 1951–1970* (Oxford: Oxford University Press, 2009), p.1
3 Ibid., p.2
4 *International Textiles* (1946), no.3, p.60
5 Dominic Sandbrook, *Never Had It So Good: A History of Britain from Suez to the Beatles* (London: Little Brown, 2005), pp.74–5
6 Ibid., p.691
7 *The Ambassador* (1964), no.11, p.3
8 *The Ambassador* (1972), no.8, p.3

1. Hans and Elsbeth Juda
Annamarie Stapleton

1 Elsbeth recalls her father's embarrassment and shame at having to receive packages of money from Gretel's mother to sustain the family. Although employed by the university, he was poorly paid and did not receive his seat as a professor until very late in his career.
2 Goldstein was described as a 'true republican, a man of his time', an accomplished speaker and representative of his generation. As well as serving in the German army during the First World War, he dedicated his professional career to teaching philosophy at the Technical Institute in Darmstadt (1903–24). His students and followers regularly called into the family home to discuss philosophy, the rapidly emerging events and socialist politics. They included Carlo Mierendorff and Theodor Haubach, who were to be involved in undermining the Nazi Party and, ultimately, the unsuccessful assassination attempt on Adolf Hitler in 1944.
3 Gretel Goldstein continued to be involved in social work, distributing clothing to the poor, travelling with her husband on a lecture tour of the United States, and taking on public-speaking engagements, long after Julius's death from cancer in 1929.
4 Terence Senter, 'The Transitional Years', in Achim Borchardt-Hume (ed.), *Albers and Moholy-Nagy: From the Bauhaus to the New World* (London: Tate Publishing, 2006), pp.85–6. Senter interviewed Hans Juda in 1972.
5 Hans Juda, obituary, *The Times* (6 February 1975), p.20
6 Publication of the Amsterdam-based periodical was suspended only from May 1940 to 1943, although an issue dated December 1940 was published under German occupation, but later disowned by the publisher. From 1943 the Amsterdam version was published sporadically, but entirely independently from the London version.
7 It was only in February 1947 that *The Ambassador* fell into problems, after the Ministry of Fuel and Power stopped the printing of all periodicals during the coal crisis; issue no.2 was published incomplete and a little late, but the missing colour section (pp.79–114) was added to the March issue.
8 Elsbeth Juda in an interview, 27 November 1992, V&A Archive of Art and Design, AAD/1987/1/207
9 Stanley Marcus, *Minding the Store* (Boston, MA, 1974; reprinted 1997), p.202
10 Editorial, *The Ambassador* (1947), no.2
11 The Ambassador (1947), no.2, advertised its subscription at $7.00 'post free' or £1 15s. 0d. to overseas subscribers only; by 1950 this was $5.00 or £1 15s. 0d., with advertising accepted from UK-based companies only.
12 Letter in AAD Juda Archive
13 *The Ambassador* (1947), no.6, p.118

14 In 1946 Hans approached Myfanwy Piper, who had cut her 'editorial' teeth on the avant-garde abstract art magazine *Axis*, to edit a new and 'sumptuous' magazine ostensibly featuring contemporary British artists. As Myfanwy wrote to Osbert Sitwell, 'it is to concentrate on large and colour reproductions in any and every process'. But for whatever reason, perhaps it was too inward-looking, or lacked relevance in the post-war environment, the publication was not a success and only one issue was published.
15 Hans had worked for a couturier whilst a student, and had learnt the hard way about the selection of samples and quality of different cloths, as well as covering the textile industry for the *Berliner Tagerblatt*. At *International Textiles* Elsbeth says she rapidly learnt to deal with the demands of top US retailers. One Ms Schiffer, a buyer for Lord & Taylor, was particularly demanding and rigorous. She wanted to see collections of materials, variety of linings and everything modelled for her first thing in the morning. The British manufacturers were not willing or able, and Elsbeth recalls having to model camel coats herself, create colour charts for companies, and advise on sales techniques, but all too often the manufacturers just could not be bothered.
16 During 1952–3 alone the Judas lent five paintings by Sutherland to the Venice Biennale of 1952 and three to the Tate in exhibitions in 1953; see correspondence and catalogues in AAD Juda Archive
17 *The Ambassador* (1946), no.11
18 Two of Hans's abstract paintings were made into textiles and produced by Heal & Son Ltd as 'Tapa' 1961 and 'Vortex' 1966; Elsbeth painted extensively after finishing her consultancy work with ICI and held a number of exhibitions of her paintings, semi-autobiographical collages and photographs from the 1990s onwards. In 2008 she was made a senior fellow of the Royal College of Art, London.
19 Although it had been initially John Piper's idea that the Judas build a new house next to theirs, and that Hans help them out by buying the farm next door to prevent development, there was some rankling at the number of guests at the Judas', and at Hans's plans for an artists' community in the farm buildings, which Piper felt had invaded his quiet retreat.
20 Undated letter from Kathy Sutherland to Elsbeth asking her to bring her 'magic camera' to Chartwell on 16 October [1954] in the Juda Archive AAD, London
21 *The Times* (6 February 1975), p.20; *Burlington Magazine* (1975), vol.117, no.868, pp. 487–8; various letters of condolence in AAD Juda Archive
22 Marcus, *Minding the Store*, p.202
23 Frances Hodgson, 'Glamour Meets Commercial Photography', *Financial Times* (2 May 2009)

2. Photography and Graphic Design: 'Just a Job Lot'
Abraham Thomas

I would like to thank Elsbeth Juda for a wonderful afternoon of stories and anecdotes, supplying me with much valuable information with which to supplement this essay. I am also grateful to colleagues in the V&A Archive of Art & Design for servicing my endless requests for old volumes of *The Ambassador* and boxes of original photographs, negatives and contact sheets.

1 Interview with Elsbeth Juda, autumn 1992, V&A Archive of Art and Design, AAD/1987/1/207
2 T. Senter, 'Moholy-Nagy's English Photography', *Burlington Magazine* (November 1981)
3 Hans Juda, interview with Terence Senter, 11 May 1972, as cited in T. Senter, 'Moholy-Nagy: The Transitional Years', in *Albers and Moholy-Nagy: From the Bauhaus to the New World* (London, 2006)

4 Later that year, Moholy-Nagy produced an exhibition design for the Dutch Artificial Silk Manufacturers at the Utrecht Spring Fair, using spatial structures capable of projecting nearly 800 fabrics. Its success led to a commission for a reduced version at the Brussels World's Fair. See Senter, 'Transitional Years', p.87.

5 Elsbeth Juda, interview with Abraham Thomas, 9 June 2011. Unless otherwise referenced, all further personal recollections and quotes from Juda have been sourced from this interview.

6 See *Crawford's: The Complete Advertising Agency* (London, 1951) and
 A. Havinden, *Advertising and the Artist* (London, 1956)

7 For examples of Havinden cover artwork, see *The Ambassador* (May and June 1948)

8 Elsbeth Juda interview, 1992

9 See A. Stapleton, 'The Ambassador', *Decorative Arts Society Journal* (2009), no.33

10 Elsbeth Juda interview, 1992

11 Stanley Marcus, *Minding the Store* (Boston, MA, 1974; reprinted 1997),
 p. 202, as cited in Stapleton, 'The Ambassador'

12 See 'Mrs Pompadour' in *Daily Graphic* (29 July 1949)

13 See Natasha Kroll Archive, University of Brighton Design Archives

14 Elsbeth Juda interview, 1992

15 Elsbeth Juda interview with Erika Lederman, 3 May 2009, Bloomberg News

16 Douglas Newton, obituary, *New York Times* (22 September 2001)

17 See A. Stapleton, 'A New Vernacular: The Time & Life Building, London', *Decorative Arts Society Journal* (1997), no.21

18 *Design* (March 1953), no.51, as cited in Stapleton, 'A New Vernacular'

19 Elsbeth recalled that she would often use Wylie for underwear features, because she found it difficult to find models willing to wear lingerie for photography shoots. Wylie progressed to a full-time career as a fashion model, after these moonlighting sessions with Elsbeth.

20 Cited in R. Muir, 'Diplomatic Service', *World of Interiors* (April 2009)

21 Ibid.

3. Art and *The Ambassador*

Gill Saunders

1 F.E. Richter, of the Economic Co-Operation Administration, New York, in a letter to Mr H. Lansdorf, director of *The Ambassador*, 11 June 1951

2 Melville, Foreword to catalogue of the exhibition *In Our View*, Graves Art Gallery, Sheffield, 1967, n.p.

3 *House & Garden* (September 1953), p.39

4 Frank Constantine (director, Sheffield City Art Galleries), acknowledgement to catalogue of the exhibition *In Our View*, 1967, n.p.

5 Melville, Foreword to *In Our View*, n.p.

6 Ibid.

7 For issue no.11 of 1953, later translated into a furnishing textile, and also used as the cover for the catalogue to *Painting into Textiles*

8 *Catalogue of Modern British and Continental Drawings, Paintings and Sculpture. The Property of Mr & Mrs Hans Juda. 1st November, 1967*, p.5

9 An interview with Elsbeth Juda, re *The Ambassador* (autumn 1992), V&A Archive of Art and Design, AAD/1987/1/207

10 The same honour was extended to Elsbeth exactly 40 years later, in 2009

11 The 'Recording Britain' collection is now in the V&A

12 This was in Hans's and Elsbeth's collection and appears as lot 128 in the Sotheby's sale catalogue

13 Sotheby's sale catalogue, lot 51; present whereabouts unknown

14 *The Ambassador* (1953), no.11

15 *Painting into Textiles* (London, ICA, ex. cat., 21 October–14 November 1953)

16 See sample in the V&A: Circ.509–1954

17 Alan Peat, *David Whitehead Limited: Artist Designed Textiles, 1952–1969* (Oldham Museum and Art Gallery, ex. cat., 11 December 1993–
 3 February 1994), p.8

18 See sample of fabric in V&A: Circ.9–1957

19 Elsbeth Juda, interview (autumn 1992), AAD/1987/1/207

20 *The Ambassador*, 1952, no. 7, pp.3–4

21 It ran to only one issue

22 Illustrated in *In Our View*, fig.14; see also CT in AAD/1987/1/185/16-55, File 2

23 Churchill disliked it so much that his wife Clementine later destroyed it to save him distress

24 Now in the National Portrait Gallery, London

25 Letter from Hans Juda to Lord Beaverbrook, 4 December 1962; AAD/1987/1/205

26 Letter from Hans Juda to Graham Sutherland, 31 March 1949; AAD 1987/1/205

27 Letter from Hans Juda to Graham Sutherland, 10 May 1960; AAD/1987/1/205

28 Memo from Hans Juda to Mr Dean; AAD/1987/1/205

29 Letter from Hans Juda to Graham Sutherland, 21 July 1960; AAD/1987/1/205

30 There is some unresolved confusion about the identity of the artist. This was possibly John Rowland Barker (1911–59), a painter and graphic designer who produced posters for Shell and ICI, and fabrics for Sanderson. Alan Peat's catalogue, however, cites another John Barker (1889–1953), who designed textiles for David Whitehead & Sons Ltd

31 Exhibited as no.147 in *In Our View* and sold as lot 123 in the Sotheby's sale

4. Furnishing Fabrics: 'A Brilliant Story'

Mary Schoeser

1 See, for example, *International Textiles* (1945), no.2, pp.59–66, which includes the comment by Sir Ernest Goodale, chairman of the Furnishing Fabrics Export Group of Great Britain (and chairman of Warner & Sons Ltd), that prints were expected to become more popular because they were easier to produce and answered more economically the desire for multi-colour fabrics.

2 *International Textiles* (6 November 1934), vol.II, no.11, p.26; 'British Made' supplement, ibid. (26 April 1935), vol.III, no.8, p.v; and, noting that in spite of trade barriers, global demand remained steady, p.xii

3 *International Textiles* (15 February 1938), vol.vi, no.3, pp.27–33; and ibid. (June–August 1940), p.48

4 *International Textiles* (12 March 1934), vol.II, no.5, pp.11–22

5 'British Made' supplement, *International Textiles* (27 November 1935), vol.III, no.22, p.vii. Welsh tweeds designed by Straub continued in production well after the Second World War; they are illustrated, for example, in *The Ambassador* (1952), no.1, p.93, on Heal's furniture.

6 See Margot Coatts, *A Weaver's Life: Ethel Mairet, 1872–1952* (London, 1983). Gospels cloths by Mairet and Cyril Risby were also illustrated, in colour, in *The Ambassador* (1946), no.1, p.87

7 *International Textiles* (11 August 1934), vol.II, no.15, pp.12–13

8 See Sigred W. Weltge, *Bauhaus Textiles: Women Artists and the Weaving Workshop* (London, 1993)

9 *The Ambassador* (1946), no.8, pp.95–7. Groag was featured again in ibid. (1955), no.12, p.74. See also Geoff Rayner et al., *Jacqueline Groag: Textile and Pattern Design* (Woodbridge, 2009)

10 See Mary Schoeser, *Marianne Straub* (London: Design Council, 1984), pp.32–70. Throughout the mid-twentieth century, apart from its use as curtaining and carpeting, felt – another British speciality woollen – was also used to upholster both modern and 'transitional' furniture; see, for example, *The Ambassador* (1946), no.5, advertisement inside front cover.

11 *The Ambassador* (1946), no.11, pp.68–77. A witty visual allusion to suitings as interior fabrics can be seen in ibid. (1947), no.8, pp.128–9. One can find proof of the impact of this feature in fabrics for contract and corporate seating such as that sold by Knoll International, which within a short space of time left behind the greys and beiges for richer and ultimately much brighter tones. See Mary Schoeser, 'Knoll: Furnishing Textiles in the Clothing Context': www.knoll.com/Multimedia/8000/KnollTextiles-IntlArt&DesignFair2008.pdf (accessed 20 April 2011)

12 *The Ambassador* (1951), no.9, p.5. Elsa Gullberg's Swedish studio had been widely known since the early 1930s for hand-woven prototypes for industry.

13 *The Ambassador* (1952), no.11, pp.80–81

14 Leichner wove prototypes for Greg's from 1944 to 1950 and in the RCA weaving department from 1948 to 1963, latterly as head. See Coatts, *A Weaver's Life*, p.104, and Weltge, *Bauhaus Textiles*.

15 For further information on Tibor Ltd, see *The Ambassador* (1956), no.3, p.103, and, for example, ibid. (1952), no.8, p.97. See also Lesley Jackson, *Alastair Morton and Edinburgh Weavers: Visionary Textiles and Modern Art* (London, 2012).

16 *The Ambassador* (1955), no.12, p.75, also stating that Grierson 'has done more than any other British designer to develop their sale'. Texture denoted quality whether the design was traditional or contemporary, as indicated in ibid. (1957), no.10, pp.80–88

17 See Susannah Handley, *Nylon: The Manmade Fashion Revolution* (London, 1999), p.55 and *passim*

18 *The Ambassador* (1953), no.1, pp.102–3. Heal's also sold contemporary nets; see ibid. (1951), no.8, p.104. The magazine's comprehensive survey on Terylene in September 1954 was followed by an article noting that apart from blends with wool, a high percentage of British-made furnishing nets were 100 per cent Terylene: ibid. (1957), no.11, p.118.

19 *The Ambassador* (1969), no.10, p.71. See also A. Richard Horrocks et al. (eds), *Handbook of Technical Textiles* (Boca Raton, FL, 2000), pp.113–14

20 *The Ambassador* (1946), no.7, p.124; ibid. (1952), no.11, p.82

21 Orlon, the DuPont acrylic brand, was isolated in 1941 and went into large-scale production in 1951. Dynel, a continuous filament modacrylic, was introduced in 1949 by the Union Carbide Corporation and was a modification of the first modacrylic, called Vinyon N, developed by the company in 1948. Acrilan 15, made from 1955 in Britain by Chemstrand Ltd, a wholly owned subsidiary of Monsanto's American company, Chemstrand (where Acrilan had begun development in 1942), was most successful at displacing wool use in carpets. *The Ambassador* (1962), no.10, pp.164–7

22 *The Ambassador* (1956), no.5, pp.105–20

23 *The Ambassador* (1951), no.10, p.10

24 *The Ambassador* (1955), no.10, p.84

25 *The Ambassador* (1948), no.10, p.91 and p.100, the latter a statement by William Turnbull Jr, director of Turnbull & Stockdale and chairman of the furnishing fabric section of the Manchester Chamber of Commerce. In *The Ambassador* (1949), no.5, pp.95–7, a report on the BIF shows the same trend. As late as 1956 (ibid., no.10, p.104) linen 'fishnets' and screen-printed gauzes by Donald Brothers, the Dundee-based manufacturers specializing in linen and jute spinning and weaving, were being presented as 'exciting . . . window treatments'.

26 After Hans's retirement in November 1964 (see p.36), his role was taken by a Thomson-appointed employee, Gordon Brunton. Correspondence with Annamarie Phelps, 27 April 2011

27 *The Ambassador* (1957), no.1, p.1

28 This point is apparent in the late 1940s promotion of cloths designed in the late 1930s by, for example, Marion Dorn; see *The Ambassador* (1949), no.5, p.97

29 For 'Rose', see Schoeser, *Marianne Straub*, p.54, and *The Ambassador* (1952), no.1, p.91. For Sutherland's prominence as a designer at the BCMI, see Mary Schoeser, 'Fabrics for Everyman and for the Elite', in P.J. Maguire and J.M. Woodham (eds), *Design and Popular Politics in Postwar Britain* (Leicester, 1997). Exhibitions continued, although the Style Centre was not officially opened until 1942. For a similar Style Centre exhibition in 1941, see *International Textiles* (1941), no.4, pp.24 *passim* and no.5, p.25 *passim*.

30 *The Ambassador* (1955), no.10, pp.106–25, also including two pages on how colour appears altered by bright sunlight. See also Alan Peat, *David Whitehead Ltd: Artist Designed Textiles, 1952–1969* (Oldham, 1993)

31 *The Ambassador* (1943), no.4, p.28

32 *The Ambassador* (1944), no.1, p.36

33 *The Ambassador* (1951), no.1, p.68

34 *The Ambassador* (1952), no.7, pp.74–7, 86–7. Among other things, Juda blamed 'art jargon' borrowed from the intellectual magazines and bad selling.

35 See, for example, *The Ambassador* (1954), no.9, p.128, including an image of some of the designs done in one day by students of Eduardo Paolozzi at the Central, where Juda was later a governor, and ibid. (1957), no.12, pp.104–9. Students of the RCA (Albeck), the Central (Beryl Coles) and Corsham Court (Eric Degg) also participated in the *Painting into Textiles* exhibition: see *The Ambassador* (1953), no.11, p.91

36 *The Ambassador* (1963), no.1, pp.56-71 and p.46 [on florals]

37 *The Ambassador* (1958), no.6, p.82, including a 'fluid abstract' by Shirley Craven, and ibid. (1966), no.4, pp.73–80. The latter's list of designers reads like a 'hall of fame', but shows photographs of them, rather than their fabrics.

38 *The Ambassador* (1960), no.5, pp.103–14; other new textiles inspired by old ones include Lucienne Day's 'Halcyon' for Heal's, from an eighteenth-century Bromley Hall design. The Style Centre had mounted a loan exhibition of chintzes in 1955, which was the precursor of the 1960 V&A show; see also *The Ambassador* (1963), no.1, pp.50–53.

39 *The Ambassador* (1955), no.9, p.100

40 See, for example, *The Ambassador* (1958), no.1, pp.88–95

41 See, for example, *The Ambassador* (1958), no.4, pp.68–73 [fireplaces], and ibid. (1955), no.5, pp.76–89 [a traditional Chelsea house and a 'palatial 18th-century residence overlooking the River Thames']

42 *The Ambassador* (1953), no.6, pp.78–85

43 *The Ambassador* (1957), no.4, pp.98–108

44 *The Ambassador* (1958), no.7, pp.90–100; ibid., (1959), no.4, pp.110–15

45 *The Ambassador* (1962), no.1, pp.61–9; ibid. (1964), no.4, pp.67–70.

46 *The Ambassador* (1952), no.1, p.95

47 *The Ambassador* (1956), no.3, pp.100–01; ibid. (1960), no.10, pp.136–45

48 *The Ambassador* (1955), no.5, p.88 [Hamilton House]; ibid. (1960), no.1, p.79 [including also showing work by Conran Contracts for Bazaar and by Dennis Lennon for Jaeger]; ibid. (1956), no.7, p.108 [Design Centre]; and ibid. (1959), no.4, pp.104–9 [with G-Plan Gallery (sic) as the backdrop]

49 *The Ambassador* (1960), no.8, pp.3–4 [with extract of a speech by HRH the Duke of Edinburgh]; ibid. (1961), no.8, pp.100–06

50 *The Ambassador* (1962), no.4, pp.40–48; ibid. (1963), no.1, pp.46–72

51 *The Ambassador* (1961), no.10, pp.75–82; ibid. (1962), no.10, pp.137–41

52 *The Ambassador* (1958), no.5, pp.68–9

53 *The Ambassador* (1967), no.1, pp.67–70

54 See Mary Schoeser, *Fabrics and Wallpapers* (London, 1986), pp.96–9

55 Well-established firms such as Sanderson, Courtaulds and Warners advertised infrequently, undoubtedly because they already had well-established networks of agents and representatives overseas.

56 *The Ambassador* (1970), no.8, pp.73–4

57 In January 1967 the magazine brought 'all the constituents of an interior under one heading – Ambassador Interiors'. This not only turned the focus away from textiles, but also placed the magazine in competition with other better-established design and interior magazines. The singular voice of Juda was replaced by interviews with managers and very brief reports on new products (and far less on new trends), often accompanied by tiny or half-tone images. See, for example, *The Ambassador* (1972), no.7, pp.46–7, and ibid. (1970), no.10, pp.66–71, which introduced its coverage with the comment that 'British furniture designers for years lagged behind their foreign counterparts.'

5. Fashion and *The Ambassador*: 'The World is the Customer of Fashion'

Claire Wilcox

1 Elsbeth Juda, interview (autumn 1992), AAD/1987/1/207

2 F. Hodgson, 'Glamour Meets Commercial Photography', *Financial Times* (2 May 2009)

3 See discovery.nationalarchives.gov.uk

4 *International Textiles* (January 1942), p.25

5 *International Textiles* (August 1942), p.19

6 *The Ambassador* (1951), no.6, pp.112–13

7 Claire Wilcox (ed.), *The Golden Age of Couture* (London, 2007), p.39

8 Ibid.

9 Ibid., pp. 40–42

10 *The Ambassador* (1948), no.2, p.76

11 *The Ambassador* (1948), no.8, p.87

12 Ibid., pp.87 and 93

13 Elsbeth Juda interview, 1992

14 I am grateful to Edwina Ehrman for pointing out that the members of INSOC drew names from a hat in order to decide which ballerina each couturier should dress.

15 Elsbeth Juda interview, 1992

16 *The Ambassador* (1949), no.10, p.114

17 Elsbeth Juda interview, 1992

18 *The Ambassador* (1960), no.7, p.88

19 *The Ambassador* (1961), no.9, pp.76–9

20 *The Ambassador* (1968), no.6, pp.35–6

21 *The Ambassador* (1961), no.5, p.23

22 *The Ambassador* (1968), no.11, pp.74–81

23 Elsbeth Juda interview, 1992

24 *The Ambassador* (1951), no.6, p.115

25 Elsbeth Juda, interview, 1992

Further Reading

Copies of *The Ambassador*, and its predecessor *International Textiles*, are available for consultation at the V&A in both the National Art Library (covering 1944 to 1972) and the Archive of Art and Design (covering 1933 to 1970).

Christine Boydell, *Horrockses Fashions: Off-the-Peg Style in the '50s and '60s* (London, 2010)

Christopher Breward and Ghislaine Wood, eds, *British Design From 1948: Innovation in the Modern Age* (London, 2012)

Frances Hodgson, 'Glamour Meets Commercial Photography', *Financial Times*, 2 May 2009

In Our View (Sheffield, Graves Art Gallery, exh. cat., 1967)

Lesley Jackson, *Alastair Morton and Edinburgh Weavers: Visionary Textiles and Modern Art* (London, 2012)

Stanley Marcus, *Minding the Store* (Boston, MA, 1974; reprinted 1997)

Painting into Textiles (London, ICA, exh. cat., 1953)

Alan Peat, *David Whitehead Limited: Artist Designed Textiles, 1952–1969* (Oldham Museum and Art Gallery, exh. cat, 1993)

Geoffrey Rayner, Richard Chamberlain and Annamarie Stapleton, *Artists' Textiles in Britain: 1945–1970* (Woodbridge, 2003)

Mary Schoeser, *Marianne Straub* (London, 1984)

Annamarie Stapleton, 'The Ambassador', *Decorative Arts Society Journal* (2009)

Lisa Tickner, ' "Export Britain": Pop Art, Mass Culture and the Export Drive', *Art History* vol. 35 no. 2 (April 2012), pp.394–419

Claire Wilcox, ed., *The Golden Age of Couture: Paris and London 1947–57* (2007)

Acknowledgements

We would like to thank Elsbeth Juda for her tremendous enthusiasm and support for this project.

Annamarie Stapleton's article in the *Decorative Arts Society Journal* kick-started this publication and we are hugely grateful for both her generosity in sharing her knowledge and her careful guidance in working on this project.

The rich content of *The Ambassador* had been explored in two previous exhibitions: *Homage: Elsbeth Juda (Jay)* at the Fine Arts Society London, 17 March – 11 April 2003 and *Elsbeth Juda (Jay) Photographs 1940–46* at L'Equipement des Arts, London. We would like to thank the Directors of L'Equipement des Arts: Michael Mohammed, Andrew McIntosh Patrick and David de Kervern.

We are grateful to Mark Eastment for his vision in the commissioning the book and to Frances Ambler for her professionalism and exceptional dedication to the project. We would also like to thank Clare Davis for her work on the book's production, the copy-editor Delia Gaze and the designer Lizzie Ballantyne.

Thanks are due to our colleagues in the V&A Museum: Ken Jackson, Clare Johnson and Paul Robins in the photostudio; Christopher Marsden and Eva White in the Archive of Art and Design and Edwina Ehrman in the FTF department. We are also grateful for the selfless work of volunteers Rachel Daley, Paola di Trocchio and Camilla de Winter.

With special thanks to Gail Sulkes.

Contributor Biographies

Christopher Breward is Principal of Edinburgh College of Art, Vice Principal of the University of Edinburgh and Professor of Cultural History. He was previously Head of Research at the V&A and is co-curator of the exhibition *British Design 1948–2012*. He has written many books on the history and culture of fashion.

Claire Wilcox is Senior Curator of Fashion at the V&A. She has curated many exhibitions including *Vivienne Westwood* (V&A 2004) and *The Golden Age of Couture* (V&A 2007) and edited the accompanying books.

Alexia Kirk is the archivist in the V&A's Archive of Art and Design, with responsibility for acquiring, preserving and providing access to the Museum's collection of artists' and designers' papers. She formerly worked as project archivist at the Theatre Museum.

Gill Saunders is Senior Curator of Prints in the Word & Image Department of the V&A. She writes, lectures and broadcasts on twentieth century and contemporary art. She is the editor of *Recording Britain* (V&A 2011).

Mary Schoeser is a freelance writer and curator. Her recent publications include *Sanderson: The Essence of English Decoration* (2010) and *Sanderson* and *Heal's* in the V&A Pattern series (2012).

Annamarie Stapleton specializes in nineteenth- and twentieth-century British design and contemporary crafts and she has been involved in a number of pioneering exhibitions at The Fine Art Society. She contributed to *Austerity to Affluence 1945–1962* (1997), *Artists Textiles in Britain 1945–1970* (2003) and *Piper in Print* (2010), wrote *John Moyr Smith: A Victorian Designer* (2002), and is currently editor of the *Decorative Arts Society Journal*.

Abraham Thomas is the V&A's Curator of Designs, and lead curator for architecture. He is the curator of several exhibitions including *Paper Movies: Graphic Design and Photography at Harper's Bazaar and Vogue, 1934 to 1963* (2007), *1:1 Architects Build Small Spaces* (2010) and *Heatherwick Studio: Designing the Extraordinary* (2012). Abraham contributed to the V&A exhibition catalogue for *The Golden Age of Couture* (V&A 2007) and is currently writing a book on the V&A's collection of fashion drawings and photographs (2013).